READINGS
in
Nineteenth-Century Art

Edited by

JANIS TOMLINSON
Columbia University

Prentice Hall
Upper Saddle River, New Jersey 07458

Library of Congress Cataloging-In-Publication Data

Readings in nineteenth-century art
edited by Janis A. Tomlinson
 p. cm.
 Includes bibliographical references.
 ISBN 0-13-104142-8
 1. Art, Modern—19th century. I. Title.
N6450.T66 1996
709'.03'4—dc20

95–10581
CIP

Acquisitions editor: *Bud Therien*
Editorial assistant: *Lee Mamunes*
Production editor: *Jean Lapidus*
Copy editor: *Maria Caruso*
Cover designer: *Bruce Kenselaar*
Manufacturing buyer: *Bob Anderson*

© 1996 by Prentice-Hall, Inc.
Simon & Schuster/A Viacom Company
Upper Saddle River, New Jersey 07458

Printed in the United States of America
10 9 8 7 6 5 4 3 2 1

ISBN 0-13-104142-8

PRENTICE-HALL INTERNATIONAL (UK) LIMITED, *LONDON*
PRENTICE-HALL OF AUSTRALIA PTY. LIMITED, *SYDNEY*
PRENTICE-HALL CANADA INC., *TORONTO*
PRENTICE-HALL HISPANOAMERICANA, S.A., *MEXICO*
PRENTICE-HALL OF INDIA PRIVATE LIMITED, *NEW DELHI*
PRENTICE-HALL OF JAPAN, INC., *TOKYO*
SIMON & SCHUSTER ASIA PTE. LTD., *SINGAPORE*
EDITORA PRENTICE-HALL DO BRASIL, LTDA., *RIO DE JANEIRO*

Contents

Preface

This anthology provides an introduction to current scholarship in nineteenth-century European art. In its emphasis on French art, it reflects the interests of recent scholarship as well as the content of most undergraduate curricula. The articles selected are intended for use in upper-level undergraduate courses as a complement to more broadly based texts. The selection and presentation thus follows a chronological, rather than methodological or thematic sequence.

Given the number and range of articles that have appeared within the past decade, the selection was not an easy one. In choosing articles, I sought to illustrate a variety of approaches by studies written in a style comprehensible to undergraduates. My own brief introductions will, I hope, facilitate their accessibility. Although my aim was to present a range of methods and themes, my choice was determined by concerns of recent scholarship: the recurrence of themes such as the female nude, the role of the critic and of exhibitions and institutions was inevitable. Articles not readily available in other paperback collections or texts were chosen in preference to others elsewhere reproduced.

Practical considerations also had a role to play. In order to keep the cost of the text within a certain range, the length of this book and the number of illustrations were limited. As a result, articles that depended heavily on numerous illustrations could not be used. Extremely lengthy articles were also excluded as I did not consider it appropriate to edit another scholar's work. Finally, the articles included were published originally in English.

I would like to thank the colleagues and teachers who have shared their knowledge, expertise, and suggestions for this collection as well as those au-

thors who so generously allowed their work to be reprinted. I would like espe-
cially to thank Zeynep Celik, Leila Kinney, Paul Tucker, and Ann Wagner, who
graciously contributed photographs as well as articles. I am also indebted to
Professor Petra ten-Doesschate Chu and Professor James H. Rubin for their
comments on the manuscript. Finally, my thanks to my research assistant, Loch
Adamson, for her indefatigable efforts in putting photographs and permissions
in their proper places.

Janis Tomlinson

The Musée du Louvre as Revolutionary Metaphor During the Terror*

ANDREW L. McCLELLAN

The images of revolutionary martyrs painted by Jacques-Louis David, the *Sleep of Endymion* by Girodet, or the transformations in painting and patronage examined by Robert Rosenblum in the exhibition catalogue *French Painting 1774 to 1830: The Age of Revolution* remain central to an examination of painting during the French Revolution. But equally important is an understanding of the Revolution's impact on institutions central to the production and exhibition of art: the Academy and the museum.

During the late eighteenth century, Enlightenment thought fostered the opening to the public of art collections formerly accessible to only the privileged few. In Paris, the Luxembourg Gallery embodied the earliest attempt to create a public museum. When it closed in 1779, d'Angivillier—Louis XVI's minister of the arts—turned his attention to the construction of a Grand Gallery in the Louvre. This project was unfinished at the outbreak of the French revolution.

The revolutionary government soon intervened, and the project became a highly politicized one. Its opening was planned to coincide with the Festival of National Unity on 10 August 1793. The procession, orchestrated by David, celebrated the triumph of the people, a triumph reconfirmed as the people could now enter a national museum in what had formerly been a royal palace. The works displayed were no longer the possessions of the king or the church: they belonged to the people. Given his role as "pageant master," it is not surprising that David became the major spokesperson for art and art education under the Revolution. He championed the abolition of the Academy—seen as a vestige of the *ancien régime*—and also that of the traditional student/master relationship. Students could now go to the Louvre to study paintings arranged in a new, rational order—by school and chronology (an order we generally take for granted today). Marking an enlightened departure from the eclectic arrangement of works formerly seen at the Luxembourg Gallery, this new order was itself a political statement.

Revolutionary goals also demanded reconsideration of the objects on display. Frivolous luxuries were not to be seen, and even paintings such as Rubens' Marie de' Medici series were considered problematic, given their celebration of the monarchy. It is perhaps ironic that, in order to serve the liberation of the people, objects and images were subject to a new type of censorship.

*"The Musée du Louvre as Revolutionary Metaphor During the Terror," by Andrew McClellan. *Art Bulletin,* vol. 70, no. 2, (June 1988). Reprinted by permission of the College Art Association, Inc.

When the monarchy in France collapsed in 1789, the ambitious project of Louis XVI's minister of the arts, the Comte d'Angiviller, to transform the Grand Gallery of the Louvre palace into the most splendid museum of art in Europe collapsed with it. D'Angiviller himself fled the country and the first Revolutionary government was left to complete the Louvre project and to claim it as their own. On 10 August 1793 the doors of the Musée du Louvre were opened and the public was invited to inspect works of art that had once belonged to the king, his courtiers, and the Church, but which now belonged to the Republic, and a space that was no longer a royal palace but a palace of the people. The purpose of this essay is to examine aspects of the formation of the Musée du Louvre at the height of the French Revolution and the symbolic values it possessed at the time.

During the last forty years or so of the *Ancien Régime,* successive governments sought to create a public museum of art in Paris that would be the envy of Europe. The majestic but incomplete and half-empty Louvre palace presented itself as the obvious setting for such a museum; located at the heart of the capital, it was at once a royal palace and an enduring symbol of French cultural ascendancy over the rest of Europe (Perrault's triumph over Bernini in the competition to design the east façade had yet to be forgotten). Moreover, the Louvre was already the seat of the various royal academies, including the Academy of Painting and Sculpture, and the vision of embracing all branches of knowledge and expertise under one roof, like a living encyclopedia, appealed greatly to the mentality of the Enlightenment.

At mid-century the Louvre was in no fit state to receive a picture gallery, however, and another royal palace, the Luxembourg, was chosen instead. Between 1750 and 1779, just over one hundred paintings, together with assorted marble tables and other *objets de luxe,* included to create an air of splendor in keeping with a royal display, were exhibited to the public on two days a week in a sequence of rooms in the east wing of the palace.[1] Across the courtyard, in the west wing, the public could view, in its original setting, the celebrated cycle of pictures by Rubens illustrating the life of Marie dé Medici, for whom the palace had been built.

It would seem that no contemporary views of the gallery survive, but fortunately the catalogue, which was sold at the door and designed to accompany a tour of the collection, provides a clear idea of how the pictures were arranged. What is important to note here about the display is that the paintings were hung according to what I would call an "eclectic" system, whereby works by different artists and of different genres were carefully juxtaposed to afford the beholder a continuous contrast of style and subject. Created by members of the Academy as a part of a wide-ranging program of artistic reforms initiated in 1747 by the current minister of the arts, Lenormand de Tournehem, the gallery was to provide artist and *amateur* alike with a visual lesson in the art of painting through direct comparison of representative examples of the three schools: the Italian, Northern, and French.[2] It was this pedagogic purpose that distinguished

the Luxembourg from the private *cabinet de tableaux* of the day. In the latter, what governed the distribution of paintings was, typically, the size and shape of the individually framed objects and the desire to achieve a harmonious, symmetrical decorative effect, with little or no regard for the stylistic qualities of particular works.[3] In the former, it was precisely those qualities in each painting which the sequence of calculated juxtapositions was intended to elucidate.

This "eclectic" system was derived from the theory, encapsulated in Roger de Piles' influential *Balance des peintres,* first published in 1708, that the art of painting was divisible into four parts of equal status—composition, design, color, and expression—and that the goal of the aspiring artist was to attain an equal degree of perfection in each.[4] To assist him to this end, the young artist was to turn to the Old Masters for guidance. According to the *Balance,* different painters had excelled in the various parts, but no one reigned supreme in all. Therefore the Old Masters had to be studied selectively, and the surest means of apprehending the strengths and weaknesses of a given artist was through comparison of his work with that of others. In other words, the assumption behind the adoption of the "eclectic" system at the Luxembourg was that the young painter would better understand and appreciate the genius (and shortcomings) of, say, Van Dyck if his work was juxtaposed with that of Poussin and Veronese. De Piles' influence on the formation of the gallery is hardly surprising, given that it was established by artists primarily for the benefit of students at the Academy. His influence on academic doctrine in the first half of the eighteenth century (and beyond) was considerable, and we must remember that many of those artists who controlled the Academy in the late 1740s were either themselves disciples of de Piles or students of his disciples.[5] Chief among them was Charles-Antoine Coypel who, as *Premier Peintre du Roy* and director of the Academy from 1747 to 1752, was responsible for the Luxembourg project. Coypel's father, Antoine, was a close friend of de Piles, and his *Discours prononcés dans les conférences de l'Académie Royale* of 1721 are highly de Pilesian in character.[6] Charles-Antoine, for his part, described de Piles one year after the Luxembourg opened as a "profound connoisseur"[7] and the frontispiece that he designed for his father's treatise, showing the allegorical figure of Painting inviting the beholder to contemplate the marvels of the great masters, serves as an excellent schematic illustration of the "eclectic" principle at work in the gallery.

D'ANGIVILLER'S LOUVRE PROJECT

When, in 1779, Louis XVI's brother, the Comte de Provence, decided to make the Luxembourg palace his Paris residence, the gallery was closed and plans to establish a much more ambitious museum in the Grand Gallery of the Louvre were set in motion. Creating this museum and making it the most magnificent thing of its kind in Europe became one of the main goals of the administration of Louis XVI's minister of the arts, the Comte d'Angiviller.[8] Between 1775 and the start of the

French Revolution in 1789, well over one million livres were devoted to buying and commissioning works of art for the king;[9] prominent architects and artists were consulted to insure that the Grand Gallery was transformed into a setting worthy of the finest collection of art in Europe;[10] new marble tables and *objets de luxe* were acquired to lend the vast space the required note of opulence;[11] and standards of picture restoration were carefully monitored to guarantee that the paintings themselves would be seen to their best advantage.[12]

Because the Revolution prevented d'Angiviller's project from being realized, one can only speculate about how the Grand Gallery would have looked upon completion. Nevertheless, enough evidence exists to allow us to conclude that in his museum the "eclectic" system of the Luxembourg would have been abandoned in favor of a more progressive ordering of the paintings according to school and chronology. Instruction in the art of painting would have given way to instruction in the history of art. First, the pattern of picture buying between 1775 and 1789 reveals an apparent desire to present at the Louvre a more comprehensive overview of the three schools of painting and a more equal balance between them than had existed at the Luxembourg. The majority of Old Master paintings acquired by d'Angiviller were of the Northern and French schools, areas in which the royal collection was previously lacking, while the handful of Italian paintings that were bought were by lesser masters—Cavaliere d'Arpino, Cignani, Schedoni, Lauri, Zuccaro, and Luti—who were not already represented in the king's collection.[13] Secondly, those involved with the museum project would have known that two of the great princely galleries of Northern Europe, the Electorale Gallery in Düsseldorf and the Imperial Gallery in Vienna, had recently been rearranged according to school, and that at Vienna a pioneering attempt had been made to demonstrate the historical development within each school by the way that works were hung.[14] These two galleries, then, had set a progressive standard for the installation of large public collections, one that d'Angiviller would have had to emulate if he hoped that his museum would rival them in modernity.

In hindsight, it seems remarkable that, as late as the winter of 1788–89, d'Angiviller still believed that the museum could be ready to open in as little as two or three years.[15] But of course after the fall of the Bastille in 1789, events took a turn for the worse for the monarchy. In April, 1791, d'Angiviller fled France, never to return. It was left to the Revolutionary government of 1793 to add the finishing touches to his project and to claim it as their own.

It is more than coincidence that the public museum of art had its origins in France during the Enlightenment. No one would deny that the insistence on the value to society of education and the desire to collect and systematically present information that we associate with the Enlightenment had a hand in persuading the kings of France (and rulers elsewhere in Europe) to open their personal art collections to the public. And yet if Enlightenment philosophy may be said to account in some measure for the idea of the museum, it was mundane politics that were responsible for its realization. Each government in Paris after 1750 that

wanted to create a public museum in the capital had its own political motives; each had a clear idea of how the Crown could benefit from the existence of this "enlightened" institution. The fusion of politics and Enlightenment attitudes towards the display of art in the Musée du Louvre at the height of the French Revolution, that is to say during the Terror, is my interest here. There were two fundamental political urges that drove Revolutionaries to complete the museum in the space of just one year: first, to provide a transparent metaphor for the triumph of the new order over the old; and, second, to create the most comprehensive, rational art museum the world had ever seen, which would in turn demonstrate the intellectual advancement of the young Republic.

THE REVOLUTIONARY LOUVRE

The Revolutionary chapter in the history of the Musée du Louvre began on virtually the same day that the tottering Bourbon monarchy finally collapsed—10 August 1792, when the Tuileries Palace was overrun and King Louis XVI was taken prisoner. Until then the Louvre had remained a royal palace and the museum a project supervised by the king's architects. As late as April of that year, the *bon du roi* had still to be acquired before the architect Mique could begin the long-overdue structural repairs to the sloping stable walls that supported the Grand Gallery from below.[16] However, with the fall of the monarchy, the king's art collection was declared national property, as Church property had been three years earlier, and the National Assembly quickly announced its interest in accelerating the completion of the museum. On 19 August the Assembly issued the following decree: "The National Assembly, recognizing the importance of bringing together at the museum the paintings and other works of art that are at present to be found dispersed in many locations, declares that there is urgency"[17] In September, responsibility for the Louvre was given to the new Minister of the Interior, the Girondin Jean-Marie Roland. Roland, with the support of the recently convened National Convention, appointed a panel of five artists—Regnault, Vincent, Jollain, Pasquier, and Cossard—and one mathematician, Bossut, to be known as the Museum Commission to oversee the project.[18] To these six men fell the task of preparing the Grand Gallery for the display and of deciding which works of art should be chosen for exhibition from a huge collection of art objects. This gathering included, in addition to the former royal collection, the full range of paintings, sculptures and *objects d'art* confiscated by the Republic from émigrés and the Church.

The Museum Commission evidently worked with considerable haste and efficiency through the winter of 1792–93, for in February it announced that the provisional arrangement of the gallery was almost finished. Although more paintings and assorted works of art continued to be added to the display during the months that followed, the organizational principles had been determined and were not to change.[19] It was at that juncture that the politicians began to take over.

It was inevitable that the birth and development of the museum would be influenced by what was happening in the world beyond its walls. A succession of events in 1793—most notably, the federalist movement and the royalist rebellion in the provinces, the initial military setbacks on the eastern front, and the assassination of Marat—pushed the Revolution to the Left and affected the government's attitude toward the Louvre. Fear of royalist conspiracy and of failure during this uncertain period sparked a vigorous campaign of "public instruction" that sought to shore up the foundations of the Republic by revolutionizing every aspect of life. The museum was not overlooked and, as will be seen, in the course of 1793–94 it became an important tool of Revolutionary propaganda. It must be stressed that the museum was revolutionized by politicians and not by the men who made up the Museum Commission, whose approach to the museum was aesthetic rather than political. The politicians were initially Dominique Garat, who, as Roland's successor as Minister of the Interior (Roland resigned in January), was responsible for propaganda, and later the Committees of Public Instruction and Public Safety. They realized that a political meaning could be imposed on the national museum and that it could be made to serve Revolutionary ideology.

Garat, who prior to the Revolution had achieved some celebrity as a *philosophe* and man of letters, was the first to link the museum project with contemporary events. In a letter of 21 April 1793, he urged the Museum Commission to press on with the gallery, "the interest in which," he wrote, "increases daily due to present circumstances." He went on to say:

> The achievement of this victory [i.e., the completion of the museum] at the present moment in time, over our domestic troubles as well as our external enemies, is by no means the least important of those to which the national effort should be directed; in particular, it would have an invaluable effect on public opinion, which is so often the sovereign mistress of the fate of empires.[20]

At that point Garat seemed uncertain just how the museum could influence public opinion and to what end; the best he could do by way of an explanation was to suggest that its very presence would tend to assuage "the fury of our passions and the calamities of the war," assuring the people that, in spite of troubles at home and abroad, calm and order reigned in the capital.

A crucial step was taken in May when the Convention directed its Committee of Public Instruction to draw up plans for a public festival commemorating the first anniversary of the birth of the Republic, to take place in Paris on 10 August 1793. Garat wrote to the President of the Convention a little over a month later to suggest that the museum and the Salon exhibition of contemporary art should contribute to the celebrations by opening simultaneously on the same day. His idea was to associate the museum with the achievements and direction of the Revolution and to prove, in his words, "to both the enemies as well as the friends of our young Republic that the liberty we seek, founded on

philosophic principles and the belief in progress, is not that of savages and barbarians." Furthermore, he observed that the inauguration of the museum on 10 August would demonstrate that the Republic had succeeded in doing in one year what the monarchy had failed to do in more than twenty (needless to say, d'Angiviller's efforts were nowhere acknowledged).[21] Garat's proposal was greeted with great enthusiasm and from that moment on the Museum Commission had a specific goal to work toward. The foundation of the museum might well have merited a celebratory festival of its own, but it was to be assimilated into the more important Festival of National Unity, as it came to be known.

The opening of the Louvre and the Festival of National Unity stand out as two signal Republican achievements of 1793, and it was highly appropriate that they occurred on the same day. To grasp the significance of this connection, it will suffice to consider briefly the purpose of the Revolutionary festival and the meaning of the Louvre in 1793.

In a tract addressed to the Convention in year II of the Republic (1793–94) entitled *Essai sur les fêtes nationales suivi de quelques idées sur les arts,* the ubiquitous Boissy d'Anglas introduced his discourse on the crucial role of the civic festival in the body politic by first summarizing the ultimate goal of the Revolution: "It is to bring people together and to effect the absolute and permanent regeneration of mankind . . . it is to return man to his natural state of purity and simplicity through an understanding and the exercise of his rights. . . . It is finally to destroy once and for all the chains that oppress and enslave him."[22]

Revolutionaries of all political colors (d'Anglas was himself a moderate) realized that such grand ambitions could only be fulfilled with the help of education. Authority alone was not enough to direct a revolution: the willing consent and participation of the people were also required. To secure participation, the minds of the people had to be won over, and this was to be done through a comprehensive system of public instruction. "It is by educating a man," wrote d'Anglas, "that you will regenerate him in a manner absolute and complete."[23] Man had to learn to be free; he had to be taught to reject his old values and to place his faith in the future of the Republic. The program of public festivals, which was gradually expanded as the Revolution progressed, gave legitimacy to the new order by filling the gap left by the discontinuance of royal celebrations and regular religious worship, and lent the experience of the Revolution a sense of what one recent historian has termed "psycho-political continuity."[24] In short, the festival was central to the concept of "public instruction" and didacticism was at the heart of Revolutionary politics.

The festival of 10 August combined and made manifest two themes that recur throughout the Revolutionary literature and that in particular figure prominently in Jacobin discourse: namely, national unity and the regeneration of the people. These concerns were transparent in the focal point of the festival—the elaborate procession and its attending imagery designed by Jacques-Louis David—but they were also to be felt in the organized spectacle at the Louvre.

The procession began at dawn on the morning of 10 August at the Place de

la Bastille, where the people drank from a fountain of regeneration, built espe-
cially for the purpose, which at once cleansed them of any association with the
past and "baptized" them as citizens of the Republic. From the Bastille the pro-
cession made its way, the people arm in arm, "the mayor with his scarf next to the
butcher or stonemason . . . the black African . . . beside the white European,"
along a carefully planned route that was punctuated by dramatic spectacles at cer-
tain strategic locations associated with the downfall of the Old Regime. At the
Place de la Concorde, for example, the crowd watched the eighty-six Departmen-
tal representatives, each with torch in hand, light a symbolic pyre placed before a
statue of Liberty, which stood on the pedestal that once supported Bouchardon's
statue of Louis XV. Thousands of birds were then set free. The procession termi-
nated in front of the altar of the Fatherland at the Champ de Mars where the
Constitution was read and a joint oath of allegiance was sworn.[25] It was a brilliant
allegorical drama, institutionalizing the emblems of the Republic while ceremo-
nially doing away with those of the monarchy, and with the nation joined as one
as it relived from one station to the next the progress of the Revolution since the
fall of the Bastille. It goes without saying that the opening of the museum was
overshadowed by the festival, but those who did visit the Louvre would have
come away with a similar sense of Revolutionary triumph over despotism and of
a bright future for the society reborn. In effect, the museum may be viewed as an
extension of the festival outdoors.

On that day above all others, the rich historical associations of the Louvre
would have seemed particularly significant. The Revolutionaries' design to re-
generate society and to cut the Republican present free from the despotic past was
put into effect on two levels. On one, new symbols for public worship were sub-
stituted for those of old: the fasces replaced the fleur-de-lis, the female image of
Liberty replaced the Virgin, and so on. And on the other, the past, in all its mani-
festations, was either destroyed or appropriated and revolutionized. David's fes-
tival skillfully blended the two possibilities: all the trappings of the new *culte
révolutionnaire* were paraded through the streets and squares, which now be-
longed to the people. To occupy the space that had previously been tightly con-
trolled was an instinctive urge after the collapse of the Old Regime. In the words
of Mona Ozouf: "The appropriation of a certain space, that needs to be opened
and forced, is the first climactic pleasure offered by revolutions."[26] This applied
to internal space no less than to space outdoors, and of all royal buildings in Paris
none was more conspicuous, and therefore more attractive to Revolutionaries,
than the Louvre. Entry to the palace, and the Grand Gallery in particular, had been
carefully regulated during the *Ancien Regime.* Until 1776, the Grand Gallery was
home to the famous scale-relief models of the strategic towns and military fortifi-
cations that dotted the periphery of France and, for obvious political reasons, was
kept under strict lock and key. Permission to visit the *galerie des plans,* as it was
known, had to be obtained from the king himself and was customarily reserved
for high-ranking courtiers, foreign ambassadors, and visiting heads of state. Even
after d'Angiviller had the models removed to the Invalides (where they may be
seen to this day) to make way for the museum, the gallery was not generally ac-

cessible, it would seem, except to those in the artistic community involved with or interested in the project.[27] In the summer of 1793 the government would have been alive to the significance of "liberating" this formerly privileged space.

Inside the museum, the feeling of Revolutionary conquest was unequivocal. The works of art on display had been prized from their pre-Revolutionary settings and returned to their "rightful" owners—the people. According to the Abbé Grégoire, those treasures "which were previously visible to only a privileged few . . . will henceforth afford pleasure to all: statues, paintings, and books are charged with the sweat of the people: the property of the people will be returned to them."[28]

In the weeks leading up to 10 August, the Museum Commission was instructed to fill the gallery to the brim in order to make manifest the full extent of the Republic's new-found wealth. Vases and tables, columns and busts, in bronze, porcelain, and a variety of precious marbles were brought from the various storage depots in the capital to create an air of sumptuousness in sharp contrast to the austerity of the times. The display was intended to dazzle the eye of the beholder. In July, Garat wrote to the Commission: "It would be appropriate to bring together for the opening everything that will enhance our precious collection of treasures to impress upon those who are coming to Paris to take part in the festival that our present political problems have in no way diminished the cultivation of the arts among us."[29]

At one and the same time, the museum served as a symbol of the stability of the state and as a tangible reminder of the triumph of the people. Furthermore, for a period of two weeks, beginning on 3 August, the public was admitted to the depot of the Petits-Augustins to view the vast hoard of property, most of it confiscated from Paris churches, arranged according to provenance. The event proved such a success that the depot's keeper, Alexandre Lenoir, was given leave to keep the exhibition open until the end of September.[30] Some time later at the Louvre, the names of émigrés were attached to works of art that had come from their collections. The journal *La décade philosophique* ridiculed the custom, remarking that a number of visitors had mistaken busts of Alexander the Great for the Prince de Condé and Plato for the Duc de Brissac, but clearly it satisfied a deep-rooted emotional need.[31]

THE MUSEUM AS REPUBLICAN ACADEMY

The Louvre was not simply a bastion of monarchy that had to be publicly liberated: it was also the home of the Royal Academy of Painting and Sculpture. During the course of the century, discontent with the hegemony of the Academy in the Parisian art world had grown steadily, to the point that on the eve of the Revolution there were many who were keen to dismantle a system that had so effectively promoted the interests of a privileged few at their expense.[32] After 1789, the academies were among the first institutions of the Old Regime to come under attack. The argument against the Academy of Painting rested on two beliefs: first,

that its hierarchical structure and the economic and social benefits enjoyed by its members were incompatible with the egalitarian reforms that were transforming society; and, second, that its traditional teaching methods were ill-suited to the proper development of artists. The museum was brought into the fray because in the Republican scheme of things it was to replace the Academy as the source of instruction for present and future generations of artists.

The assault on the Academy was led by J.-L. David and a group of fellow artists who met from 1790 as the Commune des Arts.[33] Repeated pamphlets addressed to the National Assembly by the Commune in 1790–91 demanding the abolition of the Academy produced no result. The turning point in the drawn-out battle between dissidents and Academy was David's election in September, 1792, to the National Convention as a deputy from Paris, followed shortly thereafter by his nomination to the influential Committee of Public Instruction. On 11 November, David rose from his seat in the Convention to denounce yet again the continued existence of the Academy, and as a gesture of his good faith, he there and then announced his resignation from it.[34] The alliance forged earlier between the Commune and the Jacobins proved irresistible as the Revolution shifted to the Left. The arts were brought into line with politics and the Academy's days were numbered. In the months that followed, David gradually won over an initially reluctant (or uninterested) house and by July he had persuaded the Convention to order its Committee of Public Instruction, of which he was now a member, to make a report on the suppression of the academies. Finally, on 8 August 1793, after rousing speeches by David and the Abbé Grégoire, the Convention issued a decree dissolving the academies.[35] Responsibility for the arts now passed into the hands of David and his radical colleagues.

In assuming control of the arts, the Commune was faced with the problem of taking over the Academy's functions while eschewing its methods and hierarchical organization. This they were evidently unable to do—at least to the satisfaction of the Convention. The Commune was itself suppressed and official approval transferred to a radical splinter group of the Commune, the Société Populaire et Républicaine des Arts. That occurred in the days of the Terror. The Société Populaire, as the name suggests, was run along the lines of a local popular society or club whose business it was to convert the people to the Republican cause. Artists were vetted to insure that only true Republicans were admitted. All forms of rank were rejected and the Society's meetings in the Louvre were open to anyone who wished to attend. So much for the abolition of privilege. But the Society, now that the traditional academic system was no longer available, was also obliged to address the question of how to provide artistic instruction to aspiring artists, and, more important, how to tailor this education to meet the political demands now being placed on the fine arts.[36] The history of the Academy's dissolution would be little more than a sideshow of the Revolution if it were not for the great store placed by Republicans on the regenerative powers of the arts, for it was through the arts that the people would become familiar with the history, symbols, and martyrs of the Revolution. The arts, in

other words, would play a leading role in legitimizing the Revolution, and, moreover, they would record the tremendous achievement for posterity. The experience of revolution was so different from what had gone before, the break with the past so radical, that a new artistic style was called for to characterize in visual terms the magnitude and nature of the upheaval. "It is time to abandon the traditional French style," wrote G.-F. Bouquier in a remarkable and well-known passage of Revolutionary rhetoric, and in its place must be substituted "an energetic design, a masculine technique, a rigorous color, a bold brush, and a firm touch."[37] Republicans advocated that it was in the museum that these qualities would be acquired.

In the eyes of the critics, the fundamental problem with the academic system was its reliance on the rigid master-pupil relationship. The criticism went as follows: a given pupil was placed at an impressionable age in the studio of an established master to learn the art of painting (drawing was taught at the Academy); to get ahead and to benefit from his master's influence in the Academy and with potential patrons, the young painter had little choice but to imitate his manner. The faults that a painter inevitably had would thus be transferred to his pupil, who in turn would pass them on to the next generation, and so on. In theory, the system doomed the French school to perpetual decline.[38] Miraculously, toward the middle of the century, Vien and his pupils, including David, broke with normal practice and, instead of imitating one teacher, turned for inspiration to nature, the antique, and the Old Masters. Their example alone offered a way forward. Oversimplified though this reading of history may have been, it was in perfect harmony with the principles of liberty ushered in after 1789. The argument against the Academy was in the main specious, but it became disarmingly effective when put forward in a sympathetic political climate. The master-pupil relationship was done away with (at least in theory), and the young painter was given the freedom to study nature and to select the aspects of the Old Masters' styles that he most wanted to emulate and that best suited his chosen genre. From the start, in its first pamphlet to the National Assembly, the Commune had insisted that disciplined study of the Old Masters would be more efficacious than the traditional education offered by the Academy:

> It is patently obvious that this method of instruction [i.e., Academic training] . . . is ill-suited to the formation of artists Give us one that is worthy of liberty . . . one that no longer indentures students to servitude and condemns them to a narrow and impoverished outlook; give them instead a greater sense of the true goal they must aim for; evoke the spirits of the great masters: may their learned and immortal masterpieces speak powerfully and incessantly to the artist inflamed with the love of his art, that he may become their disciple or successor. It is clear that we are calling for the foundation of the national museum.[39]

Late in 1793 the Louvre succeeded the Academy as the principal training ground for the rising generation of artists.

It was the issue of how the museum could best serve these ends that led David into his next confrontation, this time with the Museum Commission. As mentioned above, the Commune had maintained that hand in hand with the abolition of the Academy must go the creation of the museum, and it is clear from their polemical pamphlets that their campaign to replace the Academy was at one and the same time a declaration of their interest in controlling the museum. On 18 December, with Terror now the order of the day and the government keener than ever to bring all institutions, including those pertaining to the arts, under its control, David rose once more from his seat in the Convention and delivered a speech calling for the dissolution of the Museum Commission.[40] His attack hinged on the same joint charge of incompetence and inconsistency with the ideals of the Revolution that had already been used to bring down the Academy. The Museum Commission, David claimed, was made up of men who were either unqualified for the job, or who, though possessed of talent, were at best lukewarm Republicans. David wanted to replace them with a panel of ten men to be known as the Conservatoire, whose professional standing was sound and whose devotion to the Republic was beyond reproach. The ten consisted of the painters Fragonard, Bonvoisin, Le Sueur, and Picault; the sculptors Dardel and Dupasquier; the architects Lannoy and David Le Roy; and Wicar and Varon. Despite the seriousness of his accusations, David failed to persuade the Convention on this occasion, perhaps because the Commission had concrete proof of its accomplishments in the form of the museum itself. In a second report on the subject, read to the house on 16 January 1794, David challenged this achievement and argued that in different hands the display could be much improved.[41] He focused on two issues that had become controversial almost as soon as the Commission began preparing the museum late in 1792: picture restoration and the choice and arrangement of the works of art in the gallery. Due to incompetence in these two areas, he explained, the museum as it stood was not a source of glory to the Republic, but of shame. Of the two issues, I shall concentrate on the choice and arrangement of the objects in the display.

HANGING THE LOUVRE DURING THE TERROR

Criticism of the display concerned both the nature of the works of art on exhibition and the system of hanging the pictures. The Museum Commission deliberately set out to dazzle the beholder, to create a spectacle revealing the full extent of the nation's treasures, and they did so, it would seem, with the approval of Garat. In August, 1793, the government was not concerned to put too fine a point on the distinction between a museum and a depot of *biens nationaux*. But to David and his Jacobin friends, this display was anathema and all too reminiscent of the *cabinets* of the *grands seigneurs* of the Old Regime. In his second report on the suppression of the Commission, David exclaimed:

"The Museum is not supposed to be a vain assemblage of frivolous luxury objects that serve only to satisfy idle curiosity. What it must be is an imposing school."[42] In addition to useless luxury goods, the gallery had also to be cleared of paintings that, in David's words, "do not deserve to see the light of day and that could only encourage bad taste and error"[43]—paintings, in effect, that reflected the predominant taste of the Regency and the "reign of Pompadour." Finally, the critics insisted that, if the museum was to contribute properly to the instruction of the public and the formation of Republican artists, then the collection must be divided into schools and arranged chronologically.[44]

The question of how to arrange the national collection had been the subject of much debate in 1793. No sooner had the Museum Commission determined on a mixed school, or "eclectic" arrangement, than it was asked to justify its decision. It comes as something of a surprise that its decision was not dictated by a shortage of time, as one might have supposed, but was reached after mature deliberation. The alternative classification by school and period had been considered but finally rejected. In a sensible and polished memoir of June, 1793, the Commission presented its argument:

> The arrangement we have adopted is like that of an abundant flowerbed that has been planted with great care. If, by choosing a different arrangement, we had demonstrated the spirit of art in its infancy, during its rise and in its most recent period; or if we had separated the collection into schools, we might well have satisfied a handful of scholars [*quelques érudits*], but we feared being criticized for having ordered something which, in addition to serving no useful general purpose, would actually hinder the study of young artists, who, thanks to our system, will be able to compare the styles of the Old Masters, their perfections as well as their faults, which only become apparent upon a close and immediate comparison.[45]

In their view, a strict arrangement by school and period was elitist and would impede the young artist's development. They implied that such an arrangement would do little for the man in the street and that their system was the more egalitarian in intention. But it was the supposed needs of students that became the focal point of the argument. Both parties publicly advocated the superiority of their respective systems and yet, in the end, one system was not demonstrably better for young painters than the other.

However, the matter was not as arbitrary as the fuss about the welfare of young painters might suggest: at bottom the debate was a struggle between opposing attitudes to display, which stood, in the eyes of the Museum Commission's critics at least, for opposing ideologies. To be sure, David and his colleagues were after power, but beneath their politicking there was a principle at stake. The "eclectic" system favored by the Museum Commission signified a return to the bygone days of the Luxembourg Gallery, which itself harked back to the age of de Piles; even the Commission's likening of the museum to an

abundant and varied flowerbed smacks of de Piles. It had, in other words, strong connotations of what had come to be seen as the leisured dilettantism of the *Ancien Régime* and therefore had to be rejected as a matter of principle. Furthermore, as I have suggested above, by the 1790s this approach to the display of paintings was becoming outmoded in the major public collections of Europe. The galleries at Düsseldorf and Vienna reveal that the same spirit of empirical inquiry and scientific analysis that was transforming man's understanding of the material world had also affected the study of art; by the late eighteenth century, there was a growing tendency in enlightened circles to view art as a cultural and historical phenomenon and to think that paintings and sculptures, like shells or flora, were susceptible of rational classification.[46] The system of organization by school and period was the system of the Enlightenment and therefore the only one appropriate to the museum of the young, forward-looking Republic. David and the other critics of the Museum Commission realized that the Revolution had provided France with a unique opportunity to create a comprehensive and rational display of art, the like of which had previously existed only in the minds of connoisseurs. It was their ambition to establish not just the grandest but also the most *modern* gallery in Europe. And of course it was fortunate for them that the failure of d'Angiviller's museum project, assuming that it would have been realized along the lines of Düsseldorf and Vienna, permitted them to put forward the school-period system as a Republican innovation and a radical departure from customs of display in pre-Revolutionary France.

When the Conservatoire came to power in January, 1794, its agenda was naturally predetermined by the issues over which the Museum Commission and its critics had fought: namely, restoration and the gallery display. The removal from the gallery of works of art that were deemed unworthy, in preparation for rearrangement of the display, began in February.[47] (The Conservatoire's word for this was *épuration*.) What is particularly interesting about this phase in the operation is the difficulty the Conservatoire evidently had in deciding what to do with many of the works of art. Disdain for *objets de luxe*, porcelain, etc., was outright, but the criterion for what pictures should be banished from view was never so clearcut.[48] The confusion was not so much over style as over content. For example, paintings that exemplified "la routine française," to quote Bouquier, were to be removed because of their potential corrupting influence, but problems arose in cases where indisputable masterpieces of the past portrayed what since the Revolution had become sensitive subjects. The desire to create the perfect museum conflicted with the Revolutionary ambition to eradicate the memory of former customs and loyalties.

A good case in point was Rubens' Medici cycle, the raison d'être of which was the glorification of the monarchy. (We must bear in mind that by this time the streets of the capital had been cleared of all royal monuments and insignia.)[49] The fate of those paintings was discussed by the Conservatoire in the summer of 1794. On the one hand, they were concerned that the sight of the "tyrant Henri IV and his wife" (Marie de' Medici) might kindle latent royalist sympathies, but, on the other, they were aware that this famous series had long

been regarded by artists and connoisseurs alike as one of the supreme monuments of the history of art.[50] In the end a compromise was reached whereby two of the less overtly royalist episodes from the series—*The Conclusion of the Peace* and *The Treaty of Angoulême*—were chosen.[51]

Another potential problem was religious art. The public exhibition of depictions of miracles, saintly ecstasies, and martyrdoms clashed with the government's avowed desire to suppress fanaticism and to replace the worship of Catholicism with the cult of Reason. And yet, if religious paintings were to be excluded, the museum would be deprived of many fine canvases by the seventeenth-century French and Flemish masters—the fruit of suppressed churches and the military conquest of Belgium, not to mention the masterpieces of the Italian Renaissance.[52] To avoid having to compromise thus the quality and depth of the Republic's collection, and thereby the symbolic value of the museum, something that neither the Conservatoire nor, finally, the government was eager to do, the Conservatoire sought to rationalize the inclusion of those works of art and to explain away the apparent contradictions with Revolutionary ideology. The solution to the dilemma lay in the arrangement of the pictures and in the idea of the museum itself.

As promised earlier by David in his reports to the Convention, the Conservatoire set out to replace what it viewed as the disorderly clutter with, in the words of its spokesman, Casimir Varon, "a continuous and uninterrupted sequence revealing the progress of the arts and the degrees of perfection attained by the various nations that have cultivated them."[53] Although, as we now know, this program was not in itself as radically innovative as the Conservatoire might have wished it to seem, what is remarkable is that its implementation in the Grand Gallery at the time was recommended because it would rule out, or at least mitigate, the discrepancy between state museum and government policy. In Varon's fascinating report to the Committee of Public Instruction of May, 1794, explaining the changes that the Conservatoire had effected in the gallery, it was suggested that their installation would neutralize the regrettable content of a great many of the paintings. Removed from their original settings, their individual identity subordinated to the system, those works of art would speak to the people no longer as meaningful icons but as stylistic exempla and historical objects. Varon wrote:

> An involuntary sense of regret interferes with the pleasure of spreading before you our riches; art has diverged from its true path and celestial origins . . . a multitude of dangerous and frivolous experiments, the results of long centuries of slavery and shame, have debased its nature: wherever one turns one sees that its productions bear the marks of superstition, flattery, and debauchery. Such art does not recount the noble lessons that a regenerated people adores: it does nothing for liberty. One would be tempted to destroy all these playthings of folly and vanity if they were not so self-evidently unworthy of emulation. But nevertheless there is some point in trying to veil these faults, to obliterate these false precepts. This is our task and we shall strive to achieve it. *It is through the overall effect of the col-*

lection that this can best be done. It is by virtue of an air of grandeur and simplicity that the national gallery will win respect. It is through a rigorous selection that it must command the public's attention[54]

In other words, the ensemble was much more than the sum of its constituent parts. Elsewhere, the prominent politician, Jean-Baptiste Mathieu, revealed his vision of the museum "where everything will be ordered and arranged with method, explained and embellished by the method itself."[55] At the Musée des Monuments Français (formerly the depot of the Petits-Augustins) at roughly the same time, Alexandre Lenoir was justifying the presence of controversial tomb monuments, such as those commemorating Louis XII and Francis I, with similar arguments.[56] Removed from the royal abbey of St.-Denis, those monuments no longer meant what they once did; they were, Lenoir implied, merely superb examples of French sculpture during its best period.

The Musée Central des Arts

The Conservatoire's grand vision of the Louvre proved difficult to realize. After the reopening of the museum toward the end of February, 1794, pressure to keep it open for the benefit of artists as well as the general public stood in the way of a complete and satisfactory reorganization of the pictures. The symbolic and practical functions of the museum were now such that the Conservatoire could not close its doors for the time it would have taken to make the sophisticated installation it had planned. Furthermore, from September, 1794, the Conservatoire was faced with the task of integrating into the permanent collection in Paris the steady flow of art objects confiscated as the booty of war by the Revolutionary army as it marched through Europe.[57] In January, 1795, *La décade philosophique,* no doubt reflecting the public's frustration at the Conservatoire's failure to fulfill its promise, published a withering report on the current state of the Louvre:

> For a long time we have been planning to give our readers an account of this superb museum, which contains the largest and most precious collection of paintings in Europe, but we were waiting until the pictures were hung in a permanent, sensible order. But it seems that those in charge take pleasure in constantly rearranging them. A picture that could be seen near the entrance to the gallery one day will be found at the far end ten days later, or perhaps even not at all. It is hard to imagine that the only goal in organizing the paintings was to arrange them by school.[58]

Of course their aim was to do more than arrange the pictures simply according to school. Nevertheless, time had run out for the Conservatoire and in March it was dissolved and a second Conservatoire appointed, consisting of two original members, Fragonard and Picault, and three new men, the painters Robert and Vincent, and the sculptor Pajou.[59] The second Conservatoire remained in office until *3 pluviôse an V* (22 January 1797), when it was replaced by a new admin-

istration and the museum was officially renamed the Musée Central des Arts. In recognition of the museum's growing size and reputation, this administration included three full-time administrators—Dufourny, Foubert, and Lavallée—in addition to the connoisseur J.-B.-P. Lebrun and a panel of artists: Robert, Pajou, Jollain, Suvée, and de Wailly.[60]

In 1796, under the second Conservatoire, the museum was finally closed to allow a definitive rearrangement of the collection and the installation of a new floor. It remained closed to the public for three full years. In April, 1799 (*germinal an VII*), with the Musée Central administration in control, the first sections of the Grand Gallery, devoted to the French and Northern schools, were ready to open; the last section of the museum, containing the Italian schools, opened two years later, on 14 July 1801, the twelfth anniversary of the fall of the Bastille.

Although not enough visual or documentary information exists to determine precisely how the Conservatoire's plan to establish a continuous historical sequence in the gallery was eventually carried out, it is clear that an arrangement of pictures by school and roughly by period did prevail. According to the museum catalogue of 1801, published to coincide with the opening of the Italian schools:

> In the second part of the gallery that has just opened, the painters, and particularly those of historical subjects, have been ordered, as they were in the first half of the gallery, according to the chronological order of their birth, and, as far as was possible, the paintings of each master have been hung together; this system has the advantage of facilitating a comparison of school with school, of painter with painter, and of works by the same artist.[61]

Bills submitted by the blacksmith responsible for hanging the gallery in the months leading up to the inaugural exhibition of April, 1799, reveal that the first thirteen sections of wall between the windows, or *travées* (six on the north side of the gallery, seven on the south), were devoted to the French school, the last nineteen (ten on the north side, nine on the south) to the Northern schools. Unfortunately, those same bills provide only minimal information about *how* each section of wall was hung (see Appendix).[62] As a general rule, each *travée* was dominated by one or two famous, large paintings and filled out with smaller canvases positioned symmetrically around the bigger ones. Contemporary views of the gallery by Hubert Robert and others confirm this pattern.[63] Though lack of detail in the blacksmith's bills permits no more than a conjectural and woefully incomplete reconstruction of the hanging scheme in year VI (1797–98), certain tentative conclusions may be drawn: first, a firm division between the schools was observed; second, within each school a higher priority was given to grouping together paintings by the same artist than to presenting a strict chronological progression based on date of birth; and, third, the emphasis in each *travée* on one famous painting reveals a vision of the history of art dominated and determined by a succession of "great artists." Our knowledge of the hanging scheme is not enhanced by the museum catalogues because the paint-

ings are not listed sequentially according to their place in the gallery, as they were in the Luxembourg catalogues, but under the artist's name, which in turn is listed alphabetically by school. The paintings themselves bore labels identifying artists and subject.[64] It is regrettable that more is not known about how the Louvre was hung during this great period in its history; perhaps one day further evidence will come to light to solve the mystery.

Conclusion

By the time the Grand Gallery opened in its entirety in 1801, debate about the subject matter of many of the paintings and the possible repercussions of exposing them to public scrutiny was a thing of the distant past. As late as March, 1799, the author of the catalogue of the French and Northern schools was instructed to cut all biblical quotations from his entries for religious paintings,[65] but there was no question of not exhibiting the paintings themselves, or of not providing often quite detailed explanations of the scenes represented. Similarly, in addition to the two paintings from Rubens' Medici cycle originally sanctioned by the Conservatoire, a further two episodes from the series were included—*The Education of Marie de' Medici* and *The Birth of the Dauphin*, paintings that would have been condemned as unacceptably royalist in 1794.[66] After the Terror, the political climate gradually relaxed and with it the museum administration's concern about what should and should not be put on display. In 1801, the Louvre contained the greatest collection of Western art ever assembled under one roof, and nothing was to prevent that fact from being self-evident to the beholder.

FREQUENTLY CITED SOURCES

CANTAREL-BESSON, Y., ed., *La naissance du musée du Louvre*, 2 vols., Paris, 1981.

DAVID, J.L., 1793, *Rapport sur la supression de la commission du muséum*, Paris.

———, 1794, *Seconde rapport sur la suppression de la commission du muséum*, Paris.

TUETEY, A., and J. GUIFFREY, eds., *La commission du Muséum et la création du Musée du Louvre 1792–93*, Paris, 1901.

APPENDIX

Partial reconstruction of the hanging scheme at the Musée Central des Arts in 1797–98. Based on records of work done by the blacksmith Blampignon (*Archives Nationales, F*[17] *1060*, "Mémoire serruries (sic) pour le Muséum," *an VI*). The titles of paintings and numbers are from the catalogue *Notice des tableaux des écoles française et flamande . . . et des tableaux des écoles de Lombardie et de Bologne*, Paris, *25 messidor an IX*.

Entrance to Grand Gallery

North wall	South wall
Travée no. 1	
"Un grand tableau d'Alexandre" (Lebrun, *La défaite de Porus*, no. 17; or *L'Entrée d'Alexandre dans Babylone*, no 19); ". . . tableau du bas du millieu de du Poussin . . . (?)	"Un grand tableau d'Alexandre famille de Darius" (Lebrun, *La Famille de Darius aux pieds d'Alexandre*, no. 18)
No. 2	
"La mort de Méleagre" (Lebrun, *La Mort de Méléagre*, no. 20); "au bas du grand tableau . . . un tableau du Poussin . . ." (?)	"Un grand tableau de Jesus renversé sur la croix" (Lebrun, *Le Crucifix aux anges*, no. 16?; Le Sueur, *La Descente de croix*, no. 99?)
No. 3	
"Tableau représentant la famille de Darius" (Lebrun, *La Famille de Darius aux pieds d'Alexandre*, no. 18); "Le tableau de dessous le grand représentant la mâne dans le désert; par Poussin" (Poussin, *La manne dans le désert*, no. 70)	"Jesus-Christ chasse les marchands du temple" (Jouvenet, *Les Vendeurs chassés du Temple*, no. 52)
No. 4	
"Un grand tableau représentant une descente de croix" (Jouvenet, *La Descente de Croix*, no. 54?)	No details given
No. 5	
"Un grand tableau représentant Jesus-Christ au temple" (Vouet, *La Présentation de J.-C. au temple*, no. 140?)	No details given
No. 6	
"Jugement de St Gervais et St Protais" (Le Sueur, *Saint Gervais et Saint Protais amenés pour sacrifier aux idoles*, no. 101); "cinq petits tableaux représentant le Musée" (?)	"La martyre de St Etienne" (Lebrun, *Saint Etienne lapidé*, no 12)
No. 7	
"Apparition et la gloire de St Gervais et St Protais" (P. de Champaigne, *Apparition de Saint Gervais et Saint Protais*, no. 212)	"La decolation de Bourdon" (Bourdon, *La Décolation de Saine Protais*, no. 2)
No. 8	
"La peste" (?) "St Jean-Baptiste par Crayer" (Crayer, *Hérodiade recevant la tête de S. Jean-Baptiste*, no. 226); "Ezau et Rebecca" (S. Koninck, *Jacob, aidé de Rébecca, surprenant à son pére Isaac*, no. 221?) "St Augustin par Crayer" (?)	"Un grand tableau de St Gervais et St Protais" (P. de Champaigne, *Translation des corps de Saint Gervais et Saint Protais*, no. 213?) "un mouton sacrifié" (Holbein, *Le Sacrifice d'Abraham*, no. 316?)
No. 9	
"Jesus mort sur les genoux de sa mère la Madeleine lui baise les mains" (Van Dyck, *Le Christ mort dans les bras de la Vierge*, no. 252?); "Un tableau	No details given

(continued)

North wall	South wall

No. 9 (continued)
 represt. Charles I" (Van Dyck, *Charles I*, no. 254?) "Ecce-Homo" (?); "les marchands chassés du temple (Jordaens, *J.-C. chassant les Vendeurs du temple*, no. 349?)

No. 10
 "Un grand tableau represt. un possedé du démon"? (?) No details given

No. 11
 "Le tableau du taureau de Paul Poter" (Potter, *Un vaste pâturage*, no. 446?); "une chasse de Louis XIV" (?); "St Augustin par Vandyke" (Van Dyck, *St Augustin ravi en extase*, no. 253); "le tableau de Venus" (?) No details given

No. 12
 "Tableau du milieu, la pêche miraculeuse . . . les deux volets . . . du grand" (Rubens, *La Pêche miraculeuse*, no. 528; two wings, nos. 529, 530); "le tableau d'Isaac Ostade, l'Hyver" (Ostade, *Un Hiver*, no. 434); "posé au milieu le grand tableau de Vouwermans" (?); "le portrait de Philippe Champagne" (Champaigne, *Philippe de Champagne peint par lui-même*, no. 217) "Un Christ" (?)

No. 13
 "Grand tableau de milieu repésentant l'adoration des mages par Rubens" (Rubens, *L'Adoration des Mages*, no. 517; two wings, nos. 518, 519); "Un tableau de Kermesse par Rubens" (Rubens, *La Kermesse,* no. 526) "L'accouchement de la reine par Rubens" (Rubens, *L'accouchement de Marie de Médicis*, no. 480); "Tableau represt. l'education" (Rubens, *L'Education de Marie de Médicis*, no. 479); "deux tableaux de Rubens faisant suite" (?)

No. 14
 "Adoration des mages par Rubens" (Rubens, *L'Adoration des Rois*, no. 512?) "la peste de St Roch" (Rubens, *S. Roche guéri de la peste par l'ange*, no 515?) "Tableau represt. l'Ascension" (Rubens, *L'Elévation du Christ en croix*, no. 486?); "la Communion de St . . ." (Rubens, *S. Francis mourant, recevant la Communion*, no. 485?)

No. 15
 "Un Crucifix" (Rubens, *Le Christ en croix*, No. 510?); "tableau de Rembrandt" (?) "Un grand tableau représentant l'assomption" (Rubens, *L'Assomption de la Vierge*, no. 484?)

No. 16
 "Tableau de milieu, Descente de Croix par Rubens" (Rubens, *La Descente de Croix de la cathédrale d'Anvers*, no. 503; two wings, nos. 504, 505; or *Le Christ descendu de la Croix,* no. 489; two wings, nos. 490, 491) "Une Descente de Croix par Rubens" (Rubens, *Le Christ descendu de la Croix*, no. 489; or *La Descente de Croix de la cathédrale d'Anvers*, no. 503)

NOTES

1. See J. Connelly, "Forerunner of the Louvre," *Apollo,* XCV, 1972, 382–389; J. Laran, "L'exposition de Tableaux du Roi au Luxembourg," *Bulletin de la Société de l'Histoire de l'Art Français,* 1909, 154–202; and A. McClellan, "The Politics and Aesthetics of Display: Museums in Paris 1750–1800," *Art History,* VII, 1984, pp. 438–464.

2. On these reforms, see J. Locquin, *La peinture d'histoire en France de 1747 à 1785.* Paris, 1912. The pedagogic purpose of the gallery was underlined in a letter of 1775 from Pierre to the Comte d'Angiviller, quoted in L. Courajod, *L'Ecole Royale des Elèves Protégés,* Paris, 1874, p. 118.

3. See C.B. Bailey, "Conventions of the Eighteenth Century *Cabinet de Tableaux:* Blondel d'Azincourt's *La première idée de la curiosité,*" *Art Bulletin* LXIX, 1987, pp. 431–447.

4. R. de Piles, *Cours de peinture par principes,* Paris, 1708.

5. See T. Puttfarken, *Roger de Piles' Theory of Art,* New Haven and London, 1985, Chap. 6.

6. A. Coypel, *Discours prononcés dans les conférences de l'Académie Royale,* Paris, 1721.

7. See Puttfarken (as in n. 5), p. 138.

8. J. Silvestre de Sacy, *Le Comte d'Angiviller,* Paris, 1910. On the architectural problems involved, see J. Connelly, "The Grand Gallery of the Louvre and the Museum Project: Architectural Problems," *Journal of the Society of Architectural Historians.* XXXI, 1972, pp. 120–132.

9. See F. Engerand, *Inventaire des tableaux commandés et achétés par la Direction des Bâtiments du Roi (1709–1792),* Paris, 1901.

10. See Connelly (as in n. 8); also see M.C. Sahut, *Le Louvre d'Hubert Robert,* Paris, 1979.

11. *Archives Nationales, O^1 1934B (80);* also see Baron C. Davillier, *Le Cabinet du Duc d'Aumont,* Paris, 1870.

12. See McClellan (as in n. 1).

13. See Engerand (as in n. 9); many of these paintings were bought at the sale of Chastre de Billy in 1785: see *Arch. Nat. O^1 1917 (1784),* fol. 399.

14. On the Düsseldorf gallery, see N. de Pigage, *La Galerie Electorale de Dusseldorf,* Basel, 1778. Pigage sent the MS and plates of his book to Paris in 1776 for the Academy's approval prior to publication; a printed copy of the book was sent to d'Angiviller in 1778—see *Arch. Nat. O^1 1914 (1778),* fol. 117. On the Imperial Gallery, see C. de Mechel, *Catalogus des tableaux de la Galerie Impériale et Royale de Vienne,* Basel, 1784, especially XIV–XV.

15. *Arch. Nat. O^1 1920 (1788),* fol. 210.

16. *Arch. Nat. O^1 1670,* fol. 217; also fols. pp. 213, 247.

17. Tuetey and Guiffrey, p. 23.

18. Ibid., p. 26.

19. Ibid., pp. 82–83.

20. Ibid., pp. 123–124.

21. *Arch. Nat. F17 1059 (dossier 15);* letter dated 4 July 1793.

22. F.A. de Boissy d'Anglas, *Essai sur les fêtes nationales suivi de quelques idées sur les arts,* Paris, *an II,* 5.

23. Ibid., p. 7.

24. L. Hunt, *Politics, Culture and Class in the French Revolution,* Berkeley and London, 1984, p. 55.

25. For an account of the festival, see *Procès-verbal des monumens, de la marche, et des discours de la fête consacrée à l'inauguration de la Constitution de la République Française, le 10 août 1793,* Paris, 1793; also see M. Ozouf, *La fête revolutionnaire 1789–1799,* Paris, 1976. On David's role in the festival, see D. Dowd, *Jacques-Louis David, Pageantmaster of the Republic,* Lincoln, 1948.

26. Ozouf (as in n. 25), p. 149.

27. The inaccessibility of the Grand Gallery prior to the removal of the relief models is mentioned by Pierre in a letter of 1779, *Arch. Nat. 0*1 *1171,* fols. pp. 207–208.

28. Abbé H. Grégoire, *Rapport sur les destructions opérées par le vandalisme,* Paris, *an II,* p. 21.

29. Tuetey and Guiffrey, p. 213.

30. Ibid., 244, 289–291. Also see the catalogue Lenoir had printed for the occasion: A. Lenoir, *Notice succincte des objets de sculpture et architecture réunis au Dépôt provisoire national* [Paris], 1793.

31. *La décade philosophique, IV, 10 pluviôse an III,* p. 213.

32. See T. Crow, *Painters and Public Life,* New Haven and London, 1985.

33. See H. Lapauze, *Procès-verbaux de la Commune Générale des Arts et de la Société Populaire et Républicaine des Arts,* Paris, 1903; also A. Detournelle, *Aux armes et aux arts! . . . Journal de la Société Républicaine des Arts,* Paris (1794).

34. See A. Brookner, *Jacques-Louis David,* London, 1980, 100–102; also see Dowd (as in n. 25), Chap. 2.

35. M. Mavidal and M. Laurent, eds., *Archives parlementaires de 1787 à 1860,* 139 vols., Paris. 1867–1896, LXX, pp. 519–524.

36. See J. Leith, *The Idea of Art as Propaganda in France, 1750–1799,* Toronto, 1965, Chap. 5.

37. G.F. Bouquier, *Rapport . . . rélatifs à la restauration des tableaux* [Paris, *an II*], pp. 2–3.

38. See, for example, "Influence de la liberté, suppression des académies," *La décade philosophique, 1, 10 floréal an II, 8ff.;* also see J.-B.-P. Lebrun, *Essai sur les moyens d'encourager la peinture,* Paris, *an III.*

39. *Adresse, mémoire et observations présentés à l'Assemblée Nationale, par la Commune des Arts,* Paris, 1791, p. 26. Generous and exclusive gallery privileges were given to artists for the purposes of study by successive administrations in the 1790s. See *Arch. Nat. F17 1059(15),* "Projet et réglement par le Muséum Français," 1793: "Sur chaque décade, les cinq premiers jours seront consacrés aux études des artistes." Under the Conservatoire, study days were increased to seven out of every ten; see Cantarel-Besson, II, p. 68.

40. David, 1793.

41. David, 1794.

42. Ibid., p. 4.

43. Ibid., p. 6.

44. See J.-B.-P. Lebrun, *Réflexions sur le Muséum national,* n.p., n.d.; *Observations sur le Muséum National par le citoyen Lebrun . . . pour servir de suite aux réflexions qu'il a déjà publiées sur le même objet,* Paris, 1793; and J.M. Picault, *Observations sur les tableaux de la République,* Paris, 1793.

45. Tuetey and Guiffrey, 187. As early as December, 1792, Roland had recommended the "eclectic" system to the Museum Commission on the grounds that it would please "tout le monde"; significantly, he likened the museum to "un parterre qu'il faut émailler des plus brillantes couleurs"; see L. Courajod, *Alexandre Lenoir, son journal et le Musée des Monuments Francais,* 3 vols., Paris, 1878–1887, I, CLXXII.

46. A small number of private collectors in Paris had also begun to arrange their pictures in a more rational fashion (see Bailey, as in n. 3, 443). In 1764, P.J. Grosley visited a private collection in Padua that was arranged along strict chronological lines; see *Observations sur l'Italie et les Italiens,* 4 vols., London, 1770, II, pp. 164–166.

47. Cantarel-Besson, I, pp. 18–19.

48. Ibid., I, 19, minutes of the Conservatoire's meeting on 25 Feb. 1794: "Dans le déplacement qui a eu lieu ce matin des objets médiocres de la gallerie du Muséum, un des vases du Japon, dont le pendant existe sous le n° 65, a été cassé au moment de l'enlèvement: il est facile de se convaincre par le pendant: que les arts n'ont rien perdu de l'anéantissement de cette production japonaise."

49. See L. Tuetey, ed. *Procès-verbaux de la Commission des Monuments,* 2 vols., Paris, 1901–1902.

50. Cantarel-Besson, I, 82. Also see J. Thullier and J. Foucart, *Le storie di Marie de' Medici, di Rubens al Lussemburgo,* Milan, 1969.

51. Cantarel-Besson, I, 82; II, 185, n. p. 217.

52. The Conservatoire's ambivalence over religious paintings is revealed in two meetings of March, 1794, where, in one, it was agreed to remove Crayer's *Saint Jerome in the Desert* for fear that it would "entretenir le fanatisme," while, on the other, it was decided that no effort should be spared to insure that Le Sueur's *Saints Gervais and Protais Brought Before Astasias* "soit le plus promptement possible en état d'être placé au Muséum." See Cantarel-Besson, I. pp. 32–33, 24, respectively.

53. C. Varon, *Rapport du Conservatoire du Muséum National des Arts. Paris, an II;* reprinted in Cantarel-Besson, II, pp. 226–229.

54. Emphasis mine. See Cantarel-Besson, II, p. 228.

55. J.B.C. Mathieu, *Rapport fait à la Convention au nom du Comité d'Instruction Publique,* Paris, an II. p. 16.

56. *Inventaire général des richesses d'art de la France. Archives du Musée des Monuments Français,* 3 vols., Paris, 1883–1898, I, 26; also see D. Poulot, "Le reste dans les Musées," *Traverses,* XII, Sept., 1978, pp. 100–115.

57. See C. Gould, *Trophy of Conquest,* London, 1965.

58. *La décade philosophique,* IV, *10 pluviôse an III,* p. 211.

59. See Cantarel-Besson, I, pp. XIII–XLI.

60. *Arch. Nat. F^{17} 1059(23),* "Organisation du Musée Central des Arts," *3 pluviôse an V.*

61. *Notice des tableaux des écoles française et flamande (sic) . . . et des tableaux des écoles de Lombardie et de Bologne,* Paris, an IX, p. ii.

62. *Arch. Nat. F*[17] *1060(4);* Blampignon, "Mémoire serruries (sic) pour le Muséum," *an VI.* We cannot be sure that this arrangement was definitive; the appearance of Lebrun's *Family of Darius* in two different locations certainly suggests that sudden changes were made as the gallery was being hung.

63. See Sahut (as in n. 10), pp 35–40.

64. *Arch. Nat. F.*[21] *569(6),* fol. 65; Cantarel-Besson, I, 138; also see *Magasin encyclopédique,* 1796, I, p. 106.

65. *Bibliothèque Doucet MS 1089,* II; meeting of 26 *ventôse an VII.*

66. *Notice des tableaux* (as in n. 61), p. 75.

Burn it, Hide It, Flaunt It
Goya's *Majas*
and the Censorial Mind*

JANIS TOMLINSON

The *Naked Maja,* painted by Francisco Goya around 1800, is often cited as one of the few nudes in the history of Spanish painting. Yet in much art historical scholarship, the significance of the painting is undermined, as it occupies a nebulous space somewhere between the paradigmatic nudity of Titian's *Venus of Urbino* and the modernity of Manet's *Olympia.* This article considers the specific context of the *Naked Maja,* examined in light of attitudes toward sexuality operative at the time it was painted. Also considered is the significance of the juxtaposition of the *Naked* and the *Clothed Maja,* probably painted about five years after her unclothed counterpart.

By the late eighteenth century, at least some members of the elite within Spain challenged long-standing sexual taboos. This relaxation of traditional mores possibly influenced patrons who commissioned Goya's paintings depicting provocative, reclining women. Royal censorship nevertheless continued to condemn such themes, as both kings Carlos III (reigned 1759-1788) and Carlos IV (reigned 1789–1808) threatened to burn masterpieces by Titian, Rubens and others depicting nude women. Such censorship of the nude had the effect of making it all the more attractive to progressive patrons, one of whom was the royal favorite Manuel Godoy, who apparently commissioned the *Naked Maja.*

Records of the room in Godoy's palace in which the *Naked Maja* originally hung suggest an obsession with the theme of the female nude. This obsessiveness is similarly implicit in Goya's painting, which isolates the female nude from any narrative context. The awkwardness of Goya's figure might suggest discomfort with the female nude, an attitude seemingly confirmed by his subsequent attempt to clothe her, by painting her pendant. The resulting juxtaposition removes the *Naked Maja* from a tradition of female nudes extending back to Titian, and also diminishes the erotic—and possibly threatening—power of the nude.

The desire to diffuse the nude's erotic charge also suggests Goya's own susceptibility to the censorial attitudes prevalent in eighteenth century Spain, which endowed the female nude with a magical power so strong that the kings of Spain sought to burn her in effigy. These attitudes were to change. In 1815, when the Inquisition sought out the artist of the painting, it was because his attitude was perceived to be politically dangerous. Although censorship continues,

*"Burn It, Hide It, Flaunt It: Goya's Majas and the Censorial Mind," by Janis A. Tomlinson. *Art Journal,* vol. 50, no. 4, (Winter 1991). Reprinted by permission of the College Art Association, Inc.

its motivations change, as seen most recently in 1991, when a reproduction of Goya's *Naked Maja* was the subject of a complaint voiced by a university professor who found its imagery offensive to women.

Style suggests that it was during the later 1790s that Francisco Goya painted a nude that has become known as the *Naked Maja,* or *Maja desnuda,* a painting first documented in the collection of Manuel Godoy in November 1800. I would here like to consider this painting (Fig. 1) in relation to a more general interest in things sexual that manifests itself in a variety of ways in late-eighteenth-century Spain. These trends blossomed in opposition to attempts made by both the monarchy and the church to repress certain themes—efforts that, not surprisingly, had the opposite effect of making these themes more appealing.[1] The structure of my argument has been anticipated by Richard Terdiman's book, *Discourse/Counter Discourse,* in which the author examines works of nineteenth-century French literature and art created to attack the hegemonic discourse of an increasingly bourgeois society, showing the extent to which such "counter-discourses" in fact participate in the dominant discourse.[2] I shall examine Goya's *Maja desnuda* and her clothed counterpart, the *Maja vestida* (Fig. 2), as an attempt to counter a dominant discourse that, in late-eighteenth-century Spain, protected itself through censorship. Coinciding with Terdiman, I will also illustrate the extent to which Goya's imagery was in fact influenced by the official censorial stance toward the female nude.

A context for the *Maja desnuda* is provided by social, literary, and visual manifestations in late-eighteenth-century Spain of a will to challenge traditional sexual taboos. The most frequently mentioned indication of this is the rise and dissemination among the upper classes of the custom of the *cortejo,* a single man who served as the escort to a married woman.[3] Contemporary opinion seems to have been divided between those who regarded the relationship as an innocent diversion and those who branded it outright adultery. The *cortejo* nevertheless became a stock character in the one-act comic interludes known as *sainetes,* and also inspired a wave of satiric literature. Despite the immorality that the custom potentially encouraged, those who wished to appear enlightened (*ilustrado*) would acquiesce in it, or so opines the husband in the satirical theatrical interlude (qualified in its title as a "*saynete crítico*"), *The Good Temper of a Husband, and Enlightenment of These Times:*

Don Pedro [i.e., the cortejo] enters:
They do whatever they please,
but what does it matter to me?
Isn't it all the rage to live like this?
Well, I swear by fashion,
for if I didn't
I wouldn't be an *ilustrado* of the times.[4]

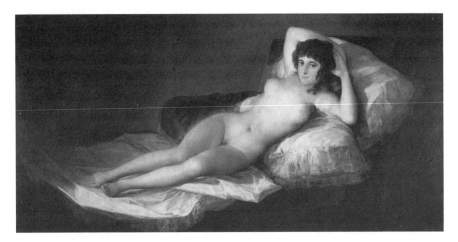

Figure 1 Francisco Goya, *Maja desnuda.* ca. 1796–1800. © Museo del Prado, Madrid. Photo: Museum.*

Texts concerning the *cortejo* and his lady are circumspect about the actual nature of the relationship; here we learn only that "they do whatever they please," a statement that offers an implicit appeal to read between the lines of these very general descriptions. This circumspection is hardly surprising, since the *cortejo* was an accessory of the upper and upper middle classes, whose sexual activities were rarely acknowledged or discussed.

More graphic description of sexual practices would of necessity lead us away from the polite classes to the marginal society that inspired Moratín the Elder's *Art of Whoring* (*Arte de las putas*), perhaps the best known of several erotic verses penned (and circulated in manuscript) in Spain in the late eighteenth century. The earliest notice we have of this work is its inquisitional censure of 1777, in which it is "prohibited entirely, even for those who have the license to read prohibited books, because it is full of false and scandalous propositions, provocations to falsehoods injurious to all states of Christianity. . . ."[5] Moratín explains procedures ranging from bargaining for prices to protection against venereal disease in a work that pays tribute to Ovid's *Art of Love* as well as to the original ancient Greek definition of pornography as writing about prostitutes.[6]

By 1770, around the time that Moratín wrote the *Arte,* the poet was well established at the Madrid court; his circle of readers undoubtedly came from the upper and more educated classes. One might suggest that it was for a similar audience that Goya painted canvases that show women lounging, chatting, or sleeping, illustrated by *Gossiping Women.* (Hartford, Wadsworth Athenaeum). The dimensions of this and other, more explicitly erotic figures, such as *Sleeping Woman,* (Madrid, McCrohan Collection) of about 1791, suggest that these or similar paintings may have belonged to a group of three overdoors documented in the collection of the Cadiz merchant Sebastián Martínez. Such a

*All figures in this text are oil on canvas unless otherwise noted.

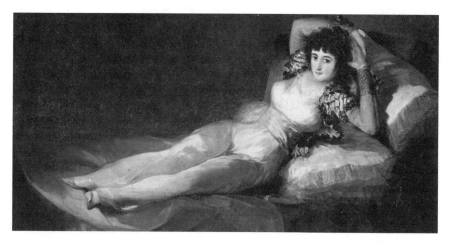

Figure 2 Francisco Goya, *Maja vestida,* ca. 1803–1805. © Museo del Prado, Madrid. Photo: Museum.

provenance would suggest the taste of at least one of Goya's patrons for sexually suggestive subjects.[7]

Yet lascivious women—particularly those without clothes—were not a subject universally favored by Goya's patrons. In 1762 King Carlos III ordered the First Court Painter, Anton Rafael Mengs, to assemble all the paintings in the royal collection that showed "too much nudity" so that they might be burned.[8] Since these included five paintings by Titian—a *Sleeping Venus* (now lost), two versions of *Venus and the Organ Player, Venus and Adonis,* and *Danae*—as well as works by Veronese, Annibale Carracci, Guido, and Rubens, we may be thankful that Mengs suggested an alternative solution of moving the paintings to his studio in the Casa del Reveque, where they were seen by Antonio Ponz in 1776.[9] The incendiary passion seems to have been hereditary, for in 1792 Carlos IV sought once again to burn the paintings. The reason for this reiteration of his father's threat has never been clarified, but given its suddenness and the date of 1792, one might wonder if Carlos IV intended these unholy pictures as an ex-voto, offered in response to the worsening situation of his Bourbon cousin, Louis XVI. This time it was the Marqués de Santa Cruz who intervened, suggesting that the works be moved to the Royal Academy, where they could be seen only by those with sufficient knowledge to appreciate their artistic merits.[10] During the reign of the intruder king Joseph Bonaparte, they were displayed in the Academy; but upon the restoration of the Spanish king in 1814 they were again sequestered. In 1827 they were transferred to what later became the Prado Museum.[11]

This censorship of the nude by Carlos III and Carlos IV was in no way functional, or motivated by a concern for the public good, since these paintings could easily be hidden from public view (a solution Carlos III had adopted as king of Naples, when confronted with a Roman statuette of a satyr fornicating with a goat that had been entrusted to the royal sculptor).[12] Instead, the censor-

ship of both Spanish kings appears to have been motivated by a view of the world that confused image and reality, and in this coincided with the censorial rationale of the Inquisition.[13] To this way of thinking, naked women, whether painted or real, who displayed themselves to male eyes offended a divinely ordained cosmology. What saved the paintings was a rationalization of this view: in anticipation of nineteenth-century arguments against censorship, Mengs (and, we may suppose, the Marqués de Santa Cruz) asserted that between a real naked woman and a painting of one there *was* a difference, grounded in the painting's aesthetic qualities. Thus, if the paintings were placed under the care of the First Court Painter (or, subsequently, in the Royal Academy), to be seen only by those able to appreciate their higher qualities, their subject matter would become secondary and the threat they posed be mitigated. The need for censorship was apparently determined by the prospective audience; and perhaps it is not coincidental that the Spanish kings became concerned with the issue as the royal collections were opened to preferred visitors to Madrid.[14]

As paintings of female nudes were being escorted to the Royal Academy in the 1790s, another figure well known in political circles was busy assembling his own collection. This was Manuel Godoy, the royal favorite, First Minister and protector of the Royal Academy, and reputedly the lover of the queen. The earliest known reference to Goya's *Maja desnuda* is dated November 12, 1800, in a description of Godoy's collection by the academician Pedro González de Sepúlveda, who mentions it in a "room or cabinet in which hung various paintings of Venus."[15] Among other paintings mentioned were Velázquez's *Venus;* today known as the *Rokeby Venus* (London, National Gallery), its pendant (then attributed to Luca Giordano and recently identified with a painting, now lost, of the Venetian school),[16] and a copy of a *Sleeping Venus* by Titian, the original of which had been moved to the Royal Academy but is today lost. That no reference is made to the clothed *Maja* (that is, the *Maja vestida)* suggests that she had not yet been painted.

Godoy's cabinet reflects a preoccupation with those themes that were the targets of traditional censorship. The use of a private cabinet to exhibit paintings with nude figures was in itself not new: the Duke of Alba had such a *gabinete reservada* and Wilhelm Humboldt remarks in his Spanish diary that fine paintings by Rubens and Guido Reni were often relegated to darkened rooms.[17] But Godoy went further. The newly appointed grandee and promulgator of enlightened reforms flaunted his defiance of censorial attitudes by forming a gallery that isolated and objectified the female nude, scrutinizing her representation through the centuries. To complete the tradition, he apparently commissioned copies of well-known works, and enlisted the services of Madrid's foremost painter, Goya. What is more, the paintings in this room were not simply paintings with nudes: they were works that removed the nude from any narrative context. The nude was transformed into icon, enshrined and sequestered for private adoration in an obsessive manner that implicitly acknowledges the prohibitions Godoy sought to deny. If the discourse of sexuality was in fact defined

in the West by the tradition of religious confession, as Michel Foucault has argued, Godoy's cabinet might be seen as an enlightened alternative to the confessional, where the male viewer obsesses about female sexuality behind closed doors, albeit without the benefit of priestly absolution.[18]

Given the highly controversial nature of its subject, it is likely that Godoy commissioned the *Maja desnuda,* for the royal favorite would have the power to challenge the taboos of his era. In so doing, he called upon Goya not only to respond to tradition, but also to pander to his compulsive scrutiny of the female nude. Isolated from narrative, the *Maja* is also removed from nature: the painting is not a response to external reality, but to the tradition of representing the unclothed female. For Goya, tradition and commission were equally loaded: for if one who contemplates such images risks damnation, what of one who paints such pictures? Scholars of seventeenth-century Spanish painting have long been aware of the controversial status of the nude in the aftermath of the Council of Trent. Velázquez's father-in-law, the theorist Pacheco, so abhorred the nude that he recommended that even the Christ Child appear dressed.[19] These prohibitive attitudes did not vanish with the (admittedly tempered) advent of the Enlightenment in Spain: during the annual awards ceremony of the Royal Academy in 1790, Joseph Manuel Quintana delivered a poem condemning the painter Lucidio, who had strayed from his call to commemorate great events and abandoned his sublime talent in order to paint effeminate works such as "Julia uncovering her breast, and Cupid sleeping in her arms."[20] Although Quintana formulates this as a criticism of effeminate tastes (implicitly contrasted with the commendable virility of historical subjects), it betrays a moralistic attitude toward the nude similar to that voiced by seventeenth-century writers.

Can we be certain that Goya and his contemporaries cast off the magical view that equated a painting of a nude with an evil reality? To answer this question with a definite yes would be to deny the religious tradition that was undoubtedly their heritage. And the *Maja* hardly suggests that Goya was at ease with his subject. This stilted representation of the attributes of female sexuality imposed on a Rococo doll intimates an inability to transcend the dogmatic relationship of sin and female flesh. It might also be noted, in defense of the hypothesis of Goya's discomfort with his subject, that it was never repeated: all his other representations of nudes are small-scale, private works—drawings, miniatures, or preliminary oil sketches.[21] That Goya did not hesitate to paint equally seductive women clothed (as in the overdoors mentioned above) suggests his adherence to the prevailing proscription not of lascivious females, but of nudes: even Carlos III had in his bedchamber a painting by Titian showing a clothed Venus looking at herself in a mirror supported by a single cupid (today lost).[22]

It is now generally accepted that the *Maja vestida* (see Fig. 2) was painted several years—perhaps as much as a decade—after the *Maja desnuda.*[23] We recall that no mention of the *Maja vestida* is made in Sepúlveda's 1800 account of Godoy's collection; it is first recorded, with its pendant, in an 1808 inventory of

Frédéric Quilliet as "Goya: Gitana nue/Gitana habillée/tous deux couchées" (Goya: nude gypsy/clothed gypsy/both lying down). The manner in which the paintings were related within the chamber remains a matter of speculation. According to Charles Yriarte, who credits his information to *quelques vieillards,* the *Maja desnuda* once hung on the verso of the *Vestida,* and the paintings were exhibited back to back, in the middle of the room. In 1914 Beroquí related the tradition that by means of a mechanism the *Maja vestida* could be lifted to reveal the *Maja desnuda.*[24]

Differences between the paintings support the hypothesis that these works were not intended to be seen side by side, but in succession. Although the poses of both figures are similar, the *Maja vestida* is brought forward to dominate the pictorial surface. Her multiple charms receive new emphasis: golden brocade slippers set off her delicate feet, a dark shadow calls attention to her pubis, her waist curves deeply inward to enhance the protrusion of her breast, her formerly blasé expression becomes more immediately intelligible as a slyly provocative smirk, set off against her raised elbow, now defined not as flesh, but as the intersection of two curves, in seeming anticipation of Picasso's *Demoiselles d'Avignon.*

The palette chosen for the *Maja vestida* corroborates her forthright character. Examining the canvas, one detects a mustard-tone underpainting (in contrast to the sepia tone used for the *Maja desnuda*) to suggest that Goya's intent was from the outset to key up the tonality of the entire work. While in the *Maja desnuda* highlights are light gray, those of the *Maja vestida* are a far more strident yellow. In her costume, the warm tones of her mustard-colored jacket and rose sash dominate; even the green of the couch is now liberally tinged with yellow. These colors reinforce the presence of the figure against the pictorial surface, in contrast to the recessive and, comparatively speaking, timid presence of her nude counterpart.

The *Maja vestida* flaunts her sexuality, which becomes a masklike shell that perhaps originally opened to reveal the *Maja desnuda*—who would have been seen as innocent by comparison. In other words, by identifying female sexuality with gaudy artifice, the *Maja vestida* leaves the nude comparatively bereft of sexual power. In the context of such hyperbole, the nude is no longer threatening: her sexuality, which in comparison to the *Rokeby Venus* had seemed so blatant, has now been travestied by her flamboyant, costumed counterpart.

Paired with the *Maja vestida,* Goya's nude is removed from the traditions of Titian and Velázquez that engendered her; and her significance is altered as she becomes inseparable from her clothed pendant. When seen together with the *Maja vestida,* the nude, who had formerly seemed so flat, is perceived as set back into space, with the result not only that her timidity is emphasized, but also that the staged space essential to voyeurism is reinstated. In short, juxtaposition to the confrontational *Maja vestida* puts the *Maja desnuda* back in her place.

What, then, might we say about the *Maja vestida?* Doesn't she now be-

come a threatening force, by assuming the role once assigned the *Maja desnuda?* I would argue not. The *Maja vestida* doesn't seem to be a real person: if the nude is taken as a standard, she is larger than life and the palette used suggests an artificiality that may well have been identified with masquerade. As mask, she invites discovery; an invitation that her owner might take up if he could unveil her at the pull of a rope. The second factor undermining her power is the identity that Goya gives her by dressing her. We recall that in 1808 she was inventoried as a gypsy, a member of a powerless and marginalized class: Goya returns to a ploy that he had used frequently in his tapestry cartoons, identifying female sexuality with a stereotypical character of the lower classes.[25] The implication is clear: sexuality is no longer a threat but a potential commodity.

What induced Goya to take the nude through the permutations here witnessed? I would suggest that the artist participated to some degree in the magical view of the world that underlay the censorial attitudes of late-eighteenth-century Spain. Accordingly, image and reality became confused, making it impossible for Goya to treat the female nude on a purely aesthetic level. This very contemporary nude, who so clearly addresses the viewer, becomes an embodiment of perversion somehow to be contained; as we have seen, Goya's solution is to dress her in a manner that identifies her sexuality with commodity and masquerade, thus divorcing it from the female form, which in turn is emptied of the sexual.

The subsequent history of the *Majas* attests to a demise of the magical view and a consequential transformation in the nature of censorship. The paintings were taken from Godoy's collection and in 1814 were found in storage with other goods sequestered during the Napoleonic War. Although it was not then known who had painted them, they were reported to the Inquisition and soon passed into its hands. About a month and a half passed before it was discovered that the painting of a "nude woman on a bed," was by Goya, as was "the woman dressed as a *maja* on a bed." (This is, notably, the earliest identification of the subject as a *maja,* an identification that implies the figure's lowly social class, forthright character, and contemporaneity.) Goya was ordered to appear before the tribunal to explain his motivation in painting these works; his testimony does not survive, and it is possible that the painter, still salaried at court, was able to circumvent an appearance.[26]

The Inquisitional intervention of 1814 illustrates a new form of censorship, now placed in the service of the state. The censor's main target was no longer the subject of the work, but rather the intentions of its creator. For in Restoration Spain, moral subversion was identified with treason, with the French, and with the fallen Godoy (who became, in effect, the scapegoat of the old order). This identification is illustrated by the initial denunciation of Goya's *Majas.* Its author opens by condemning the general collapse of morals under the government of the intruder king, Joseph Bonaparte:

These modern Attilas, not content with infusing the religious Spanish people with the venom of heresy that they held in their hearts, and that had produced as many ills as disgrace in the kingdom, to carry forth their execrable mission, tried to corrupt our customs with dishonest books, prints, and the most provocative and obscene paintings[27]

In all likelihood, the author of this statement had little idea that his investigation of "provocative and obscene paintings" would lead him to Spain's most senior court painter. To a more objective judgment, this in itself might have made him reconsider the ostensible correlation of sexual imagery and subversive politics; but this was a thought not to be entertained by the censorial mind.

NOTES

This paper was originally presented at the College Art Association annual conference in Washington, D.C., in a session titled "Censorship and the Visual Arts: Current Issues and Historical Perspectives," chaired by Elizabeth Childs, February 22, 1991. I would like to thank Elizabeth Childs and Nathalie Kampen for their comments and help in formulating the ideas presented here.

1. Scott Kendrick, *The Secret Museum: Pornography in Modern Culture,* New York: Viking, 1987, p. 29.
2. Richard Terdiman, *Discourse/Counter Discourse: The Theory and Practice of Symbolic Resistance in Nineteenth Century France,* Ithaca, N.Y.: Cornell University Press, 1985.
3. On the custom of the *cortejo,* see Carmen Martin Gaite, *Usos amorosos del dieciocho en España,* Madrid: Siglo Veintiuno Editores, 1972, Chapter 1. On the appearance of the *cortejo* in Goya's tapestry cartoons, see Janis A. Tomlinson, *Francisco Goya: The Tapestry Cartoons and Early Career at the Court of Madrid,* New York: Cambridge University Press, 1989, pp. 82–84.
4. Anonymous, *El Buen genio de un Marido, e Ilustración de estos tiempos/Saynete Crítico.* Ms. 14496, no. 39, Biblioteca Nacional, Madrid.
5. Nicolás Fernández de Moratín, *Arte de las Putas,* ed. by Manuel Fernández Nieto, Madrid: Ediciones Siroe, 1977, pp. 13–14.
6. Kendrik, *Secret Museum,* 1.
7. Pierre Gassier and Juliet Wilson, *The Life and Work of Francisco Goya,* New York: William Morrow, 1971, cat. nos. 307, 308; Sarah Symmons, *Goya in Pursuit of Patronage* (London: Gordon Fraser, 1988), p. 142.
8. Narciso Sentenach, "Cuadros selectos condenados al fuego," *Boletín de la Real Academia de San Fernando,* 2d ser., 4, no. 57, 1921: p. 50.
9. Antonio Ponz, *Viaje de España,* Madrid: Aguilar, 1947, 6:533. Other works included were Veronese's *Venus, Adonis and Cupid:* Carracci's larger version of the same subject: *Hippomenes and Atalanta* by Guido Reni: *The Rape of the Sabines,*

Diana at Her Bath, and *Bacchanal* by Rubens; and *Perseus and Andromeda, Juno, Palas and Venus,* and the *Judgment of Paris,* said by Ponz to be after designs by Rubens.

10. Sentenach. "Cuadros selectos," pp. 46–48.
11. Pedro Beroquí, *Tiziano en el Museo del Prado,* Madrid, 1946, p. 153.
12. Kendrick, *Secret Museum,* 6.
13. Hans Ulrich Gumbrecht, "Censorship and the Creation of Heroes in the Discourse of Literary History," in *The Institutionalization of Literature in Spain,* ed. by Wlad Godzich and Nicholas Spadaccini, Minneapolis: Prism Institute, 1987, pp. 239–240.
14. One result of the opening up of the royal collections was the publication of guides such as Richard Cumberland's *An accurate and descriptive catalogue of the several paintings in the King of Spain's palace at Madrid,* London: Dilly, 1787.
15. E. Pardo Canalis, "Una Visita a la galería del Principe de la Paz," *Goya,* pp. 148–150 1979: 308.
16. Duncan Bull and Enriqueta Harris, "The Companion of Velázquez's *Rokeby Venus* and a Source for Goya's *Naked Maja,*" *Burlington Magazine* 128, September 1986, p. 648.
17. Isadora Joan Rose Wagner, *Manuel Godoy: Patrón de las artes y coleccionista,* Madrid: Universidad Complutense, 1983, pp. 317–318.
18. "On the face of it at least, our civilization possesses no *ars erotica.* In return, it is undoubtedly the only civilization to practice a *scientia sexualis;* or rather, the only civilization to have developed over the centuries procedures for telling the truth of sex which are geared to a form of knowledge-power strictly opposed to the art of initiations and the masterful secret: I have in mind the confession." Michel Foucault, *The History of Sexuality,* vol. 1, *An Introduction,* Trans. by Robert Hurley, New York: Vintage, 1980, p. 58.
19. Julián Gallego, *Visión y símbolos en la pintura española del siglo de oro,* Madrid: Cátedra. 1987, pp. 68–70.
20. "Lucidio, aquel Pintor cuyo gran Genio/Frutos tan excelentes prometia,/Y que á inmortalizar los hechos grandes/Solo parece que nacido habia/De algunos Sibaritas corrompidos/Por adular el gusto afeminado,/Su talento sublime ha abandonado,/Su robusto pincel y sus ideas./Y en vez de dedicarse a las acciones/De los antiguos ínclitos Varones,/Se encuentra enteramente embebecido,/Pintando á Julia descubierto el seno,/Y al Amor en sus brazos adormido" Joseph Manuel Quintana, "Epístola." in *Distribución de los Premios,* Madrid: Real Academia de Bellas Artes de San Fernando, 1790, p. 87.
21. Cf. Gassier and Wilson, *Life and Work of Francisco Goya,* cat. nos. 366, 375, 696, 1682, 1688.
22. Harold Wethey, *The Paintings of Titian,* London: Phaidon, 1975, cat. no. L-27.
23. Relevant scholarship is summarized by Wagner, in *Manuel Godoy,* vol. 2, cat. nos. 246, 247. She proposes a date for the *Maja desnuda* of 1792–1795 and for the *Maja vestida* of 1803–1806. I am indebted to her research for the factual information on the paintings cited in this paragraph.
24. Charles Yriarte, *Goya,* Paris: Henri Plon, 1867, p. 89; Pedro Beroquí, "Adiciones

y correcciones al catálogo del Museo del Prado," *Boletín de la Sociedad Castellana de Excursiones* 6 (1913–1914), p. 502.

25. Tomlinson, *Tapestry Cartoons,* pp. 102–103.

26. *Inquisición,* legajo 4499, no. 3, Archivo Histórico Nacional, Madrid. The case is summarized by A. Paz y Melia, *Catálogo abreviado de la Inquisición,* Madrid: Archivo Histórico Nacional, 1947, p. 85.

27. Letter signed *Doctor Don Valentin Zorrilla de Velasco y Ollauri,* dated November 18, 1814, in *Inquisición,* legajo 4499, no. 3, Archivo Histórico National, Madrid.

What Mad Pride! Tradition and Innovation in the *Ramdohrstreit**

TIMOTHY F. MITCHELL

In 1808, Caspar David Friedrich exhibited *Cross in the Mountains* (Fig. 3) in his Dresden studio at Christmas time. The timing of its exhibition, as well as the painting's presentation in a gothic-arch frame designed by the artist and adorned with divine and euchartistic symbols, emphasized the evocative nature of its imagery. By combining traditional religious motifs with landscape, Friedrich challenged landscape conventions as well as the mutual independence and hierarchy of genres. His painting consequently provoked the conservative critic F.W.B. Ramdohr, who, like Wincklemann and Mengs, saw earlier art as a paradigm for modern artists. For Ramdohr, tradition established a model for the relation of form and theme. Friedrich's fusion of two genres threatened the rules which, according to Ramdohr, must govern the visual arts.

Friedrich's immediate response to Ramdohr's criticism was an often cited programmatic reading of his painting. By offering such a literal interpretation of his imagery—unique in the artist's career—Friedrich sought to appease his critic. He also narrowed the meaning of his work to a verbal equivalent, akin to that which governs conventional allegory, and in so doing undermined the evocative richness of *Cross in the Mountains.* That Friedrich felt compelled to respond to Ramdohr in this manner proves the importance that he attributed to the critic's attack.

Mitchell here shifts discussion of Ramdohr's article from a focus on the painting itself to issues arising from the ensuing critical debate. Friedrich challenged rules that Ramdohr considered as universal. Yet universality was a dangerous assumption to make within an era of increasing consciousness of historicism and cultural relativism. Friedrich's advocates countered Ramdohr by arguing that rules were neither absolute nor universal, but rather invented and determined by their cultural origin. The modern artist could no longer be expected to follow the rules of the past, since expression reflected the culture of a specific time and place. The perceived danger of this relativism was the implication that there were no rules by which art could be critically assessed: Friedrich's defenders replied that critical judgements be based not on universal rules, but on the extent to which a work fulfills the artist's intention. As Mitchell points out, the *Ramdohrstreit* illustrates a significant transformation in the evaluation of creativity, as the artist's conception now became integral to his accomplishment.

*"What Mad Pride! Tradition and Innovation in the *Ramdohrstreit,*" by Timothy F. Mitchell. *Art History,* vol. 10, no. 3, Dec. 1987. Reprinted by permission of Blackwell Publishers, Oxford.

The debate over the aesthetic worth of Caspar David Friedrich's painting *The Cross in the Mountains* (Fig. 3) has become a standard anecdote in histories of German Romantic painting, but it is usually retold as an example of the inadequacy of traditional criticism when confronting Romantic genius. The essays comprising the *Ramdohrstreit,* as the dispute is now called, are easily available, but discussions of them remain unbalanced and continue to ignore what may reasonably be seen as the crucial center of the argument. The importance of the debate is discovered not in Ramdohr's attack but in the counterarguments set against him.[1] It is here, in the defense of Friedrich's innovations, that important new developments in the interrelationship of art history and art criticism are first evident.

The event which triggered Friedrich von Ramdohr's polemic "On a Land-

Figure 3 Caspar David Friedrich, *The Cross in the Mountains,* 1808. Gemaldegalerie, Dresden. Photo: Eric Lessing/Art Resource.

scape Painting intended for an Altar by the Dresden Painter Friedrich and on Landscape Painting, Allegory and Mysticism in General," began innocently enough. Friedrich had completed a painting for Count Franz Anton von Thun-Hohenstein and it was to be sent to a chapel in the Count's castle at Tetschen in northern Bohemia. Friends had persuaded Friedrich to display the work before its departure. During the Christmas holidays of 1808, Friedrich carefully prepared the atmosphere in his studio. He darkened the room by partially covering the windows and emptied it of all furniture except a table which was covered with a black cloth. Upon this table stood the large painting enclosed in a gilded, gothic-arched frame.[2]

Here was dramatic evidence of a new direction in landscape painting. His simple image of a cross in the mountains, certainly no new theme, was "altered" by its frame. The depiction of a metallic crucifix reflecting the setting sun, surrounded by evergreens and ivy, and standing at the summit of a peak, offered an easily understood scene. However, the emblem-laden frame demanded other interpretations from the viewer. The frame's base displays the Eye of God within a triangle, from which rays of light emanate. Flanking this traditional symbol of the Godhead are stalks of wheat and grape clusters, clearly referring to the Eucharist. The sides are clustered columns from the tops of which spring palm branches forming the pointed arch. Out of these branches emerge the heads of five adoring angels. At the apex of the arch, directly above the head of one angel, appears a star. The presence of such unmistakable religious images transformed the simple landscape into an altarpiece. Friedrich, who had designed the frame himself,[3] became the proponent of a new mode of religious sensibility in art. Not all viewers were pleased by what they viewed as the artist's presumption.

The printed comments appeared from January 1809 and into 1810. Ramdohr's strong objections to Friedrich's innovations drew published responses from two of Friedrich's friends; Gerard von Kuegelgen and Ferdinand Hartmann. Even Friedrich was driven to write an explanation of his intended symbolism: the only occasion upon which he was publicly to explicate his own work. Nor was the discussion limited to this narrow circle; it attracted the attention of the entire art-loving public.[4]

If, for heuristic reasons, one wished to construct a central thesis for the controversy, it would have to be based on Ramdohr's observation that Friedrich's painting had not been "constructed according to the principles proven by long experience or made venerable through the example of great masters" (verfertigt nach Grundsaetzen, welch eine lange Erfahrung erprobt und das Beispiel grosser Meister geheiligt hat) (p. 134). Ramdohr followed the logical path of his principles by first establishing the essential characteristics of "good" landscape painting and then matching Friedrich's painting to this model. Ramdohr perceived landscape painting as consisting stylistically of two essential technical devices: aerial and linear perspective. The former controlled the quality of light and the concomitant atmospheric effects while the latter required certain compositional patterns. Forms in nature must be arranged in a se-

ries of stages into depth and related through subtly hidden progressions from one plane to the next. The existence of atmosphere must be likewise taken into account. It transforms colors from local tones to general effects and blurs details.

The comparison was invidious from the start. The qualities of Friedrich's painting selected by Ramdohr for special attention were quite naturally those which displayed the greatest divergence from the critic's rules:

> In his altarpiece, Friedrich has intentionally and directly opposed all of the basic principles. He has filled the entire foreground of his picture with a single pinnacle of rock as if with a cone, producing not the slightest indication of differing planes. He has kept out all aerial perspective, and what is even worse, he has spread a darkness across the earth thereby excluding all the favorable effects which the flow of light can present (p. 141).

Ramdohr then turns to subject-matter and asks the question: "To what degree is it possible to allegorize with landscape?" Typically, he begins with a definition of allegory which makes landscape unsuited for this task. Allegory requires that objects be perceived in relationships outside of their common settings. To achieve such an effect in landscape would be to destroy the necessary qualities of that art form. He facetiously recommends scenes in which the foliage of the trees consists of pastry or in which the sky is below the earth in order to disrupt the normal relationships. Such absurdities demonstrate, for Ramdohr, that a properly arranged landscape painting is by definition incapable of rendering allegories.

Ramdohr's attack on Friedrich's work was based as much on a recognition of the inherent power of Friedrich's imagery as it was on the stylistic weaknesses Ramdohr found so apparent. For him *The Cross in the Mountains* clearly displayed the signs of "that mysticism which now creeps in everywhere like a narcotic miasma, arising out of science, philosophy and religion" (p. 150). Friedrich's compositional inventions were insidious attractions which could corrupt the unschooled, provincial artist. While recognizing the emotional appeal of the painting and the attraction the work might have for some, Ramdohr stressed that poetic creativity could never compensate for technical deficiencies (p. 145). We will see later how Friedrich might have replied to this assertion.

This reliance on authority and prescriptive formulas and on the superiority of technique over theme makes Ramdohr's conservatism self-evident. It also supplied the issue on which all counter-arguments converged. The speciousness of his arguments seemed clear.

The defenses raised on behalf of Friedrich's work are all based on a new understanding of "rules" in art. The core of Ramdohr's aesthetic is his belief that the principles of art have been "uncovered" (herausgefunden) by the great masters of the past. These rules are not arbitrary, but rather reflect universally valid canons of art. Ramdohr's essay is but the logical consequence of his the-

ory. In opposition, Kuegelgen argues that these "rules" are only "invented" (erfunden). He maintains that the "principles" of ancient art are but descriptions of culturally determined artistic devices for unifying exterior form to inner spirit. The distinction is not a small one. It permits Kuegelgen to promote Friedrich's efforts as the true reflection of the authentic core of art.

> In all classical works of art we find the idea, the inner spiritual content, and the form, the exterior configuration, unified as in the perfect alliance of body and soul. Even as the body grows according to the dictates of life's origins, so too does the shape of the work of art flow from the idea and feeling which the artist desires to express through the form. Why then should not Friedrich likewise construct the exterior form in his own manner in accordance with his ideas and feelings, which one certainly recognizes? Because it is not in accordance with the rules which Ramdohr finds in the classics? If the past masters had always retained the old principles, would art ever have progressed? (p. 169)

Several parts of this commentary deserve careful attention. First is the way in which Kuegelgen builds his case on the well-established aesthetic criterion of unity between theme and style. Second is the observation that the "inner spiritual content" is clearly recognizable. Last, but certainly not least, is the suggestion that art progresses. This final comment proves to be the most important. Reading Kuegelgen's and Hartmann's justifications for Friedrich's nontraditional art makes the reader immediately aware of the role "historicism" plays in recasting all traditional aesthetic issues into new, "modern" configurations. Observing the evidence of history, that the varieties of style are linked to particular cultural periods, suggested that past art and the rules which shaped that art were an inadequate guide to understanding contemporary art. Ideas on the proper subject-matter for art, on the correspondences between theme and style, on the role of the artist and critic, are all re-defined under the impact of a new sense of history. The *Ramdohrstreit* is the first clear example of the new criteria being established for art criticism.

While historicism has become a complicated term, it is used here in its "Urform" as the belief in cultural relativism.[5] The belief in culturally determined values has its own history. From Vico, through Montesquieu and Winckelmann, to Herder, the idea gathers momentum. But while individuals may have stated tenets of historicism early on, the number of adherents to this new historical view first reaches what might be called a state of critical mass only in Germany around 1800.[6]

Ramdohr's criticisms were not simple-minded or unconsidered. The theoretical issues were complex and he recognized them. The attack on prescriptive formulas was not new; in fact, Ramdohr had been previously singled out for his inflexible standards. As William Vaughan notes, Ramdohr had been mentioned by Friedrich Wackenroder in his famous novella *Herzensergiessungen eines Kunstliebenden Klosterbrüders* (1797) as one of those soulless commentators

who "separate the good works from the so-called bad ones, and finally place them all in a row so that they can survey them with a cold critical gaze."[7] But it is important to remember that Wackenroder's objection was not to Ramdohr's reliance on tradition but to his lack of emotional response in judging works of art. In an oft-quoted chapter of this novella Wackenroder writes of the need for tolerance in art:

> Art deserves to be called the flower of human sensibility. In the various zones of the earth it shoots up to Heaven in ever-changing forms, and from this crop too only one sweet fragrance rises to the Father of All, who holds the earth and all things in His hand The Gothic temple is as pleasing to Him as the temple of the Greeks; and the barbarous war songs of savages is to His ear a music as sweet as elaborate chorales and anthems.[8]

Although the evidence of cultural relativity is produced here, it is not followed by a cry for a new art form unique to the present age. Nor was Wackenroder calling for a free rein in art; rather, as Werner Kohlschmidt has shown, he defends clarity in art against the uncontrolled play of fantasy.[9]

The long-standing discussion of the role of genius in art was activated as one response to Ramdohr's essay. Ruehe von Lilienstern, for example, suggests a defense as neat as Ramdohr's attack. Lilienstern asserts that rules do not apply to Friedrich because he is a genius, and precisely because of that fact knows no law except himself. A genius might stray on to a false path but would, according to Lilienstern, eventually discover the error and correct it himself. As support for his ideas, Lilienstern quotes Schiller, who describes a genius as one who solves the most difficult problems with ease and simplicity by following instinct. Johanna Schopenhauer, however, responded to the debate in terms that Ramdohr would have approved. She wrote that even a genius could produce "wild, purposeless action" (wild, zweckloses streben) if that person abandoned the traditions of art.[10] Ramdohr, in his response to Kuegelgen, declared his own objections to the "unconditional adherence" (unbedingte Befolgung) to conventions by beginning artists. Tradition was not a set of inflexible patterns. But it was a guide which was abandoned only at great risk. Ramdohr accepts the power of genius to create new forms and images, but even that creative fire must be banked by reason. Unbridled originality would lead to inappropriate and unbalanced forms, and might ultimately produce monstrous creations (p. 174).

The definition of genius and its relationship to creativity is too broad, too complicated, and too deeply studied an issue to deal with fully here, but certain points must be made. The question of artistic genius was, of course, a favorite topic of investigation during the Enlightenment, and was particularly important during the *Sturm and Drang* in Germany.[11] The tendency of some artists to claim unrestricted freedom led to such complaints as the following from Soloman Gessner to his son:

> XXX has learned from the great maxims, as he himself said, to despise the judg-
> ment of the world and to make his own feelings over the worth of his art the sole
> judge. What nonsense, what mad pride. To place the entire world in a subordinate
> position as if every one were lunatics except for oneself. What nonsense to wish
> to hear nothing but your own convictions and your own feelings.[12]

Whom Gessner was discussing is unknown, but what is characteristic of all
these late eighteenth-century uses of the term genius is the assumption that
some universal element of art is being described. Even Kant, whose ideas on
genius are normally seen as new, remains tied to a search for universals.[13] Peter
Szondi makes the point that Kant is separated from later aesthetics by a wall of
historical thought (die Wand . . . des historischen Denkens).[14] The geniuses of
these passages are not historically determined. With the rise of historicism a
new ingredient is added to the formula.

The principal source in German for the idea of cultural and artistic relativ-
ity is Johann Gottfried Herder's *Reflections on a Philosophy of the History of
Mankind* (1784–1791).[15] His intention was to trace the history of mankind and
offer explanations for its diversity. In so doing he also suggested the inherent
values of distinctive cultural periods. This claim was quickly perceived as a
threat to art. Because aesthetic values were believed to embody universal truths,
they could not be culturally determined, as Herder suggested. Friedrich
Schlegel criticized Herder on just these grounds: "to contemplate every flower,
without evaluation, only according to place, time, and kind, would finally lead
to the result that everything must be as it is and was."[16] Schlegel's own critical
writings are attempts to relate the historical perspective of art to the aesthetic
experience without accepting relativism. His comments on the problems inher-
ent in historicism as art criticism did not go unanswered.

By focusing on the importance of "principles made venerable through the
example of great masters," the *Ramdohrstreit* is but a renewal of the centuries-
old debate over the relationship of the past to the present. But now the debaters
were using the same words in radically different ways. The truism that the con-
cept of being modern requires a particular sense of the past is recognized, but
too frequently oversimplified. Juergen Habermas provides an example. He
writes:

> the term "modern" appeared and reappeared exactly during those periods in Eu-
> rope when the consciousness of a new epoch formed itself through a renewed re-
> lationship to the ancients—whenever, moreover, antiquity was considered a
> model to be recovered through some kind of imitation.[17]

What is unmentioned here is the radically divergent sense of history which
emerges at the end of the eighteenth century and the corresponding new sense
of being "modern." Previously the word "modern" had always implied a partic-
ular relationship of the past to the present. During the Renaissance, for example,

the ancient world was conceived "as floating above and outside history, the one great realization of a perfect life," to quote Felix Gilbert.[18] Even during the famous "Querelle des Anciens et des Modernes" of the eighteenth century, the issues debated did not challenge the validity of ancient art for the present. Matei Calinescu describes the situation:

> Most of the "moderns" involved in the famous Querelle des Anciens et des Modernes, or its English counterpart, the Battle of the Books, continued to consider beauty as a transcendental, eternal model, and if they thought themselves superior to the ancients, they did so only insofar as they believed they had gained a better, more rational understanding of its laws.[19]

The classical tradition could not be abandoned but only improved on. Until the early nineteenth century, prescriptive formulas could be equaled or surpassed only by understanding and applying the same aesthetic value system.

The issue of modern versus ancient should not be oversimplified. The complications are obvious when it is realized that Ramdohr was himself one of the earliest writers to deny the possibility of recapturing fully the Greek spirit. Alex Potts has brought to our attention Ramdohr's essay of 1787, "Ueber Mahlerei und Bildhauerarbeit in Rom," in which Ramdohr states that since Greek art is a product of a distant time and place, it cannot be revived by modern artists.[20] The link to Winckelmann's assertion of the cultural origins of Greek art are too obvious to dwell on, but it is interesting to note that Ramdohr acknowledges the hidden inconsistency in Winckelmann's famous essay on copying ancient models. Winckelmann establishes the necessary cultural conditions which gave rise to Greek artistic perfection, but then proceeds as if that art can be copied without commenting on the cultural differences between past and present.[21] But while Ramdohr may recognize the impossibility of fully recapturing the perfection of Greek forms, he adheres to the notion that, although unattainable, Greek ideals and the traditions which have emerged from them are still the only appropriate models for art.

It is the question of appropriateness which is attacked by Friedrich's defenders. Hartmann's and Kuegelgen's essays appeared within a short time of each other, but there is no evidence of collaboration. The similarities in their arguments are thus all the more revealing of the fundamental shift taking place in art criticism. Hartmann's essay, the earlier of the two, was so acrimonious that Ramdohr refused to respond. Kuegelgen, on the other hand, was more polite in tone and drew a written answer from Ramdohr. The more civil nature of Kuegelgen's piece may not have been of his own choosing. He writes to his brother Karl that the editors have removed all the "thorns" from his article.[22] As has already been mentioned, Kuegelgen is particularly clear in stating the crux of the issue: the principles of art are not "discovered" but "invented." He argues that ancient art was created to meet certain emotional needs determined by historical developments. The forms of ancient art are but the devices discovered

for embodying these spiritual contents. Such unification is the aim of art, but since each age is different the spirit and its formal expression will differ. Friedrich should not be criticized for introducing stylistic innovation when change is itself part of the very fabric of history. But if normative aesthetics are invalid, how can a work be judged? Against what standards should the work be compared? Both Kuegelgen and Hartmann arrive at the same conclusion.

A work is to be judged by its effectiveness in completing the inherent demands of the work, by its ability to embody fully an inner spirit. Hartmann suggests that Ramdohr confine his comments on Friedrich's work to a discussion of the artist's success in realizing his idea. He goes on to complain that the criteria used by most critics are "the stale rules and theories which are not taken from the inner essence of art but only superficially from the outer surface of various works of art."[23] In like fashion Kuegelgen admonishes the critic to honor "the artwork which gives to the sensibilities of the viewer an impression of living truth, and condemning those works which appear cold, tedious and false" (p. 170). The requirements for such criticism are not stated but implied: the critic must now recognize the work's inner law, its aim or content. The skills needed are no longer knowledge of traditions but sensitivity to changing issues and their new artistic forms. Subjective response replaces objective rules. Historicism reshapes a well-established critical approach.

The insistence on artistic coherence between form and ideas is tied to the problem of modes in art. Specific themes had long been associated with certain formal arrangements, as Poussin had suggested.[24] The continuation of this judgment based on a concern with matching subject and style is typified by Sir Joshua Reynolds's comments on Salvator Rosa's painting of bandits in a landscape: "Everything is of a piece: his rocks, trees, sky, even to his handling, have the same rude and wild character which animates his figures.[25] Reynolds speaks of the "perfect correspondence" in Rosa between his subjects and his style. But this union is predicted on a system of universal values: Rosa represents the Wild and Sublime. It is probably in this sense that Kant's statement on artistic coherence should be taken. In an often overlooked passage Kant wrote: "Now the perfection of a thing lies in the coordination of its many components with its inner destination to a purpose; hence the degree of a thing's perfection will have to come into consideration at once in judging artistic beauty."[26] Kant's critique of judgment did not alter the normal forms of art criticism. Only when universals are placed in doubt does the choice of styles become dramatically intensified. As content is now a product of unique cultural moments, there is no predetermined form, no "modes" in the sense of available, set patterns. The artist is now confronted with the double task of both sensing the "living truth" of the age and giving it an appropriate form. Modes are replaced by infinite possibilities.

The revolutionary aspect of the *Ramdohrstreit* is the reordering of the axes of judgment. Evaluating a work of art always means to place it within a set of aesthetic coordinates: one axis gauges the subject-matter (the "problem," in

recent terminology), and the other technical skill (the "solution"). Traditionally, as is the case with Ramdohr, the two axes are considered independent. Technical proficiency could be judged on its own, as could the theme, although they are normally joined in considering the real value of a work. But now, under the system employed by Hartmann and Kuegelgen, the axes are inseparable and unequal. The artistic problem or idea establishes the basis for evaluating the effectiveness of the solution. Indeed, a work can only be judged by the importance of its inner spirit. What ultimately justifies, for Kuegelgen and Hartmann, Friedrich's deviations from traditional landscape form is just such an indwelling spiritual vitality lacking in the work of contemporary landscapists such as Philipp Hackert.

In equating style with culturally and historically conditioned experience Kuegelgen and Hartmann were expressing opinions held by the artist, which find expression in his later writings. If anything, Friedrich's views are even more extreme.

> Does man make the times or the times make the man? . . . Is Mankind really free or determined by time and place? The types of subjects selected or the means of representation in the pictorial arts appear in certain time periods to express themselves very clearly and Germanically, in the difference of the practical execution. Even the manner of drawing drapery, the manner of seeing everything as flat or round. These modes of perception however unusual or even humorous we find them, speak for the opinion that Mankind is not as free of time and place as many believe (p. 129).[27]

The value of imitating the Old Masters is obviously limited when we recognize that these artists would themselves paint differently if they were suddenly resurrected in the nineteenth century. Friedrich uses the example of Raphael who he claims would paint his images in a different way in 1820 from the way he did in 1520 (p. 105). The simple fact is that for Friedrich every work of art, even by the greatest master, "will and must carry the mark of its time." For Friedrich the "living truth" of his own historical period and the content of his art was the realization of the experience of God through nature. There were numerous paths to this goal, but there was only one vital center (p. 152).[28]

Finding the proper form for the expression of this inner experience becomes the crucial issue. Friedrich's religious faith made the soul an infallible guide. The origin of the soul in God insured the accuracy of the imagery which the soul engendered. No rules or principles invented by reason alone could ever replace the artist's own inner responses about what was proper for his art. The passages in his writings which support this aspect of his theory are numerous and frequently cited. The following is typical:

> The only true source for art is our heart, the language of a pure, childlike nature. A picture which has not sprung from this well can only be dilettantish. Every authen-

tic work of art is conceived in a consecrated moment and born in a joyous one, often out of the inner forces of the artist's heart, without his realizing it (p. 92).

Because creativity resides in the individual soul, it cannot be gained by copying another's style; consequently, the technical aspects of art are the least important. Friedrich does not deny the importance of craft in artistic impact, but when compared or balanced, there is no doubt that feeling is the decisive ingredient. Skill is only significant to the degree that it augments the intensity of experience. In the words of Friedrich: "What is more important than how."[29] Friedrich might have responded to Ramdohr's assertion of values by turning the tables: he could easily have claimed that "technical proficiencies could never compensate for the loss of soul." Friedrich's term for a work of skill but lacking the necessary inner spirit is "a decorated cadaver" (eine gesmücke Leiche) (p. 108).

Two new premises for art criticism were thus emphasized during the *Ramdohrstreit;* that art must reflect the spirit of the age and culture from which it comes, and that content or meaning determines form and gives the work its significance. The two criteria are obviously linked. The key to criticism is artistic intention, and the only guide for the viewer is feeling. The *Ramdohrstreit* thus served to focus and crystallize a major shift in critical attitudes which had been emerging over at least two decades.

The debate over the aesthetic worth of Friedrich's *The Cross in the Mountains* did not, of course, mark the cessation of traditional art criticism. The struggle to overcome prescriptive formulas in the arts was long and difficult, but it was ultimately triumphant.[30] Indicative of the lingering power of normative aesthetics is the controversy over the work of the Brotherhood of St Luke in Rome. Frank Büttner has analyzed the components of this debate, which occurred a decade after the *Ramdohrstreit,* and they fit nicely with the issues just discussed.[31] The essay in question appeared in the second part of Goethe's *Über Kunst und Alterthum in den Rhein- und Mayn- Gegenden* (1817). It was published only with the initials of the "Weimarischen Kunstfreunde" but was written by Heinrich Meyer. The heart of Meyer's essay is simply that the "Nazarenes" in Rome (they are first given this now common title in this essay) have followed false models and have thus deviated from true art. What makes this debate interesting for this study is Meyer's assertion that the Rome-based artists are attempting to emulate something which is historically determined and thus not copyable. The spirit of the age prior to Raphael, the attractive simplicity, the quiet innocence of the paintings is not, for Meyer, an intentional artistic effect but a property of that age which cannot be recaptured. Only style can be learned, and for that the only models are the canons of ancient art. Meyer joins the ranks of the numerous writers on art who have, since Winckelmann, accepted the "rules" of ancient art as evidence of universal beauty.

Reactions from the artists in Rome to Meyer's essay are described by Büttner and read like paraphrases of Hartmann and Kuegelgen, but with Catholic

overtones (pp. 64–66). A typical reaction is found in the writings of Johann David Passavant.[32] Beauty is no longer "ideal" but always determined by time and place. What artists now seek are not models of beauty but related souls. Only that which had an inner, spiritual connection to the artist, and the artist's time and country, can serve as an archetype. The Nazarene theory of art is based on a philosophy of history (p. 68).

Friedrich's views on the Nazarenes must be inferred from his aphorisms on art. There is little doubt that he was referring to them when he attacked those who wished to copy styles of the past: "What was found so pleasing about the old paintings was above all their pious simplicity. We do not wish to become simple, however, as so many have done, and copy their mistakes, but instead become pious and copy their purity" (p. 91). Interestingly, Friedrich selects exactly that aspect of older art which Meyer has denied could be copied, the spiritual attitudes. For Friedrich, intentions and attitudes always determine artistic quality.

A fitting conclusion to this study is the essay on art criticism by Carl Gustav Carus. It was first presented as a lecture to the Saechsischen Kunstverein on March 10, 1835, and was then appended to the second edition of his book *Briefe Über Landschaftsmalerei* (Leipzig, 1835).[33] Carus's close friendship with Friedrich is well known, and although he did not arrive in Dresden until 1814 and was thus not present during the *Ramdohrstreit,* his explicit instructions for evaluating a painting sound as if they were written with that debate in mind. Carus divides critics into two groups: the "Kunstkenner" and the "Kunstseelen." Those who dwell on the impression made by formal qualities, and who speak exclusively of perspective, correctness of drawing, and artistic knowledge, are "Kunstkenner." The second group is smaller and consists of those endowed by nature with the ability to perceive directly the "inner, secret individuality of the art work" (p. 264). Great art is, for Carus, always the revelation of the artist's soul. In order to relate to these works the most important knowledge one can have is historical. Carus stresses the necessity of knowing the idiosyncrasies of the artist and his time, before we can fully grasp the life of the painting. Art criticism is wedded to art history.

Perception of the work's inner spirit must precede true criticism. Carus recognizes the frequency with which art criticism becomes personal commentary, in which the ideas discussed come not from the art work but from the critic. True criticism takes time, and the picture must make itself available for study. Knowledge, combined with sensitivity to art, and thorough study of the work, will lead to meaningful appreciation. The art work completes itself by embodying or realizing fully its inner spirit in comprehensible forms. The role of the critic is to apprehend this self-completion.

The concept of self-completion leads us back to the beginning. In 1785 Karl Philipp Moritz published "Versuch einer Vereinigung aller schoenen Kuenste und Wissenschaften unter dem Begriff des in sich selbst Vollendeten" in the *Berlinischen Monatschrift.*[34] His attempt to define art by its unique as-

pect of "in sich selbst Vollendetes" becomes a paradigm for art criticism and predates Kant's *Critique of Judgment.* Moritz's essay serves if not as a specific inspiration then at least as a starting-point for the later writings of Lessing, Goethe, Meyer, Ramdohr, but also for Hartmann and Kuegelgen.[35] Without analyzing the entire essay, it is possible briefly to mention the important points of Moritz's thinking. Aesthetic enjoyment is the perception of the purposefulness and appropriateness of the various aspects of the art work. Art has the special quality of being complete without any external goal or purpose. Moritz writes: "One does not contemplate art in order to use it, but one uses art in order to contemplate it" (Man betrachtet es [art] nicht, in so fern men es brauchen kann, sondern man braucht es nur in so fern man es betrachten kann). But the inner goal of art is for Moritz, unmistakably, still the quest for ideal beauty.

The value of Friedrich's painting lies exactly in its "self-completion," in the merging of style and subject, in the realization of inner spirit through appropriate forms. But history has now shown that such a union requires constantly changing forms. The progress of the spirit demands an equal progress of style. To judge aesthetic values means first to ascertain the spirit alive at the time of artistic creation. The *Ramdohrstreit* provides perhaps the best early nineteenth-century example of the emergence of a new paradigm in art criticism, in which critic and contemporary historian are joined, and where tradition demands innovation.

NOTES

I wish to thank Neil Flax for reading an early version of this article and for making valuable suggestions on its improvement. Also deserving credit is Breon Mitchell whose editorial advice helped shape the final draft.

1. The principal essays which comprise the debate over Friedrich's painting are reprinted in *Caspar David Friedrich in Briefen und Bekenntnissen,* 2nd ed. Munich, 1974, ed. Sigrid Hinz, pp. 134–181, hereafter referred to as Hinz. All page numbers given in the text will refer to this book unless otherwise specified. Sections of them are translated into English in *The Triumph of Art for the Public,* New York, 1979, ed. Elizabeth Holt, pp. 152–165. The translations in this paper are those of the author unless otherwise noted. Of the numerous studies in which the *Ramdohrstreit* is discussed, I know of only one in which the arguments supporting Friedrich are given any notice, and that is Gert Unverfehrt, *Caspar David Friedrich,* Munich, 1984, pp. 37–50. Even here, the primary emphasis is on Ramdohr's criticisms and only brief notice is given to Kuegelgen's introduction of historical relativism.

2. These details come from the memoirs of Ruehle von Lilienstern, *Reise mit der Armee im Jahre 1809,* reprinted in Hinz, pp. 177–180. Recent scholarship has complicated the origins of the *Tetschener Altar.* Before 1977 all studies accepted the information presented by Lilienstern that the painting had been commissioned

by Thun-Hohenstein, but Eva Reitharova and Werner Sumowski have published letters which indicate that Friedrich originally painted the central panel as a gift for the King of Sweden. How the gift became the altar for the Tetschen chapel remains unknown. See Reitharova and Sumowski, "Beitraege zu Caspar David Friedrich," *Pantheon,* XXXV, 1977, pp. 41–50.

3. The frame was carved by Karl Gottlob Kuehn. See Hinz, p. 133.
4. At least this was the opinion of Ruehle von Lilienstein in his memoirs, see Hinz, p. 177.
5. For a discussion of the various meanings of the term, see D.E. Lee and R.N. Beck, "The Meaning of Historicism," *American Historical Review,* LIX, 1965, pp. 568–577; and also G.G. Iggers, "Historicism," in *Dictionary of the History of Ideas: Studies of Selected Pivotal Ideas,* vol. 3, New York, 1973, ed. P.P. Wiener, pp. 456–465.
6. The basic study of historicism is still Friedrich Meinecke, *Historism: The Rise of a New Historical Outlook,* London, 1972. See also Peter Reill, *The German Enlightenment and the Rise of Historicism,* Berkeley, 1975, and Hannah Arendt, "The Concept of History," in *Between Past and Present,* New York, 1961, pp. 41–90; and Georg G. Iggers, *The German Conception of History,* Middletown, Conn., 1968. Particularly relevant to this study is A.D. Potts, "Political Attitudes and the Rise of Historicism in Art Theory," *Art History* 1978, pp. 191–213.
7. William Vaughan, *German Romantic Painting,* Yale University Press, 1980, p. 8.
8. Translation by Edward Mornin, *Outpourings of an Art-Loving Friar,* New York, 1975, pp. 45–46.
9. Werner Kohlschmidt, "Wackenroder und die Klassik," in *Unterscheidung und Bewahrung,* Festschrift für Hermann Kunisch, Berlin, 1961, pp. 175–184.
10. J. Schopenhauer, "Über Gerhard von Kuegelgen und Friedrich in Dresden. Zwei Briefe mitgetheilt von einer Kunstfreundin," *Journal des Luxus und der Moden,* 1810, pp. 690–693. Reprinted in Helmut Boersch-Supan and Karl Jaehnig, *Caspar David Friedrich,* Munich, 1973, p. 78.
11. A starting-point for study of this broad topic is Ernst Cassier, *The Philosophy of the Enlightenment,* Princeton, 1951, pp. 275–360.
12. *Soloman Gessners Briefwechsel mit seinem Sohne,* Zurich, 1801, p. 29.
13. Giorgio Tonelli, "Kant's Early Theory of Genius," *Journal of the History of Philosophy,* IV, 1966, pp. 109–131.
14. Peter Szondi "Antike und Moderne in der Aesthetik der Goethezeit," *Poetik und Geschichtsphilosophie I,* Frankfurt a/M, 1974, (Suhrkamp Taschenbuch 40, Wissenschaft), p. 15.
15. Herder, *Ideen zur Philosophie der Geschichte der Menscheit,* Weimar, 1784, translated by T.O. Churchill, London, 1800. All quotes will be cited in the text with Book and Chapter numbers followed by the page in Churchill. For a discussion of Herder's ideas, see A. Gillies, "Herder's Preparation of Romantic Theory," *Modern Language Review,* XXXIX, 1944, pp. 252–261.
16. From *Prosaische Jugendschriften,* quoted by Welleck, *A History of Modern Criticism: The Romantic Age,* New Haven, 1955, p. 8. See also Martin Schuetze, "The Fundamental Ideas in Herder's Thought IV," *Modern Philosophy,* 19, 1922, p. 369.

17. Juergen Habermas, "Modernity—An incomplete project," in *The Anti-Aesthetic: Essays in Postmodern Culture,* Port Townsend, Washington, 1983, ed. Hal Foster, p. 4.

18. Felix Gilbert, "Renaissance Interest in History," in *Art, Science, and History in the Renaissance,* Baltimore, 1967, ed. Charles Singleton, 382.

19. Matei Calinescu, *Faces of Modernity,* Bloomington, Indiana, 1977, p. 3. See also Herbert Dieckmann, "Esthetic Theory and Criticism in the Enlightenment: Some Examples of Modern Trends," in *Introduction to Modernity, a Symposium of Eighteenth-century Thought,* Austin, Texas, 1965, ed. Robert Mollenauer, pp. 65–105. For the most extensive treatment of this topic see Hans Robert Jauss, "Aesthetische Normen und geschichtliche Reflexion in der Querelle, des Anciens et des Modernes," an introduction in the new edition of Perrault's *Parallèle des Anciens et des Modernes,* Munich, 1964.

20. Potts, "Political Attitudes and the Rise of Historicism in Art Theory," p. 195.

21. For a discussion of Winckelmann's view of history see Alex Potts, "Winckelmann's Construction of History," *Art History,* 5/4, 1982, pp. 377–407. Potts suggests that Winckelmann's concept of cultural determinism was largely ignored by his contemporaries. For a discussion of the inconsistency of Winckelmann's aesthetic system see Peter Szondi, "Antike und Moderne in der Aesthetik der Goethezeit," pp. 30–44. See also Ingrid Kreuzer, *Studien zu Winckelmanns Asthetik,* Berlin, 1959.

22. Letter from Kuegelgen to his brother Karl dated 7/4/1809. Printed in F. Hasse, *Das Leben Gerhards von Kuegelgen,* Leipzig, 1824, pp. 219–220; reprinted in Boersch-Supan and Jaehnig, p. 78. The editors' actions are probably derived from the fact that Kuegelgen's essay was published in the same journal as Ramdohr's.

23. Hinz, p. 186.

24. A. Blunt, "Poussin's Notes on Painting," *Journal of the Warburg and Courtauld Institutes,* I, 1983, pp. 344–51. See also J. Bialostocki, "Das Modusproblem in den Bildenden Kuensten: Zur Vorgeschichte und Nachleben des 'Modusbriefes' von Nicolas Poussin," *Zeitschrift fuer Kunstgeschichte,* 24, 1961, pp. 128–141.

25. Quoted in W. Gaunt, *Bandits in a Landscape,* London, 1937, p. 40.

26. Paragraph 48 in *Critique of Judgment.* This passage is quoted in various places, but I first encountered it in Carl Dahlhaus, *Esthetics of Music,* Cambridge University Press, 1982, p. 34. In discussing Kant's aesthetics, René Welleck writes: "I have ignored, for instance, the awkward distinction between free and adherent beauty." From "Immanuel Kant's Aesthetics and Criticism," in *The Philosophy of Kant and Our Modern World,* ed. Charles W. Hendel, reprinted in *Discriminations: Further Concepts of Criticism,* New Haven, 1970, pp. 122–142. See also Ingrid Stader, "The Idea of Art and of its Criticism. A Rational Reconstruction of Kantian Doctrine," in *Essays in Kant's Aesthetic,* Chicago, 1982, ed. Ted Cohen and Paul Guyer, pp. 195–218.

27. For a discussion of the impact of these ideas on Friedrich's later work see this author's article. "Bound by Time and Place: The Art of Caspar David Friedrich," *Arts Magazine,* 61/3, November 1986, pp. 48–53.

28. Friedrich's circular model for artistic problems and solutions is typical of German

Romantic thinking. See Marshall Brown, *The Shape of German Romanticism,* Ithaca, 1979.

29. From "Äusserung bei Betrachtung einer Sammlung von Gemälden von grösstenteils noch lebenden und unlängst verstorbenen Künstlern," reprinted in Hinz, pp. 85–130. Quote is found on p. 102.

30. For a discussion how these issues in art criticism continue as underpinnings in our current debates on art see this author's essay, "Right Angles and Burning Giraffes: The Goals of Modernism/Postmodernism," *Arts Magazine,* March, 1987.

31. Frank Büttner, "Der Streit um die 'Neudeutsche Religios-Patriotische Kunst'," *Aurora,* 43, 1983, pp. 55–76.

32. [J.D Passavant], *Ansichten über die bildenden Künste und Darstellung des Ganges derselben in Toscana, zu Bestimmung des Gesichtspunctes, aus welchem die neudeutsche Malerschule zu betrachten ist, von einem deutschen Künstler in Rom,* Heidelberg and Speyer, 1820. The text is anonymous but Passavant's authorship has been proved by his letters: see Büttner, footnote 24.

33. Reprinted, Heidelberg, 1972, with a postscript by Dorothea Kuhn.

34. Reprinted in Karl Philipp Moritz, *Schriften zur Ästhetik und Poetik,* Tübingen, 1962, pp. 3–6, ed. Hans Joachim Schrimpf.

35. See Neil Flax, "Fiction Wars of Art," *Representations,* 7, Summer 1984, pp. 1–25, in which he discusses Goethe's 1798 essay "Ueber Laokoon" as "the first systematic application of formal or Kantian esthetics to practical art criticism."

Ingres Other-Wise*

WENDY LEEKS

Many writers have commented on the uniqueness of Ingres's odalisques and bathers within the tradition of the female nude. As Leeks notes, she is not the first to observe that these women, though assuming the subservient guise of odalisques, in fact resist the viewer's domination. The *Valpinçon bather* turns her back on us, and the *Grand Odalisque* challenges the viewer with her level gaze: both attitudes confound the voyeuristic gaze.

What does the uniqueness of these images suggest about the role of the traditional male viewer? Leeks considers the various guises that he might assume: the sultan, the eunuch, or the Peeping Tom. The role of the sultan is not applicable, since these figures resist control; the eunuch as an emasculated male, is likewise an unsatisfactory identification for the viewer. The sexual charge enjoyed by the Peeping Tom is hardly inspired by Ingres's glacial beauties. That the domineering *Grand Odalisque* was in fact painted for a female patron also leads us to question any assumption at the viewer's gender. The ambiguity of Ingres's nudes in fact destabilizes the viewer's identity.

A shifting referent of the painting's turbaned figure futher confounds the issue. It has often been noted that the source for this figure is Raphael's *Madonna della Sedia:* a model apparently antithetic in nature to the ostensibly more sensuous odalisques. The conflation of these figures—Madonna and harem fantasy—accounts for the uniqueness of Ingres's bathers, and also for our response to them. A parallel conflation is seen in Ingres's series of paintings depicting *Raphael and the Fornarina* where the turbaned Madonna is transformed into the female lover as Raphael is reciprocally transformed from lover into son in his mother's arms. The turbaned female remains ambiguous, for she is both the object of sexual desire, and the object of love for the mother.

Leeks elucidates this apparent contradiction by reference to Lacanian theory, according to which the adult's conscious sexual desire manifests an unconscious desire to be free from lack. The awareness of lack emerges with the infant's realization of itself as separate from the mother and is further confirmed by awareness of the mother's attachment to the father, and of her attachment to a wider, socialized world—represented, Leeks suggests, in the late *Turkish Bath.* Ingres's bathers, which oscillate between the erotic and (by reference to Raphael) the maternal, bring to the surface the unconscious element of sexual desire—the longing to be one with the mother.

Leeks proposes this psychoanalytic perspective as a means of bridging the gap between the "then" of the artist's creation and the "now" of the viewer's

*"Ingres Other-Wise," by Dr. Wendy Leeks. *Oxford Art Journal,* vol. 9, no. 1, 1986. Reprinted by permission of Dr. Wendy Leeks.

response. She concludes by suggesting that this approach also explains the appeal of Ingres's nudes to the female viewer. The appeal to the unconscious level of desire—the unity with the mother—is ungendered; and, what is more, the presence of the socialized female invites the female viewer to identify with the image of the nude, rather than to appreciate it only by assuming the perspective of the male viewer.

The bather and odalisque occur repeatedly in the work of J.A.D. Ingres, forming one of several recurrent themes that punctuate the artist's career and give it an unusual degree of continuity.[1] This phenomenon of repetition in Ingres's work has been variously accounted for. Hans Naef sees it as a lack of imagination,[2] and Marjorie Cohn as the pursuit of perfection.[3] For Norman Bryson it arises from a continuous struggle to overcome the authority of traditional forms by constructing a personal canon, through the mechanism of sexual desire.[4] All of these explanations ultimately focus upon the personality of the artist. They are concerned with his limitations, his aims or his conscious ambitions and with a personally inflected apprehension of the nature of sexual desire.

Bryson's account, the most recent and most complex of the three mentioned here, uses a psychoanalytic reading of the works. But its concern is with the maker not his audience, with the motivation for the production of the works and not their effectivity. The artist is more than a hundred years dead, and past the possibility of resurrection by human efforts; the paintings, however, still live, both in that they continue to exist as objects and continue to be of interest. The continued life of the paintings is shown in responses to them. To start from response and attempt to account for it—to ask why it might be that the pictures continue to excite interest—is to attempt an analysis of the living paintings, instead of trying to reconstitute a long dead artist.

One particularly interesting, if not entirely typical response to the bather/odalisques is that of Georges Wildenstein:

> His [Ingres'] sensuality is indeed often cruel in its violence. We have already observed his predilection for the women of the harem—those sexually oppressed beings; it was perhaps the same feeling, unless it was his shyness, that prompted him so often to paint his models from behind. Furthermore, we find him observing the same rigid loyalties in his sensual tastes as in his artistic preferences, and the same female body, doomed to suffering and decay, haunts his pictures just as it must have obsessed his dreams. It is hardly enough to say that Ingres had a favourite female type. Indeed, it is often the very same woman who is the model for one of his portraits and the heroine of one of his classical compositions . . . Ingres mixes Christian inspiration with mythological invention. His virgins would seem to be the sisters of his odalisques.[5]

For Wildenstein, the bathers are odalisques and as such the victims of a sadistic sexuality: the sexuality of the sultan and of the artist. From Ingres's paintings Wildenstein constructs a picture of the artist as sexually obsessed, with the inference that his "unusual sensuality"[6] bordered on the perverted. Wildenstein goes on to ask whether this "seductive beauty" of the paintings and of Ingres' dreams stems from a love in whom the artist was disappointed at the age of twenty.

Wildenstein thus fabricates a narrative of the artist's personal life to "explain" the paintings; he fits them into a love story that is also a story of revenge. But the story arises out of Wildenstein's own reaction to the paintings' subjects. He projects his response as viewer back onto the artist as maker. He transmutes response to an "action" into motivation for that "action." Yet there is a congruity that can be perceived through another set of responses, those of the viewer "I" looking at the other two.

One response to Wildenstein's reading might be to say that it tells us more about Wildenstein than it does about Ingres or his paintings. That would be to say that the sexual quirk belongs to the critic and not to the artist. But such a response would be a repetition of Wildenstein's own procedure, a reduction to the level of the personal, a characterization of the material as purely individual and aberrant. To explain the material in terms of its author's abnormality turns that material into a curiosity, an interesting "case" and little else, the "deviance" which secures and guarantees the "normal."

Concentration on the personal makes any analysis of this kind a post-mortem operation; the objects are denied life outside of the existence of their makers, since it is the psyche of the maker and not the object itself which is the subject of investigation. Such a perspective on Ingres's works limits their life. Their "real life" becomes a matter for biographical investigation in the life of the artist and historical investigation in the life of his times. Any "continued life" they might have, in subsequent and present-day responses, is circumscribed as narrowly aesthetic. In the case of Wildenstein, the "life" of the text, in this instance its relevance, subsisted only in the then of writing, not in the now of reading. The operation sets up a relationship in which the maker's products are valued only as indices of the maker's personality and that personality is set over against the viewer. A comfortable distancing results, the meaning of the object being grounded in the difference between maker and viewer—the difference between "abnormal" and "normal." This goes no way towards explaining the continued interest of the objects, should that interest extend beyond their curiosity value or their aesthetic merit.

No one who finds interest in Ingres's bathers or Wildenstein's remarks remains disinterested. That is, any response to these objects involves the responder, and some species of communication takes place between the viewer/reader and the object.[7] This is not to say that either the paintings or the writing have a conscious, intentional message which is picked up and consciously understood by the responder, nor that any intended message would be the only one and thus

the cause of the response. The objects carry meanings, some of which originate in the intentions of the artist or writer, in their understandings. Some of the meanings come from the viewer/reader, residing in their understandings—as does Wildenstein's of Ingres. The communication is therefore at the least interpersonal. And some meanings are neither intended nor understood, neither consciously conceived nor received; yet these two are carried by the object, as I shall show. The existence of all these meanings indicates that the communication involved here is not solely or essentially one between individuals—between author and spectator. It is supra–individual, taking place at the level of the social, where differentiation itself takes place. Differences acquire meaning through a process of comparison on a sliding scale from the absolutely congruent to the completely dis-similar. Without similarity, difference cannot exist and can have no meaning. The supposed "difference" of Ingres's sensuality in Wildenstein's account has meaning only in comparison with the putatively normal, with a nonsadistic male sexuality, that is, we infer, Wildenstein's own.

We have already observed one congruity between Wildenstein and Ingres. It might be that Wildenstein does what he actually presents himself as doing: he reads out of Ingres's work evidence of the artist's own sadistic interest in woman as presented in the image of the nude. Alternatively, it might be that Wildenstein reads into the images this sadism that is in fact his own. Another possibility is that Wildenstein and Ingres share this propensity, although neither of them need have been aware of it in themselves. If that were the case, differences of time and place, and the gap between the imaginary and the symbolic, might be bridged by a congruity of power relations. These two male viewers would be placed in relation to the image in the position of the scene's absent sadist. The eyes of these male viewers would "become" the eyes of a third, those of the sultan who subjects the harem inmates to sexual oppression.

It is this third possibility that makes Wildenstein's account of continued interest to the viewer "I" who, as female, would seem to be debarred from this viewing position. Work that postdates Wildenstein's, particularly work on image analysis by feminist writers, has opened up a new perspective on both Wildenstein's text and his subject matter—male depictions of the female nude. From this perspective, Wildenstein's writing retains its relevance as an instance of the operation of voyeurism, an operation that has been shown as crucial for male pleasure in viewing images of the female nude.[8] Images of the female nude are carriers of castration fear since they display the "otherness" of the female by revealing her lack of a penis. Pleasure in the image can only be achieved by the male viewer through objectification of the image, by investigating this difference, by asserting his control and dominance in punishing or saving (the sadistic element) or by transforming this threatening object into a reassuring one by denying its lack and turning it into a fetish object.[9] It is precisely this psychic formation, arising out of the Oedipal drama, that Ingres and Wildenstein share, placing them in a fantasy relation to the sultan. The sultan is not present in the image, but his relation of domination over the woman of the

harem is supplied by the dominating gaze of the male artist and male viewer as they stand in front of the canvas.[10] The two male viewers identify with the sultan as the man allowed domination over these female forms. The "communication" of the paintings thus relies on this shared psychic formation, premised on the fact that sultan, artist, and viewer are male. Were it otherwise, the bather paintings would not possess their erotic charge. For analyses such as Laura Mulvey's have shown that the nude in Western art has been a site for the exercise of male fantasy.[11] The psychic formation is not merely shared by Wildenstein and Ingres alone but is a component of male sexuality in our patriarchal society. Ingres's sexuality and Wildenstein's are not then "aberrant" because of their sadistic element, but are "normal."

Nevertheless, there is something unusual or strange about Ingres's bathers/odalisques—a strangeness most often registered by critics in their attention to the distorted anatomy of the figures[12] or the contorted spatial relations within the paintings. Connolly and Bryson both note that the figures appear enclosed in their own world and, while seeming to promise sensual gratification for the (male) spectator, they also refuse it. Connolly and Bryson again "explain" this in terms of Ingres's own sexuality. For him, the erotic charge of the figures comes from their inaccessibility, from the impossibility of his sexual desire being fulfilled.[13] Unlike the sultan with his harem, the artist cannot physically possess the women that people his images. This in itself is not unusual; it is, after all, a condition of pictorial representation. What is more unusual is that, except for the first painting in the bather series, the 1807 *Bather* at Bayonne, the figures either do not register the presence of a male intruder/voyeur/master at all or remain indifferent to a possible male presence and unthreatened by it. Only in this first three-quarter length bather is the female figure startled by an onlooker—an onlooker who from the viewing position is very close to her—and attempts to cover herself from the male gaze that the viewer of the painting supplies. This startled pose and three-quarter format was not repeated in the series.

The 1808 *Valpinçon Bather* (Fig. 4) is the first appearance of the figure that consistently recurs throughout the series; in the 1826 *Small Bathing Woman* (Washington D.C.), the Louvre *Interior of a Harem* (1828), the *Turkish Bath* (Fig. 5) and the 1864 water-colours *Bather,* at Bayonne, (and Fogg Art Museum, Harvard). In all of these the turbanned figure is a full-length upright, seen from the back. The *Grande Odalisque* (Fig. 6), its repetitions and variants, is also part of this group.[14] Although the figure is reclining, it is also full length, is viewed from the back and wears the same type of turban head-dress. The *Grande Odalisque* was also at several stages a bather, with the bath and its waterspout appearing in some of the existing versions of the work, although it does not remain in the Louvre painting.[15] Unlike most representations of the female nude, in these paintings the male viewer is not the centre of the work. These figures do not display their sexual difference for the investigation of the viewer; they are not shown being punished or saved.[16] Even the *Grande Odalisque,* where the figure is looking out of the painting towards the viewer, is unassail-

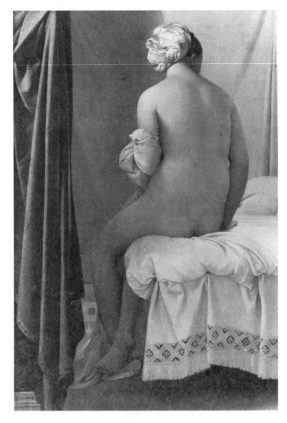

Figure 4 J.A.D. Ingres, *Valpinçon Bather,* 1808, Musée du Louvre, Paris. Photo: Lauros-Giraudon/Art Resource.

able; the level gaze lacks the coyness or enticement generally given by the male artist to naked female images. The figures in these paintings attend to the sights and sounds of their own world; they are intent on their own pleasures.

The voyeuristic component of male reaction to the female nude is emphasised by Wildenstein in his comment on Ingres's paintings. But perhaps this describes Wildenstein's reaction to his understanding of what a harem is rather than directly referring to what is shown in the paintings. For voyeuristic enjoyment of this type is at least partially frustrated in Ingres's works.[17] In order for the pictures to "work" then, is it necessary that the point of view be that of the sultan?

It is useful here to go back to some of the sources for the bather paintings. There is abundant evidence that Ingres made extensive use of prints. Both Hans Naef and Hélène Toussaint have established prototypes for poses and accessories of many of the subsidiary figures of the bather pictures (although not the central turbanned bather) in prints and illustrations of Oriental scenes.[18] There

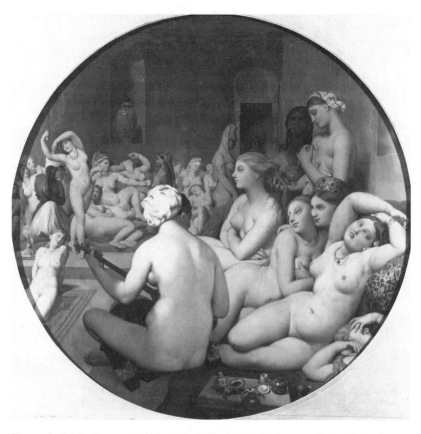

Figure 5 J.A.D. Ingres, *Turkish Bath,* 1862, Musée du Louvre, Paris. Photo: Lauros-Giraudon/Art Resource.

are also literary sources for the paintings, in particular three written accounts transcribed by Ingres into one of his notebooks: the anonymous and as yet untraced "Les Bains du sérail de Mahomet" (Cahier IX, fol. 47, verso) and French translations of extracts from two letters by the eighteenth-century English traveller Lady Mary Wortley Montagu (Cahier IX fols. 34 and 37 verso).[19]

In the first source, it is the architectural and decorative details that are described, in the third-person singular. Any activities that might take place in these surroundings are not here being observed, merely speculated upon. It seems that the author, whether male or female, visited these apartments when they were not in use. In the other two passages, Lady Mary Wortley Montagu is describing the women's public baths and not the baths in the women's quarters of a private palace.[20] No men are allowed here, indeed: "Il n'y va pas moins de la mort pour tout homme que l'on trouverait dans un bain de femmes." The ambassador's wife can freely enter the baths because she is a woman, yet she en-

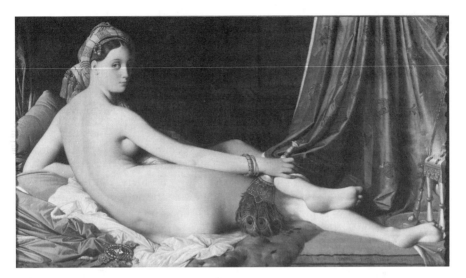

Figure 6 J.A.D. Ingres, *Grande Odalisque,* 1814, Musée du Louvre, Paris. Photo: Giraudon/Art Resource.

ters in order to observe, not to take part. Despite the entreaties of the other women she refuses to take off her clothes and join them completely. In this sense her position is voyeuristic, a position compounded by her status as foreigner, as Westerner and as diplomat's wife. She sees the women of the bath as other, as Oriental and exotic; she views them through the eyes of imperialism. In this account, the Western woman stands for the normal against which the difference of the Eastern woman is measured. A notion of Western superiority objectifies the Eastern women and subjects them to investigation, even though that investigation is not connected with the author's sexual desire. In this way it could be said that Lady Mary Wortley Montagu is playing a male role in relation to the women of the bath, with whom she does not identify.[21] The power relation existing between her and the bathers is thus analogous in some ways to that of the male spectator and the female nude.

Yet, an important ambiguity remains, for Lady Mary is a female spectator. Her presence in the baths is legitimate because of her gender. Even though she refuses to take off her clothes and become a bather herself, the English woman observes the bathers by mingling with them. Unlike the spy or Peeping Tom, the perfect type of the voyeur, whose act of looking is performed in secret, she is not only the agent who looks but is also the spectacle that is looked upon. She describes the curiosity of the bathers, who investigate her as much as she investigates them. And eventually the distance between her and the other women is broken down still further when she responds to their insistence that she join them by opening her skirt and showing them her stays. In this she comes closer to joining the women, as if by her action she were reinforcing her right to be

there through emphasising what she and the other bathers have in common—
their femaleness.[22]

The viewers and authors we have so far set in front of these bathing
scenes have a common characteristic; as Westerners they see and construct the
scenes and their occupants as exotic and other. The scenes are imbued with the
sensual and sexual emphasis by which the West has coloured its Eastern fan-
tasies.[23] Even Wortley Montagu instates this by disavowal: "Cependant il n'y
avait parmi elles ni gestes indécents, ni postures lascives."[24] This fantasy pro-
jection is evident in Wildenstein and is also apparent in Ingres. It contributes to
the fetishisation of the female figures as beautiful and precious objects, and it
also enables the artist to view and display the nudes in safety. For these fantasy
figures are classless and timeless, and as such evade the codes of propriety that
would have applied to depictions of women of the artist's own time and place.
In the bather figures the two principal methods of such evasion, geographical
and temporal distancing, are operating at the same time. The *Valpinçon Bather*
is perhaps identified as an exotic by its turban, but refers more insistently to its
prototypes in the classical nude, the fetished representation of abstract beauty
safely distanced in the remote past. Indeed, for Ingres as for other painters of his
time, part of the Orientalist fantasy was that the life of the East was seen as a
living remnant or evocation of the ancient world. In subsequent treatments the
upright turbanned bather retains some of its classical *hauteur* (what Van Liere
terms its chastity[25]) but also becomes more Orientalized by the presence of
other figures.

The male artist and the male viewer might be considered to be faced with
a difficulty when they confront the bather paintings. They might identify them-
selves with the sultan, but elements in the paintings are resistant to that identifi-
cation. This viewing point is most possible in the *Grande Odalisque,* least so in
the *Valpinçon Bather.* If he is not the sultan, the male viewer must either be the
eunuch or the Peeping Tom. The emasculated male's presence in the harem
would be accepted and unremarked by its female inhabitants, but this character
is unsatisfactory as a point of identification for the male viewer. To be placed in
the position of the eunuch would be to confirm the male viewer's fear of castra-
tion invoked by the sight of the female nude. Such a positioning would be im-
possible, since this fear is exactly what depictions of the female nude work to
avoid. It would reverse the power relations between female objects and male
subject, destroying male pleasure and making the image, literally, dreadful. The
gaze of the *Grande Odalisque* comes closest to constructing the viewer as eu-
nuch, but even here the gaze remains benign and the iconic nature of the image
defuses the threat. It is interesting to note that the *Grande Odalisque* was
painted for a female viewer, Queen Caroline Murat. Similarly of interest is the
idea that Lady Montagu might be said to take up a relation analogous to that of
the eunuch in her visit to the baths: as someone allowed to mix with the com-
pany yet not wholly of it, marked by difference; as a tolerated observer; as the
clothed or semiclothed among the naked.

The Peeping Tom's illicit view is in a sense the male viewer's "true" relation to the scene, but the space within the paintings resists that identification. The sexual charge of the peeper's position is undermined by the paintings. The figure of the *Valpinçon Bather* and the paintings in which it recurs is close to the viewing position, yet gives no sign of the viewer's presence. If she clutches the sheet to her she does so out of concern with an approach from her right and not at her back. The space within the paintings precludes the possibility of the scene being viewed through a crack in a wall, a parted curtain, a key-hole, or a window; any such partition is inconceivable, except in the case of the *Turkish Bath*. Here the turbanned figure cedes its foreground position to a tray of small objects; it is reduced in scale and joins its companions more fully within the scene that is enclosed by the tondo format. These devices effectively divide the space inhabited by the viewer from that occupied by the bathers. The viewer at the spy-hole is the Peeping Tom. In the other paintings of the series the answer to the question "Who is looking?" or "What part must the viewer play?" remains ambiguous.

The ambiguity of the viewer's role might account for some of the strangeness of these paintings, that is, it might be reflected in an uncertainty of response. The viewer's relation to the paintings is destabilized, and this instability is compounded by a shifting reference within the paintings, in the turbanned bather figure. It is well known that the turban of the central bather refers to the work of Raphael; to the portrait legendarily regarded as that of Raphael's mistress the *Fornarina* (a legend accepted as fact by Ingres) and to the religious image of the *Madonna della Sedia*. Ingres himself wrote that a copy of the *Madonna della Sedia* seen when he was a boy in his master's studio in Toulouse began his life-long veneration of Raphael.[26] The image exerted a powerful influence on Ingres and was to recur in his own works as a sort of talisman—as a print on the table in *M. Rivière* (1805), decorating the apartment where Henri IV plays with his children (1817), on the wall in a drawing of the Stamaty family (1818), as a roundel in the carpet of *Napoleon on his Imperial Throne* (1806), and in the artist's studio in the first surviving version of *Raphael and the Fornarina*. (Fig. 7) In Raphael's original, the St John figure is less distinct than the mother and child; in Ingres's versions it is even more faint or is actually absent, as in the most telling appearance of the motif, the Napolean portrait. In this work the roundels show signs of the zodiac. We might have expected Napoleon's birthsign to take pride of place, but Ingres has re-arranged the zodiac to represent his own sign, Virgo, by the *Madonna della Sedia* at the front left. The *Madonna della Sedia* stands for Ingres himself; it is the place where Ingres projects himself into the painting. This indicates a very strong identification with the Raphael image on Ingres's part.

The links between the *Fornarina* and the *Madonna della Sedia* are shown in another series of paintings by Ingres, of *Raphael and the Fornarina*.[27] In the first surviving painting of the series, Raphael's mistress sitting on his knee is evidently the model for her portrait on his easel and for the Virgin Mary in the

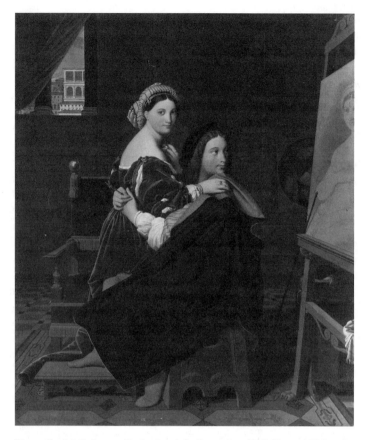

Figure 7 J.A.D. Ingres, *Raphael and the Fornarina,* 1812, Harvard University
Art Museums, Bequest of Grenville L. Winthrop. Photo: Museum.

Madonna della Sedia propped up against the back wall of the studio. In subse-
quent treatments the Madonna painting-within-the-painting disappears, but the
compositional arrangement of Raphael and his mistress/model echoes that of
the absent image, even coming to resemble it more closely as the Fornarina en-
velops Raphael in her arms and lowers her head over his. In the foreground
motif of artist and mistress the constituent elements of the two Raphael paint-
ings are mixed. The mistress of the portrait is also the mother of the sacred
image; Raphael in his lover's embrace is also the son in his mother's arms. As
the model's pose becomes progressively more Madonna-like through the series
her clothing slips further from her shoulders until in the final, unfinished ver-
sion she is half naked like the *Fornarina* portrait. The figure is mistress, the ob-
ject of sexual desire and equivalent of the odalisque, and at the same time Vir-
gin, the chaste being without sexuality who is also mother. In the *Raphael and
the Fornarina* series lies the key to the dual references of the turbanned figure

in the bather paintings—in these works the virgin and the odalisque are not merely sisters, they are one.

How can we account for this conflation? The images seem to amalgamate two different kinds of emotional response—sexual desire of male for female and reverential love of son for mother. The reverential aspect is stressed, since the mother in these images is the Madonna, the perfect mother and absolute model of motherhood. It would appear to be impossible to reconcile these two aspects, as one is defined solely by her sexual "use," the other precisely by her lack of it.

The mechanisms at work in this apparent contradiction can be elucidated by applying Lacanian psychoanalytic theory to the images.[28] According to this theory, conscious sexual desire is premised upon another desire which has been repressed into the unconscious. To desire is to be aware of a lack—to want is to be aware that you do not have. The unconscious desire beneath sexual desire is a longing to be free from lack—a desire to be complete and desireless. The infant's first experience is a state of unity with the world, since it has no awareness of itself as separate from anything around it. As it is one with its principal provider it seems to be in a state of completeness—to be one with everything is to be without lack and hence without desire. Only gradually does it come to know of boundaries between itself and the world, to perceive itself as an entity and to acquire an identity. In the first absences of its provider, the one who fills the mother role, the fact of separateness and the reality of absence are revealed to the child. In the image that the outside world reflects back to it the infant comes to recognize itself. This mirroring is not only specular but involves the other senses which perceive the behavior of others around it and from that behavior discover the space that the child itself inhabits. From the responses of the world outside of itself the infant becomes aware of its own actions and its ability to promote response. By manipulating its actions it attempts to control the reactions of others and thereby call absence into presence. Awareness of its own lack and the relationship of dependence on the provider creates an apprehension of that provider as a being who can supply what is lacking and is therefore without lack. The provider gives love, which is reciprocated, and so long as this relationship maintains an illusory exclusivity in the child's eyes the fantasy of completeness is sustained. But as it comes to awareness of the provider as a social being involved in other relationships, the illusion is broken.

The child becomes aware of the being who fills the father role. In terms of the traditional family structure, the child sees that its mother is part of a relationship other than the one she shares with the child—a relationship with the father. The power relations within the traditional family show that the father is dominant and the mother is dependent upon him. The mother's position in relation to the father is therefore analogous to that of the child and the mother: the mother must lack since she is dependent upon the father. The child's fantasy of fulfilment in the mother is thus undermined. In the Oedipal phase and through the operation of the castration complex the child is split apart from the mother.

The desire for completeness, which is also a desire for the mother, is outlawed by the existence of the father now made manifest, by his "possession" of the mother, and by the powers of punishment and approval he can wield over the child. From an experience of existence as unitary, the child has moved to an experience of the world as organised on the basis of difference. As it enters into language, the child learns to manipulate difference in order to voice demand and assuage lack, but its now repressed and unconscious desire for completeness cannot be satisfied. The satisfaction of any specific demands it makes only temporarily alleviates the pressure of its unconscious desire, so repeated dissatisfaction and the repetition of demand are inevitable.

A further consequence of the structure of the traditional family in patriarchal society is that the difference between father and mother roles, essentially a difference in power, comes to be perceived and interpreted as a gender difference. An ideological condition of the patriarchal system of relations is naturalized through the operation of the castration complex into a biological imperative. The mother's lack of power (the phallus) is interpreted in terms of her physical "lack" (the penis); the father's possession of power is inexorably linked to the form of his genitals. The child discovers its own biological sex, and through a process of identification it is also gendered—it is placed within the ideological power system that operates within its society. Its knowledge of the fact of difference is given a corresponding set of values which it internalizes and which it is also accommodated within. The child is thus socialized as part of the world of differences, whereas its first experience was of the world and itself as united and co-extensive. Yet even though the child and the adult it becomes must operate within society and within difference, its unconscious desire for unity with the world persists.

The strangeness of Ingres's bather paintings may arise from an oscillation between the conscious sexual desire of the male, normally paramount in depictions of the female nude, and unconscious desire for a return to the first state of unity and desireless-ness. The fantasy of the harem and its sexual connotations disguises this unconscious element which was unknown to Ingres the maker of the images, allowing the hidden motivation to slip past the censorship of the super-ego propelled by the force of unconscious desire. It surfaces in the paintings in the same way as it might in slips or in dreams.

The sensuous aspects of these paintings allow the exercise of voyeuristic/sadistic pleasure, but are held in check by the dominance the turbanned figure exercises over the images. This figure is marked by conscious desire in the sensuousness of its flesh, but nevertheless the sexual charge is limited because it is the figure's back that is displayed. Only secondary sexual characteristics are shown in the figure, and these very partially; its femaleness defined as lack of the penis is not shown. The turbanned figure is both the sexual mistress/odalisque and the asexual Madonna/mother, and the figure's "persona" as Madonna is crucial here. In Raphael's *Madonna della Sedia,* it might be said, a socialized moment is represented. The presence of the third figure of St John indicates a

network of relationships. In Ingres' portrait of *Napoleon* only mother and child are depicted in the roundel. At the place where Ingres identifies himself with the *Madonna della Sedia* he does so in a representation of the dual dependency of mother and child, at a moment before the child is completely socialized—it could be at the mirror moment of the child's awareness of its physical separation from the provider. If the roundel is Ingres's projection of his own identity into the painting, then Ingres's position as viewer in front of this projection would be equivalent to his viewing of his own image in a mirror.[29] A process of identification, not objectification, is taking place between Ingres and the image of the mother and child.

The turbanned bather as Madonna can be seen as a more perfect fulfilment of the repressed fantasy of completion. If Ingres identifies himself with the son in the *Madonna della Sedia* and with the artist/lover/son in the *Raphael and the Fornarina* series and thus projects himself in unconscious fantasy into the mother and child relationship, he returns to a moment of dual-unity. In the bather paintings this identification and projection is achieved in the turbanned bather figure as Madonna. This is a fantasy return to an "earlier" moment of complete unity, since the essential attribute of the mother—the child—is not here represented. If the figure continues to mean "mother," as I am convinced that it does, then the child must be incorporated within it. The figure does not display its lack precisely because it is not lacking. In Lacanian terms, in the exclusive relationship of mother and child before the awareness of difference, the mother supplies the child's lack and the child the mother's. The mother and child as a unit thus constitute the lackless or phallic mother, and it is this completing and completed unit that is represented in the turbanned bather figure. Through identification with his child-self in this figure, Ingres is again projected into the paintings. The compositions are not organised around the viewer outside the paintings but around the viewer inside them, the turbanned bather. For the unconscious wish that so radically structures these works is to be one with this mother figure—to share her experience and to see through her eyes.

However, unity with the mother is only part of the fantasy and part of the primordial imaginary state. The lost Eden of completeness was an illusion of oneness with the world and not just the mother. In the progressive inclusion of other figures around the first unitary form of the *Valpinçon Bather,* Ingres creates a world for himself and the mother/bather to inhabit. Just as the Madonna element of the central figure is overlaid with the connotations of the mistress/odalisque of sexual desire, so too the world of the bather is marked by otherness and difference. The wish is to wipe out lack and loss by escaping from difference, which includes escaping from gender. But such an escape is impossible for an already socialized, gendered male. Even in his psychic life Ingres cannot achieve this since the objects produced out of this psychic life are structured by both the unconscious and the conscious mind. The unconscious fantasy is of an ungendered world, but the objects are made by a conscious being formed through the Oedipal phase, the castration complex and the entry

into language. The image of a world which Ingres wishes to be in and of is thus a gendered image, its inhabitants invested with the mystery, the threat and the desirability, the Other-ness, with which the process of socialization has invested woman. In his maleness Ingres cannot know the world of women from the inside; he cannot know what it is to be a woman, and the wish to escape from gender is modified in the image by the operations of the conscious and the preconscious mind, being masked by the sexual desire for knowledge of the Other.

The oscillation between conscious and unconscious desire means that Ingres cannot be entirely in the picture; he cannot wholly identify with the Madonna/bather and see through her eyes. Neither can he be entirely fixed in a position of objectification outside the painting as sultan, as eunuch or as Peeping Tom. While the turbanned bather remains at a distance from the other inhabitants of the bath, a degree of identification with the figure as Madonna remains possible and Ingres' character identification outside the painting continues to be unclear. In the *Turkish Bath* the turbanned bather finally joins her companions and the sensuous, voyeuristic, objectifying elements outweigh the identification fantasy. In the *Turkish Bath* the turbanned bather is socialized, re-enacting the moment in psychic development when the mother-child dyad is broken. In this painting Ingres's identification with the figure is broken too and he is projected outside of the scene and fixed in the position of Peeping Tom. The repetition of this subject in Ingres's work can be seen as the pursuit of a perfect fantasy, the restitution of an imaginary lackless-ness, a struggle to negate the law of the Father and the tyranny of sexual desire. It was bound to fail, and failed most completely in the *Turkish Bath*. But the unassuaged desire remained, to fuel further repetitions in the two late watercolours.

For biographical reasons that may now be irrecoverable, the pressure of unconscious desire was particularly strong in Ingres. Perhaps this indicates that he was a neurotic personality. Such a conclusion might be justified, but it is of limited interest. The purpose of this psychoanalytic reading of Ingres's works is not to construct a case history of Ingres, but to attempt to account for the works and their effectivity. The value of such a reading is that it illuminates the "then" of Ingres' making of the paintings and the "now" of our viewing them. The theory of psychic development set out by Lacan is a general theory and applies to us now as it has been shown to apply to Ingres. The particular form of Ingres's images was in many ways personally inflected and historically determined, but the unconscious fantasy and its grounding in psychic development is common to us all.[30] The positions that Ingres takes up or fluctuates between as viewer/maker of the paintings are followed by subsequent viewers as they unconsciously reorganize the underlying fantasy content—the unconscious wish structuring the painting calls to the viewers' own.

This has an important consequence in the realm of responses, a consequence unusual for depictions of the female nude. Although the elements of conscious and preconscious fantasy in the images are gendered as male, the unconscious fantasy is ungendered since it is pre-Oedipal, of a stage of develop-

ment before gendering occurs when the experience of both male and female children is the same. Consequently the fantasy calls from the image to the male viewer and to the viewer "I"—the female spectator. Most images of the female nude disallow the possibility of a female spectator. They are "about" male sexuality and the exercise of male sexual fantasy and as such construct their viewers as male, either biologically or, for women, ideologically through masquerade. In the bather paintings the female spectator is not forced to abandon herself and assume an uneasy masculine role in order to consume the images. Through identification she too can enter into the image and since as a sexed, socialized female she is identifying with her like (and not with the Other as for the male), perhaps her identification can be more satisfying by giving her the fantasy of completion and a reflection of herself in the image. This would operate most successfully in the *Valpinçon Bather*. As the other figures are introduced the "maleness" of conscious fantasy is increased, the other nudes being marked by the Otherness and specifically male sexual charge that the female viewer can only partially adopt. In the *Turkish Bath* the position of the female viewer is least tenable as identification is residual and the viewing position is fixed in male scopophilia and voyeurism.

Ingres's bather paintings are formed by the tension between conflicting desires. The paintings continue to live because this conflict is still alive. The viewer "I" before traditional or "normal" depictions of the female nude is presented with the image of Otherness. For her, uncovering this conflict kills any pleasure in the image. Before Ingres' bathers her pleasure can continue to live, for here a shift in the balance of desire enables the paintings to be seen Otherwise.

NOTES

1. Other recurrent themes include Raphael and the Fornarina; Paulo and Francesca; Antiochus and Stratonice; Virgil reading the Aeneid to Augustus; Henri IV playing with his Children; The Death of Leonardo.
2. Hans Naef, *Die Bildniszeichnungen von J A D Ingres,* Bern, 1977–1981, vol. 1, p. 25.
3. Majorie B. Cohn in Patricia Condon with Cohn and Agnes Mongan, *In Pursuit of Perfection The Art of J A D Ingres,* Indiana, 1983.
4. Norman Bryson, *Tradition and Desire. From David to Delacroix,* Cambridge, 1984.
5. Georges Wildenstein, *The Paintings of J A D Ingres,* London, 1956 ed., p. 17.
6. Ibid.
7. Ernst Gombrich, "Expression and Communication," *Mediations on a Hobby Horse and Other Essays on the Theory of Art,* London, 1963. Gombrich is cited here as a useful text to work with and not because my thinking on the matter coincides with his.
8. Foundation texts in this work, subsequently developed by their authors and others,

are Laura Mulvey, "Visual Pleasure and Narrative Cinema," *Screen*, vol. 16, no. 3, 1975, pp. 6–18; and Elizabeth Cowie, "Woman as Sign," *m/f*, no. 1, 1978, pp. 49–63.

9. Mulvey, ibid. pp. 13–14.

10. The "maleness" of the viewer is taken for granted in most art-historical writing on the female nude. The importance of the viewer's identification with the voyeuristic activity of a particular, undepicted male character—the sultan or the male intruder—is discussed by Connolly in relation to Ingres' 1839 version of the *Odalisque à l'esclave:* John L. Connolly Jnr., "Ingres and the Erotic Intellect," in T. Hess and L. Nochlin, *Woman as Sex Object. Studies in Erotic Art 1730–1970.* 1973, pp. 17–27. A pictorial representation of this viewer position is reproduced in Hélène Toussaint, *Le Bain turc d'Ingres*, Paris, 1971, p. 47, ill. 73. *Curt Niab El* by Henry Dorchy (1968) shows the *Turkish Bath* from the other side, looking out across the bath to two viewing figures—the sultan and the eunuch.

11. Mulvey is dealing with film, but the processes of scopophilia, voyeurism and fetishism apply equally to painting; the conditions of film production and projection merely allow these processes a more satisfying operation for the male viewer.

12. Witness the famous remark of Salon critic Kératry in 1819 that the *Grande Odalisque* had "three vertebrae too many."

13. Connolly, *op. cit.,* p. 17: "Though these paintings may appear to invite an imagined encounter between the image and the viewer, it will be found that they generate erotic power precisely because they elude the imagination's hot embrace"; and p. 25: "To Ingres, the erotic was that which is recognizable and desirable, but known to be unattainable, and therefore all the more desirable." Bryson, *op. cit.,* p. 130: "For Ingres, eroticism is never conceived as an excess or superflux of energy, or a plenitude of being . . . in Ingres, sexual desire is less a fulfilment than a postponement of satisfaction"; and p. 150 ". . . for Ingres the beauty he seeks exists in the terms of his desire, as lack and deferral—if he is in love with the women of his inner pantheon, it is because, in their openness of form and the energy of displacement they arouse, they can never be possessed."

14. The two versions of the *Odalisque à l'esclave* of 1839–1840 and 1842 (the latter largely executed by Ingres's pupil Paul Flandrin; cf. Marjorie B. Cohn and Susan L. Siegfried, *Works by J A D Ingres in the collection of the Fogg Art Museum,* Cambridge, Mass, 1980, pp. 116–119) include a type of male figure in the eunuch, who is ignored by the two females. These two paintings are not considered here since they are not bathing scenes (although the first version was given a number of titles by Ingres, including *La Sortie de bain d'une sultane*). Nor do they include the central turbanned nude which is the identifying motif of the paintings I am discussing. *The Odalisque à l'esclave* paintings are more properly part of another series of reclining nudes beginning with the lost *Sleeper* of Naples (pre-1814) and including *Zeus and Antiope* (1851), where a male intervention is an important element (cf. Connolly, *op. cit.,* pp. 23–24).

15. The bath and spout appear (residually) in the *Odalisque in grisaille* (Metropolitan Museum of Art, New York, c. 1824–1834), in the Sudré lithograph of 1826, in the squared up drawing which Ingres prepared for the lithograph (Musée Ingres, Montauban, cat. 867.1197), and in the Réveil engraving of 1851.

16. In this they differ from other nudes in the *oeuvre*, eg., *La Source* and *Vénus*

Anadyomène (investigation), *Roger freeing Angelica* (saving), and other clothed females in series associated with sexuality and the Oedipal narrative—*Paolo and Francesca* (punishment) and *Antiochus and Stratonice* (saving).

17. E.N. Van Liere notes that the turbanned bather figure in the *Turkish Bath* "acts as a barrier" and the bather's back as a "closed door to full entrance into the world of sensual pleasures" ("Le Bain: The Theme of the Bather in Nineteenth Century French Painting," unpublished Ph.D. thesis, Indiana University, 1974, p. 27).

18. Hans Naef, "Monsieur Ingres et ses muses," *L'Oeil*, XXV, 1957, pp. 48–57; Toussaint, *op. cit.*, pp. 14–18.

19. Quoted in Toussaint, *op. cit.*, pp. 11–13:

Les bains du sérail de Mahomet.

On entrait dans un vestibule pavé de marbre dont le dessin formait la plus belle mosaïque. De là, on passait dans une chambre entourée de *sophas, sur lesquels on pouvait se reposer avant d'entrer au bain;* après s'être déshabillé dans cette chambre, on entrait dans la salle où étaient les bains, elle était ornée de six colonnes de jaspe qui soutenaient une coupole toute vitrée. La muraille était incrustée de nacre, de perles, qui produisaient de tous côtés des reflets de lumière sur celle qui se baignait et donnaient à la peau un bel éclat. La baignoire qui était posée au milieu avait la forme d'une coquille et était soutenue par une espèce de trône dressé avec le corail, les coquillages et les plus rares perles. Le trône servait à cacher les tuyaux dont les uns fournissaient de l'eau froide et chaude. Sur un côté de cette salle se trouvait une chambre où l'on faisait bouillir des plantes aromatiques dans de grandes chaudières; on en distribuait la vapeur par des canaux qui en même temps qu'ils répandaient par toute la salle une douce chaleur y exhalaient encore une odeur agréable. A l'opposé de cette chambre on en avait pratiqué une autre ornée de superbes tapis. Sous un dais éblouissant par la quantité des pierres précieuses qui y étaient attachées, on voyait un lit formé par le plus tendre duvet. Autour de ce lit on brûlait des cassolettes d'or, les *aromates les plus de l'Orient et c'était là que plusieurs femmes* destinées à cet emploi attendaient la sultane au sortir du bain pour essuyer son beau corps et le frotter des plus douces essences; c'était là qu'elle devait ensuite prendre un repos voluptueux.

Extract of letter c. May 1718:

Lady Montague (sic). Bain de femmes.

Lettres.

Réception d'une mariée turque au plus beau bain de Constantinople, et toutes les cérémonies usitées en pareille circonstance. Elles m'ont rappelé complètement l'épithalame d'Hélène par Théocrite et il m'a semblé que les mêmes usages s'étaient conservés depuis ce temps. Toutes les parentes ou connaisances parents ou connaissances des deux familles nouvellement alliées se rendent au bain; plusieurs autres y vont par curiosté et je pense qu'il y avait bien deux cents femmes rassemblées. Toutes celles qui étaient mariées ou veuves se placèrent autour des salles sur le sopha de marbre; les filles au contraire quittèrent très promptement leurs habits et parurent sans aucun autre ornement que leurs longs cheveux tressés avec des perles et des rubans; deux d'entre elles allèrent jusqu'à la porte au devant de la fiancée qui était accompagnée de sa mère et âgée d'environ dix-sept ans, magnifiquement parée et couverte de diamantes, mais elle fut aussitôt mise dans l'état de nature, deux autres filles apportèrent des vases de vermeil remplis de parfum et commencèrent une sorte de procession que suivaient les autres, deux à deux, au nombre de trente environ. Les coryphées entonnèrent l'épithalame qui fut répété en chant par les autres; ensuite les deux dernières s'emparèrent de la fiancée qui avait les yeux modestement baissés. Ce fut dans cet ordre qu'elles firent le tour du bain. Il n'est pas facile de vous donner une idée de la beauté d'un tel spectacle.

La plupart de ces jeunes filles étaient très bien faites et d'une blancheur éblouissante. Toutes avaient la peau lisse par l'usage fréquent du bain. Après avoir fait ainsi le tour des salles, la fiancée fut présentée à chaque femme à la ronde qui la saluait en lui faisant un compliment et un présent; plusieurs donnèrent des diamants, d'autres des pièces d'étoffe, des mouchoirs ou d'autres petites galanteries de cette nature. Elle les en remerciait en leur baisant la main.

Extract of a letter dated April 1, 1717. The letter is from Adrianople, but describes the women's bath at Sophia:

Lady Montague (sic). Lettres.

Bain de femmes à Andrinople.

Il y avait bien là deux cents baigneuses (j'étais en habits de voyage). Les premiers sophas furent couverts de coussins et de riches tapis. Les dames s'y placèrent, les esclaves les coiffant, toutes étaient dans l'état de nature, toutes nues. Cependant il n'y avait parmi elles ni gestes indécents, ni postures lascives. Elles marchaient et se mettaient en mouvement avec cette grâce majestueuse. Il y en avait plusieurs de bien faites, la peau d'une blancheur éclatante et elles n'étaient parées que de leurs beaux cheveux séparés en tresses qui tombaient sur leurs épaules et qui étaient parsemés de perles et de rubans. Belles femmes nues dans différentes postures, les unes jasant, les autres travaillant, celles-ci prenant du café ou du sorbet, quelques-unes négligement couchées sur leurs coussins. De jolies filles de seize à dix-huit ans qui sont occupées à leur tresser leurs cheveux de mille manières. On débite là toutes les nouvelles de la ville, les anecdotes scandaleuses, aussi elles y restent au moins quatre ou cinq heures. La femme qui m'a paru la plus considérable parmi elles m'engagea à me placer auprès d'elle et aurait bien désirer que je me déshabille pour prendre le bain. J'ai eu beaucoup de peine à m'en défendre. Toutefois elles y mirent tant d'insistance qu je fus forcée à la fin d'entrouvrir ma chemise et de leur montrer mon corset détaché, cela les satisfit extrémement. J'ai été charmée de leur politesse et de leur beauté. Il n'y va pas moins de la mort pour tout homme que l'on trouverait dans un bain de femmes. Après le repas on finit par donner le café et les parfums, ce qui est une grande marque de considération. Deux esclaves à genoux encensèrent pour ainsi dire mes cheveux, mon mouchoir et mes habits.

Norman Schlenoff (*Ingres, ses sources littéraires,* Paris, 1956, pp. 281–283) maintains the translations from Montagu were taken from the 1805 French edition of the *Letters.* Toussaint (*op. cit.,* p. 13) believes they are a free translation and Ingres may not have read the letters but have copied them from dictation. Toussaint further claims that the 'Bains du sérail' was copied by Ingres at a much earlier date than the Montagu letters.

20. See the full text of these letters in English in Robert Halsband (ed.), *The Complete Letters of Lady Mary Wortley Montagu,* vol. 1, Oxford, 1965, pp. 312–315 and 405–412.

21. See Laura Mulvey, "Afterthoughts on 'Visual Pleasure and Narrative Cinema' inspired by 'Duel in the Sun'" *Framework,* 15/16/17, 1981, pp. 12–15; and Mary Ann Doane, "The 'Woman's Film': Possession and Address," in Doane, Mellencamp, Williams (eds.), *Re-vision Essays in Feminist Film Criticism,* Los Angeles, 1984, pp. 67–82.

22. There is an interesting omission from Ingres' French text here. In the full text Lady Mary writes: "I was at last forced to open my skirt and shew them my stays, which satisfy'd 'em very well, for I say they believ'd I was so lock'd up in that

machine that it was not in my own power to open it, which contrivance they attributed to my Husband.' (Letter of April 1, 1717, Halband, *op. cit.*, p. 314). The Eastern women interpreted the foreigner's condition as evidence of her oppression—her oppression by a husband and in this evidence of her sisterhood with them; the Westerner sees their attitude as a lack of understanding and evidence of their difference from her.

23. See Edward Said, *Orientalism.*
24. Montagu letter April 1, 1717, *op. cit.*
25. Van Liere, *op. cit.,* p. 21 ff.
26. Letter to Roques of 1844, quoted in Boyer d'Agen, *Ingres d'après une correspondance inédite,* Paris, 1909 pp. 374–375.
27. The first version, produced in 1813, was lost from the Museum of Riga during the German invasion in 1941. The 1814 version is in the Fogg Art Museum, Cambridge, Mass. The third treatment (n.d., private collection USA) retains the *Madonna della Sedia,* which is replaced by the *Transfiguration* in the 1840 version (Gallery of Fine Arts, Columbus, Ohio) as it is in the final treatment of the subject, begun in about 1850 and left unfinished at the artist's death (Chrysler Museum, Norfolk, Virginia).
28. The reading which follows is my own working of the theories of Jacques Lacan for which the main reference points are most clearly set out in Juliet Mitchell and Jacqueline Rose, eds., *Feminine Sexuality: Jacques Lacan and the École freudienne,* London, 1982.
29. An interesting sidelight on this is provided by Mary Kelly in "Woman—Desire—Image" in the *Desire* issue of the ICA Documents series (London, 1984): ". . . I asked myself again what did Dora enjoy in the image of the Sistine Madonna if not the possibility of imagining the woman as subject of desire without transgressing the socially acceptable representation of the woman as mother? To have the child as phallus, to be the phallic mother, or perhaps to have the mother in being once again the child" (p. 31).
30. That this grounding is common to us all can be seen in its recurrence in the great myths. In Christianity it appears in the myth of Eden, the expulsion from Paradise and the wish to return to it after death. It is also fundamental to the myth and cult of the Virgin Mary (see Marina Warner, *Alone of All Her Sex, The Myth and Cult of the Virgin Mary,* London, 1976).

The Political Origins
of Modernism*

PATRICIA MAINARDI

Why do we discuss Delacroix's *Liberty Leading the People* in terms of the political events underlying its imagery and at the same time approach Manet's *Execution of Maximilian* with the formalist terms of modernist discourse? Mainardi here offers a possible explanation for this inconsistency and for the neutralization of political meaning in modernist painting. The turning point was the Universal Exhibition of 1855, when the government of Napoleon III sponsored an exhibition featuring major living artists. Four painters were given a retrospective exhibition: Ingres, Delacroix, Decamps, and Vernet. By showcasing these artists, whose work had previously been associated with specific political camps, the government removed their works from their original contexts and constituencies, and so neutralized their political meaning. This trend was enhanced by critical response to the exhibition, which legitimized the various styles represented by discussing them in formalist terms.

Mainardi suggests that the aim of the eclectic exhibition of 1855 was to depoliticize the art shown there. It might also be asked whether the neutralization of political meaning is the inevitable result of institutionalizing any art. Once an artist is sanctioned as a master, the political content of his or her art is often compromised. As art is relegated to the museum, exhibition practices seek common denominators to provide a coherent ground for an assessment of the works now removed from their original contexts. Generally, artists are arranged by schools, within which the individual was assessed by style, a criterion far less ephemeral than political affiliation.

In 1855, Courbet refused the government overtures to exhibit and instead set up his own pavillion. But as Mainardi points out in the book that followed this article, *Art and Politics of the Second Empire: The Universal Expositions of 1855 and 1867,* New Haven, 1987, even this anti-institutional gesture was condoned. Eclecticism had taken the thunder from the revolutionary, as Courbet's paintings were assessed in formalist terms. The new permissive—and politically neutralized—atmosphere of the 1855 exhibition made it difficult for an artist to profess independence. With its political implications ignored, any painting could be seen to feed inevitably back into the sanctioned system.

The question of modernism has traditionally been couched in formal terms addressing issues of flatness, of painterly technique, of reduction of interest in subject mat-

*"The Political Origins of Modernism," by Patricia Mainardi. *Art Journal,* vol. 45, no. 1, (Spring 1985). Reprinted by permission of the College Art Association, Inc.

ter. Manet is usually considered the first modernist painter, and the origins of the movement placed in the 1860s.[1] I should like to put these formal issues aside for the moment in order to propose another model, what might be called Institutional Modernism. By that I mean the political aspect, the structures by which art is presented to and perceived by its public. By focusing on some events of the 1850s in which the Government of the Second Empire attempted to depoliticize art, I hope to cast some light on the preconditions to our formalist-defined modernism.

Although nineteenth-century art history has usually been interpreted as the conflict between reactionaries and the avant-garde, the principal aesthetic division in France during this period would be more accurately characterized as between the Academy and all other parties. The Academy had been founded in the seventeenth century as a royal agency in charge of aesthetics; opposition to its doctrines would therefore quite naturally be interpreted as double-edged, encompassing both an aesthetic and a political stance. Conservatives never forgot that the Academy had been temporarily suppressed during the Revolution. As a result, they insisted that only a Legitimist monarch would adequately protect Academic interests, and, throughout the century, they attributed the developing aesthetic schism between Academic and anti-Academic to political events.[2]

Romanticism presented the first major challenge to the hegemony of Academic principles. As early as 1800, Mme de Staël announced that the new spirit of Republicanism required a revolution in the character of literature, and, by 1815, the *Journal des Débats* was proclaiming that Romanticism was nothing other than the extension of the political revolution.[3] Supporters of Romanticism in the visual arts took up this refrain, one critic stating that "society having changed its philosophical and political direction and renounced the majority of its old beliefs, all cultural expressions had to change as well."[4] Romanticism was thus identified by friend and foe alike as the fruit of the Revolution, and, despite the monarchist convictions of many of its early adherents, aesthetic battlelines were gradually drawn along political lines. By the 1820s, it was assumed that liberals would support Romanticism, Constitutional Monarchists might or might not, and only Legitimists would continue to be as committed to classicism as they were to the ancien régime.[5]

The best-known manifestation of the Academic-anti-Academic schism in art was the Ingres-Delacroix rivalry. Although we now define this antithesis in formal terms—as line versus color or Classicism versus Romanticism—it was perceived at the time as also embodying political issues. The Salon of 1824, at which Ingres exhibited his *Vow of Louis XIII* and Delacroix his *Massacre of Scios,* first saw the articulation of this polarization in terms of *le beau* and *le laid,* the beautiful and the ugly.[6] For if *le beau* was identified with classical academic theory, finding its apotheosis in the work of Ingres, it was also increasingly identified with order, spirituality, and—by its enemies—with the ancien régime.[7] This polarization along political as well as aesthetic lines was catalyzed by the frontal attack on Romanticism emanating from the Académie française on April

24, 1824—the anniversary of the return of the king.[8] "The Salon is as political as the elections," wrote Jal three years later. "The brush and the sketch are the tools of parties as much as the pen. The wishes of the Church and the State are manifested in a dozen pictures or statues."[9] As a result, styles themselves soon acquired political content. Even Baudelaire described Ingres's art in political terms redolent of the ancien régime: "cruel," "despotic," and "unresponsive."[10] Ingres's support came from Legitimists, Orleanists, and Clericals, who praised him as a bulwark against change;[11] their espousal of the supposedly eternal values of tradition reflected their own adherence to throne and altar. A cartoon of 1855 shows two political reactions to a formal quality, Ingres's color. The gentleman on the left, distinguished by his top hat and goatee, says, "It entrances me," while the man on the right, whose dress and porcine physiognomy are intended to convey his lower-class status, responds, "It leaves me cold."

In contrast, the quality of "ugliness," exemplified by the paintings of Delacroix, seemed tied to anarchy, materalism, and modern life, all seen as consequences of the Revolution. Although suggested by a variety of earlier critics, this reading became established in 1827 when Victor Hugo, in his Preface to *Cromwell,* proclaimed "ugliness" the standard of Romanticism. "The beautiful has only one type: the ugly has a thousand," he wrote, and went on to claim for "ugliness" the virtues of modernity, variety, dynamism, and humanity.[12] It is not surprising that in an 1830 editorial entitled "De l'anarchie dans les arts," published in the *Journal des Artistes et des Amateurs,* Charles Farcy simultaneously attacked Hugo and Delacroix and mourned the passing of "the peaceful course of the ancien régime."[13]

Political progressives often stated with approval that Delacroix had overthrown tyranny and established the principle of liberty in art. One critic wrote: "There are very few people nowadays who aren't in one way or another revolutionary; Delacroix is their man."[14] The violence in his paintings seemed to echo the turmoil of his age, and, despite the conservatism of his own politics, he was seen as the representative of intellectuals, of revolution, of anarchy. And so, as a result of the polarization and politicization of aesthetics during this period, while Ingres was being attacked by political progressives as "the ancien régime in art," Delacroix was labeled by conservatives "the far left in painting."[15]

Our modernist lineage in art was first established by conservative nineteenth-century critics, who declared that the breakdown of order caused by the 1789 Revolution had produced Delacroix, the "Apostle of Ugliness."[16] He in turn, they claimed, begot his disciple Courbet, who, it was later claimed, begot Manet.

The confrontation of the Academic and the anti-Academic was the main issue, overriding stylistic distinctions; the same moral and political attacks, couched in the same language, were leveled at successive generations who deviated from Academic principles. In the conservative view, the movements of Romanticism, Realism, and Naturalism were all indiscriminately lumped together as the Cult of Ugliness, all opposed to the Academic ideal of *le beau.* Delacroix, Courbet, and Manet were each in turn accused of forsaking beauty

for ugliness and, in political terms, all were accused of carrying on the subversive work of undermining both the French state and the French School.

Credit must go to E.J. Delécluze in particular for having established the modernist genealogy through his incessant attacks in the conservative *Journal des Débats*. It was he who had first divided the world of art into *le beau* and *le laid* at the Salon of 1824 and who later accused Delacroix of having introduced "the reign of ugliness" into art.[17] By 1850, without interrupting his attacks on Delacroix, he included Courbet as the newest recruit to the "cult of ugliness" and frankly traced the new naturalism in painting to the heresies introduced by the Romantics.[18] The attacks on Courbet, and Realist painting in general, for depicting "ugliness" are, of course, well known and need no repetition here.[19]

At Manet's first Salon, in 1861, the negative criticism he received linked him immediately both to Courbet and to what was by now a tradition of avant-garde "ugliness."[20] Such charges were to dog him throughout his career, becoming particularly vicious in 1865 when he exhibited *Olympia*.[21] He, too, was known as the "Apostle of Ugliness," and, although Baudelaire charged him with being the first artist of decadence, Baudelaire was mistaken, for that honor had previously been awarded to Delacroix.[22] Manet was, in fact, the third.

We today see the radical differences among these three artists. Their contemporaries saw, even more prominently, the gaping chasm that had opened up between Academic principles and, on the other side of the Great Divide, Our Three Heroes. What is it, then, that makes us perceive Manet, the last of this trilogy, as the archetype of modernism? One of the major factors is that he is seen as politically, morally, even emotionally neutral. And yet, it is possible that this neutrality resides, at least in part, in the public rather than in the private perception, that it is something imposed on Manet's art by what I have called Institutional Modernism, as well as a quality inherent in his work. To examine this quality of neutrality in Manet's paintings, it is necessary first to study the moment when a protomodernist reading of art became institutionalized.

By the mid nineteenth century, the Academy, though still in theory the exclusive representative of the French School, was so no longer in fact. It now represented one style among many, although that style, embodied in classical history painting, was still considered the highest category of art. This presented a problem in the organization of the first international art exhibition at the 1855 Universal Exposition in Paris. The government of the Second Empire could stand neither above nor apart from this aesthetic conflict, for political exigencies demanded that it present a strong united front to foreign competition to show that, despite the 1851 coup d'état that had brought it to power, it did in fact represent all factions. Unlike previous regimes, this one was built on popular support. Since Napoleon III could not ignore any of the various power groups that constituted his electorate, he attempted to appease them all.

Bypassing the Academy, the Imperial Commission announced that each representative of a major style would be given a special retrospective exhibition in which he was to demonstrate his "Progress."[23] That idea was taken over from

science and industry and redefined in aesthetic terms as what we would now call "development." Eclecticism, the ability to appreciate each style on its own terms, was declared characteristic of French genius.[24] The artists chosen in this historic venture, besides Ingres and Delacroix, were Horace Vernet and Alexandre Decamps. Even the renegade Courbet was approached, so eager was the government to give the appearance of unanimous support.[25] Courbet refused the invitation but, in setting up his own show, nonetheless borrowed the notion of a retrospective exhibition, for his centerpiece was *The Studio: A Real Allegory Defining a Phase of Seven Years of My Artistic Life.*

Although artists had held such shows earlier, the ideology of the individual retrospective exhibition was an innovation of 1855. It is itself a modernist tool, for it emphasizes the development of an individual self-referential style. In the traditional "School," in contrast, the artist's individuality is subsumed in the interests of shared concerns. This is pointed up by the Academy's unsuccessful counterproposal for the 1855 exhibition; namely, a show to demonstrate the development of the French School in the nineteenth century, which it saw as synonymous with history painting by Academicians.[26] Prince Napoleon described these two contradictory proposals as a show of artists (the eclectic model) and a show of works (the Academic model).[27] The innovation of individual retrospective exhibitions did not meet with popular comprehension; while critics and connoisseurs were enthusiastic about the unprecedented opportunity to study the development of an artist's style, the general public simply did not understand why it should pay to see old paintings. Low attendance plagued both the government's and Courbet's exhibitions, and both were forced to lower their entrance fees.[28]

The government's presentation of such a varied bouquet of artists as Ingres, Delacroix, Decamps, and Vernet was intended—and understood—as an attempt to cover all bases, both aesthetic and political. Alexandre Decamps's precious little genre paintings were known to be the favorites of the bourgeoisie and were widely criticized as reflecting the attributes of that class; namely, a rich and pleasant veneer concealing an essential lack of education and an absence of èlevated principles.[29] Horace Vernet glorified French military victories and was acknowledged to be the most popular artist in France, the only one known to the common people. For conservatives he was a symbol of patriotism, for progressives of chauvinism.[30] In truth, one could find exceptions to these interpretations—aristocrats who favored Decamps, political radicals who detested Delacroix—but that is not the point.[31] The main issue is that these stereotypes had enough reality to be invoked repeatedly by both critics and government officials in defining the 1855 Exposition.

This strategy can be seen as an extension of Second Empire politics, for, as Theodore Zeldin has pointed out, government policy was to encourage prominent representatives of various political persuasions to rally to its support.[32] It is my theory that the same policy was pursued in art, and here I differ with Albert Boime's theory that the government attempted to make Realism the official style.[33] On the contrary, the regime was content merely to ratify all

existing trends, provided that their principal proponents rallied to the Empire. In fact, there was no one in the Second Empire art administration who was capable of creating or carrying out a coherent policy.

The government's eclecticism in honoring a multitude of styles was reinforced by the jury, which, under the presidency of Morny, Napoleon III's half-brother (and the chief architect of his coup d'état), awarded Medals of Honor to nine different artists.[34] It was again the conservatives who understood the ramifications of this gesture, protesting that all styles were thus considered implicitly neutral and interchangeable, their differences reduced to mere questions of taste and popularity.[35] Conservatives understood quite well that the government had dealt a fatal blow to the classical hierarchy of categories, for it had established the principle that one could become as great an artist by painting monkeys as by painting gods and heroes.

But in order for gods and monkeys, to say nothing of apples and farmyards, to be accorded the same potential for greatness, subject and style had first to be disencumbered of their heavy political baggage. It was necessary to create a politically neutral methodology for evaluating art. This was done by Théophile Gautier and Prince Napoleon. Gautier, the only major art critic who had rallied to the Empire, was in consequence appointed official government critic for the Exposition.[36] His natural propensity to say something nice about everyone would, in this context, be politically valuable. Prince Napoleon, President of the Exposition, turned art critic for the occasion and established the official line on each artist. Of Delacroix, whose *Liberty Leading the People* was removed from storage for the event, he wrote:

> There are no longer any violent discussions, inflammatory opinions about art, and in Delacroix the colorist one no longer recognizes the flaming revolutionary whom an immature School set in opposition to Ingres. Each artist today occupies his legitimate place. The 1855 Exposition has done well to elevate Delacroix; his works, judged in so many different ways, have now been reviewed, studied, admired, like all works marked by genius.[37]

Delacroix the Revolutionary has been transformed into Delacroix the Colorist, and the quality of genius has been pressed into service to neutralize and depoliticize his art. Gautier praised this laundered version of Delacroix to such an extent that the artist informed him that a friend "assured me, after having heard your article read, that she thought I had died, thinking that one only so praised those dead and buried."[38] The reference to death was apt: a number of critics referred to 1855 as a cemetery.[39] What was dead and buried was the contemporary political vitality of art; art would henceforth be confined to museums. After 1855, Delacroix was elected to the Academy despite six previous failures, and even Courbet was affected by the new ambiance and became somewhat acceptable.[40] One may note that Marxist historians often cite 1855 as the end of Courbet's great political period.[41] Delacroix's friend Pérignon, looking back to

the Universal Exposition, wrote, "Today everything is forgotten, everything is smoothed over, there are no longer either halos or scars; the works appear isolated, deprived of the interest they had borrowed from circumstances, from judgments, from passing events. Above all, they've lost the train of violent passions that gave them their magic life."[42]

The magic life that disappeared with 1855 was the ability of art to carry many significances in popular understanding, to serve as vehicle for a variety of discourse. Violent passions did not, of course, disappear, but in a sense 1855 is the cemetery that marks the end of the political art wars of the first half-century. The canonization of all opposing styles after decades of vituperation had a traumatic effect on contemporaries; an article in one of the art periodicals lamented—and this is the modernist lament: "Alas, in art as in politics, isn't the error of today almost always the truth of tomorrow."[43] The security offered by tradition was giving way to the anxiety of the present, for in all facets of life France at mid century was moving into uncharted waters.

Aesthetic evaluations later in the century tended to replace political judgments with moral ones and moral judgments with formal ones. The schism of the earlier period, Academic or anti-Academic, encompassing at the same time both aesthetic and political issues, was replaced by the merely formal judgment, stated by Mallarmé in 1874 as "The jury has only to say: this is a painting or that is not a painting."[44] The eclecticism of the earlier period, so valuable in breaking the hegemony of history painting, proved to be but an interim stance, soon to be replaced by the hegemony of modernism.

The modernist view of art as contentless and politically neutral, which we take as the grounding of all that makes Manet at once so enigmatic and provocative, thus had its seeds in the deliberate manipulation of power, in Napoleon III's successful attempt to deprive art of its traditional role as partisan tool in order to co-opt it as window dressing for his regime. We may cite Mallarmé, Roger Fry, and Clement Greenberg as brilliant theoreticians of modernism, but at the same time we must acknowledge the role of Napoleon III, Prince Napoleon, and the Duc de Morny, for it was they who, even earlier, saw the political advantage that might be derived from neutralizing art.

And so, if Delacroix's *Liberty* seems more straightforward in its sympathies than does Manet's *Execution of Maximilian,* if Delacroix was a symbol of revolution' and Manet of modernism, if, in fact, neither artist was politically radical and both paintings, as recent scholarship has emphasized, share an enigmatic quality, one may account for these differences by the "magic life" that *Liberty* enjoyed, but that no longer existed in 1867.

I propose that we not leave modernism to be defined by modernists, who would state that the issues raised here are peripheral or irrelevant. Instead I suggest that whenever there is an attempt to separate art from its social and political milieu by redefining it exclusively in formalist terms, we look for two interrelated phenomena. One is the attempt on an institutional level to co-opt it for political advantage. The other is the parallel attempt on the aesthetic level, by

artists and their friends, to protect art from partisan attacks by stressing its political insignificance. In any case, modernism has existed from the very beginning, Janus-faced, in this contradiction: one face gazes resolutely at the work of art, the other attentively regards current events.

NOTES

An earlier version of this paper was read at the 1984 Annual Meeting of the College Art Association in Toronto at the Panel "Judging Modernity: Manet Revisited," chaired by Thierry de Duve. Parts of it are taken from my forthcoming *Universal Expositions: Art and Politics of the Second Empire* (Yale University Press). I am indebted to Louis Finkelstein and Joel Isaacson for their advice and criticism.

1. The most influential exponent of this reading has been Clement Greenberg; see his classic article "Modernist Painting," *Art and Literature,* 4 (Spring 1965), pp. 193–201.

2. For a sampling of such opinions, see: Charles Ernest Beulé (secrétaire perpetuel of the Académie des Beaux-Arts from 1862 to 1874), "Du Danger des Expositions," in his *Causeries sur l'art,* Paris, 1867, pp. 1–39, and Louis Dussieux, *L'Art considéré comme le symbol de l'État social,* Paris, 1838. Léon Rosenthal, *Du Romantisme au réalisme,* Paris, 1914, gives many examples of the use of 1830 Revolution to mark the decline of art; see pp. 3ff.

3. Mme de Staël, *De la littérature considérée dans ses rapports avec les institutions sociales,* ed. Paul van Tieghem, 2 vols., Paris, 1959, see especially, II: pp. 296–317. "H," "Les Scrupules littéraires de Mme la baronne de Staël, ou Réflexions sur quelques chapitres du Livre de l'Allemagne," *Journal des Débats,* February 8, 1815. René Bray traces the development in his *Chronologie du Romantisme (1804–1830),* Paris, 1932.

4. Auguste Jal, *Esquisses, croquis, pochades, ou tout ce qu'on voudra sur le Salon de 1827,* Paris, 1828, pp. 103–104.

5. Bray (cited n.3), gives 1823 as the decisive date; see pp. 140–159 for the process by which Romanticism becomes identified with liberal thought.

6. See: E.J. Delécluze, "Beaux-Arts. 1824," *Journal des Débats,* September 1, 1824. The terms *le beau* and *le laid* were used by most critics after 1824. Théophile Thoré, "Artistes contemporains. M. Eugene Delacroix," *Le Siècle,* February 24, 1831, says the Academy called everything *laid* that wasn't *beau,* and dates the inception of these "critical categories" at 1824 when the *culte du laid* was invented as a term of opprobrium for Delacroix.

7. See, for example: "Y," "Paris. Beaux-Arts. Exposition de 1824," *Le Globe,* September 17, 1824, where the critic states "on est pour les règles ou pour la barbarie" (one is either for the rules or for barbarism). Some of the most articulate anti-Ingres critics were Alexandre Decamps, Théophile Thoré, and Laurent-Jan, all in the political as well as aesthetic opposition. See: Decamps, *Le Muse, Revue du Salon de 1834,* Paris, 1834, pp. 20–26, and "Beaux-Arts. Salon de 1838," *Le National,*

March 5, 1838; Thoré, "M. Ingres," *La Revue Indépendante* III, June 1842, pp. 794–803; Laurent-Jan, "M. Ingres Peintre et Martyr," *Le Figaro,* December 30, 1855, pp. 2–7 (originally published in the 1840s and reprinted in his *Légendes d'Atelier,* Paris, 1859); Nadar [Gaspard-Felix Tournachon], "Salon de 1855," *Le Figaro,* 16, September 23, 1855. Also see: Carol Duncan, "Ingres's *Vow of Louis XIII* and the Politics of the Restoration," in Henry A. Millon and Linda Nochlin, eds., *Art and Architecture in the Service of Politics,* Cambridge, Mass., 1978.

8. See: Stendhal [Henri-Marie Beyle], *Racine et Shakespeare No II ou Réponse au manifeste contre le Romantisme prononcé par M. Auger dans une séance solennelle de l'Institut ,* Paris, 1825.

9. Jal (cited n.4), p. iv.

10. He does not refer to Ingres by name, but it is clear who is meant; see his "Exposition Universelle. Beaux-Arts. Eugène Delacroix," *Le Pays. Journal de l'Empire,* June 3, 1855, reprinted in Charles Baudelaire, *Écrits sur l'Art,* ed. Yves Florenne, 2 vols., Paris, 1971, I: pp. 403–4.

11. See: Charles Blanc, *Ingres, sa vie et ses ouvrages,* Paris, 1870, pp. 174–75; Henry Lapauze, *Ingres, sa vie et son oeuvre,* 1780–1867, Paris, 1911, pp. 465–73; also Duncan (cited n. 7).

12. On Delacroix, see, for example: E.J. Delécluze, "Exposition du Louvre 1824," *Journal des Débats,* October 5, 1824, and "Beaux-Arts. Salon de 1827," *Journal des Débats,* December 20, 1827; Louis Peisse, "Salon de 1831," *Le National,* May 30, 1831. Victor Hugo, *Cromwell,* XXII-XXXVI. I am indebted to Charles Rosen and Henri Zerner for their interesting discussion on this question; see their *Romanticism and Realism: The Mythology of Nineteenth-Century Art,* New York, 1984, pp. 18–19.

13. Charles Farcy, "De l'anarchie dans les arts," *Journal des Artistes et des Amateurs,* January 31, 1830, pp. 81–83.

14. Eugène Loudun [Eugène Balleyguier], *Le Salon de 1855,* Paris, 1855, pp. 13–14; originally published in the Legitimist journal *L'Union.* For the progressive point of view, see: Auguste Jal, *L'Artiste et le philosophe. Entretiens critiques sur le Salon de 1824,* Paris, 1824, pp. 48–53.

15. On the identification of Ingres and Classicism with the ancien régime, see: Jal (cited n. 4), p. 102; Jal divides art into *classique* and *anticlassique,* "faire beau" or "faire laid." On the identification of Delacroix and Romanticism with "l'extrême gauche," see: Delécluze, "Beaux-Arts. Salon de 1827," *Journal des Débats,* March 21, 1828. For a general discussion of the politicization of art during this period, see: Hugh Honour, *Romanticism,* New York, 1979, pp. 217–244.

16. Although the phrase "l'apôtre du laid" was undoubtedly in use earlier, the first recorded instance I have found is in an 1855 letter of Ingres, quoted in Blanc (cited n. 11), p. 183, and Lapauze (cited n. 11), p. 500; also see: Delécluze, *Les Beaux-arts dans les deux mondes en 1855,* Paris, 1856, p. 214.

17. Delécluze, "Exposition du Louvre 1824," *Journal des Débats,* October 5, 1824; and idem (cited n. 11), p. 214. On Delécluze, see: Robert Baschet, *E.J. Delécluze, Témoin de son temps, 1781–1863,* Paris, 1942.

18. See: Delécluze, "Exposition de 1850," *Journal des Débats,* 7, January 21, 1851. A similar opinion was expressed by Louis Peisse, "Salon de 1850," *Le Constitutionnel,* January 8, 1851.

19. For a discussion of the issue, see: Emile Bouvier, *La Bataille réaliste (1844–1857)*, Geneva, 1973, pp. 214–57; also see: Timothy J. Clark, *Image of the People: Gustave Courbet and the Second French Republic, 1848–1851*, Greenwich, Conn., 1973, pp. 137–138; and my "Gustave Courbet's Second Scandal: *Les Demoiselles de Village,*" *Arts Magazine* 53 (January 1979), pp. 95–109.

20. See: Hector de Callias, "Salon de 1861," *L'Artiste,* July 1, 1861, p. 7; Léon Lagrange, "Salon de 1861," *Gazette des Beaux-Arts,* July 1, 1861, p. 52. For a discussion of the relationship of the two artists, see: Theodore Reff, "Courbet and Manet," *Arts Magazine* 54 (March 1980), pp. 98–103.

21. See: Hamilton 1969, pp. 65–80.

22. Fêlix Jahyer called Manet the "Apostle of Ugliness" in 1865; see: his *Etude sur les beaux-arts. Salon de 1865,* Paris, 1865, p. 23. Baudelaire wrote to Manet in the same year: "Vous n'êtes que le premier dans la décrépitude de votre art"; Baudelaire, *Ecrits sur l'art,* II, pp. 350–52. The Legitimist Alphonse de Calonne called Delacroix "Un peintre de décadence," in "Exposition Universelle des Beaux-Arts," *Revue contemporaine* 21 (1855), p. 128. For the context of this charge, see: Koenraad W. Swart, *The Sense of Decadence in Nineteenth-Century France,* The Hague, 1964.

23. The decision is set forth in a memorandum of the Imperial Commission "Placement définitif" in the Archives Nationales, Paris, F21 519. Prince Napoleon discusses the concept in his *Visites et études de S.A.I. le Prince Napoléon au Palais des Beaux-Arts,* Paris, 1856, pp. 55–56.

24. The theory was set forth by Théophile Gautier, *Les Beaux-Arts en Europe,* Paris, 1855, pp. 5–9, and quoted by Prince Napoleon (cited n. 23), p. 59. Both Gautier's and Prince Napoleon's articles were originally published in the Government newspaper *Le Moniteur Universel;* other critics followed their lead.

25. Courbet's account of his luncheon with Nieuwerkerke sometime in 1854 describes the Government's efforts to procure his *ralliement* with a commission for the 1855 Universal Exposition. His letter to Alfred Bruyas is published in "Lettres inédites," *L'Olivier, Revue de Nice* 8 (September–October 1913), pp. 485–490.

26. The first proposal was made by the Marquis de Pastoret in 1851, forwarded by the Academy to the Minister of the Interior the same year; see: the *Procès-verbaux* of March 1, and 8, 1851. Institut de France, Archives de l'Académie des beaux-arts. Pastoret and Prince Napoleon continued to support this plan; see: Paris, Exposition Universelle de 1855, Commission Impériale, *Rapport sur l'Exposition Universelle de 1855 présenté à l'Empereur par S.A.I. le prince Napoleon,* 1857, p. 13.

27. "Discours prononcé par S.A.I. le Prince Napoléon, Président de la Commission Impériale, à la séance d'inauguration de l'Exposition Universelle, le 15 mai 1855," in *Rapport* (cited n. 26), pp. 399–403.

28. For the Government's entrance fees, see: Frédéric Bourgeois de Mercey, "L'Exposition Universelle des Beaux-Arts en 1855," *Revue contemporaine* 31 (1857), pp. 466–94; Mercey was the *Commissaire général* of the art exhibition. For Courbet's fees, see: Eugène Delacroix, *Journal, 1822–1863,* ed. André Joubin, Paris, 1980, entry of August 3, 1855.

29. See: Gustave Planche, "L'Exposition des Beaux-Arts à l'Exposition Universelle de 1855," *Revue des Deux-Mondes,* September 15, 1855, p. 1150; Antoine Etex,

Essai d'une revue synthétique sur l'Exposition Universelle de 1855, Paris, 1856, pp. 37–39.

30. For the identification with patriotism, see: Claude Vignon [Noémi Cadiot], *Exposition Universelle de 1855, Beaux-Arts,* Paris, 1855, p. 220; for the charge of chauvinism, see: Maxime DuCamp, *Les Beaux-Arts à l'Exposition Universelle de 1855,* Paris, 1855, p. 205.

31. In a recent article, Francis Haskell has attempted to use the exceptions to disprove the rule by citing critics whose politics and aesthetic positions were incongruent as well as collectors whose taste differed from the expected norm. This only demonstrates that history is a social science; regardless of individual variants, the generalization stands. See: Francis Haskell, "Enemies of Modern Art," *New York Review of Books,* June 30, 1983, pp. 19–25.

32. See: Theodore Zeldin, *The Political System of Napoleon III,* London, 1958.

33. See: Boime 1982.

34. Besides Ingres, Delacroix, Decamps, and Vernet, the medallists included Cornelius, Landseer, Leys, Heim, and Meissonier. The lists are included in the 1857 Salon catalogue.

35. See: Charles Blanc, "Au Secrétaire de la Rédaction," *La Presse,* October 30, 1855, Delacroix noted in his *Journal,* October 15, 1855, that the Academicians were outraged over the plurality of medals.

36. On Gautier, see: Taxile Delord, *Histoire du second Empire, 1848–1869,* 6 vols., Paris, 1869–1875, II, p. 272. His articles were published in the official Government newspaper, *Le Moniteur Universel.*

37. Prince Napoleon (cited n. 23), pp. 118–119; 1855 is mistakenly written as 1851 in the text.

38. Delacroix to Théophile Gautier, July 22, 1855, in Eugène Delacroix, *Correspondance générale,* André Joubin, ed., 5 vols., Paris, 1926–1938, III, pp. 279–280.

39. See, for example: Paul Mantz, "Salon de 1857," *La Revue Française IX* (1857), p. 422.

40. See: Louis Hautecoeur, "Delacroix et l'Académie des Beaux-Arts," *Gazette des Beaux-Arts* 62 (December 1963), pp. 349–364.

41. See, for example: Clark, (cited n. 19), pp. 155–156.

42. Alexis-Joseph Pérignon, *A Propos de l'Exposition de peinture,* Paris, 1856, pp. 3–4.

43. "Chronique," *La Revue Universelle des Arts,* 1855, I, p. 240.

44. Stéphane Mallarmé, "Le Jury de Peinture pour 1874 et M. Manet," in *Oeuvres complètes de Stéphane Mallarmé,* Henri Mondor and G. Jean-Aubry, eds., Paris, 1945, p. 699.

Confluence and Influence: Photography and the Japanese Print in 1850*

DEBORAH JOHNSON

Although the influences of photography and Japanese prints on painting in nineteenth-century France have long been acknowledged, they are usually considered separately, and in relation to Impressionism. They are here examined as mutually supportive influences which offered landscape painters at mid-century a new vocabulary that soon became identified with a new verisimilitude.

In France and England, photography was popularized during the 1850s through exhibitions and travel books illustrated either with photographs or with prints executed after photographs. Photographs offered a model for painters who sought to achieve a more "objective" reality. The photographs' subject matter also coincided with that chosen by landscape painters: photographic sections of the Salons of 1859, 1860, and 1861 were dominated by scenes of the Barbizon forest. As early photographers emulated the effects of painting, so did landscape painters find inspiration in the light, textures, and compositions seen in photographs. Millet and Corot both knew photographers and collected their works.

The evolution of photography coincided with, and undoubtedly corroborated, a growing concern in naturalistic representation that also led artists to consider Japanese prints. These works were known in Paris long before 1856—the date traditionally ascribed to their "discovery." Picking up on a statement by Edmond de Goncourt, Johnson investigates the "mutually supportive pictorial systems" of photography and Japanese prints.

The challenge that both pictorial systems offered to traditional compositional formats of Western art can be detected in landscape paintings of the 1850s. Japanese prints as well as photographs offered alternative concepts of representing three-dimensional space and enframement—which in turn might imply arrested motion. Photography heightened the painter's awareness of light effects and of the variety of tones presented by a scene, an awareness that becomes obvious in the tonalism of Corot's middle period. Japanese prints, in turn, may have influenced the subject matter of Millet's peasant paintings as well as the heightened colorism and flattening of elements seen in the works of both Millet and Rousseau.

*"Confluence and Influence: Photography and the Japanese Print in 1850," by Deborah Johnson. Reprinted from the catalogue *Corot to Manet: The Rise of Landscape Painting in France,* with permission of The Currier Gallery of Art, Manchester, New Hampshire.

Of the threads that tie the nineteenth century into a coherent whole, none, per-
haps, is more compelling than that century's obsession with issues of "objec-
tive" reality and perception. In the area of painting, particularly in France, land-
scape became the primary testing ground for this obsession. Landscape painting
was less bound than other types by academic rules and regulations and could
easily be checked against reality; and the land itself, in the face of nineteenth-
century urbanization, had taken on the additional romantic appeal of a place of
escape and the potential victim of extinction. While the artist might choose to
work from nature or not, a certain level of verisimilitude was a growing expec-
tation in nineteenth-century France, and artists began to search for ways to unite
"objective" reality with artful perception. Many "new" arts were uncovered as
part of this search, including British watercolors and seventeenth-century Dutch
painting. None, however, was more significant than the tandem discoveries of
photography and East Asian art, especially the Japanese print. Together, they
provided artists with both the motivation and the structure to generate the pro-
foundly new aesthetic premises of the modern age.

The reasons for their powerful influence are many and complex. Clearly a
factor was the apparent "coincidence" of their near-simultaneous appearance.
The announcement of the invention of photography was made in London and
Paris in 1839, and China and Japan were both forced open to trade with the
West during the period 1839 to 1854. More important, both the early photo-
graph and the Japanese print deviated in many of the same ways from tradi-
tional western aesthetic conventions, and thereby reinforced each other's visual
statements. Perhaps most important, however, they focused and gave direction
to nineteenth-century concerns with reality and perception. The photograph was
immediately accepted as the ultimate statement of visual truth in science and
art. The "truthfulness" of the Japanese print was also lauded, however—a sur-
prising position given the premises of decorativeness and nonillusionism funda-
mental to the print. Through the elements shared in common by the print and
the photograph, the photograph gave impeccable credibility to the print. This, in
turn, allowed access to and understanding of the print's essential abstraction.
Without the precedent of the photography, it is unlikely that the Japanese print
(and East Asian art in general) would have captured western artistic imagination
as significantly as it did.

It was particularly the landscape painters working in and around Paris in
the 1850s who first betrayed the crises, experimentation, and modifications
brought on by the appearance of photography and the Japanese print. The pri-
mary purpose of this essay is to establish a sound foundation for further study of
this phenomenon: to show that specific opportunities existed for meaningful
contact between these painters, photography (especially landscape photogra-
phy), and East Asian art in a period earlier than has been considered to this
point; and to investigate the ways in which the potential impact of the Japanese
print distinguished itself from that of the photograph, thus providing some cor-
rection of the confusion that has accompanied discussions of this issue. Secon-

darily, Corot and Millet have been focused on in order to determine how key developments in art at midcentury might have been inspired by both photography and the Japanese print. Tangentially, it is fascinating to consider the bulk of evidence that suggests that the Japanese print was "uncoverable" some time before it was, in fact, uncovered. This gives a certain amount of weight to the notion that it addressed the needs and obsessions of the specific time in which it appeared, and that it is necessary that its impact be considered together with that of photography.

Although it has rarely been acknowledged, the diversity that characterized photography in France at midcentury is impressive. Despite the simultaneity of its invention, two very different kinds of photography had been developed in France and England by 1839. The Englishman William Henry Fox Talbot produced photographic prints on paper from a negative base, closely resembling modern photographic processes. Characteristic of these prints was a grainy surface texture that subsumed detail in a warm, atmospheric veil. Aesthetically, this result was well suited to an age which had embraced similar effects in the paintings of Turner. Combined with the fact that Talbot jealously guarded his patent through the 1840s, it is not surprising that relatively little experiment evolved around the process in England before the 1850s.

In contrast, the French inventor of photography, Louis-Jacques-Mandé Daguerre, had produced works that differed from Talbot's on two critical points: since they were direct positives—that is, not printed from negatives—they were unique and not easily reproduced; and rather than paper, they were printed on small, shiny metal plates that would reveal their images only when held in specific relation to the light. Daguerre's invention was immediately bought by the State and made public to all. As a result, an enormous amount of activity by a wide variety of operators was generated which not only assured France's general leadership, but laid the groundwork for a near total reorientation of French photography in the 1850s. France was not without its early and important paper practitioners, such as Hippolyte Bayard; but the 1850s saw a turn to paper that was so enthusiastic and informed as to produce major technological options and the earliest appearance of a variety of photographic styles.

The technique of the daguerreotype simply did not hold the commercial potential of the paper negative process with its promise of multiple prints. But the early French adherence to daguerreotypy was much more a stylistic than an economic issue. The cool, tightly focused, and rigorously planar daguerreotype would easily appeal to the champions of the neoclassical mode still dominant among "important" painters in the Paris Salons. The shift to paper in the 1850s, with its very different aesthetic, reflected the stylistic "crisis" in French painting as it moved toward an increasingly painterly and idiosyncratic surface. As if announcing its bias, landscape photography, at its height as a genre in France in the 1850s and 1860s, almost invariably appeared on paper. To be sure, paper processes were easier to manipulate in the field *en plein air*. More important, the immediate source to which a mid-nineteenth-century landscape artist might

turn for precedent consisted of the painters of the Romantic school and the painters of 1830. These two rich and painterly models automatically suggested to photographers the warm-toned, fuzzy-edged, sketch-like quality of the paper print.

From the beginning, examples of photography could be seen easily and frequently throughout Paris. The distinction of the first photographic exhibition belongs to Bayard, who in 1839 (the same year as the announcement of the invention of photography!) showed thirty of his paper prints in Paris. In 1844, nearly a thousand daguerreotypes by various photographers, including the Bissons, Claudet, Derussy, Plumier, Sabatier, and Blot, were shown in the important Exposition des Produits de l'Industrie Française.[1] Their exhibition as "industrial products" illustrated the controversial issue of whether photography most properly belonged to the domain of art or science. Photography did not move firmly into position for artistic consideration until the Great Exhibition of London in 1851. Over seven hundred photographs from six countries were exhibited, all under the category of "Science and Art."[2] Nonetheless, medal winners were most frequently lauded not for the achievements of their "science," but for the beauties of their "art." The Scottish photographers Adamson and Hill, for example, were cited as deficient in technique, but won honorable mentions nonetheless, and their portraits were compared to the best paintings of the day.

The all-encompassing category of "Science and Art" was retained in the 1855 Universal Exposition in Paris, where nearly five hundred photographs were exhibited, most notably including Crimean War images by Roger Fenton and landscapes by Gustave Le Gray.[3] In this same year, the newly formed Société Française de Photographie began to hold its own annual Salons outside the structure of any official art organization, and the third exhibition of the Société in 1859 attracted an unprecedented 30,000 visitors to view 1,295 pieces by 145 photographers.[4] Pure landscape images were well represented at the exhibition, where, interestingly, they were placed in a separate category from travel, topographic, and archaeological views. The list of landscape entries is impressive and included views of the Bois de Boulogne by Jean Renaud, tree studies by Comte Aguado, flower studies by Adolphe Braun, interior courtyard scenes by Bisson Frères, views of Fontainebleau by Gustave Le Gray, and Compiègne forest scenes by Margantin (compared by at least one reviewer to landscape paintings by Théodore Rousseau).[5]

However, the 1859 exhibition of the Société was hardly more significant in its ramifications than the opening of official Salon doors to photographers in the same year, an event which crystallized the controversy regarding photography's status. As with Hill and Adamson in 1851, the photographer Nadar was compared to the best painters of the day, one reviewer going so far as to call him a Titian.[6] The leading spokesman for the opposition was none other than Charles Baudelaire, who published a now-famous denunciation of the technique. "Photography's real task," he wrote, ". . . is in being the servant of sci-

ence and art, but a very humble servant like typography and stenography which have neither created nor improved literature."[7]

On a fundamental level, Baudelaire's position is a typically Romantic one of the time in its skepticism of the power of technology to create art. The kind of photography against which he spoke, however, was that patterned after paintings he disliked equally. For the most part, these works were sentimental, moralist, and maudlin, and heavily reliant on the realistic credibility of form for impact. More profoundly, it was this Realist "cult of nature" with which he was disturbed, its confusion with the beautiful, and the absence of dream and fantasy. To Baudelaire, an artist of this type no longer created life, but merely reproduced it. This led to questions of intentionality throughout the essay that became central to the debates around photography: like the Realist painter, how much control might the photographer exercise over the medium and predict and *intend* the results he or she achieved? Even critics sympathetic to photography, such as Philippe Burty, could not allay this concern and, declaring photography the perfect instrument by which to record the age, underscored its "objectivity" and subsumed its potential for aesthetic creativity.

At this same time, travel books illustrated with photographs (or prints after photographs) proliferated and were significant on several levels: they appealed to the wanderlust of the age, widely popularized photography as a preeminent reproductive technique, and continued to identify it with notions of absolute reality. At least three great early programs of French photographic documentation found their way into print: Lerebours's *Excursions daguerriennes: vues et monuments les plus remarquables du globe [Daguerreotype excursions: the world's most notable views and monuments]* of 1841 and 1843, illustrated with prints after daguerreotypes; Girault de Prangey's photographs of Italy, Greece, and Egypt published in 1846; and the twenty-four portfolios published from 1851 to 1854 by the Imprimerie Photographique of Blanquart-Evrard, the most important publisher and proselytizer of paper photography in the 1850s. To varying degrees, all three ranged themselves within the tradition of Romantic travel lithography found in earlier publications such as the *Voyages pittoresques,* begun in 1819. It is the confrontation between aesthetic convention and empiricism, however, that makes these photographs so commanding and new. This is particularly true of a fourth project, the Missions Héliographiques, begun in 1851 to document systematically the great historic monuments of France. Although never published, its negatives formed an archive of public record and helped to keep photography in the French consciousness.

It is difficult to believe that the landscape painters of the 1850s could ignore the activity outlined above, particularly after photography's entry into the Salon; in fact, Barbizon forest scenes dominated the photography sections of the Salons of 1859, 1860, and 1861, and their photographers were regarded as international leaders of the genre.[8] It is inconceivable as well that the painters could have missed the photographers setting up tripods in "their" forests.

Charles Marville, Edouard-Denis Baldus, Gustave Le Gray, Adolphe Grand-guillaume, Charles Desavery, Paul Gaillard, Paul Delondre, Constant and Pierre Dutilleux, and Eugène and Adalbert Cuvelier all worked in and around the Forest of Fontainebleau from the late 1840s through the 1850s. Beyond this group, several other photographers at midcentury specialized in landscape, including Blanquart-Evrard with studies of rocky seascapes and trees from 1851–1854; Henri Le Secq with landscapes and marines from the first half of the 1850s; Charles Nègre with views of the French provinces from 1851; and Louis-Alphonse Davanne and Ildefonse Rousset, whose landscapes and marines routinely won the highest praise in the press, beginning in the late 1850s.[9]

The relationship of photographers and their work with the Barbizon landscape painters can be drawn even more precisely. The experiments of Constant Dutilleux, Grandguillaume, and Adalbert Cuvelier with the photographic print process of cliché-verre while at Barbizon certainly inspired a number of neighboring landscape painters to experiment likewise. With this process, the artist "draws" a design with a sharp tool directly onto a glass plate coated with photographic collodion, and then exposes the plate against a sheet of sensitized paper to sunlight. Charles Daubigny, Théodore Rousseau, Jean-François Millet, and Camille Corot each produced a body of important clichés-verre, creating a significant pocket of artistic activity and absorbing photographic principles firsthand. Corot, more taken with the process than the other painters, also experimented with a less common technique: he painted the glass plate with varying degrees of opaque ink before exposing it to sunlight.

Earlier, in 1843, Daubigny had etched a landscape from a daguerreotype for Lerebours's *Excursions daguerriennes.*[10] Eugène Isabey owned several unusual daguerreotypes by Hippolyte Macaire of Le Havre whose marines were among the first to reflect an interest in (and capture) the phenomenology of waves, clouds, and smoke in motion.[11] Virtually all of these individuals were themselves photographed. But no artists were more involved in photography—or at least documented as such—than Millet and Corot.

Millet counted among his acquaintances the photographers Nadar, Etienne Carjat, Félix Feuardent, and the Cuveliers, all of whom photographed him. On at least one occasion, in a letter of 1861 to Rousseau, he characterized Eugène Cuvelier's photographs as "very fine," and supposed that Rousseau had seen Cuvelier recently.[12] He frequently wrote friends, Feuardent among them, to request photographs that "would be useful" to him.[13] No doubt this relates to the observation of American painter Edward Wheelwright, studying with Millet in 1855–1856, that the latter was positively enthusiastic about using photographs as an aid in landscape painting.[14] Millet is said to have explained that "photographs are like casts from nature, which never can be as good as a good statue. . . . But photography, used as we use casts, may be of great service."[15] While this pronouncement is conspicuously Baudelairean in tone, it is disappointing in revealing so little of how Millet actually used photographs.

Corot was especially friendly with the Dutilleux, Grandguillaume, and

Cuvelier families. It was Grandguillaume and Adalbert Cuvelier who taught him the cliché-verre process with which he ultimately made more than seventy prints over the period 1853 to 1874. He served as best man at Eugène Cuvelier's wedding in Barbizon and went on to hire Pierre Dutilleux and Charles Desavery to photograph several of his paintings. Many photographers made his portrait—most notably, a stunning studio shot by Victor Laisné from c. 1852, less formal characterizations by Adalbert Cuvelier and Grandguillaume from 1852–1853, and a charged and telling image, apparently by Charles Marville in 1854, of Corot and Narcisse Diaz posed on boulders in the Forest of Fontainebleau. At his death, more than three hundred photographs were found in his studio, two hundred of which were described by his biographer Alfred Robaut as "après nature" and which can be connected to Desavery, Grandguillaume, and the Cuveliers.[16]

Knowledge of photography on the part of French landscape painters can be readily established by midcentury; it is more difficult to determine the precise point at which accessible East Asian art—particularly the Japanese print—began to attract artists. Nonetheless, there is no question that East Asian art and photography were entering public consciousness at the same moment.[17] Japanese art was, in fact, available long before the traditionally accepted date of 1856, when Japanese prints were said to have been discovered by French printmaker Félix Bracquemond, or even 1854, the date of the first opening of Japanese ports to trade. As will be discussed further on, the awareness of alternative pictorial structures and the apparent turning point in the work of many of the landscape painters in this decade indicate the influence or at least the knowledge of Japanese art.

A certain amount of controversy has surrounded the question of exactly how accessible East Asian art was in western Europe prior to 1860, or even if it was available at all. Both China and Japan were officially closed to free trade with the West from 1621 and 1639 to 1842 and 1854, respectively; this stricture was rigorously enforced by Japan, which expelled all foreigners except for the Chinese, Koreans, and Dutch. Even in Japan, however, official policy toward the West was not an even-pressured stranglehold on free enterprise, but responded to the ethos of particular eras and rulers, tightening and loosening in turn. In addition, there were regular and predictable opportunities for contact with, trade in, and purchase of indigenous objects on the part of foreigners and nationals alike. This resulted in the establishment of legitimate public collections of Japanese and Chinese art and craft in the West decades before this art was said to have been "discovered" in France.

China, which had prohibited trade, travel, and immigration before Japan, experienced particular difficulty enforcing this policy.[18] Foreign ships were allowed to sail into China "with tribute," and although they were forbidden by Chinese law, Chinese merchants maintained an active import/export station in Japan. After Ming emperors (from 1684 to 1717) failed to enforce the ban on foreign trade, it was abolished; thus, at a productive moment in its own artistic

history, China became the veritable center of trade in the East—a position that no future edict was able to assail. What had been in the early sixteenth century a trickle of classic Chinese goods westward swelled in the next century into a flood of diverse objects. By 1692, in Paris alone, there were no less than twenty dealers specializing in Oriental items, and many of the great historic collections of Oriental porcelain and lacquer date from this period. Significantly, this would include the French royal collection nationalized at the end of the eighteenth century, and public collections originally established by aristocratic houses shortly thereafter.

Japan was far more effective in the observation of its own regulations. Nonetheless, Japan was also represented in the marketplace with diverse products by the middle of the seventeenth century. Foreign trade with China was interrupted in the 1650s, and the Japanese profited by the hiatus not only with the marketing of their own goods, but with imitations of Chinese objects. In 1686, two years after China abandoned commerce restrictions, the so-called Siamese ambassadors (who were, in fact, a trade delegation) arrived at the court of Versailles with a wide range of Japanese and Chinese works of art to present to the king. The most reliable sources of Japanese products in the West, however, were the Dutch merchants allowed to remain in Japan. The Dutch were initially engaged in the shipping of vast quantities of gold, silver, copper, and camphor mined in Japan. After 1668 and the prohibition of these exports, invoices of official trade activities reveal that attention was turned specifically to porcelain and lacquerwork, and secondarily, to decorative papers, folding screens, furniture, and textiles.

However, it becomes clear from examining the activities of the United East Indies Company—the umbrella organization for Dutch presence in Japan—that documented trade in the following century represented only a part of the picture. Despite dissolution in 1796 under pressure of increased Japanese restrictions, the company did not alter the number or tasks of its employees in Japan. Although legitimate trade was now precluded, private smuggling became the raison d'être for continued Dutch presence. It is undoubtedly through these means that forbidden export items, such as maps, prints, and books (which the government believed to contain information about Japan it did not wish to share with the West), entered western collections.

Throughout this period, the Dutch remained the source not only of Japanese goods in the West, but also of information and publications about their host nation. While much of this activity was necessarily centered in northern Europe, it was in the early 1780s that the first privately owned, indigenous Japanese works entered France with the chief of the Dutch delegation in Japan, Isaac Titsingh. When Titsingh died in Paris in 1812, France was the center of scholarly interest in the East, largely as a result of the presence of three leading Orientalists in Paris: Abel Rémusat, Julius Klaproth, and A. Nepveu. All three collaborated on the editing of Titsingh's memoirs and the cataloging of his collection, published posthumously as *Illustrations of Japan* (London, 1822).

An extremely popular publication, it is remarkable not so much for its information on Japan (most of which had already appeared elsewhere), but for its authenticity: the presentation of Japanese literature in translation and illustrations that suffered only a minimum of change at the hands of western printers.

As potential source material, Titsingh's art collection was as important as his book, and most of it can be reconstructed at least in type.[19] Nepveu wrote that upon Titsingh's death, certain of his effects were put up for sale, primarily "ordinary furniture" and a few articles of "Chinese locksmith's work." Indeterminate items were disposed of by Titsingh's son in 1814, and in 1820, Nepveu claimed to have purchased all of Titsingh's Japanese drawings, paintings, curios, and very likely, the notes that became *Illustrations of Japan*. However, in 1827, one painting, 59 *objets,* and 126 drawings from the Titsingh collection, among other collections, were put up for sale in Paris. More items turned up at auction the following year among a group of Chinese and Persian paintings and 200 Chinese porcelains, and again in 1832, at an auction presided over by Nepveu. Several other pieces, primarily books, manuscripts, and letters, were sold at auction by Klaproth in 1840. These were significant enough to have been purchased, in part, by the British Museum, while others eventually made their way into the Victoria and Albert Museum. It is important to emphasize here that these items were on the open market in Paris at least by 1827 and perhaps as early as 1812.

The two-dimensional works can best be divided into two parts: books and manuscripts about Japan; and Japanese prints, drawings, and paintings, bound and unbound. The former category included a complete set of the *Dai-Nihon-Shi,* an important and monumental history of Japan published in 243 volumes between 1697 and 1715 that Titsingh donated at the end of the eighteenth century to the Bibliothèque du Roi; the set was consulted by the painter Jean-Honoré Fragonard. The latter category included *Nagasaki-e* (literally, pictures from Nagasaki which reflected the influence of western presence in subject, style, or technique), Nagasaki scroll painting (highly traditional, somewhat unskilled, and strongly Chinese in feeling), and single-figure color prints of women in oban size (15 × 10 inches). This last type of work was done exclusively during the Edo period (1615–1867) and, more specifically, can be dated between the years c. 1740, when color-print technology was introduced, and 1784, the year Titsingh left Japan. This particular era represents the height of the Japanese print phenomenon (*ukiyo-e*) and had an enormous impact on European artists of the second half of the nineteenth century.

Not long after its publication, *Illustrations of Japan* was superseded by the work of another former Dutch resident in Japan, Dr. Philip Franz von Siebold.[20] Of Siebold's many scholarly publications, none was more significant than *Reisen in Nippon [Trips to Japan],* published in France in 1838 as *Voyage au Japon,* which became the definitive source on Japan until the end of the century. Of five volumes, two are wholly devoted to illustrations, primarily by or after Japanese artists such as Nagasaki painters Buntsui, Takesaki, and Kawa-

hara Keiga (Toioski), and the leading *ukiyo-e* printmakers of the landscape genre, Hiroshige and Hokusai. Hokusai is, in fact, the best represented of any artist, and most of these images can be traced to the first ten volumes of his fifteen-volume *Manga* (Fig. 8), perhaps the most influential piece of Japanese art to enter the West. Significantly, Siebold's *Voyage au Japon* is the first European publication to refer to the *Manga* by name. Equally significant, many of the illustrations were reprinted in popular French periodicals soon after its publication, most notably in the well-circulated *Le magasin pittoresque.*

Siebold's *ukiyo-e* collection is still regarded as among the finest in the world. Not only did it include huge numbers of Hokusai and Hiroshige prints (somewhat predictable given the growing landscape bias in Japan during Siebold's stay from 1823 to 1829) but also rare works of the eighteenth century by Masanobu and Harunobu—and even a number of prints considered by historians unavailable in the West until late in the century, such as the ornate two-volume masterpiece *Jehon musi no erabi* by Utamaro and highly desirable metal-ground actor portraits by Sharaku. Precisely how accessible these works were before 1837 is unclear. In that year, however, Siebold constructed a museum in Leiden to house his collection and mounted the first recorded exhibition of his prints. This was augmented by *ukiyo-e* donated to the Royal Cabinet of Rarities at The Hague by two other Dutch colonists in Japan, J. Cock Blomhoff and J. F. Van Overmeer Fischer; these prints may have been on view as early as 1824.

Over the next fifty years, all three collections would be absorbed into major archives. In 1845 Siebold founded the Japanese Library at the University of Leiden, an institution which had already received works owned by Blomhoff and Fischer. This became the State von Siebold Museum in 1859 and finally a Rijksmuseum in 1864. Siebold's collection was well known enough to have attracted a variety of French visitors, including the preeminent porcelain specialist Albert Jacquemart in 1852 and author-critics Jules and Edmond de Goncourt in 1861. In 1883 the collection was merged into the National Museum of Ethnology in Leiden, where most of it still remains.

From the 1830s, French interest in Japan quickened decisively. Between 1826 and 1854, a variety of Oriental societies, journals, and reviews appeared, as well as translations by Klaproth and Hoffman of Japanese texts complete with reproductions of original Japanese prints. In terms of illustrative material, the most notable publication of this type may have been the *Forms of the Passing World, in Six Folding Screens.* Translated by the Austrian linguist August Pfizmaier, it was characterized as "a Japanese romance in the original text containing facsimiles of fifty-seven Japanese woodcuts."[21]

The *Didot-Bottin annuaire,* the annual Parisian business gazette, recorded increasing numbers of boutiques specializing in Japanese objects, forming an enclave along the rue Vivienne. Most, like *Giroux et Cie.,* dealt primarily in porcelain and were seasoned, respected merchants. Perhaps the most diverse in stock was the shop of the Houssayes which opened in 1826 as a tea-importing

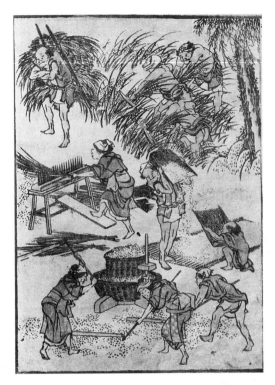

Figure 8 Hokusai, "Harvesting Rice," *Manga [Sketch-book],* vol. 3, 1815. Woodblock print. The Metropolitan Museum of Art, Rogers Fund, 1931. Photo: Museum.

firm selling Japanese objects as a sideline. By 1842 it could advertise that it "held and directly received from China and Japan . . . rare and curious objects in porcelain, lacquer, ivory, paper, fans, material, and furniture."[22] Within the next decade, J. G. Houssaye had moved the firm to a new location on the rue Vivienne and christened it *A la porte chinoise.* This was the same boutique where artists like Edouard Manet, Edgar Degas, and James McNeill Whistler would later compete for choice robes and *ukiyo-e.* The street itself, as the art and auction district of Paris, would traditionally have attracted artists.

In 1842, in order to bring the bloody Opium Wars to a halt, China surrendered Hong Kong to Britain, opened four harbors to free trade, and granted foreigners the right to live in port and to journey inland. At this moment, Chinese objects were exported in unprecedented quantities, but the type and kind seem to have changed little. The same could be said for the impact of the opening of Japanese ports in 1854. Still another shop, *L'empire chinois,* appeared on the rue Vivienne by 1856, and at least one major auction per year was recorded in Paris: for example, in 1856 nearly two hundred Japanese objects were sold by

the former commissioner of commerce of Japan; in 1857 three lots totaling nearly a thousand pieces of Chinese and Japanese art were sold by the duchesse de Montebello; in 1859 an anonymous collection of 114 Chinese and Japanese objects was sold; and in 1860 a collection of 323 items.[23]

Both China and Japan were well represented at the Great Exhibition of 1851 in London, although neither government participated officially.[24] Dominating the display were artistic items such as furniture, porcelain, screens, lacquer, prints, drawings, and paintings; and the British Museum took advantage of the exhibition to acquire *ukiyo-e* by the printmakers Shuntei and Masayoshi. Four years later in Paris at the Universal Exposition, Japan and China were apparently not represented at all. Although one might expect that collectors and merchants would have displayed Oriental wares as they had in 1851, the political climate may have precluded this: Sino-European relations were shrouded in the aftermath of rekindled hostilities, and Japan was in the throes of invasion by a number of western powers. In 1857 a relatively small international exhibition in Manchester, England, although lacking official British support, was nonetheless able to construct an "Oriental Museum." According to French critic Théophile Thoré, porcelain and pottery were represented by those nations' "most brilliant examples," and in a general discussion of prints, he cited the presence of *ukiyo-e* and the "old woods [used] for the illustration of Japanese books." [25]

Several more books on Japan, important for their faithful reproductions of *ukiyo-e,* increased the quantity of source material on that art. Adalbert de Beaumont and Eugène V. Collinot produced a large and lavish portfolio in 1859 entitled *Recueil de dessins pour l'art et l'industrie [Collection of drawings for art and industry]* based for the most part on prints from Hokusai's *Manga* (Fig. 8), *Ringa,* and *100 Views of Mt. Fuji;* Laurence Oliphant's two-volume *Narrative of the Earl of Elgin's Mission to China and Japan,* published in Paris in 1860, was illustrated by over fifty prints, primarily from the *Manga,* from the *100 Views of Famous Places in Edo* by Hiroshige I or II (Fig. 9), and from the *54th Chapter of the Tale of Genji* by Kunisada II; and the baron de Chassiron's 1861 publication, *Notes sur le Japon, la Chine et l'Inde,* included fifteen facsimile colored woodcuts, most after the *Manga,* but several from other Hokusai publications such as the *100 Views of Mt. Fuji, the Hokusai Gafu,* and the *Hokusai Gashiki.*

Most of this heightened activity in the 1850s involved a sophisticated respect for and understanding of the art of East Asia that, as the discussion above suggests, developed over a long period of time. For this reason, it is difficult to accept the common notion that Japan was "rediscovered" by the West only after 1854, and impossible to accept the artistic apocrypha that is the corollary to this: that the first piece of *ukiyo-e* uncovered in France was found in 1856 as packing in a crate of porcelain.[26] The supposed work in question, yet another volume of Hokusai's *Manga,* was already in the collection of the Bibliothèque Nationale in 1843, and by 1856, it was on the verge of near-cult status.

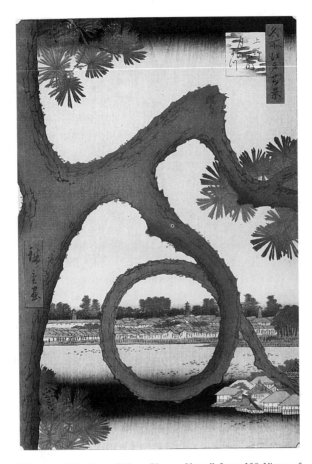

Figure 9 Hiroshige, "Moon Pine at Ueno," from *100 Views of Famous Places in Edo,* 1857. (Courtesy of) The Brooklyn Museum, The Brooklyn Museum Collection 896.89. Color woodblock print. Photography: Philip Pocock.

There is little question that the landscape painters of the 1850s would have had ample enough opportunity to examine the "alternative realities" represented by the photograph and the Japanese print, and that they would have been attracted to the options they presented. Already characterized as renegades by the Salon system and established hierarchy of the arts, these artists were free to explore the new, the experimental, even the controversial. More important, both the photograph and the Japanese print presented themselves most impressively—in terms of quantity and quality—in the area of landscape. Although some of these painters had begun to question the French landscape tradition prior to 1840, it is unlikely that they had as yet perceived viable means toward a redefinition of that tradition; however, the appearance and experience of pho-

tography and the Japanese print over the period 1840 to 1860 provided those means, especially as both the photograph and the print held certain powerful pictorial idiosyncrasies in common.

It may have been Edmond de Goncourt in his book on Utamaro of 1891 who first noted that photography and the Japanese print offered certain mutually supportive pictorial systems.[27] On the most fundamental level, both the photograph and the print presented a destabilized definition of reality, at least in terms of traditional structure. Paintings in the dominant western Renaissance tradition were typically contained and finite, the proverbial "window onto the world" in which a box of space, clearly defined by nonintrusive framing edges, presented that world as calculable and whole. In contrast, the photograph and the print presented a fragmentary view of the world based upon discontinuous forms and unexpected juxtapositions. The factors generating this fragmentary view differed.

The early photographer, only moderately in charge of the edges of the image, unavoidably truncated incidental objects while focusing on the real point of interest (Fig. 10); it is part of the genius of photography that as its aesthetic matured, "haphazard" cropping was exploited as a positive characteristic, evolving into the genres of the *instantanée* and the snapshot, and eventually influencing painting attitudes. Similarly, the absence of finite framing edges in Japanese art was inherent from its beginnings in the scroll form. Within this format, space literally unrolled as narrative continuity without definitive beginning, middle, or end. As *ukiyo-e* developed, printmakers saw no need to restrict themselves to the small and regularized sizes of the woodblock—although the block itself might end, the image frequently spilled over onto several other blocks, resulting in similarly truncated forms. One need only compare a typically stable and timeless landscape in the Renaissance tradition from early in the century with a more random, destabilized image after midcentury to appreciate the radical shift in reality-definition this represents.

These types of framing edges encouraged other formats that the photograph and the print shared. Suggestions of arrested motion were most common: a spirit of temporality, momentariness, or movement continuing beyond the frame into "real" space that dramatically contradicted the whole, contained, and timeless quality of premodern painting. Most notably, the intrusive framing edge encouraged significant perspectival miscues. This primarily took the form of aggressive abutments of near and distant zones. *Ukiyo-e* artists, particularly in the nineteenth century, cultivated this dramatic impact and, in fact, heightened it, by allowing the entire image to pull to the surface (Fig. 9). Photographers, on the other hand, soon learned to work against this: a broad empty foreground is among the most typical characteristics of early photography, assuring that the main motif is pushed back at least to middle distance. This, in itself, tended to introduce a perspectival rush into space that threatened to exaggerate or distort the relationship between zones. Either way, the representation of three-dimensional space within a rational, centralized one-point perspective

Figure 10 Gustave Le Gray, *Forest of Fountainebleau,* 1851. Albumen print from a waxed paper negative.

system—the Renaissance box of space—was potentially subverted. The dynamic tension resulting from perspectival miscue became increasingly systematized in landscape painting at midcentury.

Where, then, did the photograph and the print part company in what they could offer the landscape painters at midcentury? It is obvious that the apparently "objective" reality offered by the camera image would be a compelling factor, one with which artists would have to come to terms. Art critics began to demand increasingly "correct" views and painted images and by midcentury, in a kind of self-fulfilling prophecy, noted a shift toward more "objective" painting. In fact, with a few notable exceptions, such as Narcisse Diaz, nearly all the progressive landscape painters began to distance themselves markedly from Romantic pictorial conventions around 1850. These artists were first lauded, then faulted for their relationship to camera vision. Rousseau was criticized by Baudelaire for a mechanical response to nature, and Emile Zola charged more directly that "a highly colored photograph must be his [Rousseau's] ideal."[28] Charles Blanc accused Daubigny of idealizing the camera image, while the artist was at pains to dissociate himself from the "banality" of the photograph.[29] Meanwhile, in a series of satirical cartoons, Nadar offered Daubigny the backhanded praise of suggesting that one could swim in his marines, and Corot's drawings were favorably compared with photographs by Le Secq.[30]

Finally, with Baudelaire as leader of the charge, photography became the polemic with which to attack the Realist painters. What had begun as unreserved praise for the "truth" of the camera was initially followed by the insistence that artists represent their subjects more accurately, but then the critical tide unequivocally reversed itself. Even Burty, usually a supporter of photography, characterized photographer Comte Aguado as a match for the Realists in creating works that "live but do not think."[31] Photography was perceived as "unfeeling," to be used by painters not as model but as aide-mémoire.

The linking of Realist painting with photography at midcentury was, of course, based on more than the observation that both pursued a passion for simple truths or a representation of the quotidian and mundane. Realism as expressed in the work of its leader, Gustave Courbet, and in photography, represented an intense "search for archetype"[32] that invariably resulted in an insistent, iconic quality of subject. This effect was to some degree unavoidable in the early photograph. Long exposure times, mechanical patterns of light, and the relative absence of middle tone gave to the photograph a blunt and hyperliteral quality. This was heightened to a compelling degree not only in the work of Courbet, but also in that of Manet and much of the painting that followed.

It was the treatment of light, however, as a significant and unique factor in the photograph that was perceived as its single strongest aesthetic contribution. Many critics noted its magnificent effects, especially the unparalleled depth and richness of tone common to both the daguerreotype and the paper print. In addition, the symbolic importance of light as the maker of the camera image should not be underestimated in an era which nurtured major advances in the optical sciences, venerated the seventeenth-century Dutch painters, and finally spawned the celebration of light that is called Impressionism. More than an interest in the phenomenology of changing patterns of light which both shared, photography and landscape painting at midcentury saw sun and light as virtual generating forces. Le Gray wrote that it was the manipulation of light that allowed the photographer to control the image and that image's final outcome:

> The artistic beauty of a photographic print consists nearly always in the sacrifice of certain details; by varying the focus, the exposure time, the artist can make the most of one part or sacrifice another to produce powerful effects of light and shadow, or he can work for extreme softness or suavity copying the same model or site depending on how he feels. [33]

This transformation of a world in full color into "powerful effects of light and shadow" must have been compelling to a generation of painters traditionally more attentive to chiaroscuro than to hue. Burty noted that the broad massing of light and shade was something of a specialty of French photographers, as opposed to the greater concern with detail manifest in the work of the English.[34] The context for this specialty was clearly derived from French painting

the century for humble images of humanity in the context of a simplified nature.[36] While this was in marked contrast to British notions of nature as the experience of the dramatic and the sublime, this taste is uniquely paralleled in prints by Hiroshige and Hokusai, especially in the latter's *Manga,* and might account for the considerable popularity of this work in France at midcentury.

No one could have felt the humble symbiosis of humanity and nature as expressed in the *Manga* more profoundly than Millet, who at least by the early 1860s owned a volume from the series and had begun to collect Japanese prints in earnest. He shared this interest with Rousseau, said to be his closest artist friend. Millet's biographer, Alfred Sensier, recorded a tiff among the three in 1864 over the acquisition of certain prints. Millet wrote the latter: "What plaguey wind is this that blows on us from Japan? I, too, came near having a very disagreeable affair with Rousseau in regard to some pictures which I brought back from Paris. While I wait to hear what happened between you and Rousseau, I want you to believe that no sort of meanness has been done by me toward you"[37]

Millet's own *Manga*-like images of men and women at work on and struggling with the land first appeared around 1846. It is not impossible for him to have examined the *Manga* by this date, and if he had not, the mutuality of spirit and language between the two must be acknowledged as remarkable. However, it is more significant that through the 1850s, Millet's figures grew increasingly idiosyncratic in pose, gesture, and activity—in much the same way that Hokusai was intensely involved in the quirkiness of body posture as it pushed and pulled at the earth. This is, of course, the same quality that would later attract Degas to both Millet and the *Manga.* It is particularly apparent in Millet's drawings—the area in which the artist typically tested out new ideas and produced works more daring and experimental than in any other medium. His highly contrasted black-and-white drawings are especially sympathetic to Hokusai's similarly monochromatic scheme in the *Manga;* in addition, both stressed a charged, dynamic, and information-laden line.

Millet's response to the monochromatic works of Hokusai and to their rich and varied line continued through the 1860s, and came to a climax after 1866 in a group of startling pen and ink drawings, such as *Plain at Sunset* of 1869 (Fig. 12). This work, based wholly upon the shifting rhythms of reed pen, provides a variety of marks whose nearly autonomous function later influenced van Gogh in drawings which were in turn ascribed to the study of Japanese art. At this same time, however, Millet initiated a new phase of dialogue with the Japanese print. His interest no longer remained focused upon the monochromatic figure studies of Hokusai, but began to shift decisively to the highly colored landscape prints of Hokusai and Hiroshige (Fig. 9), reflecting, no doubt, the greater general interest in these works. It is probably not coincidental that Millet's first concentrated interest in pure landscape can be dated to this point in the mid-1860s; in concert with this, color became not only prominent but dominant in his work.

Figure 12 Jean François Millet, *Plain at sunset,* ca. 1869, pen and brown ink. Musée du Louvre, Département des Arts Graphiques, Paris. © Photo R.M.N.

With the important exception of the *Manga,* the nineteenth-century Japanese print positively commanded attention in its strength of color: bright primary hues without interceding half-tones not only contradicted traditional western emphasis on color transition through chiaroscuro, but also ignored subtle tonal traditions in Japanese art as well. Just as c. 1850 we can trace a shift to a kind of photographic naturalism in the work of several landscape painters, throughout this decade we can also perceive a general trend toward more daring approaches to color. At its simplest, this might take the form of higher-keyed color or the adoption of dramatic contrast for which there is little precedent in the West.

Once again, it was in drawing that Millet seemed to test this new approach to color. By the middle of the 1850s, he began to reintroduce color slowly and tentatively into his drawings, injecting passages of pure local color into schemes that still revolved around the establishment of midtone. By 1865, however, when he took up drawing in earnest in a series of pastels commissioned by Emile Gavet, he presented a fully mature and jewel-like palette based on color contrast and intensity not easily matched by any other artist in this decade. This is equally reflected in paintings of this period. Works like *Starry Night* (New Haven, Yale University Art Gallery) from 1855–1867 and *Spring* (Paris, Musée du Louvre) from 1868–1873 would be virtually inexplicable without taking into account the example of the Japanese print and its emphasis upon color; more

importantly, the function of color as shape and form and the concomitant de-vices of silhouette and value reversal are dramatically nonwestern in origin, and prove Millet to be at the forefront of Japanese color impact.

This sophisticated understanding of the function of color in the color print becomes clear in comparing Millet's work with Rousseau's. Rousseau, too, began to collect Japanese prints at least by the early 1860s, and a similar shift to consistently higher intensity color in his work became apparent at the same time. While this was a significant development, demonstrating the artist's abil-ity to move in a radical direction even in old age, Rousseau nonetheless retained respect for color as atmosphere and for the establishment of a strong middle tone. In fact, Zola's charge that Rousseau's ideal "was a highly colored photo-graph" was incisive. As the decade progressed, Rousseau's painting revealed the dual impulses of photographic naturalism and a growing intensity of color. Nowhere, however, does color achieve the abstract autonomy of form as it is found in Millet's coloristic works of the same decade.

The importance of Japanese color was not restricted to highly keyed con-trasts and general intensity. In its most sophisticated use, bright, local color without half-tone produced an aspatial, surface-oriented image by precluding modeling in depth. In the Japanese print, this tendency to flatness was purpose-fully cultivated by many of the devices described earlier: the intrusion of the framing edge which visually pulled objects to the surface plane of the work, and raw abutments of foreground and background zones which eliminated any ratio-nal suggestion of spatial illusion. Historians have asserted that the early photo-graph was similarly prone to flattening effects, especially when contrasting tones of black and white subsumed middle grays or, in contrast, when middle gray was overwhelmingly predominant. However, we have seen that photogra-phers soon learned to compensate for this by, for example, introducing open foregrounds which assured some degree of recession into space. That flattening effects were not prominent in the early photograph is confirmed by the pro-nouncement of a critic in 1855, who wrote that photography was an excellent source of study for exercises in perspective;[38] flattening effects could be found consistently and purposefully only in the Japanese print.

Similarly, decentralization as a conscious compositional feature in the Japanese print has no real parallel in any western media. Even where the edges of a characteristic early photograph and a Japanese print may appear similar in the apparent randomness of their framing, the photographer invariably revealed his or her western heritage in placing the subject matter squarely in the center of the picture. In contrast, the Japanese artist, exposed from the very start to works without stationary focus at all, learned to see and compose in a manner that can only be called cinematic. The subject unfolds in a continuum that almost pro-hibits the centralization of one's point of interest. Each of the devices discussed above—intercepting framing edges, surface flatness, dramatic contrasts of color and shape—is in the service of this continuum, this cinematic vision, in a way that distinguishes its use from that of simple convention as in the photograph.

The profound understanding of this vision in the Japanese print, particularly as it relates to flatness and decentralization—its most unique and perhaps important pictorial components—was left to the next generation of French artists to explore. However, it was Millet, once again, who seemed to be among the first of the "older generation" in the 1860s to modify his compositions in a specifically Japanese way. The cinematic unfolding of subject finds its most obvious parallel in the series work of the Japanese print artists, not only the fifteen volumes of the *Manga* or the multipartite single subject prints, but the many works conceived as the *100 Views of Famous Places in Edo* or the *100 Views of Mt. Fuji*. Millet, too, became interested in the notion of series in works like *The Four Times of Day, The Twelve Labors of the Field,* and *The Four Seasons.* While there are surely precedents in western art for works in series, particularly in medieval art, the renewed interest in the series is very much a nineteenth–century phenomenon which develops under the influence of Japanese art. Millet, as the first nineteenth-century French artist to re-explore the series concept, was in the vanguard of this activity.

Millet also seemed consciously to manipulate perspective in works which, after c. 1865, grew increasingly strange and dramatic. Once again, this was most apparent in his drawings. While the looming anatomic components of *Meridian* of 1865 (Fig. 13) have been compared to photographic idiosyncrasies, this type of frontal plane distortion would have been actively eliminated in the early photograph, especially in figure compositions. Instead, the unusual worm's-eye vantage point and resultant inversion of spatial recession better suggest the witty effects in certain plates of Hiroshige's *100 Views of Famous Places in Edo,* well known by this date. Moreover, the figure in Millet's work has a decisive object quality—as if it could as easily be a haystack as a figure—underscoring a possible source in study of Hiroshige's landscape prints. At least one landscape painting of this period, *In the Auvergne* of 1867–1869 (Chicago, Art Institute), seems to have derived its dramatic spatial construction from works like *Meridian:* although less aggressive in feeling, the painting is equally dependent on looming frontal-plane distortion for its powerful Japanese-like effect.

Similarly, works like *Entrance to the Forest of Barbizon in Winter* (Fig. 14) of 1866–1867 and *The Windstorm* of 1871–1873 (Cardiff, National Museum of Wales) rely for much of their effect on Millet's urge to flatten space. The former drawing, although a reworking of earlier ideas, is also suggestive of the spirit and aesthetic of Hiroshige's popular landscapes of the 1840s and 1850s: it is resolutely vertical in its push to the surface plane, especially via chalky wisps of snow which spot the surface and in the projection of highest light from the scene's apparent background; it is redolent with atmospheric space—identified as western influence when it appears in Hiroshige—which subtly pulls against the flattening impulse; and it is evocative of the quiet, spirit-laden presence identified in Japan as the reflection of Zen Buddhism.

From the 1850s through the 1860s, Millet's involvement with the Japanese print moves from one distinctive phase to another: specifically, from the ini-

Figure 13 Jean François Millet, *Meridian,* ca. 1865, pastel. (Courtesy of) The Philadelphia Museum of Art: The William L. Elkins Collection E' 24–3–15. Photo: Museum.

tial influence of Hokusai's *Manga* to other works by Hokusai, to color prints by Hokusai and Hiroshige, and finally, to the late print series of Hiroshige. In this shift to Hiroshige, Millet might have taken his cue from his friend Rousseau. Unlike Millet, Rousseau was exclusively a landscape artist, and may have been attracted to Hiroshige on the same level of sympathetic interests that linked Millet and Hokusai. More importantly, Rousseau revealed in his work of the 1860s a consistent and intuitive understanding of the Zen spirit underlying Hiroshige's landscapes, and a specific awareness of his aesthetic devices. Thus, while Rousseau generally intensified his palette in this period and tentatively explored flattening effects, the slow and symphonic recession of elements on a diagonal plane—a Hiroshige hallmark—also began to appear in Rousseau's work. Another Hiroshige motif—the gently lit scene in which the highest light appears along the top edge of the image—similarly appears.

Initially, the appearance of photography was the hottest fuel to fire the fundamental Realist debate of the century. Together with the Japanese print, it also offered options toward its resolution. It is not surprising that photography as the theoretical expression of Renaissance ideals—a world of visible facts—would need to be discarded by nineteenth-century painters slowly but surely rejecting the core of Renaissance tradition. When it was discarded, what came to replace it as model was the Japanese print. Many critics at midcentury consid-

Figure 14 J. F. Millet, *Entrance to the Forest at Barbizon in Winter,* ca. 1866–1867, conté crayon and pastel. Gift of Quincy Adams Shaw through Quincy Adams Shaw, Jr., and Mrs. Marian Shaw Haughton. Courtesy, Museum of Fine Arts, Boston. Photo: Museum.

ered the greatness of the Japanese print to be its marriage of the imaginative and the real, the creation of artifice from the raw material of nature, at a time when French painting seemed hopelessly polarized in its dedication to one or the other. Thus, we find that Baudelaire was a collector of *ukiyo-e,* and had he lived long enough to write about it, he may have seen the Japanese print as a reasonable resolution of the dilemma he posed regarding photography.

Where the photograph provided asymmetrical compositions and movement arrested in midaction as evidence of visual realism, these same elements in the hands of the Japanese artist were included as aspects of decorative and effective pattern making. Rather than aspects of slice-of-life realism, these were actually subtle and purposeful devices of nonillusionism consciously used to maintain surface flatness. It is this stylization of the Japanese print, corroborated by the implicit realism of the photographic image, that helped move nineteenth-century painting definitively into the modern era. In terms of its impact

in the West, the relationship between photography and the Japanese print was symbiotic, perhaps best recalling Roger Fry's defense of Matisse in 1912 with the words, "to arouse the conviction of a new and definite reality . . . not seek[ing] to imitate form, but to create form, not to imitate life, but to find an equivalent for life."[39]

NOTES

1. See Helmut Gernsheim, *The History of Photography: From the Camera Obscura to the Beginning of the Modern Era,* London: Oxford University Press, 1969, p. 119.
2. Yvonne Ffrench, *The Great Exhibition: 1851,* London: Harville Press, 1950).
3. *The Exhibition of Art-industry in Paris* (London, 1855).
4. Philippe Burty, "Exposition de la société française de photographie," *Gazette des beaux-arts* II, 1859.
5. Ibid.
6. Nigel Gosling, *Nadar,* New York: A. Knopf, 1976, p. 21.
7. Charles Baudelaire, "The Modern Public and Photography," *Salon of 1859* in *Baudelaire, oeuvres complètes,* Paris: Editions du Seuil, 1968, p. 398.
8. Philippe Burty, "La photographie en 1861," *Gazette des beaux-arts XI,* 1861.
9. Rousset felt so close to—or competitive with—the Barbizon painters that following the example of Daubigny, he outfitted a boat as a studio and produced *Le tour de Marne* in 1865 in response to Daubigny's *Le voyage en bateau.*
10. Lerebours, *Excursions daguerriennes: vues et monuments les plus remarquables du globe,* vol. 2, 1843.
11. Van Deren Coke, *The Painter and the Photograph: From Delacroix to Warhol,* Albuquerque: University of New Mexico Press, 1972, p. 197.
12. Aaron Scharf, *Art and Photography,* London: Allen Lane, 1968, p. 92.
13. Ibid., p. 93.
14. Aaron Sheon, "French Art and Science in the Mid-Nineteenth Century: Some Points of Contact," *Art Quarterly,* Winter 1971, p. 442.
15. Julia Cartwright, *Jean-François Millet,* London: S. Sonnenschein and Co., Ltd., 1902, p. 161.
16. Alfred Robaut, *Les oeuvres de Jean-Baptiste-Camille Corot,* Paris: H. Floury, 1905.
17. For a complete discussion of the history of Japanese contact with the West from the seventeenth through the nineteenth centuries, and the art collections which resulted, see Deborah Johnson, "The Impact of East Asian Art on the Parisian Avant-Garde, 1856–1868," Ph.D. disseration, Brown University, 1984, Chapters 1 and 2.
18. For more information, see ibid.
19. For full information on Titsingh and his collection, see ibid.
20. For full information on Siebold and his collection, see ibid.
21. Klaproth translated the *Sankoku tsuran zusetsu* of Hayashi (Rin) Shihei in 1832,

and Hoffman translated the *Yo-san-fi-rok* of Kano Tamboku in 1848 and produced the *Histoire et fabrication de la porcelaine chinoise . . . et du Japon* in 1856. Unfortunately, the details of Pfizmaier's publication are obscure.

22. Listing under "Houssaye" in the *Didot-Bottin annuaire,* Paris, 1842.

23. Fritz Lugt, *Répertoire des catalogues de ventes publiques,* 3 vols. The Hague: M. Nijhoff, 1938.

24. *Art Journal Illustrated Catalogue of the Great Exhibition* (London, 1851) and Sir Matthew Digby Wyatt, *The Industrial Arts of the 19th Century Produced by Every Nation at the Great Exhibition,* 2 vols. (London, 1851–1853).

25. Théophile Thoré, *Trésors d'art en Angleterre,* Paris, 1857, pp. 447–448.

26. First asserted in Léonce Benédite, "Félix Bracquemond, l'animalier," *Art et décoration* 17, February 1905.

27. Edmond de Goncourt, *Outamaro* [sic], Paris 1891, p. 55.

28. Scharf, *Art and Photography,* p. 94.

29. Ibid., p. 95.

30. Ernest Lacan, *Esquisses photographiques,* Paris, 1856.

31. Burty, "La photographie en 1861," in *Gazette des beaux-arts,* p. 248.

32. André Jammes and Eugenia Parry Janis, *The Art of French Calotype,* Princeton: Princeton University Press, 1983, p. 99.

33. Quoted in *ibid.,* p. 98.

34. Burty, "La photographie en 1861," in *Gazette des beaux-arts;* p. 239.

35. Halation occurred when light acting upon the emulsion also struck the uncoated side of the glass and was refracted back through the emulsion, causing a redevelopment or erosion of dark areas.

36. For a good discussion of the extended impact of the *Voyages pittoresques,* see Bonnie L. Grad and Timothy A. Riggs, *Visions of City and Country,* Worcester: Worcester Art Museum, 1982.

37. Alfred Sensier, *Jean-François Millet, Peasant and Painter,* trans. Helena de Kay, Boston, 1881, p. 170.

38. A. Bonnardot, "La photographie et l'art," *Revue universelle des arts II,* 1855.

39. Roger Fry, "The French Post-Impressionists," reprinted in *Vision and Design,* New York: Brentano's, 1924, p. 102.

Manet in His Generation:
The Face of Painting
in the 1860s*

MICHAEL FRIED

Since publication of his seminal study, *Absorption and Theatricality: Painting and Beholder in the Age of Diderot* (1980), Michael Fried has been concerned with defining a tradition of French painting centering on the relation between beholder and image. A point of departure for this concern, manifested by painters in France throughout the later eighteenth and nineteenth centuries, is the criticism of Diderot. In the introduction to his second book, *Courbet's Realism,* Fried briefly traced the evolution of these traits in the works of David, Géricault, Daumier, and Millet.

Millet's mature works exemplify the complexity of the theatrical by midcentury. On the one hand, they show peasants fully absorbed by their tasks, apparently oblivious to the viewer and thus to be considered antitheatrical or absorptive. But, on the other hand, Millet's compositions and quotations of earlier artists imply an awareness of self-presentation and a concomitant theatricalization of his chosen subject. This ambiguity reveals, for Fried, a specific "historical crisis, namely the growing inability of the dramatic tradition to establish the illusion (to engender the conviction) that the beholder does not exist." (*Courbet's Realism,* p. 286). Courbet's painting provides a unique—and unconscious—response to this crisis, by neutralizing the relation between the beholder (or the artist as primary beholder) and the canvas. As illustrated by the painter and canvas at the center of the *Studio of the Painter,* in Courbet's works, the artist-beholder is corporeally fused with the image created.

In concluding his study on Courbet, Fried suggested that Manet might be seen as Courbet's antithesis, given Manet's insistent theatricality. Manet's consideration of the beholder is historically contextualized in "Manet in His Generation" as Fried traces a renewed concern with issues of absorption and theatricality in the critical discourse of the 1860s. Paintings by Legros, Fantin-Latour, Whistler, and Manet show that this discourse influenced creation as well as the critical assessment of these works. The criticism also provides a context for understanding traits of Manet's paintings that baffled contemporary viewers, and which, according to Fried, reveal the inherent conflict between motifs of absorption and their presentation to the viewer. This apparent contradiction could also be seen in the works of Manet's contemporaries: the subject of Whistler's

*"Manet in His Generation: The Face of Painting in the 1860s," by Michael Fried. *Critical Inquiry,* vol. 19, Autumn, 1992. Reprinted by permission of The University of Chicago Press.

Woman in White for example, appears in a highly absorptive, trance-like state, but is portrayed in a manner that aggressively addresses the viewer. Manet takes this appeal even further, as both his open facture and his mise en scène betray an awareness of the beholder that undermines the fiction of absorption.

This essay was originally the third in a series of three lectures bearing the collective title "Manet's Modernism" and amounting to a partial rough draft of what will be a book on the art of Édouard Manet in the crucial but still inadequately understood decade of the 1860s.[1] Ideally I would begin by summarizing the first two lectures (entitled "Manet's Sources Revisited" and "In Pursuit of the *Tableau*"), but the argument of each is sufficiently complex to make that impractical. So I will simply say that throughout the lectures (as throughout the book in progress) I stress the importance of viewing Manet as a member of a specific artistic generation, which I call the generation of 1863 in honor of its moment of maximum visibility, the Salon des Refusés of that year.

If there is a single painting that more than any other represents that generation it is Henri Fantin-Latour's famous *Homage to Delacroix* of 1864 (Fig. 15).[2] (Delacroix had died the year before.) There we find Fantin-Latour himself, born in 1836, wearing a white blouse and seated to the left of the portrait of Delacroix; standing partly in front of him in a place of honor (and seemingly aware of the distinction) is James McNeill Whistler, born in 1834; standing behind Fantin-Latour is the least known but by no means the least gifted or interesting of the group, Alphonse Legros, born in 1837; and standing on the other side of the portrait of Delacroix, hence also well placed, is Manet, born in 1832. We shall be looking again at Fantin's canvas, but for the moment let me note the presence too of Champfleury (seated with his arms crossed between Whistler and Manet), a novelist and early critical champion of the art of Gustave Courbet who in the 1850s and 1860s was associated with the literary and artistic creed of Realism, and Charles Baudelaire (seated at the lower right), who had passionately admired Delacroix, was Manet's friend, and in this context emblematizes Realism's ostensible antithesis, romanticism.

A full account of the role of the generation of 1863 as well as of Manet's place within it would have to make historical sense of that conjunction—of the dual allegiance of the young painters, who identified themselves as realists, to both Courbet and Delacroix.[3] But in the present essay I want to focus instead on an issue that vitally engaged all the painters I have just named: that of the relationship between painting and beholder. (This is the central theme of my books *Absorption and Theatricality* and *Courbet's Realism,* which form the background to much that I will be saying.)[4] More precisely, I want to examine a selection of works by Legros, Fantin, and Whistler before turning, all too briefly,

Figure 15 Henri Fantin-Latour, *Homage to Delacroix,* 1864. Musée d'Orsay, Paris. Photo: Giraudon/ Art Resource.

to Manet, in an attempt to show how the construction of the painting-beholder relationship in the *Déjeuner sur l'herbe* and other works of the period at once reflects concerns Manet shared with Fantin, Whistler, and Legros *and* embodies Manet's most radical departure from the norms of their art (the fact that Legros, Fantin, and Whistler are all on one side of the portrait of Delacroix and Manet on the other is not without significance).[5] Throughout this essay the writings of contemporary critics will prove indispensable to my efforts to penetrate the world of avant-garde painting in the 1860s and understand its premises and aspirations; two critics in particular, Edmond Duranty and Zacharie Astruc, bear so intimate a relation to the generation of 1863 that they may be said to belong to it themselves.

Nothing is more revealing of the extent to which we have still not come to terms with the issues at stake in advanced French painting in the early 1860s than the obscurity that surrounds the name of Alphonse Legros.[6] Legros, a prodigiously gifted artist, came from a poor family in Dijon. He arrived in Paris in the early 1850s and became a student at the so-called Petite École, where he came under the tutelage of Lecoq de Boisbaudran, a teacher who emphasized the training of the memory, and became friends with the young Fantin-Latour with whom he often copied in the Louvre. In 1857 his *Portrait of the Artist's Father,* a work closely based on Holbein's *Erasmus,* was accepted by the Salon (Legros was then just twenty); two years later a more ambitious painting, *The Angelus,* appeared in the Salon of 1859, where it attracted favorable notice from

Baudelaire. But more than any other picture of those years, it was Legros's *The Ex-Voto* (1860; Fig. 16), exhibited in the Salon of 1861 and hanging today in the Musée des Beaux-Arts in Dijon, that established Legros's early reputation as the most promising artist of his generation.[7]

From among various descriptions of that painting by contemporary critics, I want to cite one by Edmond Duranty, who knew Legros personally and who also appears in Fantin's *Homage to Delacroix* (he is the bearded figure in profile at the lower left). His description of the *Ex-Voto* comes from an extraordinary (and, so far as I can tell, almost completely unknown) short essay, "Those Who Will Be the Painters (À Propos of the Recent Salons)," published in Fernand Desnoyers's *Almanach Parisien* for 1867. The future painters to whom Duranty's title refers are the young realists I have been calling the generation of 1863. His account of that generation begins:

> In 1861 a remarkable painting appeared at the Salon, entitled *The Ex-Voto;* it represented old women, kneeling in the countryside at the foot of a column bearing a votive image. It was signed Legros.
>
> One recognized in it to begin with the temperament of a painter, a painter who knew how to exploit simple and large resources without falling into the particular techniques of one atelier or another. At the same time, and more importantly, the feeling of modern life was manifested strongly in this work.
>
> There were *common* old women, dressed in *common* clothing, that the artist took for his personages, but the rigid and machinelike stupidity that the painful and difficult existence of the poor gave to their crevassed faces appeared with a profound intensity. The accent of a particular world was completely expressed. Everything that can strike, arrest, and hold one before these beings; everything that is meaningful, concentrated, violent in them shone forth from this group of old women, from their faces, their clothing, the countryside, and the votive column.
>
> And by a forced accord, the very means of the painting identified so well with the nature of the personages thus rendered, that one was gripped by one single impression, vivid and clear; one cried out, it's well painted, there is a true work, a strong work [*une oeuvre vraie, une oeuvre forte;* the word *oeuvre* here carries something of the connotations of a key eighteenth-and nineteenth-century art-critical term, *tableau,* which in certain contexts—as we shall see—designated a fully unified painting].[8]

Almost every sentence in this description rewards close attention. Consider, to begin with, the statement that "the rigid and machinelike stupidity that the painful and difficult existence of the poor gave to their crevassed faces appeared with a profound intensity." What Duranty is responding to here is the evocation of a certain *automatism* in the women's expressions and demeanor and the further suggestion that that automatism is *visibly* a function of their humble and constrained mode of existence. The foremost recent precedent for effects of that

Figure 16 Alphonse Legros, *The Ex-Voto,* 1860. Musée des Beaux-Arts, Dijon. Photo: Giraudon/ Art Resource.

type was the peasant paintings and drawings of Jean-François Millet, whom Legros admired and whose art was controversial throughout the 1860s precisely because of the single-mindedness with which it sought to evoke the total absorption of peasant men and women in their repetitive, automatistic, in that sense mechanical labors (as in The *Gleaners* [1857; Musée d'Orsay, Paris]), or in prayer at the end of the day (as in *The Angelus* [1859]), or, an extreme case, in brute physical exhaustion (as in the *Man with a Hoe* [1860–1862]).[9] In French painting from the mid–eighteenth century on, the representation of absorption carried with it the implication that the figure or figures in question were wholly unaware of the presence before the canvas of the beholder; in this sense it was an *antitheatrical* device, one that was instrumental to attempts by successive generations of French painters to make pictures that would somehow negate or neutralize what I have called the primordial convention that paintings are made to be beheld; and in fact those critics who continued to admire Millet during the 1860s invariably praised his art on those grounds. A number of writers, however, Baudelaire and Gautier among them, were put off by the obviousness of Millet's ostensibly antitheatrical aims, which for them had the contrary

effect of too blatantly seeking to persuade the beholder that the figures in the painting were oblivious to his presence.[10] (So that Millet's figures seemed to them, not actually absorbed in their labors and hence unaware of being beheld, but merely pretending to be both. Which is to say they found his paintings egregiously, unbearably theatrical.)

In *Courbet's Realism* I argued that Courbet pursued a fundamentally different strategy but one that was equally antitheatrical in intent (more on Courbet further on). And I presented that strategy as a response to what I saw as the growing inability of the depiction of absorptive states and activities—most importantly, in Millet's paintings—to read unequivocally as antitheatrical. I still think this is largely right, but what I hadn't fully appreciated when I wrote those pages was the persistence throughout the 1860s (and after) of the view that Millet's peasants *did* appear oblivious of the beholder, and I certainly hadn't recognized that for a significant number of critics in the 1860s the sheer excessiveness of his art—the very single-mindedness or all-too-obviousness of his pursuit of absorption—came to be perceived as a positive virtue. Throughout those years, too, Millet and Courbet were contrasted with one another on the grounds that whereas Millet's art masterfully evoked the total determination of the peasant's actions, gestures, and—however minimal or restricted—inner life by his or her immersion in a brutalizing routine, Courbet's art was exclusively concerned with the quasi-photographic depiction of material surfaces and hence lacked all suggestion of psychological and/or spiritual "depth." (One of the most surprising facts about French art criticism in the 1860s is how much more interest there was in Millet than in Courbet throughout the decade.)

Now it was recognized from the first that Legros and the other young painters looked to Courbet as their principal master, and in fact the *Ex-Voto* was associated by critics with Courbet's monumental signature painting, the *Burial at Ornans* (1849–1850).[11] No doubt largely for that reason, contemporary critics failed to connect it with Millet, whose paintings of peasant subjects were much smaller in scale and altogether different in style. But with Duranty's commentary as our guide, it becomes plausible to view the *Ex-Voto* as *combining* Courbet and Millet: the women in black could very nearly have stepped out of the *Burial* (as was said at the time), and of course the picture's relatively large scale and realist descriptive mode are closer to Courbet than to any other modern artist; at the same time, its powerful, explicit thematization of absorption in prayer links the *Ex-Voto* with Millet, whom Legros also admired. (As does its evocation of what Duranty calls "a particular world," by which he means a world *apart,* in that sense a hermetic world, enclosing its inhabitants.)[12] Not, however, that we would quite wish to endorse Duranty's insistence on the "rigid and machinelike stupidity" of the women; for all the single-mindedness of Legros's evocation of simple religious devotion, Duranty's language itself seems excessive, as if his own commitment to an ideal of "profound intensity" led him to go beyond what was there to be seen—to treat Legros's picture as even more Millet-like than it is. A similar tendency is at work in his claim that

"everything that is meaningful, concentrated, *violent* in them shone forth from this group of old women"—the word *violent* in particular feels overdone. But precisely for this reason both Legros's picture and Duranty's essay—not only as description but also as rhetoric—bear witness to a shift of taste within the pictorial avant-garde by virtue of which the *excessiveness* in the depiction of absorption that in the view of certain critics amounted to a fall into theatricality could be recuperated as an artistically legitimate mode of *intensity.*

But Duranty's description of the *Ex-Voto* is concerned with more than just the appearance of the women or the absorptive tenor of the scene as a whole. To recall his words: "And by a forced accord, the very means of the painting identified so well with the nature of the personages thus rendered, that one was gripped by one single impression, vivid and clear; one cried out, it's well painted, there is a true work, a strong work." I take the phrase "the very means of the painting" to refer primarily to matters of pictorial structure or composition, which is to say I understand Duranty to be directing our attention to what he saw as a perfect match between the *Ex-Voto*'s stressed thematics of absorption and its overlapping of "flat," silhouetted forms in an extremely shallow space as well as its conspicuous truncation of those forms by the framing edge. Just as in Duranty's view there was something concentrated and violent, rigid and machinelike, in the painting's treatment of absorption, so there was for him something concentrated and violent and perhaps also rigid and machinelike in the way in which no less than eight kneeling women in black have been compressed as if on top of one another into the right-hand third of the canvas (only three or at most four of their faces seem available for our inspection) as well as into just a few feet of depth. Even the kneeling woman in white, who is set apart from the others, has the lower portion of her body abruptly and severely—in that sense violently—sheared off by the bottom of the picture.

In short Duranty seems to have been struck by a certain *forcing* both of the painting's thematics of absorption and of the arrangement of the figures of the women spatially and with respect to the framing edge; and what I find striking in turn is that he registers that perception in a phrase that itself makes use of the notion of forcing: *"By a forced accord,* the very means of the painting identified so well with the nature of the personages thus rendered, that one was gripped by one single impression, vivid and clear" (emphasis added). Here too we can note the recuperation of an excessiveness that at earlier moments in the modern French tradition was likely to have been perceived as inescapably theatrical. In the Diderotian system, a dramatic ideal of pictorial unity was equated with an effect of internal dynamic necessity, but such an effect was supposed never to appear forced or willed, in which case the (antitheatrical) illusion of *internal* necessity would have given way to a (theatrical) impression of *external* constraint. Around 1860, however, a new desire for pictorial intensity—more exactly, a desire for a new sort of pictorial intensity—changed all this by positively valorizing certain kinds of effects of forcing and willing within an absorptive framework. As I've already suggested, the change is most evident in

writing about Millet, who was praised for the strength and, implicitly, the perspicuousness of his artistic will, his indomitable *volonté* (the adjective *voulu,* willed, surfaces around this time as intrinsically good, not bad);[13] the new emphasis on forcing and willing also permeates the critical response to Gustave Moreau's *Oedipus and the Sphinx,* the runaway success of the Salon of 1864 and a work that, for a time, did much to seal Manet's critical doom (I'll be glancing at Moreau's *Oedipus* at the end of this essay); but no art-critical text of the period is more revealing of the transvaluation of previous values and assumptions than Duranty's discussion of Legros's *Ex-Voto* in "Those Who Will Be the Painters."

One additional point that isn't directly based on Duranty: The excessiveness and intensity that mark the *Ex-Voto's* treatment of absorption find further expression not just in the compositional forcing we have noted but also, crucially, in a *double* or *divided* relationship to the beholder. Under the Diderotian pictorial regime, as I have said, the representation of figures wholly absorbed in what they are doing, feeling, and thinking carried with it the implication that they were unaware of being beheld—more strongly, that for all intents and purposes the beholder did not exist.[14] But there is also a sense—at least this is my claim—in which the excessiveness and intensity I have been emphasizing entail a fundamentally different relationship to the beholder. This second relationship is implicit in the silhouettelike forms, shallow space, and cropping of the figures by the framing edge; it is also expressed in the brilliant white form of the kneeling woman in the near foreground; and it is made virtually explicit by the red-framed, gold-ground ex-voto itself, above all by the way in which the latter is displayed more or less directly *facing* the beholder. Although the black-and-white photograph I am forced to use gives little idea of the vividness of the ex-voto, I hope it is nevertheless apparent that the relation of the ex-voto to the viewer can hardly be said to have been determined by the requirements of the action. On the contrary, there is more than a hint of contradiction between the placement and orientation of the group of kneeling women in profile toward the right and the placement and orientation of the ex-voto at the left, which stands further back in space and faces out of the painting. (Note too the slippage between the orientation of the four-sided post supporting the ex-voto and that of the ex-voto itself.) Moreover, the bright, eye-catching colors of the primary image and perhaps also its subject, a crucifixion, bear witness to a desire not simply to face the beholder but as if violently to strike and hold his gaze.[15] In short I find in Legros's *Ex-Voto* a double structure of *denial of* and *direct address to* the beholder, a structure that by its very nature is consistent with the logic of the excessive thematization of absorption to which Duranty's text first alerted us. To put this slightly differently, the excessiveness that I earlier said turned out to be recuperable as intensity (in the eyes of many critics, at any rate) also turned out to seek expression in a kind of theatricality—not, however, the theatricality traditionally associated with excess (rhetorical or gestural overkill of the sort often called melodramatic) but the more abstract or presentational theatricality of *fac-*

ingness as such. My larger claim is that the double structure at work in Legros's *Ex-Voto* is, in one way or another, deeply characteristic of the painting (and not just the painting) of members of the generation of 1863. In fact I take that structure to be perhaps *the* defining "formal" feature of their art, and I want now to look at several more examples of what this means before turning, in corroboration and contrast, to Manet.[16]

In the work of Henri Fantin-Latour the doubleness tended to be expressed in and through different kinds of pictures, of which in this essay I will consider two. First, Fantin throughout his career was a master of the absorptive portrait, typically involving a woman reading. Pictures of this type—for example, his *Woman Reading* (1861; Musée d' Orsay, Paris) and *Reading* (1863; Musée des Beaux-Arts, Tournain), the model for both of which was his sister Marie[17]— were invariably, infallibly, successful. In this format (both works are just over three feet high), treated with a refined realism appropriate to the genre, absorption never failed to work its magic, which included two distinct but intimately related *effets de réel:* first, persuading the viewer that this is how the world really looked (indeed how it really *was*); and second, suspending or eliding the distinction between representation and sitter, or at any rate inciting commentators to lose their rhetorical hold on the distinction in their enthusiastic accounts of the picture before them. Here for instance is Théophile Thoré, the greatest critic of an older generation, on *Reading:*

> The most charming, the most intimate, the most naturally distinguished of all the portraits of women [in the Salon] is that of a woman reading by Monsieur Fantin-Latour. A young, fair-haired woman, wearing a modest, loose brown jacket and grey skirt, seated, seen from the knee up, and set against an even, neutral background. No accessories distract the reader, or those looking at her. She holds in her hands her book, foreshortened, the open pages bathed in light. Her small right hand, lying in this light on the pages of the book, is exquisite. What attention! How well she reads and how she reflects upon what she is reading! And what breeding, despite her plain clothing! And how just, harmonious, and tranquil are the colors! What a happy woman, with her grey wool skirt and her little white collar![18]

In Thoré's description—reminiscent of passages in Diderot's *Salons* of a hundred years before—we can sense the material painting *almost* dissolving, *almost* being replaced by the young woman herself. (A third reality effect that was a precondition of the first two was that no one seems to have been aware that an absorptive subject such as we find in *Woman Reading* or *Reading* was at all conventional. It appeared ever-fresh, purely spontaneous, a found object not a deliberate arrangement, as if nothing quite like it had ever been painted before. *This* was absorption's deepest magic.)

But pictures like these, just because of their underlying conventionality and genre specificity, could not fully satisfy either Fantin's pictorial ambitions

or the demands of the critics who expected more of his talent. In his *Homage to Delacroix* of 1864 (Fig. 15) he therefore developed a new sort of allegorical group portrait that was conspicuously not absorptive in its composition. Rather, seven of the ten personages look directly out of the picture; Manet too stands facing outward but his gaze drifts abstractedly towards the left; at the left-hand edge of the picture two figures, Duranty (seated) and the painter Louis Cordier (standing), look toward the right; and the monochrome portrait of Delacroix gazes proudly off toward the right as well. Nevertheless the overall impression is of a strongly frontal or say *facing* work, and what is fascinating is that contemporary critics seem to have been troubled by that facingness to the extent of denying that Fantin's painting was composed at all. So for example Théophile Gautier wrote:

> In the foreground are grouped, half-length, turning their backs on the object of their veneration in order to look at the public, friends of the painter, artists and writers, linked by a common admiration for the illustrious master so much regretted by all. M. Fantin-Latour's work is rather a collection of portraits than a reasoned composition organized according to its motif; but the portraits themselves are very well painted and very accurate In spite of the bizarreness of the arrangement or rather in spite of the absence of all arrangement, there is true merit in this canvas which has strongly captured the public's interest.[19]

In Gautier's view, Fantin's canvas, for all the strength of its individual parts, was not a reasoned composition—not a true *tableau*—because it lacked a principle of internal coherence; and it seemed to him to lack such a principle not only because its personages faced out of the painting but also because in doing so they turned their backs on the portrait of Delacroix. (The same complaint was voiced by numerous other critics.) The resulting structure might be said to be *willfully* nonabsorptive, which I take to be the implication of Gautier's statement that Fantin's picture is not "organized according to its motif." The motif Gautier has in mind is the Delacroix portrait at which no one looks, and what would have given the canvas the unity it seemed to Gautier to lack would have been if Fantin had found a way to focus the attention of at least some members of the group on that motif while at the same time preserving the portrait-character of the individual representations.

In a sense Fantin had anticipated these objections. At any rate, he had originally planned a composition depicting the crowning of a bust of Delacroix, featuring a dark-suited man—the one performing the crowning—seen largely from the rear (the drawing is dated 6 January 1864). Three weeks later, he abandoned the idea of a crowning in favor of a composition based on a framed portrait of Delacroix hanging on a wall above a table bearing a bouquet of flowers with twelve figures to the right and four to the left. Here too, however, a conspicuous dark-suited figure who appears to be honoring the portrait in some way has been depicted from the rear; to his right another figure, seen partly

from the rear, sits in a chair so as to look directly at the portrait on the wall; while the rest of the figures seem, if not to be gazing out of the composition, at any rate to be more or less frontally oriented. The precise meaning of the over-all arrangement, especially its right-hand half, is far from certain. But these and other preparatory drawings for the *Homage to Delacroix* leave no doubt that Fantin grappled hard with just those issues his treatment of which in the final painting brought him so much criticism.

He did not cease grappling with them after exhibiting the *Homage to Delacroix*. Almost immediately he began to plan his next painting, another real-ist allegory to be entitled *Truth* [*La Vérité*], in which a naked female figure of Truth holding a mirror was to be surrounded by a representative group of painters, sculptors, architects, musicians, and writers paying homage to her. Significantly, almost all the preparatory drawings for *Truth* depict Truth more or less directly from the rear, and in several of them a clothed male figure in the near foreground also seen from the rear holds up a standard that we know from still other drawings was emblazoned with the word *Vérité* in capital letters. Dur-ing this same period Fantin also explored a composition based on the idea of a dinner of artists and writers, and on one sheet, dated 3 December 1864, he made small sketches of both *The Dinner* (with facing figures [Fig. 17]) and *Truth* (a more absorptive composition; the sheet as a whole exemplifies the double struc-ture noted in the Legros). Eventually the project for *The Dinner* gave way to *The Toast!*, a more complex composition in which figures posed around a table (that is, not simply frontally) were combined with at least one figure seen mostly from the rear and in which a toast is being proposed in honor of either one or two old masters—Velázquez alone or Velázquez and Rembrandt (we know this from marginal notations to the drawings)—depicted in framed por-traits on the rear wall in the second of these the portrait is draped and the bare-headed figure to its right resembles Manet). Finally, Fantin brought together the ideas of *The Toast!* and *Truth* in a composition he went on to develop into a large-scale painting that was exhibited in the Salon of 1865 with the title *The Toast! Homage to Truth*. Because Fantin himself destroyed that painting soon after the Salon closed (only a few fragments survive), we can never know ex-actly what it looked like; accordingly, our conception of it is based on two drawings (one of which is illustrated here, Fig. 18) and an oil sketch, all of which are essentially frontal in organization.[20] But one previously neglected fact seems worth emphasizing: according to two critics, Louis Auvray and Louis de Laincel, the final painting included two men wearing stovepipe hats and portrayed from the rear, and Auvray says in addition that they were shown looking directly at the figure of Truth.[21] (Men in hats appear in the back rank of several of the drawings we have glanced at, and in the second of the two preparatory drawings for *The Toast! Homage to Truth* the hatted figure toward the right is depicted from the rear, perhaps in conversation with another, hatless figure farther to the right. What's new and surprising is that in the final canvas Fantin placed two such personages in positions that both Auvray and de Laincel

Figure 17 Henri Fantin-Latour, Study for *The Dinner,* 1864, Graphite on laid paper. Musée du Louvre, Paris [RF 12395]. © Photo R.M.N.

describe as *en face* relative to Truth.) This suggests that *The Toast! Homage to Truth* represented an attempt to embody in a single ambitious composition the double relation to the viewer that, with Duranty's help, we found in Legros's *Ex-Voto*. But whereas Legros's picture established that relation within an absorptive framework (and so was a critical success), Fantin's picture gave pride of place to the naked figure of Truth holding a mirror and facing out of the painting, and so must have struck its viewers as hopelessly confused, even contradictory, in orientation.[22] Indeed the force of the contrast between the top-hatted men depicted from the rear and the otherwise mainly frontal structure of the work as a whole would in effect have cast the men as emissaries from the space *in front of* the picture, which could only have made *The Toast! Homage to Truth* utterly incomprehensible to its public.[23] Even before the Salon opened Fantin too seems to have had his doubts, and when the picture was criticized harshly his doubts deepened. Soon after the close of the Salon he destroyed it. What I want to underscore, however, is not so much the unanimous view that the work was an artistic failure as Fantin's constant engagement throughout 1864 and 1865 with two (or, if we take into account the Courbet-like inclusion-of-the-viewer-in-the-picture implications of the final version of *The Toast! Homage to Truth* and certain of the drawings with figures depicted from the rear, *three*) distinct and competing principles of pictorial organization that he repeatedly sought to bring together in a single composition.[24]

The third member of the generation of 1863, the expatriate American James McNeill Whistler, poses a somewhat different problem.[25] If we examine the critical response to the best-known of Whistler's paintings of the early

Figure 18 Henri Fantin-Latour, Study for *The Toast! Homage to Truth,* 1865, Charcoal stump on laid paper. Musée du Louvre, Paris. (RF 12919). © Photo R.M.N.

1860s, the *Woman in White* (Fig. 19), the one indisputable success of the Salon des Refusés, a version of the double structure seen in Legros and Fantin emerges; and the question that then must be asked is to what extent that structure inheres in Whistler's painting and to what extent it is a projection of critical fantasy. What I mean is this: one of the staples of the critical response to the *Woman in White* in 1863 was the notion that the woman herself was distracted, in a trance, sleepwalking, mad. So for example Fernand Desnoyers described her as a spirit or medium;[26] his brother Carle Desnoyers (writing under the pseudonym "Le Capitaine Pompilius") called her Ophelia;[27] the Count Horace de Viel-Castel compared her to Lady Macbeth in the sleepwalking scene;[28] while Jules Claretie, less sympathetic than the others, wondered whether she was a madwoman, "this stiff, unmoving figure that one would take for Lady Macbeth or for Ophelia."[29] What all these characterizations have in common is the idea that she is absorbed, distracted, in any case unaware of being beheld; we cannot doubt that that impression, whether intended by the painter or not, was part of the painting's extraordinary charm. At the same time, the *Woman in White* was criticized for some of the same features we remarked in Legros's *Ex-Voto* and associated with a different, indeed opposite, relation to the viewer. Those features include its shallow, "flattened" space—specifically, the carpet on which the woman stands was felt by certain critics to be more vertical than

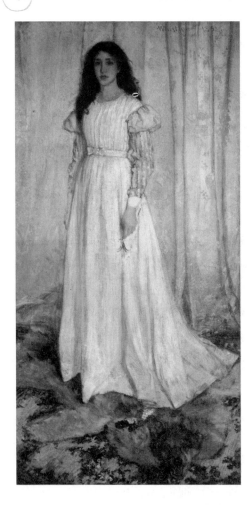

Figure 19 James McNeill Whistler, *The White Girl* (Symphony in White, No. 1), 1862. Harris Whittemore Collection, © 1994 Board of Trustees, National Gallery of Art, Washington, D.C.

horizontal[30]—and its unusually close cropping of the image by the framing edge (one writer admired the painting but thought that a few more inches of canvas above the figure's head would have given it still more éclat).[31]

But the most telling commentary for my purposes is by de Viel-Castel who, as I've said, compared Whistler's figure to the sleepwalking Lady Macbeth; he went on to discuss what he took to be the wolf's pelt on which she stands (it's now thought to be a bearskin), focusing in the end on the animal's head, "stuffed and furnished with enamel eyes, [which] thrusts menacingly towards the beholder."[32] In other words, de Viel-Castel found in Whistler's canvas *both* an absorptive, beholder-denying structure (keyed to the woman's state of mind) *and* a facing, beholder-aggressing one (based on the orientation of the animal pelt), which recalls Legros's *Ex-Voto* and Duranty's commentary on it. I don't quite wish to say that de Viel-Castel's description captures Whistler's in-

tentions in the *Woman in White* or even, putting the question of intentions aside, that it accurately records the painting's appearance *tout court.* I myself would never have thought to see the bear's head in that light, and I wouldn't even have felt authorized to describe the young woman as absorbed or distracted on the basis of the picture alone; she doesn't seem unmistakably absorbed or distracted enough to have justified the use of the terms in the absence of the criticism I have cited. But it doesn't follow from this that the critics were mistaken or that the qualities they found in Whistler's canvas were simply projected there by them in the first place. Rather, the response to the *Woman in White* makes it plain that there existed in the first half of the 1860s a highly structured discursive field oriented to the issues of absorption and beholding and within which the *Woman in White,* like the other works we have considered and will consider, was bound to be seen, described, and, ultimately, judged—and, before all these, within which it was *painted.* It follows that the task of the art historian should be to seek to understand that field in as much of its complexity as can be encompassed rather than to try to imagine what one or another painting would have looked like if the field had not existed.[33]

A brief glance at the writings of—with Duranty—one of the two leading critical spokesmen for the generation of 1863, Zacharie Astruc, will help bring us to Manet. (Astruc is absent from the *Homage to Delacroix* but was included in *The Toast! Homage to Truth;* he is also the person whose portrait Manet is shown apparently painting in Fantin's *An Atelier in the Batignolles* [1870].) No feature of Astruc's criticism is more self-evident than his taste for absorptive painting, grounded, as was true of so many critics during those years, in an almost unqualified admiration for Millet. Moreover, the terms of that admiration are in the double register of excess and antitheatricality that we first remarked in Duranty's commentary on Legros. As early as 1860, for example, Astruc praised the depiction of movement in Millet's *Gleaners* as the product of an "*excessive* observation" before going on to say of Millet's intensely absorptive art, "We are no longer before a painting, but before nature" (recall Thoré on Fantin).[34] And in 1868—to show the constancy of his views—he characterized Millet's genius as "astonishingly willful," meaning that not as criticism but as praise, and went on to write, "Nothing for the spectator,—here, no theater— everything for the thing in itself [the scene being represented]."[35] By now these were *topoi* of favorable Millet criticism.) As in Duranty's article of the year before, the excessiveness and willfulness that one might have thought would be perceived as forms of theatricality—that for decades *were* so perceived—are recuperated as intensity of absorptive effect.

What, however, are we to make of another feature of Astruc's criticism: his advocacy, most forceful in his *Salon of 1868,* of the *portrait* as "the touchstone of perfect and, above all, reasoned creations"?[36] In an obvious sense, nothing could be less absorptive than portraits in which the sitter gazes out at the viewer, though as Fantin's portraits of women reading suffice to prove, absorptive portraits were certainly possible; but it seems clear that these were not

what Astruc had in mind. Indeed Astruc drew a sharp contrast between the portrait and the *tableau,* which emerges as strongly if implicitly absorptive. "The portrait," he wrote, "must exhibit itself by the expressive language of the features, and so to speak communicate to us its meaning as soon as we behold it; consequently it must strike us,—and that's the opposite of the *tableau* which allows its most beautiful parts to penetrate [the beholder] little by little." And: "The portrait has none of those resources of tone, felicities of handling, or surprises of conception, it is powerful, it impresses us like an object that has taken from a living being the intensity of its personal life."[37] In other words, for Astruc the *tableau* is "slow" and relatively passive with respect to the beholder (being apparently unaware of the beholder, it leaves it to him to come to terms with it in his own time), whereas the portrait, being essentially confrontational, is instantaneous and aggressive, almost threatening, almost *alive,* in its mode of address. But as I've suggested, there is an important sense in which Astruc's vision of Millet (to mention only that) implies a conception of the willfully and excessively absorptive *tableau* as itself in crucial respects portraitlike—not because one or more figures in the painting face the beholder (they conspicuously don't), but because such a *tableau,* like Astruc's ideal portrait, is particularly intense and *striking* (a notion we first met in Duranty's account of the *Ex-Voto* and one of the period's highest terms of praise). Understood in this light, what seems merely contradictory in Astruc's thought—his passion for absorption and his advocacy of the portrait, his idolatry of Millet and his partisanship of Manet—may be understood as a further, paradigmatic expression of the new double or divided sensibility I've been trying to evoke.[38]

Still another expression of that sensibility that invites comparison with Astruc's theorization of the portrait are certain stunning flower pieces by Fantin-Latour in which the flowers in their vases, instead of having been depicted from a somewhat elevated point of view as one would expect, are seen close-up and as it were face to face (the pictures also feel tightly cropped). An example is the ravishing *Chrysanthemums* (1862, Museum of Art, Philadelphia) which—arriving at last at Manet—may be compared with one of his most electrifying small paintings, the portrait of *Victorine Meurend* (1862, Museum of Fine Arts, Boston).

In *Courbet's Realism* I presented Manet's paintings of the 1860s in dialectical relation to Courbet's Realist canvases of the late 1840s and 1850s. Very briefly, I interpreted Courbet's Realist pictures as the product of an attempt by the painter (or painter-*beholder*) to transport himself as if corporeally into the painting on which he was working, an attempt that, at least in principle, would have had as a consequence—but also as a kind of inner motivation—the removal or displacement of the painter-beholder from before the painting. In other words, with respect to that beholder, the painting's *first* beholder, the painting would indeed have neutralized the primordial convention that paintings are made to be beheld. In Manet's pictures of the early 1860s, however, something altogether different takes place, which I described in terms of an acknowledgement of the inescapableness of beholding as painting's fate.[39] I went on to

suggest that that act of acknowledgment holds the key to Manet's pictures' alleged flatness: as though what has always been taken as a declaration of flatness is rather the product of an attempt to make the painting in its entirety—the painting *as* a painting, that is, as a *tableau*—face the beholder as never before.

One implication of the present essay is that simply contrasting Manet and Courbet in this way doesn't quite do justice to the historical situation. Most important, it elides the question of Manet's relation to other painters in his generation whose respective responses to the problem of the theatrical differed from his but whose art, like his, signals the emergence of a new pictorial sensibility keyed to the values of what I have been calling excessiveness, intensity, willfulness, instantaneousness, *strikingness*. The decisive difference between Manet and the others, it now becomes clear, is that from the outset he tended strongly to reject absorption as a vehicle of that pursuit and those values, though it's important to observe—it's one more link between Manet and the others—that that rejection wasn't absolute: at least three pictures of the 1860s—*The Reader* (1861), *Monk in Prayer* (1865, Museum of Fine Arts, Boston), and *Boy Blowing Bubbles* (1867)—make use of traditionally absorptive subject matter, at the same time as in each of them aspects of mise en scène and paint-handling are at odds with the ostensibly beholder-denying implications of the motif. (In the *Monk at Prayer,* for example, the skull seems to near both the kneeling figure and the picture plane to be comfortably the object of the figure's meditation.) Other paintings, such as the early *Portrait of the Artist's Parents* (1860), *Christ Mocked* (1865), and, especially, the various versions of the *Execution of the Emperor Maximilian* (1867), bear a more equivocal relation to an absorptive thematics. On the whole, however, it seems fair to say that Manet in his most characteristic works of the 1860s pursued a strategy of denying or voiding absorptive effects while not quite purging his compositions of absorptive motifs; or to put this the other way round, of making use of various motifs that, treated differently, *could* have yielded absorptive effects (for example, the "conversing" figures in the *Déjeuner sur l'herbe,* the grieving angels in the *Angels at the Tomb of Christ,* the firing squad in the Mannheim *Maximilian,* even the maid presenting the bouquet to her mistress in *Olympia*) but that, as Manet rendered them, appeared to contemporary viewers (and, the evidence suggests, to modern viewers as well) bafflingly detached, opaque, noncommunicating, without psychological interiority of any kind. It was the denial of absorptive effects, or rather of the psycho-ontological basis for such effects, that lay at the core of Manet's notorious "pantheism" (Thoré's term, not the most felicitous)[40] by virtue of which the human subject appeared to have been treated as if it were no different from inanimate matter (as if Manet's figures were "stuffed," *empaillés,* as another commentator has it).[41] And this in turn was linked to another quality that Manet's art possessed in the eyes of his earliest commentators: his paintings, with their strong compositional gestalts, unorthodox drawing, naked contrasts of light and dark, often clashing colors, and virtuoso but unfinished-seeming execution (more on the last of these below) *forced* the spectator to look

at them; but the terms in which they did so, in the absence of the kind of content absorption would have provided, seemed to all but a few critics superficial and meretricious.[42] In the context of the larger argument of this essay, we might say that Manet in the first half of the 1860s pursued strikingness directly—as a function of facingness—instead of by way of an intensification of absorption and all that entailed.[43]

Here it is helpful to juxtapose one of Manet's major works of the early 1860s—I choose *The Old Musician* (1962; Fig. 20)—with Legros's finest extant painting, the little-known but superb *Vocation of St. Francis* (1861; Fig. 21).[44] By now it should be clear that whereas Legros's painting was intended by its maker to be powerfully absorptive—it depicts a decisive event in the youthful Francis's spiritual life—Manet's involved a repudiation of absorption and its characteristic effects. Indeed so emphatic is the impression that the figures of the seated violinist and his entourage have been arrayed before us so we might look at them—so they might be beheld—that it comes almost as a shock to realize that only one figure, the violinist himself, gazes directly out of the picture as if to meet our gaze head on. (This remains a stable feature of Manet's multifigure paintings: no more than a single personage ever looks back at us. The nearest thing to an exception is the *Olympia,* with its gazing courtesan and startled cat.)[45] The other figures seem instead to be looking distractedly elsewhere, at nothing in particular, an effect that is all the more disconcerting in that their gazes follow independent paths (note too how in the case of the tophatted figure toward the right, based on Manet's earlier *Absinthe Drinker* [1859], we have been given only the vaguest indication of his eyes). By the same token, the *profil perdu* of the young girl holding an infant at the left amounts to the subversion of a traditionally absorptive motif. For example, in the art of the eighteenth-century French painter Antoine Watteau, Manet's chief historical source for his presentational compositions, *profils perdus* function as indices of interiority; whereas the profile of the young woman in the *Old Musician* seems merely a silhouette, a surface configuration that, far from evoking features lost to our view (and by implication the state of mind of someone "lost" in thought or feeling), confirms the facingness and nonabsorptiveness of the painting as a whole.[46] In any case, Manet's canvas contrasts fundamentally not only with the absorptive mise en scène of Legros's *Vocation of St. Francis* (or his immediately previous *Ex-Voto*) but also, as it were oppositely, with the nonabsorptive group-portrait structure of Fantin's *Homage to Delacroix* in which most of the personages look directly out of the canvas and all are meant to be perceived as distinct psychological presences. In short, the *Old Musician* possesses the *abstract* qualities Astruc associated with the portrait while effectively nullifying or suspending the psychological as such. It aims to strike the beholder forcibly as soon as it is beheld, and it seeks by its conspicuous lack of narrative or dramatic coherence as well as by various "formal" devices, including the fact that every figure touches those next to him or her, to compel the beholder to take it in as a whole, a single intense facing object of vision. I have already suggested

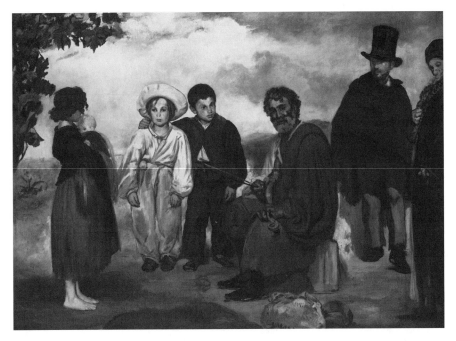

Figure 20 Edouard Manet, *The Old Musician,* 1862. Chester Dale Collection, © 1994 Board of Trustees, National Gallery of Art, Washington, D.C.

that I regard this too as a recurrent feature of Manet's art. Indeed I regard the feature I mentioned a moment ago—that no more than one figure gazes directly out of any painting—to be an expression of that pursuit of wholeness (or singleness), so different in kind from the pursuit of unity of effect implicit in the absorptive ideal.[47] It's as if the painting itself, the *tableau* conceived now as a single instantaneously apprehensible facing entity, gazes at the beholder through a single pair of eyes, which of course makes the parallel with Astruc's theorization of the portrait even more to the point.[48]

In an important sense, however, the differences between the *Vocation of St. Francis* and the *Old Musician* reveal a common aim or function. Specifically, Legros's placement of four kneeling silhouettelike figures in an extremely shallow space, the almost brutally close cropping of those figures by the framing edge (Manet crops only the single figure at the extreme right), and the way in which they have been compressed or, to use Duranty's word, forced into little more than half the surface area of the canvas, all imply the sort of abstract facing relation to the beholder I attributed to similar features of his *Ex-Voto,* a relation that is made explicit, or at least overtly problematic, in the *Old Musician.* Moreover, the illuminated missal at which St. Francis gazes, like the painted image of a crucifixion in front of which the women in the *Ex-Voto* kneel, is open to our gaze; not only that, the left-hand page contains a colored illustration

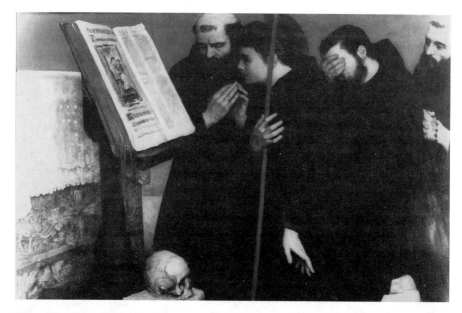

Figure 21 Alphonse Legros, *Vocation of St. Francis,* 1861. Musée des Beaux-Arts et de la Dentelle d'Alençon (Orne, France). Photo: Museum.

of the Mother and Child (like the crucifixion, a picture within the picture); perhaps most important (though unverifiable in black-and-white), St. Francis's frankly painted bright red staff, which he seems to have just let slip from his grasp, all but leaps from the canvas to strike and seize our gaze. So despite Legros's commitment to an absorptive thematics, or rather in keeping with his predilection for an excessive version of such a thematics, the *Vocation of St. Francis* appears no less "modernist" in certain vital respects than the *Old Musician*. In fact the *Old Musician* may well show the influence of the *Vocation,* which Manet would have seen when it was exhibited at Louis Martinet's, his dealer too, in 1861. Nevertheless, the future turned out to belong to Manet not Legros, and my claim is that the eventual revolutionary impact of Manet's paintings of the first half of the 1860s can't be understood apart from their repudiation of absorption, as difficult of access as that repudiation and its "formal" concomitants made his art in the short run—and if it is a matter of intellectual access, in the long run too. (By *eventual* revolutionary impact I mean that it took the advent of impressionism to establish Manet's centrality even as it also massively simplified his achievement. The consequences of that simplification have been profound, both for painting and for art history.)

Because the *Old Musician* was never exhibited at a Salon, we have no record of contemporary responses to it. But this isn't true of Manet's next large-scale painting, the *Déjeuner sur l'herbe* (originally called *Le Bain*) (1863; Fig. 22). One of the most intelligent and positive commentaries it elicited was that of

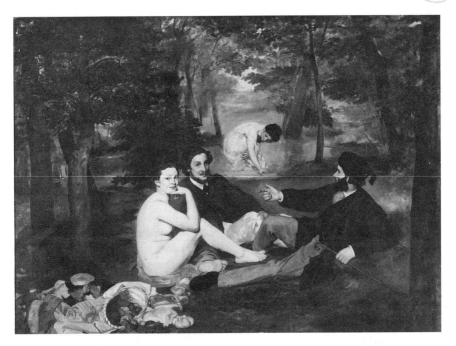

Figure 22 Edouard Manet, *Le Dejeuner sur l'herbe,* 1862–1863. Musée d'Orsay, Paris. Photo: Lauros-Giraudon/Art Resource.

Carle Desnoyers (writing as "Le Capitaine Pompilius"), who recognized Manet's gifts and went on to make a number of arresting observations. Here is his (sympathetic) critique of what for him was the most problematic aspect of Manet's art—its execution:

> If Manet's paintings were enveloped by their definitive form; if, in that supreme touch that closes a work by energetically signing it with a magisterial stroke, they affirmed the young master's new principle, one would be able to believe that it was the healthy and vigorous look of this art that confounded or horrified the representatives of the worm-eaten school. Unfortunately, that's not the case: the connoisseurs grasp with their first *coup d'oeil* the exceptional qualities of this admirable *ébaucheur* [maker of *ébauches,* that is, sketches], but for the public, for whom it's necessary to dot one's i's; for the Institute, which appreciates only painting that smacks of study and research, Manet's compositions are barely able to pass, with respect to how they are rendered, as approximations.["L"][49]

A few paragraphs later Desnoyers concludes with the brilliant formulation: "In a word, such a work truly completed would be a solemn event. In the state that Manet has left it for us, it is only interesting: it is conditional, it isn't effective" ("L").[50]

Before saying anything about Desnoyers's remarks, I want to cite some related observations by another critic, Théodore Pelloquet. In his response to Manet's pictures in the Salon des Refusés, Pelloquet took the *Déjeuner* to task for its failure even to seek to establish itself as a *tableau*. In this connection he complained that, try as he might, he couldn't figure out Manet's *intention;* consequently the picture seemed to him nothing more than a large rebus whose meaning could never be guessed. He went on:

> The execution [of the *Déjeuner*] is far from offering me sufficient compensation; it's a rebus too. Here and there I see fragments that come close to nature, particularly in one of the naked woman and one of the heads in the foreground, but that's not enough, the rest of the picture is of a wholly inexplicable incoherence. One can't really designate this product of Manet's labors as an *esquisse* or an *ébauche* [as most critics, including Desnoyers, had done]. In an *esquisse* properly understood and properly executed, all the parts are rendered to the same degree [of finish, though Pelloquet doesn't use that word]. [Whereas] nothing explains or justifies M. Manet's incoherence, his inequality of execution.[51]

My aim in quoting Desnoyers and Pelloquet at this juncture is threefold. First, I want to focus attention, if only for a moment, on the crucial question of Manet's paintings' facture, the character of their painted surfaces. Second, I want to stress that for at least one commentator, Pelloquet, Manet's violation of current norms of finish consisted, not in leaving his pictures in the condition of mere sketches—the usual complaint—but rather in eliciting an *unevenness* of execution that made those paintings unintelligible on the level of technique. (Pelloquet also saw that this linked Manet's technique to his treatment of his subjects.)[52] And third, I want to take advantage of Desnoyers's comment that the *Déjeuner* for all its virtues lacked or eschewed "that supreme touch that *closes* a work by energetically signing it with a magisterial stroke" (emphasis added) to suggest that what contemporary viewers saw as the bizarreness of Manet's paintings' facture—the resistance his execution offered even to those critics who, like Desnoyers, believed in his abilities—may be understood as a further manifestation of his radical rejection of the ideal of closure that was both ground and aim of absorptive painting. It's as though Manet in the 1860s found himself compelled to seek a mode of execution that would be consistent with, that would somehow "project," the facingness, instantaneousness, intensity, and strikingness that Astruc associated with the portrait—and as though the means by which he tried to do this not only were powerless to enforce such a reading, they threatened, by their glaring departure from traditional norms of finish, to doom his already difficult art to utter incomprehensibility. Desnoyers was one of several critics who weren't personally repelled by Manet's execution (Astruc and Thoré were others). But he recognized, with detached lucidity, that the denial of closure on the plane of technique meant that Manet's paintings would appear to the public as settling for the *à peu près*, the merely approximate, which is exactly what happened. They would seem—they did seem—at best conditional, not effective: it would take the im-

Figure 23 Gustave Moreau, *Oedipus and the Sphinx,* 1864. The Metropolitan Museum of Art. Bequest of William H. Herriman, 1921 (21.134.1). Photo: Museum.

pressionists to *make* them effective, *après coup,* at the cost of the massive simplification to which I've referred. This is largely why the spectacular triumph of Gustave Moreau's *Oedipus and the Sphinx* (1864; Fig. 23) at the Salon of 1864 sealed Manet's fate for a certain time. Here was an intensely absorptive painting, wholly—in effect instantaneously intelligible as regards subject, action, and mise en scène, and executed with a dry scrupulousness that seemed to the many critics whom it swept away to enforce as by a sovereign artistic will and down to the smallest jewel-like details, themselves bearers of that will, precisely the effects of closure that Manet in my account found it necessary to refuse.[53] The contrast, in most critics's eyes, between Moreau's *Oedipus* and Manet's *Angels at the Tomb of Christ* (1864; Fig. 24), one of two paintings by him in the same Salon and a work the execution of which is at least as problematic as that of the *Déjeuner,* could not have been more devastating (the scandal of the *Olympia* in 1865 was

Figure 24 Edouard Manet, *Angels at the Tomb of Christ,* 1864. The Metropolitan Museum of Art. Bequest of Mrs. H.O. Havemeyer, 1929. The H.O. Havemeyer Collection (29.100.51). Photo: Museum.

made all but inevitable by the fiasco of the year before).[54] In this respect as in others, to situate Manet's paintings of the 1860s in their artistic context is to realize how much work remains to be done before we can imagine that we see them whole.[55]

NOTES

1. The series comprised the Harry and Lynde Bradley Foundation Lectures, which I gave at the University of Chicago in April 1991, at the invitation of the Committee on Social Thought and the University of Chicago Press. The book on which I am working will also be called *Manet's Modernism;* it critiques, builds upon, and goes far beyond my "Manet's Sources: Aspects of His Art, 1859–1865," *Artforum*

7, Mar. 1969, pp. 28–82 and "Painting Memories: On the Containment of the Past in Baudelaire and Manet," *Critical Inquiry* 10, Mar. 1984, pp. 510–542.

2. On Fantin-Latour, see in particular the rich exhibition catalogue by Douglas Druick and Michel Hoog, *Fantin-Latour* (Grand Palais, Paris; National Gallery of Canada, Ottawa: California Palace of the Legion of Honor, San Francisco, Nov. 1982-Sept. 1983). On the *Homage to Delacroix,* see pp. 167–180.

3. See Jean Rousseau, "Salon de 1864," *Figaro,* 26 May 1864, who associates Champfleury with realism and Baudelaire with the romanticism of 1830; and "Salon de 1864," *L'Univers illustré,* 1 June 1864, where Rousseau asks how an alliance has come to be established between two schools that for so long were at war with one another. "It must be," he writes, "that realism has singularly modified its program, and we would be curious to know the new formula" ["Il faut que le réalisme ait singulièrement modifié son programme, et nous serions curieux d'en connaître la nouvelle formule"; all translations are my own unless otherwise noted]. Other artists of roughly the same age who belonged to a somewhat more extended realist circle include Émile-Auguste Carolus-Duran, Théodule Ribot, Otto Scholderer, and, stretching the term to include the key figure in the etching revival of the 1860s, Félix Bracquemond (who stands next to Manet in the *Homage to Delacroix*). An invaluable guide to the periodical art criticism of the 1850s and 1860s is Christopher Parsons and Martha Ward, *A Bibliography of Salon Criticism in Second Empire Paris,* Cambridge, 1986.

4. See Fried, *Absorption and Theatricality: Painting and Beholder in the Age of Diderot,* 1980: Chicago, 1988, and *Courbet's Realism,* Chicago, 1990.

5. Fantin and Legros knew each other from the mid-1850s on; Whistler met them in 1858, which led to the formation of the "Society of Three." Fantin and Manet met in the Louvre in 1857. According to Fernand Desnoyers, a journalist and critic who was close to the group, Fantin, Legros, Carolus-Duran, and other unnamed painters were so impressed by Manet's *Guitar-Player* in the Salon of 1861 that they visited him en masse to pay their respects. Desnoyers describes the *Guitar-Player* as having been painted "in a certain *strange* new manner of which the astonished young painters believed they alone had the secret, a manner of painting that occupied a middle ground between that called realist and that called romantic" ["Le musicien espagnol était peint d'une certaine façon, *étrange,* nouvelle, dont les jeunes peintres étonnés croyaient avoir seuls le secret, peinture qui tient le milieu entre celle dite réaliste et celle dite romantique"] (Fernand Desnoyers, *Salon des Refusés: La Peinture en 1863* [Paris, 1863], p. 40). See also John Rewald, *The History of Impressionism,* rev. ed., New York, 1973, pp. 50–52.

6. On Legros, see especially Timothy Wilson et al., *Alphonse Legros (1837–1911)* (exhibition catalogue, Musée des Beaux-Arts, Dijon, Dec. 1987-Feb. 1988).

7. On the *Ex-Voto,* see ibid., pp. 49–51. Originally the painting depicted a group of women kneeling before a coffin in a dark interior; Legros soon changed his mind, but in a strong light (or a good color reproduction) the coffin can be seen showing through from underneath.

8. Edmond Duranty, "Ceux qui seront les peintres (à propos des derniers salons)," in *Almanach Parisien,* ed. Desnoyers, Paris, 1867, pp. 13–14.

En 1861, un remarquable tableau parut à l'Exposition de Peinture, intitulé l'*Ex-Voto;* il représentait de vieilles femmes, agenouillées dans la campagne au pied d'une colonne portant une image votive. Il était signé LEGROS.

On y reconnaissait d'abord le tempérament d'un peintre, d'un peintre qui savait se servir de ressources simples et larges, sans tomber dans le procédé spécial d'un atelier donné. En même temps, et chose plus importante, le sentiment de la vie moderne éclatait fortement dans cette oeuvre.

C'étaient de vieilles femmes *communes,* habillées de vêtements *communs,* que l'artiste avait prises pour personnages, mais la stupidité rigide et machinale que l'existence pénible et étroite des pauvres donnait à ces faces crevassées apparaissait avec une profonde intensité. L'accent d'un monde particulier était complètement exprimé. Tout ce qui peut frapper, arrêter, retenir devant les êtres; tout ce qui est significatif, concentré, violent en eux rayonnait autour de ce groupe de vieilles femmes, autour de leurs visages, de leurs habits, dans la campagne, et le long de la colonne votive.

Et par un accord forcé, le moyen même de la peinture s'identifiait si bien avec la nature des personnages ainsi rendus, que l'on était saisi par une seule impression, vive et nette; on s'écriait, c'est bien peint, voilà une oeuvre vraie, une oeuvre forte.

On the importance of the concept of the *tableau* for French painting and art criticism, see Fried, "Manet's Sources," pp. 72–73, where I suggest that Manet in the 1860s was specifically concerned with a notion of the *tableau; Absorption and Theatricality,* pp. 88–105, 211–212, where I consider early theorizations of that concept by Shaftesbury, Grimm, and Diderot; and *Courbet's Realism,* pp. 234–238, where the point is made that critics of Courbet's art often complained that his pictures were mere *morceaux,* fragments, rather than true *tableaux.* The second of the three Bradley lectures explored the status and meaning of the concept of the *tableau* in the 1860s. See also Steven Z. Levine, *Monet and His Critics* (New York, 1976), for a sustained investigation of the role of the concept of the *tableau* and related notions in the critical response to impressionism.

Duranty's underlining of the adjectives *communes* and *communs* is probably an ironic response to the negative review of the *Ex-Voto* by Paul de Saint-Victor, who referred demeaningly to the women's "laideur ingrate et commune" (Paul de Saint-Victor, "Salon de 1861," *La Presse,* 25 June 1861). On Duranty's life and career, see the magisterial study by Marcel Crouzet, *Un Méconnu du réalisme: Duranty (1833–1880)* (Paris, 1964). This isn't the place for a discussion of his later criticism, but it should be noted that he adapts his 1867 account of Legros's *Ex-Voto* in his most famous critical text, *La Nouvelle Peinture* (1876); indeed Duranty's arguments in the latter can't fully be understood if they are considered apart from his earlier writings and allegiances (as in Carol Armstrong, *Odd Man Out: Readings of the Work and Reputation of Edgar Degas* [Chicago, 1991], pp. 73–100).

9. See Fried, *Courbet's Realism,* pp. 40–45.

10. See Baudelaire, "Salon of 1859," *"Curiosités esthétiques," "l'art romantique," et autres oeuvres critiques de Baudelaire,* ed. Henri Lemaître, Paris, 1961, p. 372, and Théophile Gautier, "Salon de 1861," *Le Moniteur universel,* 6 July 1861 (a key early critique).

11. For example, see de Saint-Victor, "Salon de 1861"; Léon Lagrange, "Salon de 1861," *Gazette des Beaux-Arts,* 1 July 1861, p. 52; Olivier Merson, *Exposition de 1861: La Peinture en France,* Paris, 1861, p. 219.

12. This in turn is linked to what Duranty describes as the *Ex-Voto*'s evocation of "the feeling of modern life" (on the face of it a surprising claim), via a certain notion of *character* and the *characteristic* (or the *type:* both are implicit in Duranty's description of the old women in Legros's painting). That is, for Duranty and other critics of the 1860s the conviction of modernity was to be achieved through the representation of typical or characteristic persons of various sorts, and this in turn could be facilitated by the (often elliptical) description of the particular closed milieux in which those persons had their habitual, in that sense automatic, place. What was called for, in other words, were effects of absorptive hyperlegibility, not the promotion of *il*legibility, as is usually claimed. (See T. J. Clark's discussion of "the essential myth of modern life: that the city has become a free field of signs and exhibits, a marketable mass of images, an area in which the old separations have broken down for good," in T. J. Clark, *The Painting of Modern Life: Paris in the Art of Manet and His Followers* [New York, 1984], p. 49.) Baudelaire's great essay of around 1860, "Le Peintre de la vie moderne" (*"Curiosités esthétique,"* pp. 305–396), bears on this topic as does an important but neglected article by de Saint-Victor, "Societé des Aqua-Fortistes," *La Presse,* 27 Apr. 1863. See also Baudelaire's brief discussion of Legros's *Angelus* and Amand Gautier's *Soeurs de charité* in his "Salon de 1859," pp. 330–335. Moreover, the effects to which I have just referred were often described as especially *striking* (in French, *frappant*), a notion that plays a major role in the present essay, as will emerge. All this is to say that the issues in question belong to a problematic of what Philippe Lacoue-Labarthe calls onto-typography; see for example his *Typography: Mimesis, Philosophy, Politics,* ed. Christopher Fynsk (Cambridge, Mass., 1989) and *Musica ficta: (Figures de Wagner)* (Paris, 1991). My thanks to Stephen Melville, who read and commented on this paper in draft, for pressing Lacoue-Labarthe on me until I got the point, and to Martha Ward, who helped me see the extent to which my emphasis on the absorptive closure-character-modernity nexus differs from other accounts of the experience of modernity in the 1860s.

13. Millet himself, in a famous letter of 2 June 1863 to the critic Théodore Pelloquet, said that he wanted the things in his paintings "not to have the air of being brought together by chance for the occasion, but they should have between them an indispensable *and forced* connection" ["Que les choses n'aient point l'air d'être amalgamées au hasard et par occasion, mais qu'elles aient entre elles une liaison indispensable et forcée"] (Jean-François Millet, *Écrits choisis* [Caen, 1990], p. 44; emphasis added). In the same letter he wrote: "To characterize! That's the goal" ["Caractériser! voilà le but"] (p. 45). Two years earlier, Théophile Thoré (writing under the nom de plume Willem Bürger) praised Millet for possessing "a wholly personal style and an opinionated will" ["un style tout personnel et une volonté opiniâtre"] (Willem Bürger [Théophile Thoré], "Salon de 1861," *Salons de W. Bürger,* 2 vols. [Paris, 1870], 1:35). In the same essay Thoré criticized a painting by Courbet for lacking "those willed effects that always strike one in Courbet's works" and attributed to those who came from the Jura, as Courbet did, "an invincible will" ["l'ensemble manque de ces effets volontaires qui frappent toujours dans les oeuvres de CourbetCes enfants du Jura ont une volonté invincible"] (ibid., 1:99). But Courbet is less often seen in these terms than are Legros, Fantin-

Latour, Ernest Meissonier, Puvis de Chavannes, Théodule Ribot, and Gustave Moreau—all, including Courbet, absorptive painters to a greater or lesser degree. It's also true that Manet is sometimes criticized for the willed harshness, incompleteness, or unintelligibility of his art; but the negative judgment here bears not on the factor of will as such but on the alleged qualities in question. Or rather the willing of *those* qualities leads to the charge of *parti-pris* and the further accusation of seeking to attract attention at any price (see n. 42). I might add that in *Courbet's Realism* I compared Courbet's paintings with photography with respect to the different relations in each between will and automatism (pp. 278–83); I would now add Millet's paintings to that comparison inasmuch as they were seen by both admirers and detractors as intensely willed representations of figures absorbed to the point of outright automatism. In any case, the valorization of will and willing in the art criticism of the 1860s refutes Edgar Wind's assurance' that *voulu* is always "a term of aesthetic censure" (Edgar Wind, *Art and Anarchy* [New York, 1963], p. 88). See also nn. 35 and 53.

14. Thus in Joris-Karl Huysmans's novel, *L'Oblat,* in one scene that takes place in the Musée des Beaux-Arts in Dijon, the praying women in the *Ex-Voto* are described as "meditating, absorbed, *far from visitors,*" a phrase that make sense only if it is read as referring to visitors to that museum, where the painting already hung ["Les expressions simples et concentrées de ceś orantes recueillies, absorbées, loin des visiteurs, devant la croix, dégageaient une saveur religieuse réelle"] (Joris-Karl Huysmans, *L'Oblat* [Paris, 1903], p. 220; emphasis added). It's not irrelevant that Huysmans was also an art critic of some distinction; see his *L'Art moderne/Certains* (1883, 1889; Paris, 1975).

15. My use of the masculine pronoun for the beholder reflects the fact that the beholder was thematized as male in the criticism and art under discussion.

16. Note in this connection that the Ex-Voto itself is divided between a pictorial upper component—the red-and-gold crucifixion scene—and a nonpictorial lower one—a black rectangle containing in its corners four stylized white tears. This is suggestive not only because it illustrates the fact of division but also because, in its blackness and perhaps also by virtue of its imagery of weeping, the second of the two elements may be read as emblematizing the blindness to being beheld that I have argued is implicit in the representation of absorption. Readers of *Absorption and Theatricality* may recall the discussion there of an analogous conjunction of elements—two playing cards in a drawer, one facing the beholder, the other blankly turned away—in Chardin's *Card Castle* of ca. 1737 (pp. 48–49); the parallel in this regard between paintings near the beginning and the end of the absorptive tradition I have been charting is further evidence for the coherence of the tradition as a whole. (On the link between tears and blindness, see Jacques Derrida, *Mémoires d'aveugle: L'Autoportrait et autres ruines* [Paris, 1990], pp. 123–130.)

17. See Druick and Hoog, *Fantin-Latour,* pp. 95–96, 141–143.

18. Bürger [Thoré], "Salon de 1863," *Salons de W. Bürger,* 1:384. (Thoré's memory seems to have deceived him; there is no white collar):

Mais le plus charmant, le plus intime, le plus naturellement distingué de tous les portraits de femme est celui d'une *Liseuse,* par M. Fantin-Latour. Jeune fille blonde, en modeste caraco brun et jupon gris, assise, vue jusqu'aux genoux, sur un fond uni, neu-

tre. Aucun accessoire qui puisse distraire la Liseuse ni ceux qui la regardent. Elle tient des deux mains son livre vu en raccourci, et dont la tranche est frappé de lumière. Sa petite main droite, également en lumière sur les pages du livre, est délicieuse. Quelle attention! Comme elle lit bien et comme elle pense à ce qu'elle lit! Et qu'elle est de race fine, malgré sa toilette discrète! Et comme la couleur est juste, harmonieuse, tranquille! L'heureuse femme, avec son jupon de laine grise et son petit col blanc!

19. Gautier, "Salon de 1864," *Le Moniteur universel,* 25 June 1864:

> Sur le devant sont groupés, vus à mi-corps, et tournant le dos à l'objet de leur véneration pour regarder le public, les amis du peintre, artistes et littérateurs, que réunit une commune admiration du maître illustre tant regretté de tous. L'oeuvre de M. Fantin-Latour est plutôt une collection de portraits qu'une composition raisonnée et dirigée dans le sens de son motif; mais ces portraits sont eux-mêmes fort bien peints et très-ressemblantsIl y a, malgré la bizarrerie de l'arrangement ou pour mieux dire malgré l'absence de tout arrangement, un véritable mérite dans cette toile dont le public s'est fort préoccupé.

> Another critic, Ernest Chesneau, writes that "[Fantin's] *tableau* hardly exists as a *tableau,* it's only a pretext for portraits; there is neither composition, nor a clearly marked intention, it's not at all an *oeuvre* in a word" ["Mais le tableau en lui-même n'existe point comme tableau, il n'est lá qu'un prétexte à portraits; il n'y a ni composition, ni intention nettement marquée, ce n'est point une oeuvre en un mot"] (Ernest Chesneau, "Salon de 1864," *Le Constitutionnel,* 7 June 1864).

20. Fantin's correspondence suggests that he would have liked to include Legros, the English painter Edwin Edwards, and Scholderer, each of whom, for different reasons, was unable to pose for him; the final painting comprised portraits of Fantin, Whistler (in a Japanese robe), Manet, Bracquemond, Cordier, Duranty, Astruc, Antoine Vollon, and Jean-Charles Cazin (see Druick and Hoog, *Fantin-Latour,* p. 191). For a small illustration of the oil sketch, whose present location is unknown, see ibid. The preparatory drawings for *Truth, The Dinner, The Toast!,* and *The Toast! Homage to Truth* are discussed in some detail in ibid., pp. 181–192; see also Luce Abélès, *Fantin-Latour: Coin de table: Verlaine, Rimbaud et les Vilains Bonshommes,* Paris, 1987, pp. 6–12.

21. According to Auvray, Fantin depicted himself seated in the center foreground, his back to the public but with his head turned toward the beholder. (Another critic, Amédée Cantaloube, tells us that Fantin pointed with his finger at the figure of Truth [see Amédée Cantaloube, "Le Salon de 1865," *Le Grand Journal,* 21 May 1865].) Among the other figures in the painting were two men "seen from the rear, with their hats on their heads in the presence of a naked woman whom they gaze at from the front" ["deux autres vus de dos, avec le chapeau sur la tête en présence d'une femme nue qu'ils regardent en face"] (Louis Auvray, *Salon de 1865* [Paris, 1865], pp. 51–52). For his part, de Laincel ironically deplores the bad manners of those in the painting (he doesn't say how many or whether we see them from the rear) who "in front of a woman—of Truth!—keep their hats on their heads—horrible stovepipe hats!" ["Ces Messieurs sont dénués de politesses et des sentiments de convenance les plus élémentaires. Comment donc en face d'une femme, de la Vérité! ils gardent sur leur tête leur chapeau,—un affreux tuyau de poêle!"] (Louis de Laincel, *Promenade aux Champs-Elysées. L'Art et al démocratie. Causes de décadence. Le Salon de 1865* [Paris, 1865], p. 13).

22. All the more so if, as is likely, de Laincel was correct in noting that the men in the painting seemed neither to see Truth nor to wish to see her. After commenting on the men in hats, he continues: "Then, nonchalant and distracted, they look about, this one to the right, that one to the left. One would say that having Truth before them, they don't see her, don't want to see her and don't at all look as if they're seeing her." (It's not clear whether de Laincel is referring here solely to the men in hats or to other figures as well.) ["Puis, nonchalants et distraits, ils regardent, qui à droite, qui à gauche. On dirait qu'ayant la Vérité devant eux, ils ne la voient pas, ne veulent pas la voir et ne tiennent pas du tout à la voir"] (ibid.). Needless to say, we are on insecure ground trying to reconstruct the internal dynamics of Fantin's composition on the basis of comments such as the above. But Fantin may indeed have intended most of the figures in the painting to appear unaware of the figure of Truth: in a letter of 3 February 1865 to Edwin Edwards, Fantin writes that the men in his picture "drink to their ideal, Truth, and by one of those licenses that painting is allowed and that is one of its charms, their Ideal, the subject of their toast, appears for him who looks at the painting" ["Ils boivent à la Vérité leur idéal et par une de ces licences permises à la peinture et qui sont un de ses charmes, leur Idéale, le sujet de leur toast apparaît pour celui qui regarde le tableau"]. This suggests that the figure of Truth appears *only* for the beholder, which is what Edwards takes him to be saying. "I find it very ingenious that the participants seem not to perceive Truth—she must appear only for the [painting's] beholders and my dear [Fantin]," Edwards responds in a letter dated February. ["Je trouve très spirituel que les convives n'ont pas l'air d'apercevoir la Vérité—elle doit apparaître aux spectateurs et à mon cher seulement."] To which Fantin replies in a letter dated 15 February: "You're right, it's only I [in his role of intercessor, pointing at the Truth] who see her. Yes, Shakespeare, but me! Banquo didn't strike greater fear in Macbeth, than Truth in me" ["Vous avez raison, il n'y a que moi, qui la verrai. Oui, Shakespeare, mais moi! Banquo ne fit pas tant peur à Macbeth, que la Vérité pour moi"]. Fantin's letters to Edwards are in the Bibliothèque Municipale, Grenoble; Edwards's letters to Fantin are in the archives at Brame and Lorenceau, Paris. My thanks to Philippe Brame for allowing me to consult those archives and to Douglas Druick for sharing with me his extensive knowledge of Fantin's correspondence.

23. In a fascinating article on exhibition spaces in Paris between the 1870s and 1890s, Martha Ward has called attention to the fact that male visitors to the Salon (and most other exhibitions) typically did not remove their hats. See Ward, "Impressionist Installations and Private Exhibitions," *Art Bulletin 73,* Dec. 1991; pp. 606, 609.

24. Or if we distinguish between the inclusion of the viewer and the (even more Courbet-like) inclusion of the *painter,* we are dealing with *four* distinct principles of organization. Consider in this light Fantin's remarks in a letter to Edwin Edwards. At work on *The Toast! Homage to Truth* and already somewhat anxious about its basic conception, Fantin describes the critical beating he expects to take when the painting is shown in terms of blows that will fall on *his own back.* "But am I going to take a beating," he writes, "oh my back, it aches already, I'm beginning to feel all that on my back" ["Mais que je vais être batonné, oh mon dos, il

me cuit déjà, je commence à me sentir cela sur le dos"] (Henri Fantin-Latour, letter to Edwin Edwards, 15 Feb. 1865, Bibliothèque Municipale, Grenoble: see also the letter dated 3 February). It's as if the intercessor role Fantin constructs for himself leaves his back exposed—as it were outside the picture—even as it allows him to sacrifice himself for his creation. Further on in the same letter he explains to Edwards that he will insert in the Salon catalogue only the words *The Toast* (as in fact he did) "and I, when I point to Truth, that makes Toast to Truth" ["A présent, au catalogue je n'aurai que ce mot, "Le Toast" et moi, alors je montre la Vérité, cela fait Toast à la Vérité"] (ibid.). Here too Fantin conceives of himself *both inside and outside* the painting, or at any rate he conceives of the full title of his painting as a kind of rebus that calls for the viewer to bring together a partial title (in the catalogue) with the figure of Fantin himself pointing at Truth (within the canvas).

Fantin's excited imagination of the beating he is bound to receive may also be read in terms of the pursuit of the *striking* that will be a major theme of this essay. Indeed in his letter to Edwards of 3 February he recounts the negative responses of those to whom he has shown his composition but adds that he considers this "a sign that I will strike truly" ["signe que je frapperai juste]. So it's really an *exchange* of blows that he comes to envision. All this no more than hints at the complexity—also the strongly fantasmic character—of Fantin's endeavor during these years.

25. Whistler, the only non-French member of the group, settled permanently in London in 1863 and in fact took Legros with him, which is largely why the generation of 1863 has been slighted by historians: it held together as a distinct generation for just a few years (by the time the Salon des Refusés took place it was already geographically dispersed), and of course it was swiftly followed by the most long lived and coherent of artistic generations, the impressionists. Moreover, Whistler soon broke with Legros (himself not an easy character) and repudiated his own realist beginnings. Nevertheless, his early paintings and etchings are mainly to be understood in the context of French developments. The early dissolution of the young realist group was noted by the critic Paul Mantz, who commented in 1865: "Evidently their enthusiasm is dampened, the group is troubled and disperses" ["Evidemment l'enthousiasme s'éteint, le groupe se trouble et se disperse"] (Paul Mantz, "Salon de 1865," *Gazette des Beaux-Arts* 19, 1 July 1865, p. 6).

26. See Fernand Desnoyers, *Salon des Refusés,* p. 27.

27. "Le Capitaine Pompilius" [Carle Desnoyers], "Lettres particulières sur le Salon," *Le Petit Journal,* 11 June 1863, p. 2; hereafter abbreviated "L." On the identity of "Le Capitaine Pompilius," see n. 50.

28. See Comte Horace de Viel-Castel, "Salon de 1863," *La France,* 21 May 1863.

29. Jules Claretie, "Lettres familières sur le Salon de 1863," *Jean Diable,* 6 June 1863: "Mais est-ce le portrait d'une folle, cette figure roide et fixe qu'on prendrait pour lady Macbeth ou pour Ophélie?"

30. See Chesneau "Le Salon des Refusés," *L'Art et les artistes modernes en France et en Angleterre,* Paris, 1864, p. 191, and "Un Bourgeois de Paris" [Auguste Villemot?], "Salon de 1863," *La Gazette de France,* 21 July 1863.

31. Alexandre Pothey, "Lettres à un millionnaire sur le Salon de 1863," *Le Boulevard,*

31 May 1863: "La figure de M. Whistler est mal dans le cadre; nous pensons que quelques pouces de toile, ajoutés au-dessus de la tête, lui donneraient encore plus d'éclat."

32. De Viel-Castel, "Salon de 1863": "Dont la tête empaillée et pourvue d'yeux d'émail, se dresse menaçante vers le spectateur."

33. Moreover, it would not be hard to show that an analogous double structure characterizes other Whistler figure paintings of the mid-1860s, such as *Purple and Rose: The Lange Leizen of the Six Marks* (1864), a work that invites comparison with the central group in Courbet's *Painter's Studio; Caprice in Purple and Gold: The Golden Screen* (1864); and *Variations in Flesh Colour and Green: The Balcony* (begun in 1864, perhaps finished as late as 1870).

34. Zacharie Astruc, *Le Salon intime: Exposition au Boulevard des Italiens,* Paris, 1860, p. 66: "Les mouvements sont d'une observation excessive. Nous ne sommes plus devant une peinture, mais devant la nature." On Astruc's life and career, see Sharon Flescher, *Zacharie Astruc: Critic, Artist and Japoniste (1833–1907),* New York, 1978.

35. Astruc, "Exposition Universelle," *L'Étendard,* 8 Jan. 1868: "Étonnament volontaire . . . Rien pour le spectateur,—ici, point de théâtre,—tout pour le fait en lui-même." In the same article Astruc remarks that in comparison "with the works of this hand that engraves the things [it represents] with such intensity, all other painters are weak. Yes, his execution is awkward, monotonous, often puerile; he lets one see his effort, he reveals the difficulties of his craft that are for others play; but see the master, observe the miracles of that will endowed for the aim that it pursues." ["Auprès des ouvrages sortis de cette main qui grave les choses avec une pareille intensité, tous les autres peintres sont chétifs. Oui, son travail est maladroit, monotone, souvent puéril; il montre sa peine, il affiche des difficultés de métier qui sont pour d'autres un jeu; mais voyez le maître, observez les miracles de cette volontè douèe pour le but qu'elle poursuit."]

36. Astruc, "Salon de 1868," *L'Étendard,* 29 July 1868: "C'est la pierre de touche des créations parfaites, et surtout raisonnées." See also Astruc, "Trésors d'art de Paris: Exposition retrospective," *L'Etendard,* 13 July 1866, where he claims that the portrait "best seizes the gaze" ["attache davantage le regard"].

37. Ibid.: "Le portrait doit s'exposer par le langage expressif des traits, et nous communiquer pour ainsi dire sa pensée dès que nous l'envisageons; il doit frapper, par conséquent,—et c'est l'inverse du tableau qui laisse peu à peu pénétrer ses plus belles parties [The verb *envisageons* calls attention to the fact that we face the portrait even as it faces us.]Le portrait n'a point les ressources du ton, les agréments du faire, les surprises de l'idée; il est puissant, il impressionne comme un objet ayant pris à un être l'intensité de sa vie personnelle."

38. See in this connection Astruc's vivid account of the *rapidity* with which Manet's paintings in the Salon des Refusés affected, indeed *struck,* the viewer (*Le Salon,* 20 May 1863, pp. 2–5; the crucial passage is quoted in Fried, "Manet's Sources," p. 73). It's likely that Manet was familiar with Astruc's ideas about the portrait and that his *Portrait of Zacharie Astruc* (1866) should be seen as in implicit dialogue with them; in "Manet's Sources" I suggest that it represents Manet's most extreme attempt to make a portrait bear full conviction as a *tableau* (p. 72).

39. See Fried, *Courbet's Realism,* pp. 284–287. Such a view of Manet already informs "Manet's Sources" and is spelled out in Fried, "Thomas Couture and the Theatricalization of Action in Nineteenth Century French Painting," *Artforum* 8 (June 1970): 45, where I remark that Manet's paintings of the first half of the 1860s "may be said to take account of the beholder; in any event they refuse to accept the fiction that the beholder is not there, present before the painting, which Diderot a century before had insisted was crucial to the convincing representation of action." See also Fried, *Three American Painters: Kenneth Noland, Jules Olitski, Frank Stella,* exhibition catalogue, Fogg Art Museum, Cambridge. Mass., 21 Apr.–30 May 1965, pp. 49–50.

40. Bürger [Thoré], "Salon de 1868," *Salons de W. Bürger,* 2:532. The passage reads:

His present vice is a sort of pantheism that doesn't value a head more than a slipper; that sometimes accords even more importance to a bouquet of flowers than to the physiognomy of a woman, as for example in his famous painting of the *Black Cat* [the *Olympia*]: that paints very nearly uniformly furniture, carpets, books, clothing, flesh, and the accents of the face, as for example in his portrait of M. Emile Zola, exhibited in the present Salon. [Son vice actuel est une sorte de panthéisme qui n'estime pas plus une tête qu'une pantoufle; qui parfois accorde même plus d'importance à un bouquet de fleurs qu'à la physiognomie d'une femme, par exemple dans son fameux tableau du *Chat noir;* qui peint tout presque uniformément, les meubles, les tapis, les livres, les costumes, les chairs, les accents du visage, par exemple dans son portrait de M. Emile Zola, exposé au présent Salon.]

41. Théodore Pelloquet, "Salon de 1863," *L'Exposition,* 23 July 1863. The same year Adrien Paul remarked of the *Déjeuner* that Manet treated living beings and inanimate things exactly the same: "il trait de la même façon les êtres et les choses" (Adrien Paul, "Salon de 1863," *Le Siècle,* 19 July 1863).

42. Thus Paul: "Manet's Spanish paintings don't attract one's attention, they seize it by force; one feels oneself stopped as by the edge of a woods and one comes away stripped clean [that is, by a highwayman]" ["Les toiles espagnoles de M. Manet n'attirent pas l'attention, elles la prennent de force; on se sent arrêté comme au coin d'un bois, et l'on s'en revient dévalisé"] (Paul, "Salon de 1864," *Le Siècle,* 29 May 1864). Félix Deriège: "The white, the black, the red, the green make a frightful racket in this painting [the *Olympia*]; the woman, the negress, the bouquet, the cat, all this confusion of disparate colors, of impossible forms, seizes your gaze and stupefies you" ["Le blanc, le noir, le rouge, le vert font un vacarme affreux sur cette toile; la femme, la négresse, le bouquet, le chat, tout ce tohu-bohu de couleurs disparates, de formes impossibles, vous saisit le regard et vous stupéfie"] (Félix Deriège, "Salon de 1865," *Le Siècle,* 2 June 1865). And "Un Bourgeois de Paris" (who however is not unadmiring): "His acid and irritating color attacks the eyes like a steel saw; his personages cut themselves out incisively, with a crudity that no compromise softens. He has all the harshness of those green fruit that should never ripen" ["Son coloris aigre et agaçant entre dans les yeux comme une scie d'acier; ses personnages se découpent à l'emporte pièce, avec une crudité qu'aucun compromis n'adoucit. Il a toute l'âpreté de ces fruits verts qui ne doivent jamais mûrir"] ("Lettres d'un bourgeois de Paris. La Comédie du Salon, 9ᵉ cercle. Les limbes," *La Gazette de France,* 21 July 1863).

See, however, Thoré's claim that the new French painting on view at the

Salon des Refusés (with Manet obviously at the forefront) "aspires to render the effect in its striking unity, without worrying about the correctness of lines nor the minutiae of accessories" ["Au lieu de chercher les contours, ce que l'Académie appelle le *dessin,* au lieu de s'archarner au détail, ce que les amateurs classiques appellent le *fini,* on aspire à rendre l'effet dans son unité frappante, sans souci de la correction des lignes ni de la minutie des accessoires."] (Bürger [Thoré], "Salon de 1863," *Salons de W. Bürger,* 1:414), as well as Gonzague Privat's statement two years later that "M. Manet has sought the *tableau* without concerning himself enough with forms or details" ["M. Manet a cherché le *tableau* sans se préoccuper assez de la forme et des détails"] (Gonzague Private, *Place aux jeunes! Causeries critiques sur le Salon de 1865* [Paris, 1865], p. 136). Both statements are quoted and briefly discussed in Fried, "Manet's Sources," pp. 72–73.

43. It's in this connection that the familiar topic of the relation of Manet's paintings of these years to Japanese prints should be reconsidered (a point I owe to Stephen Melville), along with the larger question of Manet's use of sources in earlier European painting (my main concern in "Manet's Sources" and "Painting Memories").

44. *The Old Musician* is central to my argument in "Manet's Sources," where I insist on its centrality for any attempt to understand Manet's intentions in the early 1860s. See, however, Theodore Reff's psychologistic and social-historical interpretation of that painting in *Manet and Modern Paris: One Hundred Paintings, Drawings, Prints, and Photographs by Manet and His Contemporaries,* exhibition catalogue, National Gallery of Art, Washington, D. C., Dec. 1982–Mar. 1983, pp. 19–20, 171–191.

45. This point is made in "Manet's Sources," p. 69.

46. On the importance of Watteau for Manet's painting in the 1860s, see Fried, "Manet's Sources." In fact the figure of the girl holding an infant has several overlapping sources, including Velázquez's *The Drinkers* (with respect to her *profil perdu* in particular), one or more pictures by Louis Le Nain, and Henri-Guillaume Schlesinger's *The Kidnapped Child.* See Fried, "Manet's Sources," pp. 30–31, 45–46, and Reff, *Manet and Modern Paris,* pp. 174–177, 188–189. Significantly, Legros's St. Francis also seems to have been largely based on Velázquez's *Drinkers,* but whereas Manet's use of the letter emphasizes its facing aspects as opposed to its absorptive ones (both are there in the original), Legros appears to have found in it a sanction for the intensification of absorption. In *Manet's Modernism* I stress the point that Manet was one of a number of painters in the 1860s who made more or less explicit use of the art of the past; others include Legros, Fantin, Ribot, Moreau, Puvis de Chavannes, and James Tissot.

47. And different too from what in *Courbet's Realism* I described as "Courbet's pursuit of a hitherto unexampled mode of *unification* through rhythmic repetitions, thematic continuities, and metaphorical equivalences across the pictorial field," a pursuit that, as I also remark, "[gave] rise to universal impression of lack of *unity,* as if there could be no unity worth the name that wasn't based exclusively on conflict, opposition, and contrast" (Fried, *Courbet's Realism,* p. 234). In certain respects, Manet's essentially facing or presentational—in that sense theatrical—art may be seen as discovering equivalents for the effects of conflicts, opposition, and contrast that were fundamental to the Diderotian conception (more on this in *Manet's Modernism*).

48. The "portraitlike" character of Manet's art was sufficiently evident for hostile crit-
ics to turn it to their own purposes; for example, Marius Chaumelin charged that
Manet's pictures in the Salon of 1869, the *Balcony* and the *Luncheon in the Studio,*
amounted merely to "portraits" of a balcony and a luncheon. See Marius
Chaumelin, "Salon de 1869," *L'Art contemporain,* Paris, 1873, p. 332. And Ernest
Duvergier de Hauranne wondered if Manet's *Chemin de fer* of 1874 was a *tableau
de style* or a portrait, in which case the figure of the young girl looking through the
iron toward the railroad tracks would be "a portrait seen from the rear" ["Est-ce un
portrait á deux personages on un tableau de style que le *Chemin de fer* de M.
Manet . . . ? Les informations nous manquent pour résoudre ce probléme; nous
hésitons d'autant plus qu'en ce qui concerne la jeune fille ce serait tout au moins
up portrait vu de dos"] (Ernest Duvergier de Hauranne, "Le Salon de 1874," *Revue
des Deux-Mondes,* 3d per., 44th year, 1 June 1874, p. 671; my thanks to Stephen
Melville for alerting me to Duvergier de Hauranne's remarks.) Also, this is as
good a place as any to acknowledge a certain partial affinity between the respec-
tive problem of *facing* (also of *striking)* in the present essay and in my studies of
late nineteenth-and early twentieth-century English-language literary "impression-
ism." See Fried *Realism, Writing, Disfiguration: On Thomas Eakins and Stephen
Crane,* Chicago, 1987, pp. 91–161; "Almayer's Face: On 'Impressionism' in Con-
rad, Crane, and Norris." *Critical Inquiry* 17 (Autumn 1990): 193–236; and "Re-
sponse to Bill Brown." *Critical Inquiry* 18 (Winter 1992):403–410. As of now,
however, the two problematics are separate and distinct; exactly how they bear on
one another is a matter for further thought.

49. "Le Capitaine Pompilius" [Carle Desnoyers], "Lettres particulières sur le Salon":
Si les tableaux de M. Manet étaient enveloppés de leur forme définitive; si, jusque dans
cette touche suprême qui clôt une oeuvre en la signant énergiquement d'une griffe magis-
trale, ils affirmaient le principe nouveau du jeune maître, on pourrait croire que l'aspect
de cet art sain et vigoureux a dû confondre ou horripiler ces représentants des écoles ver-
moulues. Malheureusement, il n'en est pas ainsi: les connaisseurs saisissent au premier
coup d'oeil les qualités exceptionnelles de cet admirable ébaucheur: mais pour le public,
à qui il faut mettre les points sur I'I: pour l'Institut, qui ne sait estimer encore que la
peinture qui sent l'étude et la recherche, les compositions de M. Manet ne peuvent guère
passé, comme rendu, que pour des à peu prés.

On the word *ébauche,* see n. 51.

50. "En un mot, telle oeuvre achevée serait solennelle. Dans l'état où M. Manet nous
la livre, elle n'est qu'intéressante: elle est conditionnelle, elle n'est pas effective."
Carle Desnoyers seems never to have published art criticism under his own name
and was mainly known, under the nom de plume Edouard de Biéville, as a play-
wright and journalist. But his "Lettres" on the Salon of 1863 deserve to be recog-
nized as a brilliant contribution to the art-critical literature of the 1860s (his obser-
vations on Manet, not all of which I have quoted here, are especially interesting).
This isn't the place to present the arguments that identify "Le Capitaine Pompil-
ius" as Carle Desnoyers, but I feel they are conclusive. I might add that I sense the
same authorial presence behind a remarkable paragraph on Manet's pictures in the
Salon of 1865 by the pseudonymous "Rapinus Beaubleu," "Salon de 1865," *Le
Hanneton,* 11 June 1865 p. 2.

51. See Pelloquet, "Salon de 1863," 23 July 1863:

L'exécution est loin de m'offrir une compensation suffisante; c'est aussi un rébus. Je vois bien ça et là des morceaux qui approchent de la nature, particulièrement dans une des femmes nues et dans une des têtes du premier plan, mais cela ne suffit pas, et le reste est d'une incohérence tout à fait inexplicable. On ne saurait désigner le travail de M. Manet sous le nom d'esquisse ou d'ébauche. Dans une equisse bien comprise et bien faits, toutes les parties sont exécutées au même degré les uns que les autres. L'incohérence, l'inégalité d'exécution de M. Manet ne s'expliquent et ne se justifient en rien.

For a discussion of the mid-nineteenth-century notions of the *ébauche* and the *esquisse peint,* both of which can be rendered in English only by the word *sketch* (and hence should be kept in the original French wherever possible), see Albert Boime, *The Academy and French Painting in the Nineteenth Century* (London, 1971), pp. 37–41, 43–44.

52. Compare Thoré's remarks apropos of Manet's *Young Lady in 1866* (better known as *Woman with a Parrot*) in the Salon of 1866: "An *ébauche,* it's true, like Watteau's *Isle of Cythera* in the Louvre. Watteau would have been able to push his *ébauche* to the point of perfection. Manet still struggles with that extreme difficulty of painting, which is to finish certain parts of a painting in order to give to the whole its effective value" ["Ébauche, c'est vrai, comme est, au Louvre, l'*Isle de Cythère,* par Watteau. Watteau aurait pu pousser son ébauche à la perfection. Manet se débat encore contre cette difficulté extrême de la peinture, qui est de finir certaines parties d'un tableau pour donner à l'ensemble sa valeur effective"] (Thoré, "Salon de 1866," *Salons de W. Bürger,* 2:318).

53. Among the many critics who describe Moreau's *Oedipus* in these terms are Chesneau, "Salon de 1864," *Le Constitutionnel,* 3 May 1864; Rousseau, "Salon de 1864," *Figaro,* 19 May 1864, pp. 2–4; de Saint-Victor, "Salon de 1864," *La Presse,* 7 May 1864; and Maxime Du Camp, "Salon de 1864," *Les Beaux-Arts à l'Exposition universelle et aux salons de 1863, 1864, 1865, 1866 et 1867,* Paris, 1867, pp. 106–119. In Chesneau's words: "All the details, their form and their disposition as well as the general organization of the painting, have been meditated on, thought through, and put down with intention. Each portion of the work from the smallest to the largest has been seriously *willed*" ["Tous les détails, leur forme et leur disposition aussi bien que la combinaison générale du tableau, ont été médités, réfléchis et posés avec intention. Chaque morceau de l'oeuvre, de plus petit au plus grand, a été sérieusement *voulu*"]. Chesneau's remarks are especially interesting in that he also claims, contradictorily, that the unity of the painting is such that "all trace of effort is absent" ["tout trace d'efforts est absente"] (Chesneau, "Salon de 1864"), a remark that betrays his allegiance to the Diderotian ideal in its classic form even as his valorization of the *voulu* amounts to a partial break with that ideal. (We might think of this as a more conservative expression of the divided sensibility I have been analyzing.)

54. So for example Chesneau, after enthusing at length over Moreau, says of Manet merely: "This year the paintings of M. Manet figure among those admitted to the prize competition. The jury has been indulgent" ["Cette année les tableaux de M. Manet figurent parmi les oeuvres admises au concours des récompenses. Le jury a été indulgent"]. The sudden advent of Moreau appears to have rendered Manet's

paintings indescribable, or at least not worth the effort of description. Moreover, the terms in which Moreau is praised during the next several years may be read as usurping the discursive space that Manet's paintings conceivably might have occupied; see in particular Gautier's characterization of Moreau's public in what amounts to Baudelairean imagery the very year Manet exhibited the *Olympia* (Chesneau, "Salon de 1865," *Le Constitutionnel,* 9 July 1865).

Manet's other picture in the Salon of 1864 was the *Incident in a Bull-Ring,* which some time afterward he cut down to make the *Dead Torero,* now in the National Gallery of Art in Washington, D.C., and the fragmentary bullfight scene, in the Frick Collection in New York.

55. A final note. The intuition that paintings, Manet's in particular, bear a special relation to the human face is central to Stéphane Mallarmé's important article, "The Impressionists and Édouard Manet," first published in English in *The Art Monthly Review* 1, 30 Sept. 1876, pp. 117–122; repr. *Documents Stéphane Mallarmé,* ed. Carl Paul Barbier, 7 vols. Paris, 1968–1980, 1; pp. 59–86. (The text cited here is the first English translation. The French original of Mallarmé's article has been lost; recently the English translation has itself been translated back into French— but of course the new French version has infinitely less authority than the English version, which Mallarmé read and approved. See Mallarmé, "Les Impressionistes et Édourad Manet," trans. Philippe Verdier, *Gazette des Beaux-Arts,* 6th per., 6 [Nov. 1975]: 147–156.) The crucial paragraph reads:

Woman is by our civilisation consecrated to night, unless she escape from it sometimes to those open air afternoons by the seaside or in an arbour, affectionated by moderns. Yet I think the artist would be in the wrong to represent her among the artificial glories of candle-light or gas, as at that time the only object of art would be the woman herself, set off by the immediate atmosphere, theatrical and active, even beautiful, but utterly inartistic. Those persons much accustomed, whether from the habit of their calling or purely from taste, to fix on a mental canvass the beautiful remembrance of woman, even when thus seen amid the glare of night in the world or at the theatre, must have remarked that some mysterious process despoils the noble phantom of the artificial prestige cast by candelabra or footlights, before she is admitted fresh and simple to the number of every day haunters of the imagination. (Yet I must own that but few of those whom I have consulted on this obscure and delicate point are of my opinion.) The complexion, the special beauty which springs from the very source of life, changes with artificial lights, and it is probably from the desire to preserve this grace in all its integrity, that painting—which concerns itself more about this flesh-pollen than any other human attraction—insists on the mental operation to which I have lately alluded, and demands daylight—that is space with the transparence of air alone. The natural light of day penetrating into and influencing all things, although itself invisible, reigns also on this typical picture called *The Linen* [Manet's *Le Linge*], which we will study next, it being a complete and final repertory of all current ideas and the means of their execution. [pp. 73–74]

Several points should be stressed: (1) The association between painting and the face is mediated by *woman;* the faciality of painting is essentially feminine. (2) The passage's thematics of femininity is itself inextricable from the question of *theatricality,* which here militates against artificial lighting and in favor of effects of daylight and air. More broadly, Mallarmé's logic of femininity and faciality construes impressionism—to which he attaches Manet—as an antitheatrical move-

ment. (In this and other respects, his article bears early witness to the simplification of Manet's art that impressionism brought in its train. And of course by 1876 Manet had himself been deeply influenced by the new painting.) (3) The connection between painting, femininity, faciality, and natural light and air is established by way of the notion of (woman's) *complexion* on the grounds that painting as an art "concerns itself more about this flesh-pollen than any other human attraction" and so has a special affinity for women's faces seen under conditions that preserve the "integrity" of that "grace." Note, however, that the gender implications of the key term "flesh-pollen" are inescapably masculine (pollen is produced by the "male" organ of the flower): as if the faciality Mallarmé evokes were somehow bi-gendered, or as if the presumed masculinity of the beholder's gaze were thus inscribed within his evocation of woman's and painting's respective complexions.

A fourth point turns on distinguishing sharply between "flesh-pollen"—a natural substance, for all its strangeness—and cosmetics—a foreign substance applied to faces from outside. The passage quoted above, indeed Mallarmé's entire article, should be read in opposition to Baudelaire's defense of cosmetics in *The Painter of Modern Life.* ("The Impressionists and Édouard Manet" begins by citing Baudelaire in order to establish its distance from him.) This means that Jean Clay is exactly wrong when he sums up Mallarmé's argument by saying:

Not to paint women, but *the way* these women are painted. Not faces, but that which, on these faces, is painting: makeup. To paint, not the structure of the model (bones, muscle), but the surface areas where the object offers itself as light sedimentation, and to render these sprinklings of powder by the powder of the pigment. Manet, in this respect, would have chosen to identify the object that he paints and the procedure that makes it possible to paint it. He would flatten the referent on the canvas, favoring in his choice of objects the rich surfaces that are already those of painting.

He also says: "The ultimate Mallarméan reversal: if the face is only worth something to the artist because it is already a painting (a painted/cosmetic surface), the painting in its turn is worth something as a face." Nothing could be more foreign to Mallarmé's meaning than this conflation of his thought with Baudelaire's, just as nothing could be farther from Manet's intentions as I've made them out than Clay's postmodernist assertion that his was "a borderline art, always reactive, with no other aim than to place all tradition, even its own, in an untenable position" (Jean Clay, "Ointments, Makeup, Pollen," *October,* no. 27 [Winter 1983]: 43, 8).

The First Impressionist Exhibition and Monet's *Impression, Sunrise*: A Tale of Timing, Commerce and Patriotism*

PAUL TUCKER

Impression, Sunrise has become inextricable from discussions of Impressionism, the movement to which it gave its name when it was exhibited at the first exhibition of the *Societé anonyme des artistes, peintres, sculpteurs, graveurs* in April 1874. Here Tucker considers both painting and exhibition within the social and historical climate of France following its defeat in the Franco-Prussian War. Monet left France during the war in which the Emperor Napoleon III was captured, Paris beseiged and finally conquered. Upon his return, Monet confronted the ravages of war as well as the occupation of his homeland by German forces. Many of his paintings of the 1870s depict subjects that bear witness to national recuperation, a theme discussed here as well as in Tucker's earlier book, *Monet at Argenteuil* (New Haven, 1982). In that book and in his subsequent *Monet in the 90s* (Boston, 1989), Tucker shows how the resurgence of nationalism that followed the Franco-Prussian War and continued to grow through to the end of the decade provided an important subtext for Monet's imagery.

This article also counters the common view of the first Impressionist exhibition as one universally mocked by the critical press: a point of view often summed up by one critic's comparison of *Impression, Sunrise* with "wallpaper in an embrionic state." Perhaps to enhance the achievement of the artists involved, art history has overemphasized the negative criticism—a point discussed here and subsequently developed in the exhibition catalogue, *The New Painting: Impressionism 1874–1886* (San Francisco, 1986). In fact, criticism was often positive, and the initiative of the artists who created a venue for exhibition independent of official sponsorship was widely praised. Given the humiliation that followed the Franco-Prussian War and the collapse of the Second Empire, France was clearly ready for alternatives to moribund traditions: the first Impressionist exhibition could not have been more appropriately timed.

*"The First Impressionist Exhibition and Monet's *'Impressionism Sunrise'*: A Tale of Timing, Commerce, and Patriotism," by Paul Hayes Tucker. *Art History,* vol. 7 no. 4, Dec. 1984. Reprinted by permission of Blackwell Publishers, Oxford.

The facts about the first Impressionist exhibition are well known.[1] It opened on 15 April 1874 on the second floor of number 35 boulevard des Capucines in the former studios of the notorious Parisian photographer Nadar. The thirty participants, led by the Impressionists Monet, Degas, Pissarro, Renoir, and Sisley, exhibited over two hundred works that were seen by about 4,000 people, including some rather unsympathetic critics. By the time it closed on 15 May, history had been made. For the first time, Paris had witnessed a large-scale independent exhibition of avant-garde art mounted as a direct challenge to the salon, the academy, and the official art world. Prompting seven more shows of these and other artists over the next twelve years, this first Impressionist exhibition became the symbol for the defiance of tradition and the emergence of a united modernist group.

However, in discussing the show, we have generally overlooked the fact that while a few critics gave the exhibition scathing reviews, more liked it than not. We also have not considered the show's relationship to public sentiment in the years after the Franco-Prussian War. And we have not fully understood the significance of Monet's *Impression, Sunrise*. Although it would emerge as the mocked paradigm for the show, the painting too should be seen in relation to the disasters of 1870 and 1871: that is the subject of this article.

Everyone felt the magnitude of the war and its aftermath. "The year which has just ended," wrote one journalist in January 1872, "will be for France one of the saddest and most painful. You have to go back five centuries in our history to find a year as ill-fated. . . . 1360 could be a match . . . the treaty of Brittany to the treaty of Versailles."[2] With the defeat by the Prussians, the loss of Alsace and Lorraine, the forced indemnity of five billion francs, and the destruction of the capital during the Commune, the analogy with the horrors of 1360 when British troops brought France to its knees in the Hundred Years' War was appropriate indeed.

To reinstate France's former glory and power, there was a widespread appeal to the general population for a return to seriousness, diligence, morality, and patriotism. Only through a country-wide commitment to a change of ways would the nation be able to recover and advance. Art was to play a role in this revitalization. "Today, called by our common duty to revive France's fortunes, we will devote more attention to . . . the role of art . . . in the nation's economy, politics, and education. . . . We will continue to back the cause of beauty so closely aligned to the causes of truth and good. And we will struggle for the triumph of those teachings which will help the arts to rebuild the economic, intellectual, and moral grandeur of France."[3]

This call had considerable effect. Scenes of reconstruction filled the popular press, where one could also find evocations of past art, sometimes as in the case of Géricault's *Raft of the Medusa*, transformed to fit the times. Military paintings increased in number and prominence at the salon. The salons themselves became forums for the reassertion of the country's cultural prowess

while salon critics focused on whether that prowess was present or not, almost everyone of course wanting it to be.

The official administration of the fine arts tried to insure that it was. Charles Blanc, the newly appointed Director of Fine Arts and his assistant Jules Simon (whose title had appropriately been changed in 1871 from Superintendent of Fine Arts to Ministère de l'Instruction Publique des Cultes et des Beaux-arts), instituted new, more rigorous salon rules. Those who had received *hors-concours* status were no longer automatically admitted, and, instead of being able to elect the entire jury from their ranks, participating artists could only vote for a minority of members, all of whom had to have been medal, honor or prix de Rome winners at past salons. The majority of the jury was made up of members of the Institute. As a result, there were half the number of works in the salon of 1872—the first salon held after the war—as there had been in the unrestricted salon of 1870.

The salon of 1872 was an important event, as Blanc and critics of all persuasions understood. It was the opportunity "to show jealous Europe all that the genius of France could produce in the aftermath of its defeat."[4] The reassertion of the country's artistic powers, of course, would be evidence of the nation's resurgence.

Unfortunately, for many, the salon did not fulfill these hopes. "Coming after the war and the terrible events of the past year," observed Jules Castagnary, "the show should have had an original and gripping make-up. Instead, it is absolutely devoid of character.... You walk around there not knowing what country you're in or what year it is. It doesn't have the soul or life of France."[5]

The salon did reflect the moment in a number of important respects. A large portrait of Adolphe Thiers hung in the first room of paintings, where one could also find military scenes drawn from the past or from the war. French heroes, heroines, and saints filled the sculpture garden, and at regular intervals patriotic music drifted over the arena provided by the Paris garrison band.

The music and the heroism, however, did not deter many critics from declaring that there were serious problems with the painters in the show—especially in comparison to the sculptors, whose evident skill, allegiance to nature, and patriotic subjects were widely seen as preserving the honor of French art.[6] The painters for the most part were treating banal or time-worn themes in ways that were either unoriginal or geared merely to appeal to the thousands who trooped through the exhibition. They appeared, to many critics, to be incapable of producing "la grande peinture" or the great artist. This had been a problem in previous decades—Thoré had even asserted as early as the 1840s that the quality of French painting was deteriorating—but in the years after the war, it provoked even greater concern. "What's lacking," wrote Jules Claretie, "what's been lacking for a long time now is the 'blé', the 'froment artistique' ... the genius."[7] Claretie felt painting was in a period of transition; other critics were much harsher. "It seems impossible to raise the old issue of the decadence of

our school without boring everyone," observed Théophile Silvestre, "but we should state and reinstate this cruel truth; we can't say it enough."[8]

The one category of painting that nearly everyone agreed was the "most fertile and the most remarkable" was landscape.[9] Even Charles Blanc had to agree, although he disliked landscape's lack of idealism.

The triumph of landscape, however, posed two major problems. First, views of quiet glades or rustic fields, no matter how they were rendered, could not be considered "la grande peinture." Second, many critics, even liberal ones, expressed concern about the genre. Its "level is very high but it oscillates between very restricted limits, which makes it difficult to say if it is declining or progressing. . . . It's like a stream which after having been raised by the sublime efforts of some great geniuses in the first half of this century is now suspended between the uncertainty of a new effort and the harshness of the fall."[10] Some critics went further. "As ill luck would have it, the triumphant landscape painters hardly change more than the soldiers in the circus."[11] Thus, with even the most acclaimed genre running into such critical difficulties, it was clear that painting was in a precarious state.

Charles Blanc thought he had a solution. In 1871, he decreed that the number of annual prix de Rome winners would be increased and that as part of their fellowship they would be obliged to copy great works throughout Europe. Their copies would be placed in a new museum that would be open to all for study. The museum hadn't opened by 1874 so the project had not had any effect.[12] Nor had his tighter salon rules. In fact, they had caused such furor when instituted in 1872 that Blanc permitted a separate salon of rejected works in 1873. The show reminded everyone of the infamous Salon des refusés of ten years earlier and unfortunately, it fared no better critically. "As for novelty, the fire, the brilliance, the great genius," wrote one critic, "alas, it is neither in the palace nor in the shed, neither in the Salon nor its counterpart."[13]

Even a more liberal salon in 1874 where artists were allowed to submit three works instead of two and where 3,657 works were accepted (as opposed to the 2,067 in 1872) did not seem to ease the frustration about painting and the salon forum. "The annual exhibition that just opened at the Palais de l'Industrie," wrote Charles Clement in May 1874, "is the last that will be held under the auspices of the fine arts administration. From now on, the artists will be free to do it themselves."[14]

Just a month earlier in April 1874, Blanc actually suggested in an article in *Le Temps* that such a change would be an improvement. "If the government exhibitions were not supermarkets, if the state organized its own, leaving the artists free to organize theirs, we would have a select, well-spaced salon."[15] Although his motivations were personal and political, it was clear that something had to change. The organizers of the first Impressionist exhibition understood this very well. Their show opened a week after Blanc's article appeared.

Monet and his friends founded the Société anonyme des artistes, peintres, sculpteurs, graveurs, etc. on 27 December 1873, more than six months after

they had gathered at the Café Guerbois and decided to pursue the idea of an alternative to the salon. The idea was not new, of course. Monet had thought about it in the 1860s and Courbet and Manet had mounted independent one-man shows before. But the general perception of painting's decline, the depression that hit France in the winter of 1873–1874, the increased dissatisfaction with the salon, and the widespread calls for leadership in the arts all made the moment right for such an undertaking.

Monet and his fellow organizers carefully planned their venture although they could not have foreseen the homage history would pay them. They had sympathetic critics announce the formation of the group in January of 1874, three months before the show was scheduled to open.[16] They intended their show to coincide with the salon but they chose 15 April as their opening date to upstage the salon by two weeks. They rented one of the most renowned artistic spaces in Paris, the studios of the photographer Nadar, and they sent out announcements to appropriate sources—newspapers, journals, art critics, and friends. They also made the exhibition space attractive, transforming Nadar's studios into a fashionable picture gallery with dark flocked wall covering and good lighting, both gas and natural. The artists kept long hours there—from ten until six and then from eight until ten in the evening. And they offered a ten percent discount for buying from the show. Marketing was clearly an important consideration.

The rules for the group were quite democratic. Everyone paid a membership fee, agreed to draw lots for hanging positions, and agreed to contribute all proceeds to a pool. The number of works a participant could show was theoretically governed by the amount he paid, two works per 60 francs. This rule, however, was not enforced as everyone only paid the 60 francs and nearly all exhibited more than the limit. Monet, for example, showed two seascapes, a landscape, a city view, an interior-genre scene, and seven pastels, attesting to his diverse talents. Bracquemond exhibited thirty-three works, eight of which were prints after paintings.

The make-up of the group was peculiar though calculated. The Impressionists and their friends comprised only half of the thirty participants. The other half was made up of people who have long since been forgotten, people like Attendu, Beliard, Colin, Levert, Meyer, and two Ottins (Auguste-Louis-Marie Ottin actually exhibited a bust of Ingres!). Although the idea of inviting more traditional artists caused some anger among the Impressionists—Degas wanted them more than Monet or Pissarro did—the result was effective. On the one hand, it gave the show an academic guise; on the other, it made the Impressionists' advances quite clear.

The idea proved quite successful, for most of the critics who reviewed the show mentioned the contrast in the group without discussing the traditionalists' work. The comments about the Impressionists' efforts, however, were not always kind; "The Salon des refusés was a Louvre in comparison to the exhibition on the boulevard des Capucines"; Monet's *Impression, Sunrise* was "less

finished than wallpaper in an embrionic state."[17] These derisive remarks have come to characterize the show's critical reception, and with some justification. There were some terrible things said: "Seeing the lot," wrote the critic for *La Patrie,* "you burst out laughing, but with the last ones you finally get angry and you're sorry you did not give the franc you paid to get in to some beggar."[18]

But these negative blasts must be set alongside the many positive comments that were made, sometimes even by the same critics. Louis Leroy, for example, who laughed at Monet's *Impression, Sunrise,* liked the same artist's *Déjeuner.* Castagnary, who felt that the Impressionists' technique and lack of finish was simply a mannerism that they would eventually be forced to abandon, found plenty to praise in Monet's *Boulevard des Capucines,* as did several other writers.[19] In fact, of the nineteen reports on the show, six were very positive, three were mixed, but generally positive; one was mixed but generally negative; four were negative; five were notices or announcements.[20]

Nearly everyone hailed the organizers' efforts. Emile Cardon who made the above reference to the Salon des refusés claimed "the sketches of this new school are disgusting," but asserted that the show "represented not just an alternative to the salon, but a new road . . . for those who think art, in order to develop, needs more freedom than that granted it by the administration."[21]

The administration, the Ecole des Beaux-arts, the salon, and academic painters were frequently chided. Emile d'Hervilly in his review of the show which appeared in *Le Rappel* just two days after the opening, called the administration and the salon jury "the two cripplers of French art."[22] "Instead of the rhetoric taught at the Ecole des Beaux-arts," the Impressionists' show, in his opinion, was filled with "fresh," "gripping" works whose "generous exaggerations are even charming and consoling when one thinks of the nauseating banalities of the academic routine." Monet's pictures, he claimed, were rendered with "infinite grace and spirit." His *Boulevard des Capucines,* for example, was a "kaleidoscope of 'la vie parisienne'." "One cannot encourage this daring undertaking too much," he concluded, an event he claimed critics and amateurs had been recommending for a long time.[23]

D'Hervilly's review was followed by three more in the next four days, all of which expressed support for the show. The most comprehensive came from the pen of Armand Silvestre, who had already written favorably about Monet, Pissarro, and Sisley in Durand-Ruel's catalogue of gallery artists the year before. From that catalogue, Silvestre excerpted a section that sensitively distinguished the differences between the three Impressionists: Monet was "the cleverest and the most daring," Sisley, "the most harmonious and the most timid," and Pissarro, "the most real and the most naive."[24] His support in 1874, however, was not unreserved. He was uneasy, for example, about their exclusive pursuit of the impression and their apparent belief that everything in the world was beautiful and worth rendering. But at the same time, he felt that "their vision which does not resemble any master of the past is affirmed with a conviction that cannot be slighted," that "their pleasant colors and charming

subjects will extend their influence," and, most important, that "the means by which they seek their impressions will infinitely serve contemporary art." "It is the range of painting's means that they have restored. . . . And don't believe that this makes the palette a banal percussion instrument as one might initially think. . . . You need special eyes in order to be sensitive to the subtlety of their tonal relations, which constitute their honor and merit."[25]

The suggestion that this new art would advance French painting was echoed by Jean Rousseau, Philip Burty, and Ernest Chesneau, all of whom felt the group had powers that the academics lacked. Rousseau, though more reticent than the others, still asserted that "it would be necessary to bless all the brutalities of the Impressionists if they delivered us from the insipid perfection of Bouguereau."[26] Burty claimed the Impressionists had "already conquered those who love painting for itself."[27] Chesneau thought the show was premature but that in "a couple of years the Impressionists will triumph because of their conviction and their open quarrel with all traditional conventions."[28]

There was a novelty in particular about Monet's paintings that Chesneau found exhilarating. "Never," he asserted, "has the northern light of day ever been rendered with the power found in Monet's *Déjeuner*. Never has the prodigious animation of a public street . . . the agitation of the trees along the boulevard in the light and dust, the intangible, the fugitive, the instantaneous . . . ever been understood and fixed with such prodigious fluidity as in this extraordinary, marvelous sketch . . . the *Boulevard des Capucines*. We salute a masterpiece." The latter was still an "ébauche" for Chesneau, "a chaos of indecipherable palette scrapings," something that had to be transformed into a finished piece, but "what a 'coup de clarion' for those who have a subtle eye and how far it goes along the way into the future."[29]

Monet's *Impression, Sunrise*—which for future generations came to represent Impressionism and which according to legend (and Louis Leroy's comments) gave the movement its name—was passed over by most serious reviewers; it was discussed only five times, each briefly. Chesneau simply said he hardly stopped in front of it.[30] There are several ironies to this. John Rewald has suggested that the painting in the show was not the famous Marmottan canvas (Fig. 25), but rather a picture which is now in a private collection in Paris.[31] Monet exhibited the Marmottan painting in the third Impressionist exhibition in 1879, something he would not have done—according to Rewald—if the work had been in the 1874 show, as Monet never repeated his submissions. Rewald also points to Monet's description of the 1874 entry as having "pointing shipmasts in the foreground" which the Marmottan version lacks, and to the sun which he felt appeared to be setting in that picture rather than rising.

Unless new documents come to light, we probably will never know for sure, but other evidence makes it likely that the Marmottan picture was the famous canvas. It was identified as such by two eminently qualified sources: Monet's friend and earliest biographer Gustave Geffroy in his article on Impres-

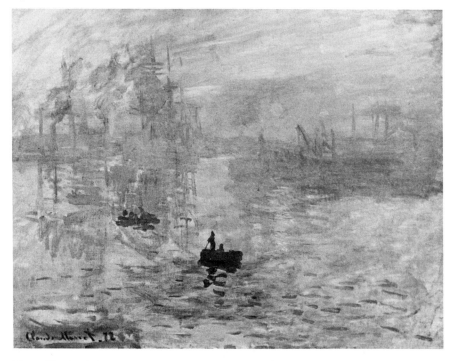

Figure 25 Claude Monet, *Impression, Sunrise,* 1872. Musée Marmottan, Paris.

sionism for the *Revue Encyclopédique* of 1893 and the art critic and supporter of Impressionism Théodore Duret in his *Histoire des Peintres Impressionnistes* of 1906.[32] In addition, there is no compelling reason to believe Monet was so doctrinaire that he would not repeat a submission, especially if it were a picture of the Marmottan's quality. Furthermore, Monet's description of the painting that Rewald cites was actually a distant recollection that the artist made more than thirty years after the fact.[33] Finally, the sun is in fact rising, as is evident from a study of the site.

The picture shows the avant-port of Le Havre, as a photograph of the area taken at the turn of the century reveals (Fig. 26). Monet is standing on the jetty that he and Boudin had painted many times before, but now, instead of looking north out to the channel as he had in earlier views, he turns to the east, to the commercial wharfs of Le Havre and to the rising sun. Unlike the photographer, Monet has concentrated only on the area to the right of the jetty, showing more of the dock that protrudes out from that side while cropping the houses we see in the photograph on the left. Behind the masts of tall clipper ships on the left in Monet's picture are not trees but the smoke stacks of packboats and steamships while on the right in the distance are other masts and chimneys silhouetted against the sky. In the middle ground, smaller fishing boat masts or cranes also

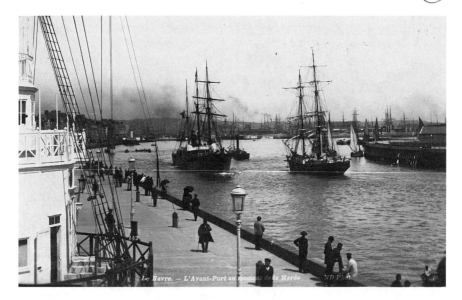

Figure 26 Photograph of the avant-port of Le Havre, ca. 1900.

break the horizon while in the foreground two small rowboats float on the rip-pling water.

The steamboats spouting their clouds of smoke are yet another apparent paradox in this picture, as they seem in such contrast to the quiet beauty of the scene. However, they suggest the final and most poignant irony—that Monet may have seen this painting of a highly commercial site as an answer to the postwar calls for patriotic action and an art that could lead. For while it is a poem of light and atmosphere, the painting can also be seen as an ode to the power and beauty of a revitalized France.

Monet, of course, had not been around during the Franco-Prussian War or the Commune, having fled the country in the summer of 1870, staying first in London and then in Holland. He returned only in the late summer or early au-tumn of 1871. However, he had not been unconcerned about the situation. "We've been completely without news of Paris since we left London," he wrote to Pissarro in June 1871. "It's impossible to get a French newspaper here. I hope to have one tomorrow."[34]

Monet must have felt some pangs of sorrow when traveling from Holland to Paris across countryside that had only recently been evacuated by the enemy, for he arrived at the capital to find the newspaper reports of destruction to be true. Similar pangs must have struck him when he left Paris to settle in Argenteuil, a town that lay just eleven kilometers to the north. Argenteuil had been occupied by the Prussians and had lost its railroad and highway bridges, the latter having been burned by the French themselves as they retreated to the capital.[35]

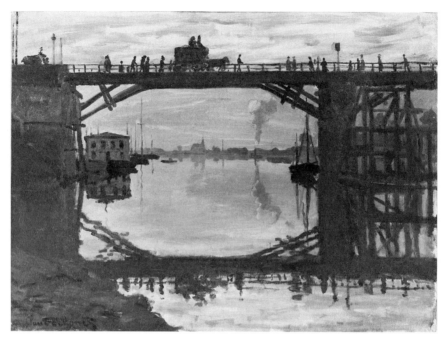

Figure 27 Claude Monet, *The Highway Bridge,* 1872. Private collection, France.

However, when Monet paints the highway bridge soon after he arrived (Fig. 27), it is not the painful reminder of France's defeat. The bridge is under reconstruction and open to traffic. Indeed, the interlocking timbers of the scaffolding, the clarity and precision of the euclidean-like square of the first span, the steamboat bellowing smoke, the factory chimneys and the calm waters all seem to speak about France after the war, rebuilding her monuments, reopening her lines of communication, revitalizing her economy, and restoring order. There is none of the frivolity of *La Grenouillère* here and none of the exaggerated brushwork of the prewar paintings. This is serious stuff, with restrained application of paint, clear definition of form and soothing color.

Although Monet never expressed his concerns explicitly, he painted many pictures just after he returned to France that support a contextual reading of this kind: *The Pont Neuf* (1872, private collection, England) for example, where the steamboat appears once again, now spouting smoke in front of the oldest bridge in Paris, a kind of homage perhaps to the past and a statement of confidence about the present. Or *The Bridge Under Repair* (W.194), *The Path Through the Vineyards* (W.219), *The Promenade* (W.221), or, most strikingly, *The Train* (Fig. 28), a scene so full of smoking factories that it seems more like the urban industrial sprawls of Gary, Indiana, or of Pittsburgh. There are three other purely industrial scenes that Monet rendered in the same year—*The Factories*

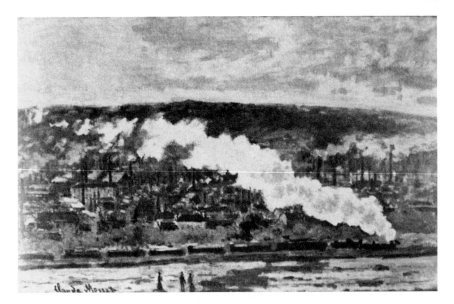

Figure 28 Claude Monet, *The Train,* 1872. Private collection, England.

at Robec (W.206) and two pictures which are now lost (W.214 and W.215)—
and at least half a dozen additional works that reveal the presence of industry or
progress in the landscape, as if Monet was presenting a St Simonian utopian
world as the logical choice for his defeated country.

Not since his *Industrial Landscape* (W.5) from the first years of his career
was Monet ever so involved with this theme of industry and progress. And
never had he been more successful. In 1872, he sold *The Highway Bridge* to
Manet, *The Train, The Path Through the Vineyards,* one of the lost industrial
landscapes, and a good number of other pictures to Durand-Ruel, as well as sev-
eral works to other collectors. That year he earned more than 12,000 francs, a
considerable sum since doctors and lawyers in Paris at the time were only mak-
ing 9,000–10,000. There obviously was a market developing for his work and a
growing interest in subjects of a serious but progressive nature.

Impression, Sunrise, painted most likely in the same year of 1872 must be
seen in the same context. It shows a site that all Frenchmen would have been
proud of and seems to celebrate the renewed strength and beauty of the country,
just as the critics had called for. In fact, it could be understood as Monet's ulti-
mate utopian statement.

Anyone who lived in France in the early 1870s knew that Le Havre was
one of the busiest ports in the country,[36] It actually had grown so much in the
1860s—a growth that Monet would have seen from suburban Sainte-Adresse—
that it had become the second largest port in France just behind Marseilles. It
moved more than 2,700,000 tons of cotton, sugar, machinery, and dry goods,

handling more than 2,500 ships a year. To accommodate this traffic, the town had enlarged its docks during this decade and between 1858 and 1868 had built 160 warehouses capable of holding more than 120,000 tons of merchandise along the docks to the east (just to the right of center in Monet's picture).

The ocean-going vessels, steamships, and packboats that Monet includes in his scene together with the dark forms along the horizon to the right all testify to the city's commercial prowess. This is emphasized particularly by the many vertical and diagonal boat members, which like emblems stretch toward the emblazoned sky, itself apparently energized by the smoke which gushes from the boats' boilers below. Beyond these smokestacks and masts, according to contemporary maps of the area were a number of substantial industries, as Le Havre was also a highly industrialized city with huge iron, machine, cotton, and cable factories. Many of these had been established in the early part of the century, but like the port they had increased tremendously from midcentury onwards. One of the largest concerns, the Mazeline Machine Company, by the later 1860s was employing over 1,000 workers. It was located just to the left of Monet's misty background.

To the right, there appears to be less shipping activity, although there are a number of vertical and diagonal lines on the wharf that juts into the scene. This area in the 1870s was actually not being used as a docking place; instead, it was under construction, part of an enormous expansion of the avant-port that had been approved before the war, begun shortly after the armistice was signed, and not completed for five years. Such public undertakings were widely seen as proof of the country's resilience. That Monet so unabashedly includes it perhaps attests to his shared sentiment, a suggestion made stronger by the fact that the construction site is neatly located between the rising sun and its reflections, as if this orange orb distributing the promises of a new day is rising above the tangible evidence of renewed hope and strength.

The sense of renewal or of becoming is felt in the picture as a whole: in the sun's clear spherical penetration of the mist, in its dappled reflections which pull it forward, in the billowing smokestacks on the left and that side's contrast with the right, a contrast between the throbbing, established wharfs with their prominent verticals, more distinct forms, and broader though paler sky versus the not yet realized docks on the right with their shorter, stubbier thrusts, denser atmosphere, but more vibrant sky. Appropriately, the energy of the scene seems to emanate from the left and culminate on the right; the paler gray of the sky on the left rendered in horizontal zig zag strokes leads the eye across the picture to the thicker slightly diagonal strokes of bolder orange-yellow above the sun to the right. Below, in the water, the curved strokes in the middleground on the left mirroring those of the smoke above them lead from the small dark middle boat to the bolder one in the foreground and then to the more independent blue-green touches on the right that enclose the docks under construction like the brightening sky above.

This progressive, consummately beautiful scene, where man clearly has his place, strongly recalls Turner, or even more appropriately the port views of Joseph Vernet and Claude Lorrain, an apt combination for Monet of nineteenth-century innovation and French tradition. And, like these past masters, Monet idealizes his scene; Le Havre was not in fact a very attractive city, as various guidebooks of the 1850s and 1860s pointed out: "You find less interesting architecture there, less evidence of the human spirit in the scientific realm, fewer refined customs . . .; it is an industrial commercial foyer of mercantile activity with a population devoted entirely to the cult of circumflex business."[37] It was precisely that cult that fascinated Zola's Roubau in *La Bête humaine* when as a railroad engineer he arrived at Le Havre just after six in the morning. "He was not very interested in the passenger station but concentrated above all on the dock traffic and the enormous trans-shipment of cargo and its continuous movement to and fro between the big commercial concerns in Le Havre and places all over the world. . . . The factory chimney's were smoking away and there were huge stacks of coal in the depots alongside the Vauban dock. Noise of activity was already rising from the other docks as well."[38]

That activity, of course, was especially important in the years after the war, particularly as France had lost two of its most important industrial areas of Alsace and Lorraine. But as Monet suggests, the French economy did surge forward in 1872—so much so that the country in an extraordinary public outpouring was able to repay half of its five billion franc indemnity to Germany by March 1873 and the second half, unbelievably, by September of the same year. It was only then that the German soldiers who had been occupying sixteen departments in the country finally left French soil, an evacuation which prompted considerable relief and which stimulated images in the popular press that spoke in clear metaphors about the new day for "la belle France."

It is perhaps surprising that no one saw Monet's painting in this way, although it is more remarkable that so few even mentioned the work. Sunsets and sunrises, of course, had been the stock-in-trade of landscape painters for centuries, and there is little doubt that the apparent banality of the scene together with the critics' paramount interest in the radical style of the Impressionists' work accounts for their silence. Since then, the painterly verve of the picture and the sheer beauty of the scene have prompted ideas—rightly enough—about Monet's personal relationship to nature and his novel technique. But it is hard to believe that Monet's efforts to capture this particular moment in time were not inspired, at least in part, by France's post-war efforts and her hopes for a new day and that he was unaware of the associations his work had with past art, associations that were also pertinent for French painting after the war. Ironically, the popular artist Gill in *L'Eclipse* of 12 April 1874, just three days before *Impression, Sunrise* went on view, proposed a painting for the upcoming salon that seems to express a similar sentiment, albeit in different terms (Fig. 29).

Figure 29 Gill, *Pleine Mer! L'Eclipse,* 12 April 1874.

More introverted and at the same time more expansive, Monet's painting, while capturing all the glories of the dawn, likewise contains all the complexities of the moment. It testifies on the one hand to Monet's romantic pursuit of beauty. "You'll find beautiful things to paint in France," he reminded Pissarro while in exile in 1871, "the country's not lacking in that regard."[39] On the other hand, it perhaps reveals his patriotic vision of his sobered, rejuvenated homeland, making it an apt paradigm indeed for the new art movement and its first group show.

NOTES

1. John Rewald was the first to document the first Impressionist exhibition in his *History of Impressionism,* New York, 1946. His pioneering efforts have been the basis for all subsequent studies, the most important of which are: Hélène Adhémar and Sylvie Gaché, 'L'Expostion de 1874 chez Nadar,' *Centenaire de l'Impressionnisme,* Paris, 1974, pp. 221–270; Ian Dunlop, "The First Impressionist Exhibition," *The Shock of the New,* New York, 1972, pp. 54–87; Daniel Wildenstein, *Claude Monet, biographie et catalogue raisonné,* Paris, 1974, pp. 65–70; Jacques Lethève, *Impressionnistes et symbolistes devant la presse,* Paris, 1959, pp. 59–70; Joel Isaacson, *The Crisis of Impressionism,* Ann Arbor, 1980, pp. 2–4; Ralph T. Coe, "Claude Monet's *Boulevard de Capucines:* After a century," *The Nelson Gallery and Atkins Museum Bulletin,* February 1976, pp. 5–16; Lionello Venturi, *Les Archives de l'impressionisme,* II, Paris, 1939, pp. 255–256. I am also indebted to Carl L. Baldwin, "The Salon of 1872," *Art News,* May 1972, 20ff.

2. Daleria, "1871," *L'Opinion Nationale,* 1 January 1872, p. 1.

3. Emile Galichon, "A nos lecteurs," *Gazette des Beaux-Arts,* October 1871, pp. 281–283, as quoted and translated in Baldwin (n. 1), 20.

4. Claudius Stella, "Salon de 1872," *L'Opinion Nationale,* 11 May 1872, p. 1.

5. Jules Castagnary, "Salon de 1872," *Le Siècle,* 11 May 1872, pp. 1–2.

6. This reaction—the first of its kind for the Paris salon—is set out by Ruth Butler, "Rodin and the Paris Salon," *Rodin Rediscovered,* Washington, 1981, pp. 24–28 and 47, n. 1. The decline of French painting is discussed by Joseph C. Sloane, *French Painting between the Past and the Present,* Princeton, 1951, pp. 37–47, and in Sloane, "The Tradition of figure painting and concepts of modern art in France from 1845 to 1870," *Journal of Aesthetics and Art Criticism,* VII, 1948, pp. 1–29; Anne Coffin Hanson, *Manet and the Modern Tradition,* New Haven, 1977, pp. 4–9.

7. Jules Claretie, "Salon de 1873 (fin)," *Le Soir,* 26 June 1873, p. 3. Thoré had declared "that after the death of the heroic school of the Empire, and the birth of two new schools, that of Géricault and Delacroix and that of Ingres, French painting was without system, without direction, and abandoned to individual fantasy." Théophile Thoré (W. Burger pseudonym), *Salons,* Paris, 1868, pp. 114–115 as quoted in Hanson (n. 6), p. 7.

8. Théophile Silvestre, "Salon de 1874," *Le Pays,* 8 May 1874, p. 2.

9. Armand Silvestre, "Salon de 1873-Peinture-Le Paysage," *L'Opinion Nationale,* 29 May 1873, p. 3; or Jules Guillemot, "Salon de 1874," *Le Soleil,* 13 June 1874, p. 3. For Blanc's opinion see Charles Blanc, "De l'Etat des Beaux-Arts en France à la veille du Salon de 1874," *Le Temps,* 7 April 1874, p. 3.

10. Armand Silvestre, "Salon de 1873-Peinture-Le Paysage," *L'Opinion Nationale,* 1 June 1873, p. 3; or Ernest Chesneau, "A côté du Salon-Chintreuil," *Paris Journal,* 6 May 1874, p. 2. This rise of landscape had been going on for many years. See, for example, Sloane (n. 6), pp. 104–106.

11. Jean Rousseau, "Le Salon," *Le Figaro,* 31 May 1874, p. 1.

12. Blanc (n. 9).

13. Jules Claretie, "Salon de 1873-salon des refusés," *Le Soir,* 31 May 1873, p. 2.

14. Charles Clement, "Exposition de 1874," *Journal des Debats,* 5 May 1874, p. 1.

15. Blanc (n. 9).

16. The first mention of the group's formation was made by Armand Silvestre, "Chronique des Beaux-Arts," *L'Opinion Nationale,* 25 January 1874.

17. Emil Cardon, "Avant le Salon-L'Exposition des Revoltés," *La Presse,* 29 April 1874, pp. 2–3. Louis Leroy, "L'Exposition des Impressionnistes," *Le Charivari,* 25 April 1874, p. 80.

18. *La Patrie,* 21 April 1874, as cited in Dunlop (n. 1), p. 78.

19. Castagnary, "L'Exposition du Boulevard des Capucines-Les Impressionnistes," *Le Siècle,* 29 April 1874, p. 3. Other writers who liked Monet's *Boulevard des Capucines* include Ernest Chesneau, "A côté du Salon, II, Le Plein Air, Exposition du Boulevard des Capucines," *Paris Journal,* 7 May 1874, p. 3; E. d'Hervilly, "L'Expositon du Boulevard des Capucines," *Le Rappel,* 17 April 1874, p. 2; Léon de Lora, "Petites nouvelles artistiques-exposition libre des peintres," *Le Gaulois,* 18 April 1874, p. 3; Jean Prouvaire, "L'Exposition du Boulevard des Capucines," *Le Rappel,* 20 April 1874, p. 3.

20. The six very positive reviews are: Philippe Burty, "Chronique du jour," *La Republique française,* 16 April 1874, p. 2; E. d'Herville, "L'Exposition du Boulevard des Capucines," *Le Rappel,* 17 April 1874; p. 2; Léon de Lora, "Petites nouvelles artistiques-exposition libre des peintres," *Le Gaulois,* 18 April 1874, p. 3; Jean Prouvaire, "L'Exposition du Boulevard des Capucines," *Le Rappel,* 21 April 1874, p. 3; "Echos de Paris," *Le Figaro,* 24 April, 1874, p. 2; Philippe Burty, "Exposition de la Société anonyme des artistes," *La Republique française,* 25 April 1874, pp. 2–5; Emil Cardon, "Avant le Salon," *La Presse,* 28 April 1874, p. 3.

 The three mixed but generally positive reviews are: Armand Silvestre, "Chronique des Beaux-Arts-l'exposition des revoltés," *L'Opinion Nationale,* 22 April 1874; Jules Castagnary, "Exposition du Boulevard des Capucines—les impressionnistes," *Le Siècle,* 29 April 1874, p. 3; Ernest Chesneau, "A côté du Salon, II, Le Plein Air, Exposition du Boulevard des Capucines," *Paris Journal,* 9 May 1874, p. 2. The one mixed but generally negative is Marie-Ametie Chartroule (Marc de Montifaud pseudonym),"Exposition du Boulevard des Capucines," *L'Artiste,* 1 May 1874, pp. 307–313.

 The four negative reviews are: *La Patrie,* 21 April 1874; Louis Leroy, "L'Exposition des Impressionnistes," *Le Charivari,* 25 April 1874, p. 80; Emil Cardon, "Avant le Salon-L'Exposition des Revoltés," *La Presse,* 29 April 1874, pp. 2–3; Jules Claretie, *L'Independence belge,* 13 June 1874.

 The five announcements appeared in *Le Constitutionel* 13 April 1874, p. 2; *Paris à l'Eau-Forte,* 19 April 1874, pp. 12–13; *Le Journal* Amusant, 25 April 1874, p. 3; *L'Opinion Nationale,* 2 May 1874, p. 3; *La Patrie,* 14 May 1874, p. 2.

21. Cardon (n. 17).

22. D'Herville (n. 19).

23. Ibid.

24. Silvestre (n. 20).

25. Ibid.

26. Rousseau (n. 20).

27. Burty (n. 20).
28. Chesneau (n. 19).
29. Ibid.
30. The five people who mentioned Monet's *Impression, Sunrise,* were: Leroy, Montifaud, Castagnary, Chesneau, and Silvestre.
31. Rewald (n. 1) 4th revised edition, 339, n. 23.
32. Théodore Duret, *Histoire des Peintres Impressionnistes,* Paris, 1906, p. 83. Gustave Geffroy, "L'Impressionnisme," *Revue Encyclopédique* III/73, 15 December 1893, column 1221. Other writers to accept the Marmottan version are: O. Reuterswald, *Monet,* Stockholm, 1948, p. 65; L. Degand and D. Rouart, *Claude Monet,* Geneva, 1958, p. 54; M. Serullaz, *Les Peintres Impressionnistes,* Paris, 1959, pp. 5–6, 71; William Seitz, *Monet,* New York, 1960, p. 92; R. Niculescu, "Georges de Bellio," *Revue Roumaine d'Histoire de l'Art,* I, 1964, no. 2, pp. 263–264, "Georges de Bellio, l'ami des impressionnistes," *Paragone,* 247, September 1970, pp. 32, 53, and "Georges de Bellio, l'ami des impressionnistes," *Paragone* 249, November 1970, pp. 62–63; François Daulte, Claude Richebé, *Monet et ses amis,* Paris, 1971, no. 5; Denis Rouart and J.D. Rey, *Monet-Nympheas,* Paris, 1972, p. 87; Anne Dayez, *Impressionism, A Centenary Exhibition,* New York, 1974, pp. 151–153; Daniel Wildenstein (n.1). M. Bodelson, "Early Impressionist Sales, 1874–94 in the light of some unpublished procès-verbaux," *Burlington Magazine,* CX, June 1968, p. 335 is the only writer to side with Rewald.
33. Monet's recollection was made to Maurice Guillemot, "Claude Monet," *Revue illustré,* 15 March 1898.
34. Monet to Pissarro, Zaandam, 2 June 1872, as cited in Wildenstein (n. 1), p. 427.
35. For the history of Argenteuil and an analysis of Monet's work there see my *Monet at Argenteuil,* London, 1982.
36. On Le Havre see Eugène Chapus, *De Paris au Havre,* Paris, 1855; Frédéric de Coninck, *Le Havre, son passé, son present, son avenir,* Havre, 1869; Felix Faure, *Le Havre en 1878,* Havre, 1878; J. Morlent, *Le Havre en miniature,* Havre, n.d.; Th. Nègre, *Le Havre, étude de géographie urbaine,* Havre, 1947; "Les travaux de l'avant-port au Havre," *L'Illustration,* LXIII, 18 April 1874, p. 247.
37. Chapus (n. 36).
38. Emile Zola, *La Bête humaine,* trans. Leonard Tancock, Harmondsworth, 1977, pp. 83, 81.
39. Monet to Pissarro (n. 34).

Edgar Degas
and the Representation
of the Female Body*

CAROL M. ARMSTRONG

⌐Other articles included in this anthology have dealt with the female nude by considering the social/historical context or biographical/psychological implications. Armstrong brings us back to the image to discuss its three essential components: the implied (presumably male) viewer, the form, and the facture. Armstrong's article might also be considered with Tucker's discussion of the first Impressionist exhibition, since Degas exhibited a series of nudes at the last Impressionist exhibition of 1886. Although art historians stress the presence at that exhibition of Georges Seurat's *Sunday Afternoon on the Island of the Grande Jatte* in 1886, it was Degas's nudes that inspired the most vocal critical response, discussed by Martha Ward in her essay on the exhibition in *The New Painting: Impressionism 1874–1886* (San Francisco, 1986).

Armstrong's analysis of these nudes within the context of tradition and of selected paintings by Degas helps us to understand their original impact. Two earlier paintings, *The Spartan Youths* and *The Interior,* take the juxtaposition of male and/or female as their subject. If the interaction of the two in *Spartan Youths* is somewhat ambiguous, in *The Interior* it is not. The main theme is the male gaze, or the male subject that objectifies the woman beheld. In the 1886 series, the role of the male viewer would be challenged by the positioning of the self-involved females and by the breakdown of any traditional perspectival system, which might provide the viewer a fixed vantage point.

Degas' challenge to conventions of visual appropriation goes further. Armstrong's analysis of the *Bather* of 1885 demonstrates how Degas's presentation in fact deflects the gaze. The nude is deployed to resist easy access, as the facture—which itself has been related to the touch or even caress of the female body—functions autonomously from that form, and in certain passages even threatens to obliterate it. These traits, further developed in the series exhibited in 1886, have been identified with a misogynist treatment of the female nude. But, is it correct to give such a label to the artist who first interrogated and destroyed the domination of object (the nude) by subject (the male viewer)? Arm-

strong's qualification of the structure as celibate rather than misogynist seems far more appropriate to these works.

In Western painting the female body has a genre all its own, that of the female nude. As the master genre of the official French salons of the nineteenth century,[1] it can be said to have been conceived as a genre with no other purpose but the deployment of the gaze and the brush—the "pure" acts of looking, forming, touching, painting, whose aim was to display as much while meaning as little as possible, to aestheticize and idealize the gaze and the object of delectation, and to metaphorize tactile response through facture and formal rhymings. The female nude would come to constitute one of the principal leitmotifs of avant-garde practice, from Courbet to Matisse and Picasso; and it is no wonder that the erotic appropriation of the body in paint would so easily lend itself to aestheticization and abstraction.[2,3] That potential was there from the very beginning of the genre.

One of the things any painted object does is to resist signification at some level because of its very objecthood. And the female nude—because of *its* objecthood—may be seen as almost emblematic of that level of resistance. In fact, the female nude has been linked to that stratum of painting most in tension with the work of signification—the stratum we connect to what we call, inadequately, "abstraction": facture, the handling of paint per se, foregrounded as an obvious fact of the painting. Femaleness and facture, facture and the female nude, they go together somehow. One need think only of Titian, the first great painter of the female nude in the Western tradition.

The link between facture and the female body was made, in Titian's case, by Paul Valéry:[4] "It is easy to see that for Titian, when he painted Venus in the plenitude of her perfection *as goddess and as painted object . . . to paint was to caress,* to join two kinds of sensuality in one sublime act, in which possession of the Beauty through all the senses was joined" (italics mine).** Valéry's passage is about the erotic possession of the female body, thematized in the painting of the female nude. But it also states a relationship between the female body, the corporeality of the act of painting, and the physicality of paint itself, between gaze and painterly touch, viewed body and painted object; thus, at least implicitly, it emphasizes facture as an issue.

The female nude was also linked to the other level of painting that we connect to "abstraction"—to form per se. Valéry had this to say about Ingres, the nineteenth-century master of the female nude and the artist whom Degas

**Unless otherwise noted in the References, the English translations from the French are mine.

most admired: "M. Ingres pursues grace to the point of monstrosity; the spine is never supple or long enough for him, the neck never flexible enough, the thighs never slick enough, or bodily curves conducive enough to the gaze which envelops and touches them as it sees them." Grace, long spine, flexible neck, slick thighs, curves and contours: this is the language used by Valéry to describe Ingres's nudes. The gaze turned on the female nude in this case (and the disembodied touch which it implicates) is an eroticized gaze, but it is also a highly aestheticized one. In fact, eroticism and aestheticization are here inextricably linked—*form* is declared as the object of the erotic gaze. If one considers just these two passages and these two painters, it would seem, then, that the female body in Western painting, or at least the female nude as a genre, is purely a matter of facture and form, and that formalist practices of criticism would be and have been more appropriate to it than semiotic ones.

The justice of this view is suggested in another passage by Valéry on Degas's nudes. In the same text that I have been quoting, Valéry treats Degas's engagement with the nude thus: "All his life, Degas sought in the Nude, observed from all sides, in an unbelievable quantity of poses . . . the unique system of lines that would formulate any given moment of the body with the utmost precision and the utmost generality."[5] According to Valéry—and in this respect his is a common modern judgment—Degas's treatment of the female nude was particularly formalist (elsewhere Valéry calls Degas an "abstract artist";[6] But, again according to Valéry, Degas's formalism was peculiar: of a structural, systematic nature, grounded in the study and formulation of the body's movements, and hence of its dematerialization into motion and design, it seemed to be both antierotic and genderless, or at least androgynous—a fusion of the terms of the male and the female body. This too was a common judgment about Degas and the female nude.

Valéry's commentary is important because it is representative of the formalist attitude toward Degas's nudes. Another well-known writer, whose very different judgments about Degas and the female body are significant, is Joris-Karl Huysmans:

> not just a case of a man's wavering distaste for women—it is even more than that—it is the penetrating, sure execration that these women themselves feel for the deviated joys of their own sex, an execration which fills them with atrocious desires and leads them, all on their own, to soil themselves, proclaiming loud and clear the humid horror that they feel for their own bodies—which no lotion, no amount of cleaning, will clean.[7]

Countless critics contemporary to the artist argued for a case of misogyny; Huysmans's piece on Degas's nudes of 1886 was merely the most notorious and explicit of these arguments.[8] On the other hand, many writers since then have argued against the case of misogyny; Huysmans's text is the basis of the best of the recent counterarguments, that of Edward Snow, who claims that it is the male

viewer, not the female body, whose position is made deeply problematic in Degas's nudes.[9] It is not my concern to argue for or against Degas's misogyny; based on a sentimental fascination with the artist's biography rather than on an engagement with his complicated representational concerns, this debate is a highly reductive one—in fact, I believe that the pronouncements of critics like Huysmans and Snow may be considered as two sides of one representational coin. It *is* my concern to show how the questions of form and facture as attached to the female nude and the notion of the antierotic representation of the female body may be juxtaposed, with an eye toward understanding the significance of the formalism of the female nude, both as a genre and in this one artist's practice.

I have chosen to write about Degas's oeuvre because he was the "classical" painter of the female body of the nineteenth century, preoccupied with its representation almost to the exclusion of all else; and he was the one "avant-garde" painter, besides Manet, his closest contemporary, who responded critically to the master genre of official painting, the female nude. In the following study of a selected group of his works, I would like to show that Degas's nudes may be seen as a deliberate revision of the syntax of the female body and of the structure of viewing in which it was traditionally situated; that they may be seen as describing a relationship between viewer, space, and body that speaks to the traditional positioning of the *male* body, the meaning of its exteriority, its projection into a field of vision, and ultimately into disembodiment and invisibility; finally, that they problematize the formalism of the female nude, and the meaning of its apprehension through form and facture. These are all; as I also intend to show, connected issues.

Degas's treatment of the female body begins with an engagement in history painting and genre pictures, in other words, with the female body inserted into narrative and anecdotal situations. In both cases Degas begins with references to neoclassical compositions and to the repertoire of gender conflict associated with history painting. Instances of each are found in the *Spartan Youths* of 1860 (Fig. 30), Degas's first and most important history painting, and in *The Interior* (more luridly known as *The Rape*) of 1868 (Fig. 31), which the artist termed his "genre painting." Both images purport to illustrate scenes from texts, one classical, *The Life of Lycurgus*,[10] one realist, Duranty's *Les Combats de François Duquesnoy* (or alternatively Zola's *Thérèse Raquin*).[11,12] In both the artist appropriates a format associated with David's history paintings—the rifted, divided-down-the-middle, frieze-space format of *The Oath of the Horatii*, for example. As in David's imagery, both paintings depict the matching-off of the sexes, though in neither case is there a public message to justify the gender-conflict theme.

Indeed, in *The Spartan Youths* the opposition between male and female, which is the staple of much history painting and such an important element of David's pictures, is thematized to the exclusion of all else. This painting is a rehearsal rather than a significant event, a simple scene of athletic practice; there is no story to be told here. The oath represented by David in the unified, stiff-

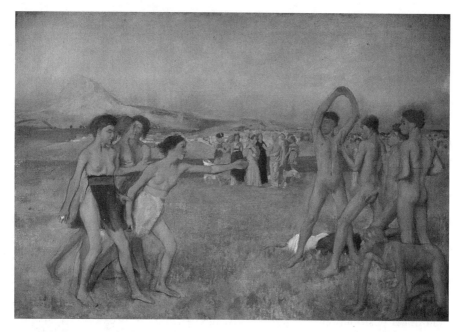

Figure 30 Edgar Degas, *The Spartan Youths,* 1859–1860. National Gallery, London. Photo: Bridgeman/Art Resource.

armed gesture of the sons of Horatius at the crucial moment of the story (the moment when the Horatii swear to fight to the death the representatives of the opposing kingdom, the three sons of Curatius, in defense of Rome) is transformed into a nonnarrative gesture of challenge made from the female to the male half of the painting. There is no narrative context for the opposition of the sexes; it is simply the theme of *The Spartan Youths.*

In *The Interior* Degas refers once again to the Davidian composition, to the oppositional format replete with the looming gap in the middle, here resonating with lurid orthogonals—the lines of the floorboards which, in the traditional single-point perspective system, would have marked the viewer's lines of sight. And once again Degas seems to take the opposition between male and female as his subject. The meaning of this opposition has often been debated. There have been several attempts to read *The Interior,* most notably those of Quentin Bell and Theodore Reff. None of them, however, has been conclusive, for although the painting is full of clues (the furnishings, the open valise, the corset strewn on the floor, as well as the contrast between clothed and unclothed, dominant and defeated figures) and although it seems obviously illustrative and hence demands to be read, *The Interior* is like a piece of detective fiction with no solution; it is a picture that seems to require a caption. It has received one, in the title *The Rape* that has been pinned to it by critics, equally inconclusively (Degas apparently denied it).

Figure 31 Edgar Degas, *The Interior,* 1868–1869, Philadelphia Museum of Art, Henry P. McIlhenny Collection in memory of Frances P. McIlhenny. Photo: Museum.

Thus the opposition between male and female that was the sole subject of *The Spartan Youths* has become a puzzle in *The Interior.* Again this is because of Degas's transformation of the narrative structure of the history painting upon which he was drawing. If in *The Spartan Youths* he took the active pole of David's narrative painting and transformed it beyond recognition, in *The Interior* he turns to the still side, to the figures of the women in the *Oath* and that of Brutus in the painting of that name. Both figures are still in *The Interior,* as still as the objects about them; there is no gesture to counter and make meaning of their stillness and the resonating gap between them, no active/passive relationship to make sense of the opposition between male and female, as there is in the picture's neoclassical sources.

There is a gaze, however. Indeed, *The Interior* thematizes the visual relationship between male and female that informs the genre of the female nude. For it is not quite right to say that there is no gesture here, no action: the male figure in *The Interior* gestures and acts through his gaze. As a body, he is all gaze; his activity is constituted as that of viewing, and the relationship between the two as that of viewer to body, a subject acting upon an object through the gaze. This relationship is substituted for the earlier narrative opposition on which it appears to be based—the verb of looking simply replaces that of acting. That is the "text" of this picture; it is also its definition of the male part in the representation of female bodies.[13]

As for the female figure in *The Interior,* she is there in that domestic space, with her blank white back turned to the viewer, to signal the captionlessness of the picture. She is described as a piece of muteness which meets and deflects a gaze. And this is the picture's definition of the female place in painting. Where David's *Oath* spelled out the male and female roles in history painting—the male half as that of significance, the side which signals the message; the female half as that of stillness, the side which works against the grain of the narrative, opposed to the main drive of the story and to its message—Degas's *Interior* translates those roles into that of the look and that of the object. The relationship between the two, constituted in oppositional terms, is declared as the problem of the picture.

The importance of the *Spartan Youths* and *The Interior* resides in their reconstruction of the narrative relationship between male and female bodies, and their problematizing of the opposition between the two. This is how Degas begins; it is important, I think, to see his nudes against such a background.

One of these nudes is the *Bather* (After the Bath) of 1885 (Fig. 32), a rare instance, in Degas's oeuvre, of the reclining, frontal nude, but an important picture to him, since he executed it twice. Though like his other nudes it has no textual source, it does have a pictorial one, Cabanel's *Birth of Venus;* this famous example of the academic nude was also painted twice, once in 1863 and then again in 1875. The *Bather* is a significant image and its reference to *The Birth of Venus* a significant move, for it problematizes both the official pose and pretext for the nude and the traditional means of apprehending it through form and facture.

The *Bather* declares itself as an object of the gaze—if nowhere else, in the arm flung over the face of the woman to hide her gaze, to hide from ours, to define the gaze as the issue. This arm bears further looking at; it is Cabanel's arm, which in turn is Ingres's arm (Cabanel's *Venus* seems to derive from Ingres's *Odalisque and Slave* of 1842. Not only the arm over the face is borrowed, but the other arm as well, the exposed breasts, the swing of the hip and knee—in short, Degas's *Bather* is a wholesale reworking of *The Birth of Venus* (and, secondhand, of the *Odalisque and Slave*), in which the mythological and oriental justifications for the nude are deleted.

Manet's *Olympia,* with its quote of Titian's *Venus of Urbino,* is the more famous version of a lifted pose, and a more obvious challenge to the official nude and its official pretexts.[14] Olympia's challenge lay in her ambiguous identification as prostitute, courtesan, and sixteenth-century nude, in her deadpan gaze, her high positioning and her refusal of the langorous, curvaceous pose of self-abandonment, in her coiffure and traces of bodily hair, the Baudelairean cat and the bouquet of flowers sent her by her client: flat, deliberate misreadings of Titian's *Venus* which conspire to unsettle the pretext for the nude, the reading and enjoyment of her body and the status of the male viewer.

In Degas's *Bather,* by contrast, there is no gaze to meet, half-meet, or not meet ours; the gaze of the nude is explicitly covered. There is no tipping of the

Figure 32 Edgar Degas, *After the Bath,* ca. 1885. Pastel on paper. Courtesy of William Beadleston, Inc., New York.

body up and away from us—quite the contrary—no question of a model's or a woman's identity, no question of setting or client, nor even any question of quoting. Although the *Bather* makes reference to the pose of another nude, it does so without the overt quotation marks and the broad mistranslations typical of Manet's practice in general.

Yet Degas's *Bather* carries on a dialogue of its own with the official imagery of the nude, and its lifting of Cabanel's pose is an equally problematizing one. For as much as the *Bather* declares herself as an object of the gaze, so are her masses and contours rearranged in such a way as to deflect and resist its pressure. Take the gesture of the arm again: where in Ingres's *Odalisque* and Cabanel's *Venus* it is lifted back to expose and stretch the line of the breast and continue the line of hip and waist, and where in the latter it is flung over the brow to almost hide, and in so doing to stress, the flirtatious glance of the nude, in Degas's *Bather* the arm is angled over the face to cancel out the inviting glance, and though fully exposing the chest, it transforms the fleshy hill of breast into the bony angle of an awkward shoulder. The same is true of the arm on the floor, pushed against the chest so that a comparison between breast and elbow is forced. Flesh is turned into bone; movements of stretching and facts of contact become ones of torsion and pressure; and a gesture of exposure, ease, and self-abandonment becomes one of protection, discomfort, and mortification. Added to this is the rearrangement of hip and leg, pulled over to combine a side view with a frontal one, to transform a sensuous thigh into a straining rump and flank, to hide flatly both pubis and pelvis rather than to disclose them. Hands and feet have become unfinished stumps, lengths of titian hair a blunt rope of russet, the face a half-obliterated skull. There is something of an image

of martyrdom in all this, in these deliberately rearranged, angled limbs. In its transformation of *Venus,* the *Bather* manages a conflation of Susannah and St. Sebastian.

The *Bather* has no textual source, it is true; but Degas himself, in speaking of his nudes, was wont to refer to the Susannah theme: "Two centuries ago I would have painted *Susannah at Her Bath;* now I paint mere women in their tubs."[15] (The Susannah theme is also suggested in the oppositional relationship between male gaze and female body in *The Interior* and in the apocryphal title given it, *The Rape.*) Moreover, implicitly and explicitly, writers have likened Degas's female figures to the bodies in the works of the German, French, and Flemish primitives, to the mortified limbs and flesh of crucifixions and martyrdoms, frequently characterizing his stance vis-à-vis the female body as a cruel one:

> What is Gothic in Degas is Gothic in the severest sense. Gothic line, but tenser, more jagged . . . than any of the primitives of France . . . Degas rejected all softness, he seized an ankle, but not the flesh. The puppets which nestle together softly in Ingres, move by taut wires in Degas, and their motion is the dance of death. Not a sound emanates from their mummified faces. Bones have expressions and human backs are bent in anguish, arms howl and legs whine.[16]

The characterization of the *Bather* as Susannah-cum-St. Sebastian, as Venus reinterpreted as Susannah, and Susannah in turn reinterpreted as St. Sebastian, is not so far-fetched; it is partially indicated in the writings of critics contemporary to the artist. Like these writings, it is exaggerated, but it is also somehow right. Yielding flesh transmuted into straining bone, bounding curves into joints pulled and pushed around; the relaxed, abandoned, sensuous body of the goddess of love transformed into the resistant, disarticulated one of the martyr, and the look declared as a kind of pressure, a violence inflicted on the body like a rape or a subtle torture—in sum, the body of delectation turned into that of mortification, in both senses of the word: this, though perhaps overstated, is the meaning of Degas's transformation of Cabanel's *Venus.*

Manet's Olympia is as notorious for the way she is painted as she is for her quotation of the pose of the *Venus of Urbino.* Titian's famous facture is transformed in *Olympia* into stark, unmodulated contrasts and broad, harsh areas of signboard paint which refuse the union of visuality and tactility so fundamental to Titian's *impasto*—the translation of gaze into caressing touch suggested in Valéry's passage on the great painter of the female nude, the transformation of painted surface into the fleshy thicknesses of the female body.

This brings us to the problem of facture in Degas's *Bather.* It is foregrounded as a concern; this should be immediately evident. Yet the picture does not at first glance constitute a refusal or a denial of tactility. On the contrary, Degas's *Bather* presents the viewer with just as many invitations to touch as does Cabanel's *Venus* or Ingres's *Odalisque.* In the *Venus,* the garland of putti

echoes the contour of the body, inviting the gaze of the viewer to turn into touch through the almost-but-not-quite gesture of the putto farthest to the right; in the *Odalisque,* the spill of her hair is echoed in the loops of the hookah pipe, the swing of the hip in the curve of drapery over the balustrade in the back, and the smoothness and slickness of white flesh in the filmy white drapery and satin garment, while the thumb resting on the curve of her forearm presents the viewer with an incident of vicarious tactility; in Degas's *Bather,* touch is everywhere evoked, concentrated, and diffused—in the masses of drapes, material, and toweling surrounding the bather's body, and in the web of pastel strokes on the surface of the paper, covering and hovering over her form. The implications and invitations to touch, the inviting, softening echoes of the body in its surroundings, the vicarious details of contact seen in Cabanel's and Ingres's pictures are loaded directly, in Degas's *Bather,* into the fact of facture itself.

Thus touch as an extension of the sight of the female body is something not only allowed but declared in the surfaces of Degas's *Bather,* or so it appears. There is no challenge there. Yet it is a peculiar allowance, a strange declaration, for inasmuch as this body is constituted through facture-as-touch, so is it lost: the object of sight seems to recede, to disintegrate behind the fabric of touch. The body lies behind and separate from the gauzy web of white laid over it—it is virtually obliterated by its surface, a uniform mesh of hatching lines normally associated with the chiaroscural definition of mass and volume and with the printerly evocation of light and shadow, here made into a kind of screen stretched flat so that its warp and woof are displayed.

The palette of yellow, orange, and green that constitutes the peculiar surface of the *Bather* is a further confusion of the traditional distinction between line and color, hence between surface and edge, skin and volume, sensuous and intellectual appropriation of the body. Color is displaced into the materials of the room and displayed as a weave of separate threads of pigment, while the body caught up within it seems by contrast rather drained of color. Moreover, surfaces and edges—the body's expanses and its limits—are confused, as in the meeting of thigh and calf, and the blending of body and ground seen in the feet and nether thigh. All the means of defining the body are unraveled here: the contour that defines the buttock is repeated, given a kind of nervous, electric jolt in that wriggling second line, as if to mark a fundamental, deliberate hesitation in the very act of defining, delimiting, and delineating the body.

Thus the means of graphic and painterly definition of surface and form are disassembled, transformed into a constitutive field that will not hold together. Not only is the uniform texture of a painted surface put at a fundamental remove from the real textures of skin, flesh, and blood; it is also a surface in which vision and touch are at odds, rather than in harmony with one another. In fact, it would now seem that Degas was concerned to show that the artist's (and hence the viewer's) constituting touch was *not* an extension of the sight of the body, as suggested in the rhymings in Cabanel's *Venus* and Ingres's *Odalisque,* but a kind of obliteration and negation of it. This is supported by the way the

web of pastel replicates the weave of canvas, pulling the field of touch away from the body which it is supposed to create and apprehend, back to the very ground on which it is laid.

Degas's reworking of the facture associated with the nude is consistent with his reworking of its form and pose: both are stated as problems in the imagery of the female body. While the nude is returned to the ground-floor level of form and facture, the easy coalescence of the latter into body and the sublimation of the viewer's response are blocked. Because they are pulled apart, form and facture are declared as the constructs of gaze and touch, shown to be subject to a viewing and constituting presence which is allowed no release from these activities. At issue in the formalism of the nude is an elision between the erotic and the representational appropriation of the female body: in the *Bather,* that elision is forbidden.

The *Bather* is an exception among Degas's nudes because of its frontal pose; more commonly they are turned completely away from us. This is the case in the Jeu de Paume *Tub* (Fig. 33), part of a series of some ten nudes that Degas exhibited together in the last Impressionist show of 1886. Such was the insistence on backs turned to the viewer that Huysmans termed this series an "insulting adieu"—a final retreat from, a rejection and negation of, the viewing public.[17] Such also was the insistence on privacy and exclusion, on a world of female bodies existing in relation only to themselves, that Degas himself gave the series a title consisting of a list of reflexive verbs: "Suite de nus se baignant, se lavant, se séchant, s'essuyant," thereby insisting not only on the ablutionary activity of the nudes but on their reflexive actions and gestures, on the reflexive life of the female body; this was a fact noted by Huysmans as well. In the following commentary I shall use *The Tub* to represent the series as a whole.

The Tub presents the viewer with a back and a reflexive gesture—the elbow angled around to reach at the back, the sponge glued to the nape of the neck. Though similar to the details of vicarious and imminent contact seen in Ingres's and Cabanel's nudes, replete with the stress on ear and nape, this gesture subtly negates the message of such details. For this body's very physical, indeed muscular contact with itself, its emphasis on touch, is directed away from rather than toward the viewer. It is not an invitation—quite the contrary. It is not only the gesture that is reflexive and exclusive but the body as a whole, folded entirely over on itself, the line of breast and midriff sandwiched against a thigh, an exterior contour become an interior crease, outermost joint connected to innermost fold of a uterine shape, the other outer contour forming a line that circles back on itself, emphasizing closure. These forms of circularity and closure are echoed in the shape of the tub itself and in the handles, hips, and backs of the pitchers on the ledge—rhymings like many others in the genre of the female nude, but deflecting rather than delectable ones, parts of a system of abstract design that confirms closure and refusal of the gaze rather than access and enjoyment. This, then, is a female body that is entirely reflexive, existing in relation to itself, deflecting and excluding the viewer, refusing all exteriority. As

Figure 33 Edgar Degas, *The Tub,* 1886, Musée d'Orsay, Paris. Photo: Giraudon/Art Resource.

such, it negates the traditional function of the female nude: to be present to the gaze of others; it negates as well the function of the nude's aestheticization and abstraction: to provide a sublimated mode of appropriation.

The female nude, when free of narrative situations, is most often constituted frontally and horizontally—as a kind of landscape, its significant part the torso, its limbs merely elongations of the line created by the supine, stretched-out torso. This is the case in the *Venus* and the *Odalisque,* and despite its torsion, in the *Bather* as well. The body in *The Tub* is constituted rather differently; its geography is difficult to read. Neither fully horizontal nor vertical, it reads first as all torso, without legs either to continue its line or to support it; then as all arms; then as a series of stumps—the elbow, the feet, the U-shaped body. As much as the *Bather,* the figure in *The Tub* is a matter of torsion and tension, forcefully arranged into a complex of opposing, straining limbs—with her feet in runner's starting position, her absent calves, her thighs swung back behind her stiffened supporting arm, her hip swung around and flattened out, her shoulder dislocated, her arm pulled back to press against the frame and to meet her arched and crease-marked neck. No easily supine geography, this; in fact, hers is a body caught uneasily between landscape and architecture—the landscape of the reclining torso and the upright architecture of supporting, articulating, and gesticulating limbs—between the body continuous and fluid and the body sectioned and branched; in short, between male and female bodies as

they are constituted in their most extreme representational poles (as in David's *Oath,* for example).

But there is more than that here, more than a body caught between horizontality and verticality, landscape and architecture, geography and gesture, male and female. It is a body inverted and reversed, and as such, although it is closed and in the process of being cleaned, it might be said to belong to the category of the grotesque as Mikhail Bakhtin defines it.[18] This comparison is appropriate only insofar as Degas's images work to upend bodily canons; his is by no means a popular imagery of the body. It is perhaps also more appropriate to Degas's private series of images of groups of naked prostitutes of approximately 1880, with their thighs splayed, their legs and rumps in the air, black hairy heads likened to black smudged genitalia, masturbating and mooning the viewer. There is nothing so blunt in *The Tub* or in the series to which it belongs, yet it does pertain, albeit more subtly, to the same corporeal category. Certainly Huysmans, with his emphasis on onanistic gesture and women soiling themselves, described the nudes this way—and not entirely without reason, given their reflexivity.

The Tub fits the category of the grotesque in its disarrangement of the order of the body. The figure in this painting is depicted as a function of its rear and nether portions—all support for and extension of its butt and haunches, around which the whole mass of the body pivots. The geometry and symmetry of the body in *The Tub* are further disrupted by its one-arm support stance, so that it is an arm, and not the legs, which supports the body; a hand which makes contact with the floor and is thereby compared to the feet; thighs, not arms, which are aligned along the sides of the body; and finally, the continuous line formed by the arms which marks not the body's symmetry, but its vertical axis.

Thus *The Tub* is a representation of a female nude whose bodily syntax has been entirely disarranged: reflexive and closed, tilted and inverted, caught between the male and the female poles of verticality and horizontality, gestural extremities and uterine interiority—joined reflexively, in a kind of pictorial onanism, as Huysmans saw. Not only is the female body constituted as an object that deflects the gaze and externalizes the viewer, thus negating the function of the nude; it is also presented as a profoundly unreadable entity, precisely because the female body as a field of sight and touch, as well as its function as gesture, are all turned in on themselves.

Edward Snow argues—in contrast, he claims, to Huysmans—that it is the position of the male viewer and the place of the male body, its externalization and disembodiment, that are most in question in images like *The Tub.* This seems correct: the reflexivity, the reversals and inversions characteristic of *The Tub* are all ways of calling into question the male figure, as viewer and as bodily presence. If the reflexive gestures and forms work to turn the linguistic function of the body against and in on itself, quite literally—they are gestures that turn against communication, that turn in on the body's thicknesses and silences—they also speak to the fact of exclusion. The rhymings of this image—

to abstraction and aestheticization as closure, circularity, interiority, rather than delectation and appropriation—speak to the pressure of exclusion as well.

Images like *The Tub* have been considered voyeuristic—by the artist himself, in his invoking of the Old Testament narrative of Susannah and the Elders; he also tells us that he wished to see and depict the nude as if through a keyhole.[19] This confirms, in part, the notion of exclusion—voyeurism is predicated on being *outside;* but in part it contradicts it, for the other, the outsider, the possessor of the gaze, is implicated at every turn. This is the case in *The Tub,* where everything about the framing of the nude forces an awareness of an outside gaze and an external presence: the overhead view, the way the body and its space are so closely aligned with so many edges—the elbow with the upper frame, the rim of the tub with the lower frame, the woman's buttocks with the ledge. And then there is the ledge itself seen impossibly overhead, its cropped objects and its protruding elements stressing the fact, and the pressure, of the edge. Not only is this an impossible, awkward, too-close view which speaks so much to exclusion that it allows no place for the viewer to stand—one would have to climb atop the ledge to see it thus, yet one may not, since it is rather insistently vertical; it also easily implies a threat, an unseen presence, with whom we are forced to identify, as we identify with the camera angle when it moves with a perpetrator or a protagonist and forces us to see past thresholds, past the edges of doors and windows, to a victim's unaware back. Edges, and the fact of proximity: if they speak of exclusion, they also speak of the pressure of imminence, of imminent inclusion. In *The Tub* the line is trod between exclusion and inclusion, proximity and barrier, presence and absence; it is thus that we are made aware of the viewer (whom we, along with Snow and Huysmans, assume to be male) as a thing outside and unseen, a gaze without a body, a position in space characterized by its exteriority and its invisibility.

All the pressures of detachment, disappearance, and disembodiment that belong to the Western gaze are included in *The Tub.* I am thinking here of the peculiar system of corporeality that attaches to the traditional single-point perspective, in which the body of the viewer (again usually assumed to be male), located in a fixed place outside the painting and defined as prior to it, is dematerialized into a single point—a position in space; into lines of sight, a transparent field or plane of vision intersecting those lines of sight, and a vanishing point—the condensation of the gaze and the body of the viewer into another single point which reflects the viewer back at himself in the form of invisibility. In this system the field of vision, the transparent plane bisecting the imaginary lines extending out from the body of the viewer, literally represents disembodiment—the body extended beyond itself to become a projection, a transparency, a rectangle, and a system by which negative space is ordered.[20]

It might be wrong to confuse the single-point perspectival system of the West, and all that it implicates, with the possessive "perspective" on the female body. Yet both seem to be at issue in *The Tub:* both are implicated and both negated. Degas's art is very much a spatial one, full of interior spaces marked

by obvious orthogonals; one need think only of *The Interior.* These are not seen in *The Tub,* but it is nevertheless the suggestion of depth, below the ledge and behind the basin, that makes the implied proximity, the emphasis on edges, and the flatness of this image resonate. Indeed, it helps to see *The Tub* as a play on the normative, perspectival view, uprooting the rooted viewer, moving him out of position and shoving him toward and above the plane of the picture; robbing him of his measurable distance from it and thus of his sense of geometrical kinship to it; cutting a piece out of the view (the line of the ledge is like a fragment of an orthogonal, cropped and dislocated, cut out of its proper spatial, proportional, and positional context, adhering to the frame), and finally excluding the horizon, the lines of sight, and the vanishing point—all the means of reading spatial and positional relationships. This is not a simple neglect of perspectival space; it is a deliberate dislocation of it, of all its principles of positioning, centering, measuring, distancing, exteriority, and priority. The disembodiment of the male viewer is thus doubly treated in *The Tub:* through the looming sense of his invisibility promoted in it, and through his spatial dislocation. On the other hand, the intransigent physicality, the folded-over thickness and thereness, the formal presence of the female body are also doubly stressed—through the facts of its reflexivity and its illegibility.

This is to say that we see *The Tub* from two points of view, belonging to the male and the female body: that of interiority on the one hand, and that of exteriority on the other; that of physicality and that of disembodiment—a represented physical presence closed off through its very representation, and an outside viewing presence profoundly dislocated through the very acts of viewing and representing. There is more than just the female body at stake here, and certainly more than misogyny: representation and corporeality in general, so fundamentally linked in the Western tradition, are put in tension with each other. So are physicality and discursivity (the discursivity, in this case, of the gaze and the point of view), the one internalized and the other externalized, the centrality and subjecthood of the male body dislodged and the objecthood of the female body affirmed, yet closed off. The positions and meanings of both the male and the female body in Western painting are thus disclosed and foreclosed upon.

The Tub shares features with *The Interior* and its replacement of the narrative opposition between male and female with a scopophilic one; it shares features with the *Bather* and its problematization of the form and facture of the nude, and the pressures of gaze and touch that attach to it. *The Tub* contains the same turned back as *The Interior* and the same viewing presence, now outside the frame of the image. It has the same pressured, angled-around feeling to it as the *Bather,* the same refusal of appropriation. And, I might add, it shares the same reflexivity: constituted at the level of facture in the *Bather,* in the equivalence that it asserts between field of touch and ground of representation (rather than represented body); constituted at the level of gesture in *The Tub,* where there are traces of the same web of pastel marks in the room and across the back of the woman, like traces of her own sponge-wielding gesture. In both pictures

the field of corporeal representation closes back on itself, in one negating the body, in the other the viewer. The reflexivity of *The Tub* is what accounts for the peculiar illegibility of its body; it also accounts for the polarization of interiority and exteriority, subject and object, male and female presences, all in the representation of one body, whereas in *The Interior* they were laid out side by side like separate parts of a broken sentence. Neither celebratory (Snow) nor vitriolic (Huysmans)—or perhaps they are both—Degas's representations of female bodies are deconstructive. If they are radical in any way, it is after this fashion: in their declaration and separation of the subject and object of the female nude, in their exposure and closure of the metaphors and means of union and sublimation engaged in it.

I began by saying that the female nude was attached to formalist rather than semiotic preoccupations, and by commenting on the relationship between the female nude and twentieth-century abstraction. I want to end with this point: while later, bolder artists maintained and celebrated the female nude as a formalist field, it was the conservative, "misogynist" Degas who operated on it, prying apart its subject and its object. (Valéry considered Degas a kind of scientist, a modern equivalent of Leonardo;[21] Freud's interpretation of Leonardo[22] is appropriate here.) The female body—the object—constituted as a field of closed form, facture, and gesture, is declared as unapprehensible; the viewer—the subject—remains separate, his myth of sublimated union through aesthetic vision denied him. Each is folded away from the other. This is Degas's special entry into the world of abstraction, via the route of the female nude. How different it is from that of the most notorious formalist of our century, Pablo Picasso (who admired Degas's work and owned some of his images of prostitutes), with his tremendous myth of virility and his myriad pictorial devices for formal apprehension and erotic appropriation. The appropriate myth for Degas, whether biographically true or not, is that of abstinence (rather than misogyny); certainly that was the myth that Huysmans and Valéry preferred, not to mention Snow, more recently. For the relationship between the subject and object, between the sexes of painting, played out so disjunctively in Degas's nudes is best described as a structure of celibacy.

This is the nature of Degas's pictorial engagement with the female body, and of his formalism. If there is a certain sadness in his enterprise, this is where it lies.

NOTES

1. Clark, Timothy J., 1985. "Olympia's Choice," in *The Painting of Modern Life: Paris in the Art of Manet and His Followers,* New York: Knopf, 1985, p. 79.
2. Steinberg, Leo, "The Algerian Women and Picasso at Large," in *Other Criteria,* New York: Oxford University Press, 1972, p. 174.

3. Duncan, Carol, "Virility and Domination in Early Twentieth Century Vanguard Painting," *Artforum* XII:1–4 , December 1973, pp. 30–39.

4. Valéry, Paul, *Degas Danse Dessin,* Paris: Gallimard, 1938 (1936), p. 58.

5. Ibid., p. 59.

6. Ibid., p. 48.

7. Huysmans, Joris-Kari, *Certains,* Paris: Tresse et Stock, 1894 (1889), p. 27.

8. Ibid., p. 22.

9. Snow, Edward, "Painterly Inhibitions," in *A Study of Vermeer,* Berkeley: University of California Press, 1979, p. 25.

10. Pool, Phoebe, "The History Pictures of Edgar Degas and Their Background," *Apollo* LXXX, October, 1964, pp. 306–311.

11. Bell, Quentin, *Degas: Le Viol.* Charlton Lectures on Art, Newcastle-upon-Tyne: University of Newcastle-upon-Tyne, 1965.

12. Reff, Theodore, *Degas: The Artist's Mind,* New York: Metropolitan Museum of Art and Harper and Row, 1976, p. 307ff.

13. Berger, John, 1972. *Ways of Seeing,* London: British Broadcasting Corporation and Penguin Books, 1972, pp. 45–64.

14. Clark, Timothy J., 1980. "Preliminaries to a Possible Treatment of 'Olympia' in 1865," *Screen* (Spring 1980), pp. 18–41; Clark, "Olympia's Choice."

15. Halévy, Daniel, *Degas parle,* Geneva: La Palatine, 1960, p. 14.

16. Meier-Graefe, Julius (trans. J. Hobroyd Reece), *Degas,* London: E. Benn Limited, 1923, pp. 79–81.

17. Huysmans, Joris-Kari, *Certains,* Paris: Tresse et Stock, 1894, p. 23.

18. Bakhtin, Mikhail, "The Grotesque Image of the Body and Its Sources," in *Rabelais and His World,* Bloomington: Indiana University Press, 1984, p. 303ff.

19. Lemoisne, P.A., *Degas et son oeuvre,* vol. I, Paris: Arts et Metiers Graphiques, 1946–1949, p. 107.

20. Bryson, Norman, *Vision and Painting: The Logic of the Gaze,* New Haven, Conn.: Yale University Press, 1983, pp. 104–106.

21. Valéry, Paul, *Degas Danse Dessin,* Paris: Gallimard, 1936, p. 53.

22. Freud, Sigmund, "Leonardo and a Memory of his Childhood," in *The Standard Edition of the Complete Psychological Works of Sigmund Freud,* ed. James Strachey, vol. XI: *Five Lectures and Psychoanalysis, Leonardo da Vinci and Other Works,* London: The Hogarth Press, 1957(1910).

Ethnography and Exhibitionism at the Expositions Universelles*

ZEYNEP ÇELIK LEILA KINNEY

Since the appearance of Linda Nochlin's article. "The Imaginary Orient" it has become commonplace to assess western imagery of the Orient as a construction of a mythic and sexualized locale. Here, Çelik and Kinney question the formulation of Orientalism as a unilateral appropriation of a mythic "Other" by examining the transformation and influence in late nineteenth-century France of belly-dancing, an art form that illustrates a process of interchange and reciprocal reformulations.

The International Expositions that took place in Paris during the second half of the nineteenth century offered occasion for the representation of power relations linking France and her colonial possessions, here traced by an examination of the exposition sites. Also integral to the representation of colonial cultures was the theatrical spectacle. Central to these was belly-dancing, an art formulated for Parisian audiences. Distinct from the belly-dancing seen in nineteenth-century Istanbul, Egypt, and Algeria, that seen on the exposition stages reinforced orientalist conceptions disseminated in literature and painting.

The reception and success of belly-dancing was dependent on its coincidence with a Parisian economy of leisure. More specifically, it intersected with the sexualized attractions of popular dance halls, a side of Parisian culture best known to art historians through the posters of Toulouse-Lautrec or Georges Seurat's *Le Chahut.* The overlapping and interchange between these two spectacles, the ostensibly ethnographic and the popular, is examined in this article.

The Parisian dance hall culture facilitated the sexualization of belly-dancing; reciprocally, the ethnographic entered the domain of popular culture, with the International exhibitions, theme parks such as the Pays de Fées ("Fairyland"), or with La Goulue's pavillion at the Foire du Trône. Simultaneously, we witness an expansion of the vocabulary of exotic dancing to incorporate elements originating in the Parisian dance halls. The site for these interchanges is the female body: as the dance is increasingly sexualized, we seem to move away from issues of Orientalism to issues of patriarchy, a transition that denies a fixed identification of the "Other."

*"Ethnography and Exhibitionism at the Expositions Universelles," by Zeynep Çelik and Leila Kinney. Reprinted from *Assemblage,* 13, 1990, by permission of the MIT Press, Cambridge, Massachusetts. Copyright © 1990 by the Massachusetts Institute of Technology.

The Parisian *expositions universelles* were elaborate mechanisms of cultural production, systems of representation on a grand scale. Among their novel technologies was the creation of ersatz habitats; these scenarios of a reductive presentation of different cultures generated easily apprehended, symbolic imagery. In such an environment the stereotype acquires authenticity; it gathers strength for a seemingly inexhaustible cycle of repetition and regeneration. One of the stereotypes that gained currency at the world's fairs, and remains viable today, is the *danse du ventre*.[1] An enactment of the eroticized mystique of the Orient, the belly dance could be described as a pivotal element in what Barthes has designated " a second order semiological system," a myth of Islamic culture.[2] The account that follows is less concerned with a technical description of that system than with its "motivation" and "waves of implantation"—a plot of interlocking sectors leading from the fairs to their periphery, to Montmartre and beyond. What is significant about the phenomenon is not simply its spectacular geography, the unlikely cast of characters, or even the range of visual practices involved. In this deceptively simple by-product of the nineteenth-century fairs, one finds a manifestation of the interacting structures of patriarchy and Orientalism. Yet for all the evidence of this interaction, its precise nature remains in question.

The postulate that patriarchy operated similarly in diverse circumstances has forged an uneasy alliance between the feminist and postcolonial critiques of European cultural authority.[3] The uneasiness has arisen, in part, because the alliance was not formed strategically; rather, it emerged from a convergence upon a common set of theoretical principles: the inert and timeless status of the dominated entity, the controlling nature of the empowered observer, and the tendency to speak for the silenced group; in short, the exercises of power associated with the categories of the Other, the Gaze, and the Voice. If less connected to each other than to a similar lexicon, which itself was used strategically, the feminist and postcolonial affiliation can best be observed when both speak from the position of "the Other." This term marks the cognitive territory where the procedures of each discourse coincide, and conflict between them emerges.

Devising analytic procedures to explain the operations of power in realms as diverse as political, economic, or gender relations without first assuming the outcome—a similar pattern of patriarchial oppression—remains especially challenging. Our attempt to do so begins with (or to be more precise, *began* with) [4] a recognition of the inadequacy of dualism and demystification to the task.[5] As the circuit of representation followed by the belly dance in Paris will suggest, the dynamic of cultural contact was the occasion for unpredictable interactions, which continually reformulated cultural identities and destabilized the binary system upon which otherness is based. By holding in place the problem of the Other without expecting to find in it a tailor-made resolution, we hope to address a number of still fundamental questions: Is cultural authenticity a demand as well as an illusion in the age of mass communication? Is the feminization of the Orient—most notoriously expressed in fantasies of the harem—integral to

its subjugation? Are the binary oppositions inherent in the construction of the Other disrupted when differences of gender and culture coincide? Does exoticism—and its projection of a pseudodistance—collapse when obsessively repeated and reenacted?

The universal expositions of the nineteenth century were intended as microcosms that would summarize the entire human experience—past and present, with projections into the future. In their carefully articulated order, they also signified the dominant relations of power. Ordering and categorization ranked, rationalized, and objectified different societies. The resulting hierarchy portrayed a world where races, sexes, and nations occupied fixed places assigned to them by the exposition committees of host countries. The forms through which non-Western cultures were represented at the fairs were predicated upon the social arrangements already established in the "host" culture, France; thus it is important to describe the parameters established by the exhibition committees, for they set the patterns of national representation and provided the channels of cultural expression through which the knowledge produced by the expositions would be fashioned.

The site plans of the expositions, for example, signify power relations graphically.[6] Beginning with the 1867 universal exposition in Paris, a dual system was established: a Beaux-Arts plan, highlighted by imposing structures for the main displays of industrial and artistic artifacts, and a picturesque array of buildings interspersed in the parks and gardens of the exhibition grounds. A major component of the non-Western exhibits almost always was situated in the picturesque sections, where technological novelties, entertainment, and commercial attractions were located.[7] This spatial division—between inside and outside, center and periphery—was reinforced by the architecture of the exhibition pavilions, as described, for example, by Hippolyte Gautier in 1867. The center of the exposition, he noted, was occupied by a large circular building representing the globe, which recalled a Roman circus, where the marvels of industry, science, and art were conglomerated. Outside the external walls of this "circus," he continued, was a crowd of "bizarre constructions . . . a strange city, composed of specimens from all kinds of architecture." Walking through this section was similar to embarking on a world tour. It was no longer necessary to take a boat to the Orient from Marseilles, for the expositions created a prefabricated and idealized tourism *en place*.[8]

This distinction between the didactic and the picturesque zones, where entertainment and exotica commingled, remained a feature of the design of later fairs, even as the site plans varied. Frequent references by official guides and visitors to this basic division of space suggest that it was deliberately imbued with significance, yet designed to be apprehended casually, as an effect of the imaginary "*voyage autour du monde.*" Since this topographical system coincided with other kinds of information about the relative status and nature of foreign cultures, the fairgrounds constructed social relations on multiple levels. They significantly expanded the persuasive mechanisms of previously estab-

lished accounts of other cultures; the expositions were more powerful than pictorial, literary, or journalistic descriptions because they presented simultaneously a physical, visual, and educational discursive field, organizing a range of perceptual responses to a global hierarchy of nations and races.

Alterations in the site plans indicate successive attempts to stage and visualize these affiliations effectively. In 1878 France's most important and turbulent colony, Algeria, was placed in front of the Trocadero Palace. The palace's eclectic style referred to the Islamic architecture of the colonies, but its siting, size, and form as a whole created an image of France as a protective father/master with his arms encircling the colonial village. In 1889, however, the French colonies were given a separate location on the Esplanade, occupying a huge area between the Quai d'Orsay and the rue de Grenelle; the modification was made in order "to convey a real idea of the economic state of [France's] diverse possessions overseas."[9]

Another adjustment occurred in 1900, when the pavilions of the two most prominent colonies, Algeria and Tunisia, were placed in the Trocadero Park, on the main avenue that bisected it and the Champs de Mars and connected the Trocadero Palace to the Eiffel Tower via the Iena Bridge. Viewed from the bridge, looking toward the palace, the Algerian and Tunisian pavilions defined the axis and stylistically complemented the Trocadero's Islamic references. When seen from the palace looking toward the Eiffel Tower (Fig. 34), the white stucco architecture of the pavilions, abstracted from various precolonial monuments, contrasted with the engineering aesthetics of the tower. The industrial progress of the empire, therefore, was juxtaposed with the preindustrial forms of its colonies. This arrangement symbolically replicated the tactics of assimilation and contrast that dominated French colonial policy.

The transformations in the planning principles for each exposition thus articulated power relations and revealed a desire to enhance supremacy through representation.[10] In addition, the cross-cultural character of the international exhibitions produced a formalized comparative apparatus; although its conceptual model was industrial competition, its form of enunciation often was aesthetic and cultural. France's colonial possessions had a dual role to play in this context. Their very existence demonstrated French material power. Yet not only their economies, but also their indigenous cultures were extensively displayed at the expositions. They, too, glorified French industrialization, but in an antithetical sense. Since indigenous cultures were offered as evidence of local conditions and contemporary reality, their present state seemed to recall that of the industrialized nations' past and therefore provided a measure of their relative advancement and superiority.[11]

The elaborate forms of presenting people at the exhibitions contributed to this politicized chronology. The human displays were organized into national and racial hierarchies in accordance with the norms of the emerging discipline of anthropology.[12] A "science of other men in another Time," as Johannes Fabian describes it, anthropology tends to assume a "petrified relation" between

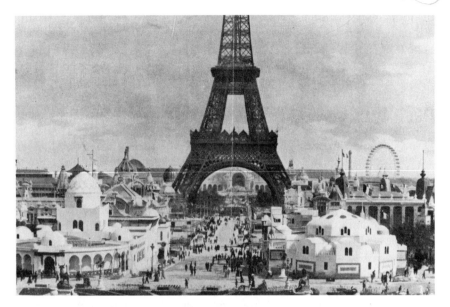

Figure 34 View toward the Eiffel Tower from the Trocadero Park, with the Tunisian Palace to the left and the Algerian Palace to the right, 1900. *Figaro Illustré* 124 (July 1900).

the observer and other societies, whose history is perceived to be fixed and unchanging.[13] Indeed, spatial and temporal distance determined the display format of other people in the world's fairs. Architecture provided an "authentic" setting and a visual summary of the represented culture. In the Islamic exhibits from 1867 on, mosques, baths, caravanserais, houses, and rows of shops were built, drawing on examples well known from architectural surveys and expeditionary literature. "Natives" were placed in this scenery, dressed in regional costumes and performing artisanal tasks, which seemed to belong to another age. Such architectural villages were considered to be one of the most scientific aspects of the fairs, because they claimed authentically to reconstruct other cultures.[14] In effect, however, these societies were assimilated into the conceptual order of the exhibitions, reinforcing a perception of their apparently underdeveloped status. The fabricated streets, shops, artisans, and merchants created a visible difference from the industrialized nations, within a framework of familiar categories.

Ultimately, however, the success of the ethnographic displays rested upon their theatrical presentation, in which documentation intermingled with certain kinds of entertainment deemed culturally authentic. This component of the indigenous exhibits received greater emphasis over the decades during which the expositions evolved. For example, while the Islamic quarters in the 1867 exposition were presented with minimal human animation of their architecture, in 1878, theaters were introduced; thereafter, they became indispensable to every

Muslim display. In these theaters, music accompanied *tableaux vivants* from local daily life, in which weddings or shopping at a bazaar, for example, were enacted. In spite of the variety of activities presented, <u>belly dances formed the core attraction from the beginning</u>, to judge by the coverage they received in official and unofficial accounts of the exhibits and their increasingly elaborate choreography in successive fairs. In 1889 the number of spectators who came to watch the Egyptian belly dancers averaged two thousand per day.[15] As Gautier had remarked in 1867, the universal expositions brought the Orient to Paris; Europeans unable to travel to the Near East could now flock to the exhibition's Islamic theaters and there catch a glimpse of the lasciviousness attributed to the sultans. How did the belly dance become the "representative" Islamic art form at the universal expositions?

In Egypt, a semiautonomous governate of the Ottoman Empire in the nineteenth century until it came under British sovereignty in 1882, belly dancing had never been such a spectacle. The dance went back to the ancient kingdoms; it was also widespread in the early Roman period; thus it predated Islam. The *ghawazi,* the dancing women of Egypt, performed unveiled in the streets, to small audiences. On special occasions, such as a marriage or a birth of a child, they would dance in the courtyard of a house or in front of its entrance, for both men and women. They would not be allowed inside a harem (the women's quarters of a household), but it was not uncommon for the *ghawazi* to entertain a private party of men in the men's quarters. In 1834, however, the street performances of the *ghawazi* were prohibited, and the dance was restricted to private quarters alone.[16] In other words, just as Egyptians attempted to remove belly dancing from public view, Orientalist painting and travel literature were reversing this phenomenon by presenting belly dancing to Parisian audiences as an Islamic theatrical performance.

A similar custom existed in Istanbul, where dancers called *çengis* could be hired for special events in both the male and female quarters of Muslim houses. Although the performance corresponded to the definition of the belly dance in other cultures—feet stable on the ground while other parts of the body moved—these dances were not characterized in Ottoman accounts by the accentuated eroticism of the belly dance in the exhibition settings. Furthermore, at precisely the moment that belly dancing was being presented in Paris as a reflection of Ottoman culture, it was disappearing from upper-class households in Istanbul. There, as part of the Ottoman Empire's modernization, the importation of European social and cultural models changed patterns of entertainment in both public and private settings. European-style ballet was substituted for belly dancing, even in the harems.[17]

Colonial Algeria presented a different pattern. Here the dancers, young Ouled-Nail girls, came from the poorest desert tribes. The commercialization of the dance of the Ouled-Nails was closely associated with the growth of prostitution under French rule; it also provided a means of accumulating a dowry.[18] In Algeria, the dance became increasingly erotic as it changed locales from the

desert between Bou-Saada and Laghouat to urban centers, and, eventually, to the stages of the Parisian universal expositions. The French feminist Hubertine Auclert recognized this transformation at the time. The belly dances she saw at the Paris fairs, she concluded, were a "grotesque spectacle . . . nothing but a horrible imitation," compared to the dances in the Algerian countryside. The Ouled-Nails in the desert, whom Auclert called "charming," provoked the erotic imagination of spectators without being vulgar; the dances symbolized love-making without literally representing it, in her words, "*l'amour sans l'amour.*"[19] Auclert's attempt to recover the innocence of the belly dance by (re)situating it in a more pristine place of "origin," free of the contamination of recent history and commercialized sexuality, could be characterized as an example of "the salvage paradigm."[20]

These three cases demonstrate variable forms of negotiating the control of belly dancing. In Egypt the government tried to counteract the promotion of the belly dance in French painting and travel literature; in Istanbul the tables were turned as the elite imported French dances; and in Algeria, where French colonizers encouraged the belly dance, this exploitation was in some measure exploited in turn by the Ouled-Nail dancers, who used it to enhance their marriageability. It was, therefore, an anything but pure belly dance that was presented as an Islamic ethnic form at the universal expositions, where, moreover, its performative aspects were refashioned for the benefit of Parisian audiences.

The belly dances reenacted in flesh and blood one of the aspects of Muslim life most intriguing to Europeans, which had been disseminated by Orientalist painters and writers in the generic mode of "manners-and-customs" for at least seventy-five years.[21] It is important to realize that protests of the rampant typification of the Orient, and of the sexualized representation of Oriental women in particular, surfaced as early as the formulations themselves, although they are rarely mentioned in standard histories. The Ottoman writer Ahmed Mithad Efendi, for example, described the typical odalisque of European fantasy in his 1889 *Avrupa 'da Bir Cevelan* (A tour in Europe).

> [This] loveable person lies negligently on a sofa. One of her slippers, embroidered with pearls, is on the floor, while the other is on the tip of her toes. Since her garments are intended to ornament rather than to conceal [her body], her legs dangling from the sofa are half naked and her belly and breasts are covered by fabrics as thin and transparent as a dream. Her disheveled hair over her nude shoulders falls down in waves. . . . In her mouth is the black end of the pipe of a *narghile,* curving like a snake. . . . The ornament in the room consists of an inlaid cupboard, chair, book stand, and chandeliers. . . . A black servant fans her.[22]

In capturing the Ingresque formula, Mithad Efendi indicates the epistemological status that such representations had achieved. The belly dances, in other words, depended for effect upon a deliberate redundancy of representation.

They amplified the calculated eroticism in countless Orientalist paintings of women by making it more accessible; if anything, they heightened the "reality effect" of a body of Orientalist imagery already legitimized by travelogues and paintings.

This passage also exemplifies, in a highly condensed form, the dilemmas that will characterize tactics of demystification. Laced with sarcasm, Mithad Efendi's hypothetical description acquires a critical edge that, at first, only insinuates the distortion inherent in such imagery. He then goes on to decry it as a "misconception," one that contradicts reality.

> This is the Eastern woman Europe depicted until now. While such an image consists of beautiful things that please the eye, it is not reality, but only a dream, a poem. It is such a dream that the opinion and the belief it generates also become unreal. It is assumed that this body is not the mistress of her house, the wife of her husband, and the mother of her children, but only a servant to the pleasures of the man who owns the house. What a misconception![23]

Having relegated the image to an aesthetic, if not fully psychic, imaginary, Mithad Efendi pronounces it exaggerated, illusory, partial—a falsification, in a word. At a crucial juncture, a moment of reckoning that can be found in most critiques, an impulse "to correct" emerges. In general, it can be elaborated as follows: if representation can establish social fact, then countering its claims would appear to be strategically effective; if the problem is ignorance, misrepresentation, or bad faith, an adequate solution can be found in knowledge, representation, and good faith.

The limitations of this type of response have been widely rehearsed. One lies in its static nature; ultimately, it regenerates the struggle for power, with its drive to substitute one truth or representation for another, to reclaim the hierarchy by inverting it. Another is an inability to account for the resilience of fantasy and its purchase on "opinion" and "belief." The problem remains: how is the persistence, the appeal of a particular distortion sustained? The duplicity of myth demands, to recall Barthes, a different kind of consumption: "the reader lives the myth as a story at once true and unreal."[24]

The axiomatic element in this instance is not difficult to locate: the self-evident assumption that the "Eastern woman" be circumscribed by juridical, if not exclusively sexual, relations to "the man who owns the house." The supposition that the women in question (the ones represented and the ones not) are an expression of the "rights of man" propels gender into an ambiguous role. When men speak both of and through the intermediary category of women, the narrative of power relations can be described as a form of free indirect discourse in which the masculine position, exploiting the advantages of mobility, remains neither completely absorbed by nor entirely severed from the values that the feminine position entails.

Certainly, then, distortion and ignorance of indigenous societies can be

demonstrated; the belly dance is a fabricated, simulated difference. Yet to situate it only in relation to what it was not—an authentic representation—assumes that something of the sort is possible.[25] In addition, it reinforces the dubious claim to authenticity that the representational system of the expositions made in the first place. It is more useful to trace the pattern of distortion itself, which reveals the highly selective nature of cultural importation. Cultural information, that is, must be packaged in ways that are physically and economically profitable—capable of a kind of reproduction that reinvents the form while eliciting a willing investment in its structure of belief and opinion. The ethnographic displays at the exhibitions recontextualized an erotic fascination with Muslim women, in a spectacle that linked imperial power, legitimate edification, and libidinal motivation.

There was more to these *tableaux,* however, than an expansive repetition of the *déja-lu* and *déja-vu.* Indeed, tautology is one of the signal attributes of myth. Yet the belly dance became part of an unforeseeable synthesis. Although culled from the Orientalist stock of imagery, its entry onto the Parisian cultural scene required an interplay with specific local institutions and social practices; if the imagery provided the belly dance's condition of appearance, the interplay dictated the terms of its survival. In addition to the painting gallery, the model for display of foreign people at the universal expositions is to be found in the Parisian entertainment industry—in the cabarets, café-concerts, *jardins d'hiver,* and *bals publics* abundant and flourishing in Paris during the second half of the nineteenth century. With their capricious nomenclature—the Eldorado, New Athens, Madrid, Japanese Divan—and geographically diverse style and decor, the Parisian establishments provided the rationale for the entertainment districts in the indigenous quarters of the exhibitions, which otherwise would have appeared strikingly uncharacteristic and illogical.[26]

The *brasseries à femmes* are one crossroads of the ethnographic project of the fairs and the Parisian economy of leisure. Although not unknown before the 1867 exhibition, they acquired a distinctive identity there. Designed as sample rooms for beverages and comestibles, their regionally attired waitresses at the same time purported to stage national forms of sociability, all the while turning a profit. Detached from this environment and established in the Parisian economy by the end of the following decade, they acquired new functions, notably as hospitable milieu for unlicensed but informally organized prostitution, and for other attractions as well.[27] To mention one well-known example, Agostina Segatori's café Le Tambourin, where Van Gogh and Toulouse-Lautrec exhibited paintings in 1886–1887, was populated by waitresses in Italian costume, to accompany the decor of tambourines illustrated with dancing women.[28] While shedding the context of ethnographic demonstration, the *brasseries à femmes* retained some significance on this level, if only as trademark. The prefabricated, ornamental quality of cultural difference in these establishments perhaps renounced any pretense to effective representation of it. But what is abandoned on one level may return to advantage on another. The sheer number of ethnic

and racial types gathered into the peripheral regions of the fairs may have camouflaged the placement of cultural difference in categories structurally similar to, if not identical with, class stratifications. The migration of the *brasseries à femmes* from the fairs into the Parisian economy thus provides a jolt of recognition, in which the latent concatenation of cultural and social hierarchies is realized.

With generic odalisques or peasant, Andalusian, and Irish women on offer, it would seem that any old difference could find favor, as long as the rule of exoticism was obeyed. Should the belly dance be measured against this kind of equivalence, in which all concoctions of difference merge into an indifferent similarity? As one unit in the overall pattern of exoticism, perhaps; but as a discrete activity, it remained distinctive. Exoticism is dependent upon trade and transportation.[29] In practice, it requires a transplantation of some sort, one that can simultaneously preserve the peculiarity of the foreign object and insert it into a new environment. The belly dance survived on different soil by aligning with a part of the entertainment industry that capitalized upon and domesticated eccentricity. Introduced, we recall, in 1878, in what could be designated a second wave of theatricalization in the ethnographic displays, the belly dance was situated within the orbit of popular dancing, and its organization and personnel came to resemble that of the entrepreneurial sector of dance in Paris. The emergence of "stars" of the belly dance is one indication of its incorporation into this aesthetic economy.

The ascendance of the eroticized female performer in nineteenth-century Parisian culture is most often situated within the sexual politics of the ballet, whose history is institutionalized and whose carnally motivated male patrons— the jockey club—are readily identifiable.[30] A somewhat different chronology and set of issues figures in a history of popular dance, but a similar feminization of performance and orchestration of titillation can be found there. And the production of the "star" is even more conspicuous in this less formalized domain. The *bals publics* that became prominent in Paris during the July Monarchy were characterized by unrehearsed routines interspersed with virtuoso displays of technique more or less improvised, depending upon the locale.[31] Toward the middle of the century, female exhibitionism increasingly replaced the earlier emphasis upon male agility. So-called choreographic celebrities appeared as early as the "polkamania" craze of the 1840s, and the notoriety of these women began to change the dynamics of the dance hall. The substitution of spectatorship for participation in Parisian dance halls over a period of thirty to forty years is an even more graphic indication of the sexualized appropriation of working-class female bodies than the traditional rituals of entertainment at the Opéra or dramatic theaters.

Celebrity, of course, cannot stand alone. The least autonomous of phenomena, it requires the support of word and image in their most institutionalized forms. And the apparatus of publishing and publicity that surrounded Parisian entertainment readily encompassed one type of dance and another. The

roster of "choreographic celebrities" emerged complete with ghostwritten memoirs (notably those of Céleste Mogador and the infamous Rigolboche), detailing stories of immigrant struggle in the streets of Paris, discovery in predictable locales, and overnight rises to fame.[32] A journalist described this pattern, evidently well established by 1865, in an account of a certain "Fille de l'Air," a dancer at Mabille:

> Within two weeks, she will become a European celebrity; within six months, she will write her memoirs, and within one year, she will make a fortune in Berlin, [just] like Rigolboche and Finette, two ex-stars of the Parisian balls, who still pass abroad as the latest novelty. Then, within two years, nobody will be talking about her at all, because in Paris, everything is forgotten.[33]

Compare the story of Rachel Bent-Eny, who was known as "La Belle Fathma," after the Prophet Mohammed's daughter, even though she was of Algerian Jewish origin. She had come to Paris not from Algeria but from Tunisia, along with her father, who was a member of the orchestra recruited for the colony's display at the 1878 exhibition. "The Giant of Susa," as he was known, made little Fathma, so the legend goes, dance in front of a crowd. About seven or eight years old at the time, she immediately became a big success and performed her variation of the belly dance several times a day. After the exposition closed, Fathma's family stayed in Paris for economic reasons, like many other immigrants. She grew up and "blossomed" in the streets of Paris, established her reputation in the commercial fairgrounds on the outskirts of the city, and eventually performed on her own stage within the grounds of the Concert de Paris on the Champs Elysées, where she "triumphed." After first appearing at the Grand Theater and in the rue du Caire at the 1889 exhibition, she moved to her own *boîte*, the Concert Tunisien, a hall with a capacity of one hundred spectators (Fig. 35).[34] Thus Fathma already was a star attraction by the time she performed at the 1889 exhibition, presumably as evidence of the indigenous culture of Tunisia, rather than of Paris, as she had become.

The minor media explosions that accompanied each universal exposition helped to promote this burgeoning literature, as Paris turned itself inside out for foreign and touristic consumption. Packaged and promoted above all were the sexualized attractions of Parisian entertainment. The perceived licentiousness of popular dancing had attracted official surveillance and intervention from the beginning. Without the *Gazette des Tribunaux's* depositions of revelers hauled in by the vice squads, the practice of the cancan and chahut—reputed to be indecent deformations of the quadrille—would not be dateable to the 1830s, but rather to the 1880s, the period of their standardization in dance-hall routines and representation in modern life painting.[35] Bureaucratic wisdom apparently feared just what the literati and journalists relished: that energetic bodily movement verged on sexual pantomime and that moral defiance schooled political resistance.[36] The boulevard press, anecdotal literature, and naturalist novels of the

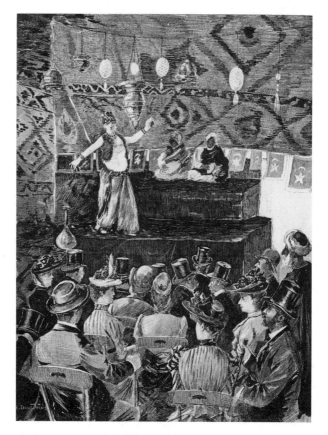

Figure 35 *Concert Tunisien, rue du Caire,* wood engraving after E. Dousdébès, 1889. Département des Estampes et de la Photographie, Bibliothèque Nationale, Paris. © Cliché Bibliothèque Nationale de France, Paris.

period vied in their attempt to catalogue the vice and pleasure of the city, and popular dance figured prominently in their descriptive inventories. It is difficult to say whether these accounts thrived more on the attraction or the revulsion provoked by popular dancing, but they elaborated and promoted fantasies about working-class women, gradually producing a response instinctively applicable to the belly dance as well.

Joris-Karl Huysmans's account of Raffaëlli's *The Quadrille at the Ambassadeurs* (Fig. 36) includes a particularly trenchant example of the exaggerated carnality found in this genre of writing. The so-called naturalist quadrille retained the chahut's suggestive acrobatics and the cancan's frothy titillation, while intensifying the precision movements.[37] Yet the visual properties of the watercolor in question are barely adequate to the atmosphere Huysmans evokes:

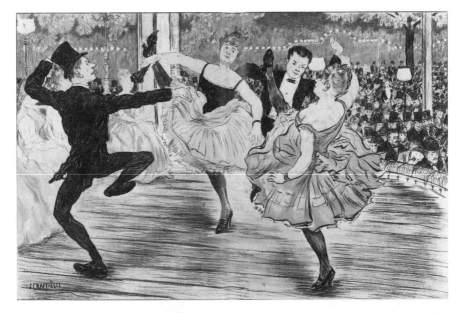

Figure 36 Jean-Francois Raffaëlli, *The Quadrille at the Ambassadeurs,* color lithograph. *Paris illustré* (August 1886).

"You have to see the carnivorous smiles of those mouths, the dance of these little cattle, the cancan of the eyes on these three-franc "lays," which light up the depths of corridors or lure, for a quick piece of work, in the wasteland of the night."[38] The cluster of bestial and predatory figures in Huysmans's characterization of the dancers, which continues throughout the passage, subsumes into his description the erotic degradation that popular dancing was called upon to enact, in an increasingly professionalized manner. Huysmans did not invent these terms; they were typical of nineteenth-century discourse on sexuality. But he did fashion them into a stylish amalgam of working-class slang and polished crudity, which is more pronounced than any effort to record or classify. *Who* is seen in this image, finally, is less important than the incitement *to* see it ("*il faut le voir*") and, by extension, the locales that offer such sensational provocation.

Secondary or tertiary descriptions of popular dance presume a viewer concordant with the setting. Seurat's *Le Chahut* (Fig. 37) pictures this "archetypal" viewer, at least according to the painting's owner, the poet and critic Gustave Kahn:

> As a synthetic image of the public, observe the pig's snout of the spectator, archetype of the fat reveler, placed up close to and below the female dancer, vulgarly enjoying the moment of pleasure that has been prepared for him, with no thought for anything but a laugh and a lewd desire.[39]

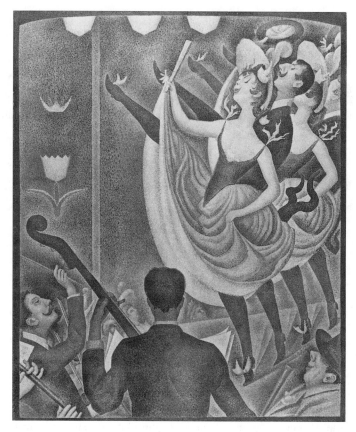

Figure 37 Georges Seurat, *Le Chahut*, 1889–1890. © Rijksmuseum Kröller-Müller, Otterlo Holland.

In the "diagram of ideas" that, Kahn argues, the painting aspires to be is registered a conscription of sexuality for the purposes of commercial diversion. The linear armature and shimmering surface manage to hold in contact a peculiar combination of rigidity and evanescence, an alloy of degradation and pleasure that reveals to Kahn the psychosocial dynamic of the dance hall. In his "demonstration of the subject," the transaction of looking is structured by the animal nature of the spectator, not of the dancers, and the pyramid of gender and class upon which the act is built flickers through its rhythmic figuration.

At what juncture do these habits of looking and association overlap with those elicited by the "indigenous" dancers at the expositions? Two further examples may help to locate this imbrication.

Edmond de Goncourt's memoirs treat the rue du Caire constructed for the 1889 fair virtually as a red-light district. After dining in the Eiffel Tower with the Zolas, Daudets, and Charpentiers, Goncourt and his party descend to the

street lined with monuments, houses, and shops composed of fragments sal-
vaged from buildings demolished in Cairo.[40] He characterizes it as a magnet for
"libertine curiosity in Paris" (including, apparently, his own), filled with what
he calls a "population in heat reminiscent of cats spraying on the coals."[41] Not
to be outdone by his colleague Flaubert, presumably, Goncourt's description of
the *danse du ventre* is filled with sexual fantasies: "For me, it would have been
interesting danced by a nude woman," he begins. He then surveys the dancer's
body, especially the "dislocation" of the "belly" and "ass." He associates her
gyrations with sexual movements and provides a taxonomy of the differing
"pitch and roll" characteristics of fornication with Moorish as opposed to Euro-
pean women.[42] From the author of a *bal public* scene (in the novel *Germinie
Lacerteux*) threatened with censorship when it was staged in 1888, we might
expect such connoisseurship of the carnal. And we can safely assume that the
imagery providing momentum for this transformation of the belly dance into a
striptease is the corpus of nude, semipornographic photographs of dancers in
wide circulation (Fig. 38).[43] Although commercial studios duly expanded this
genre to encompass Oriental dancing, some photographs of Muslim dancers
published concurrently with the expositions retain a documentary aura, captured
in imperfectly posed figures and uncertain gazes (Fig. 39).[44] If Goncourt's re-
sponse is in any way exemplary, it is because it demonstrates the possibility of
merging different kinds of appropriation, one psychic and sexual, another
ethnographic and detached, a potential that anchors colonial power at the indi-
vidual level. These models of possession, though divergent in inception and
focus, collaborate in the constitution of a colonized female body.

Descriptions of the performances intended for a wider readership are more
circumspect, but still loaded with fantasy and condescension; an excerpt from a
long article written for the *Figaro Illustré* on the Egyptian dancers in 1900 is
representative.

> As though pinched by a needle, the dancer started moving with the hideous con-
> tortions that all the Fathmas and Féridjées have saturated us with. With the vibra-
> tions of her hips and torso, she gives the illusion of a sea that calms down and
> where the long and slow waves die on the sand, like wings that rise and palpi-
> tate.[45]

The lyrical transport to distant shores is embedded in a topography of the
dancer's body generated by that familiar equation of woman and nature. What-
ever embodiment of imperial power the entertainment districts realized de-
pended upon the invitation to make such projections.

The composition of an intelligible Oriental subject required an assimila-
tion of fragments of knowledge, experience, and imagery that no single rule of
demonstration or mode of representation can reveal. Because the ritual of ap-
propriation remained approximate, contingent, and variable, it seemed to re-
quire interminable repetition. If a saturation point was reached by the turn of the

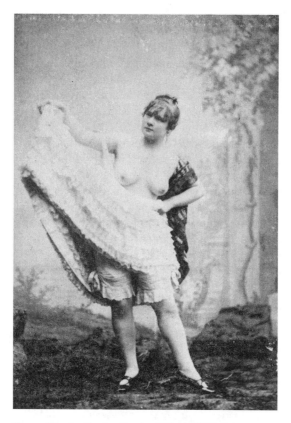

Figure 38 *La Goulue* (Louise Weber), 1886. Département des Estampes et de la Photographie, Bibliothèque Nationale, Paris. © Cliché Bibliothèque Nationale de France, Paris.

century, it was only after the belly dance infiltrated Parisian entertainment even further.

In addition to the expanded use of entertainment in ethnographic displays, the appearance of enterprises designed explicitly to capitalize upon the crowds of visitors attracted by the fairs characterized the 1889 exhibition. The Pays de Fées, an amusement park built on the avenue du Rapp outside the principal entrance to the fair on the Champs de Mars, demarcates the economic and cultural orbit that eventually extended from the ethnographic exhibits to the dance halls of Montmartre. This prototype of Disneyland and countless later theme parks was promoted as an incarnation of both the *Contes de Perrault* and the *One Thousand and One Nights* (Fig. 40). The youthful blond *parisienne* of Jules Chéret's invention never had a more appropriate milieu to announce, appearing in a poster for the establishment as the primordial Tinkerbell (Fig. 41). Alongside sets based on various European fairy tales was Ali-Baba's cave and a blue

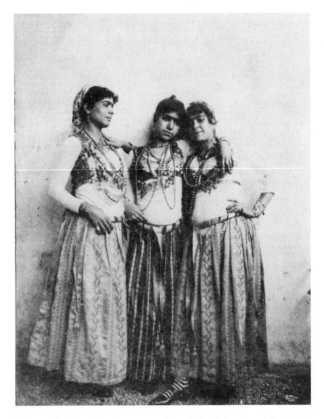

Figure 39 Egyptian dancers on the rue du Caire, 1889. Delort de Gléon, *La rue du Caire à l'esposition universelle de 1889* (Paris, 1889).

elephant whose belly housed a platform for a dancer known as "La Belle Férid-jée." Implied in these juxtapositions is a notion of the Orient as the childhood of European civilization; the admixture of innocence and fantasy purifies the precept and enables its dissemination across generations. After this temporary establishment closed, its elephant was removed to the outdoor garden of the Moulin Rouge, the dance hall in Montmartre that opened just after the close of the exhibition.[46] Apparently the vice squad took up residence in the elephant, but, according to contemporary accounts, "La Belle Zhora" performed Ouled-Nail belly dances nearby.[47]

The Moulin Rouge is more identified than any other establishment with the transformation of the *bal public* from an arena of relatively unregulated sociability into one of lucrative exhibitionism; in this process, the cult of celebrity dancing was pivotal. Thanks to the Moulin Rouge's mobilization of nearly all the available forms of publicity—memoirs, interviews, gossip columns, guidebooks, celebrity *cartes-de-visite,* posters, and postcards—most elements of the

Figure 40 Program for the Pays des Fées, 1889. Département des Estampes et de la Photographie, Bibliothèque Nationale, Paris. © Cliché Bibliothèque Nationale de France, Paris.

economic, commercial, and artistic network through which it functioned can be identified. We know the dancers' outrageous and poignant stage names—"La Sauterelle" (The Grasshopper), "Nini Pattes en l'Air" (Nini, Paws in the Air), "La Goulue" (The Glutton), "Môme Fromage" (Kid or Mistress Cheese), "Grille d'Egout" (Sewer Grate), and "Valentin-le-Désossé" (Valentin-the-Double-jointed). We know their employer—Joseph Oller; their impressario—Charles Zidler; their salaries—three hundred francs a month; where to find their public relations—*Paris illustré, Le Courrier français.*[48] And, finally, we know a great deal about their image maker—Henri de Toulouse-Lautrec.

As the premier poster artist in Paris, Chéret was engaged to advertise the opening of the Moulin Rouge. By commissioning Lautrec to design the poster for the following season (winter 1890–1891), Zidler launched the young artist's career. He proved, in turn, to be a master of publicity. Featuring the Moulin Rouge's star dancers, La Goulue and Valentin-le-Désossé, instead of the generic *chérette* on his poster, Lautrec inaugurated a new dimension of their celebrity; the glamorous feudalism of a "star system" attached to a particular commercial establishment was born. And the system served the artist as well, who wrote proudly to his mother: "they're being very nice to me in the newspapers since my poster."[49]

One measure of the success of Lautrec's publicity can be found in La Goulue's private venture four years later, which also discloses, in one ensemble, the metamorphosis gradually undergone by the belly dance over the previous two decades. Although retrospectively described as the beginning of her in-

Figure 41 Jules Chéret, poster for the Pays des Fées. Musée de
l'Affiche, Paris. © Cliché Bibliothèque Nationale de France, Paris.

evitable decline into poverty and obscurity, it is more likely that La Goulue
risked an entrepreneurial endeavor on her own at the height of her acclaim. Not
that the predictable accounts of her life would grant such savvy to a child of the
streets. Née Louise Weber, La Goulue had come to Paris from Alsace-Lorraine
and reportedly worked as a flower vendor, then as a laundress, before being no-
ticed for her exuberant dancing at Montmartre *bals publics*. She progressed
from the Boule Noire, or some said the Médrano, to the Moulin de la Galette,
the Elysée Montmartre, where she achieved notoriety, and finally to the Jardin
de Paris, before being recruited by Oller for the Moulin Rouge, reportedly for
twice the usual salary.[50] Lautrec first caught up with her in 1887, when she ap-
peared in a small composition on cardboard with Valentin, already her partner,
or was she his protégée?[51] In any case, in 1895 she erected a booth at the Foire
aux Pains d'Epices on the Place du Trône (thus also known as the Foire du
Trône), where she starred in a so-called Moorish dance.

PLAN DE LA FOIRE AUX PAINS D'EPICES

Figure 42 Plan of the Foire aux Pains d'Epices on the Place du Trône. Département des Estampes et de la Photographie, Bibliothèque Nationale, Paris. © Cliché Bibliothèque Nationale de France, Paris.

The booth was situated on the *place* itself, which was divided into ten sectors, all dedicated to popular attractions, including a huge cyclorama of Tunisia and Algeria, a children's playground, animal acts, and games (Fig. 42). In a prominent position at the entrance to the avenue du Trône, the theater district, La Goulue occupied the borderline between sensational and dramatic entertainment. The booth itself, with its onion dome and crescent-and-star insignia marking the entrance, retained a few impoverished features of the Islamic pavilions

Figure 43 Photograph of La Goulue's booth at the Foire du Trone, incorrectly identified as the Foire du Neuilly. *Figaro illustré* (April 1902).

at the world's fairs, enough to signify in the manner dubbed "basquity" in Barthes's exemplary analysis (Fig. 43).[52]

For this occasion, La Goulue engaged Lautrec to paint the booth's two façade panels. One portrayed La Goulue's familiar role with Valentin on the floorboards of the Moulin Rouge, the other her solo performance of the "Moorish" dance on an elevated platform.[53] "They're gigantic jokes," *La Vie Parisienne* clued in its readers; "it's the chahut in fresco, the enormous swaying hips of a symbolic *bal public.*"[54] It is also a virtual diagram of the mechanisms and motivation of integrating the belly dance into Parisian entertainment. Eventually cut into fragments of portraiture by a dealer and now reassembled, the panels in their present condition exaggerate the ghostly effect of Lautrec's mordant line and spare pigment, his "language of silhouette for conversing with the public," in Arsène Alexandre's phrase.[55]

The Moulin Rouge panel recombines elements of Lautrec's previous depictions of La Goulue and Valentin. The other panel is more novel, but only insofar as it traces with great clarity the component parts of the hybrid that Islamic dancing in Paris had always been (Fig. 44.) If in the exposition environment the cabaret settings and the half-familiar movements were a

Figure 44 Toulouse-Lautrec, *Moorish Dance,* panel for the booth of La Goulue at the Foire du Trône, 1895. Musée d'Orsay, Paris.

mnemonic screen against which the belly dance could be registered, here figure and specter come forward simultaneously. The crescent motif from the exterior façade is repeated on the flat that serves as backdrop to La Goulue's dance of the "almée," a dance that seems to contain the characteristic cancan kick. In the foreground, a crowd of observers from Montmartre and abroad (Jane Avril of the Moulin Rouge, amid Oscar Wilde, Félix Fénéon, and the champagne vendor, photographer, and amateur Maurice Guibert) is arranged so that they present a "celebrity endorsement." The scenery on the right recalls descriptions of Fathma's *boîte* at the 1889 exhibition, which had included a stage covered with carpets and an elevated seat in front of a large mirror, used for musical performances. The seated *fathma* in Lautrec's panel and her turbaned male partner, who serve as percussionists, are placed in the position usually occupied by the *corbeille* of women in a café-concert setting. The entire scenario—booth, decoration, music, and the dance itself—was meant to resonate with the Islamic entertainment districts devised for the world's fairs.[56]

Meanwhile, another hybrid was being produced, in the belly dances performed at the universal expositions. In 1889 the dancers were limited to swords and mirrors, signaling the long-established European association of Islam with violence and its women with mystique. The dances in 1900, however, used more elaborate devices and added to the repertoire of "typical" Islamic accoutrements—such as the narghile—objects that obviously were industrial and Parisian.[57] The dance of the chair, performed with a chair balanced in the mouth, was reminiscent of the notorious quadrille of the Louis XIII chair, which in 1886 had become the "signature dance" of Aristide Bruant's Le Mirliton, as rendered in Lautrec's illustration published on the cover of the cabaret's journal.[58]

During the same period that the belly dance was imported to Paris, Parisian dancing was being exported abroad. As early as the 1860s, the stars produced by the *bals publics* were seen in Berlin and London. By the 1880s, this network had extended to Istanbul. Official modernization programs begun by the Ottoman government at first adopted military technology, and thereafter, French social and cultural norms. Eventually, Parisian entertainment became fashionable among the Ottoman court and upper classes.[59] Nightclubs with names referring to Parisian sites—Montmartre, Parisiana, and Concordia—or evoking Parisian images—Flamme and Café Crystal—or even deriving from Islamic legends created by the Parisian entertainment industry—Alhambra and Alcazar—became commonplace.[60] The place occupied by belly dancing in Paris, in other words, was filled in Istanbul by Parisian dancing. In time, the belly dance would be reformulated in many Islamic countries, along lines similar to those we have described: as a commercial concoction for tourists presented in the guise of an indigenous art form.

Given the migrations of the belly dance and the ensuing inversions of its cultural meaning, perhaps our essay can best be described as an attempt to present a counterdiagram of the site plans, which instead maps the circulation of colonized women's bodies. Several principles of its construction will bear reiterating. The imperial power relationship is not simply a process of cultural exchange or appropriation; rather, it operates through a continuous circulation of imagery and redefinition of meaning. It cannot be grasped by squaring two pairs of oppositions, between man and woman and colonizer and colonized. Who is the other when La Goulue interprets the dance of La Belle Féridjée? And who is in which position when Suzanne performs for an audience in Istanbul, in a place called Le Café du Luxembourg?[61] La Belle Fathma, La Goulue temporarily vacate one form of identity only to be caught failing to achieve another. It is the density of cultural interchange in specific historical situations that made us question the most frequently used concept in postcolonial and feminist discourse—the Other. And it may be useful, in conclusion, to recall briefly the circumstances in which the Other became the name for a solution to a common problem; this will amount to treating the concept as a device, not as a law.

The aggression accentuated in Jean-Paul Sartre's reworking of the Hegelian

problematic of the Other in *Being and Nothingness* (1943) was released, in the postwar period, exactly in the realms where it most mattered. In his *Anti-Semite and Jew* (1946), Simone de Beauvoir's *The Second Sex* (1949), and Frantz Fanon's *Black Skins, White Masks* (1952), the concept acquired a performative, protopolitical function.[62] For example, Beauvoir's consideration of how this "fundamental category of human thought" became attached to the division of the sexes was premised upon a universal explanation of patterns of oppression.

> Whether it is a race, a caste, a class, or a sex that is reduced to a position of inferiority, the methods of justification are the same. "The eternal feminine" corresponds to "the black soul" and to "the Jewish character."[63]

As astonishingly undifferentiated as these equations may now appear to be, the detection of a rule of judgment applicable in such diverse circumstances provided enormous momentum for cultural critique. At the same time, the concept operated at the level of individual agency; the unavoidable repression of the Other in human existence was held to account. Notwithstanding the aspects of her existential philosophy no longer considered viable, it is still possible to extrapolate from Simone de Beauvoir's argument how gender functions as an exercise of power, even where sexuality itself is not at stake. Although she devoted her entire book to dismantling the "natural" link between sexual difference and the hierarchy inherent in the Self/Other dyad, the duality of sexes continues to be constructed ("perceived," she would have said) as primordial and thus is used to stipulate multiple relations of domination and submission. The existentialist stress on the individual burden of choice, even within the inevitable alterity of human relations, enabled Fanon, during the same years, to propose a rehabilitation of the colonial subject in terms of the concept of the Other. In his psychoanalytic modification of the ontology of othering, native difference would serve as a corrective to the divided self; his revolutionary subject could achieve a unified and politically conscious identity, which would facilitate decolonization.[64]

Worked upon between 1954 and 1956, Barthes's *Mythologies* also was marked by gestures to Sartre, one of the chosen masters of experimental, artificial myth.[65] With an exemplary Negro soldier saluting the Empire and a petit-bourgeois turning to exoticism for emergency relief from the Other, "Myth Today" appeared ideally situated to steer analysis from the problem of representing identity toward the process of identification inherent in cultural coding through signification. Semiology, with its momentum of displacement and differentiation, appeared to break open the binary logic of the Other, to reverse its stasis and entropy. Yet it, too, ran aground, as Barthes himself noted in 1971. Not that mythmaking had ceased. Nor was the problem really that the chorus of denunciation had yet to "change the object itself." But demystification had proven embarrassingly prey to mythification itself.[66] Barthes's suspicion that the science of the signifier would need to be revamped culminated in an ambivalent prescription, pointing to the Lacanian imaginary as an answer.

A series of contexts that reinforced the instrumentality of the Other was succeeded by its dispersal, in the academic vernacular, into a nebulous, free-floating force signifying its own autonomy and deconstructive or psychoanalytic authority. The protest in the last decade against feminism's complacent use of woman as subject nevertheless has suggested that dualism lingers; often expressed in postcolonial rhetoric, the challenges to feminism frequently indict a form of Cartesian cogito that had claimed to be living a Lacanian existence.[67] The shift from an objectifying, substantive, distancing Other to one of deferral and desire is a subject in itself, much too complicated to explore here.[68] Finally, the concept is an expression of a cultural condition as much as an analysis of it.

Suffice it to say that feminist and postcolonial critics should question bipolar logic. The concept remains useful, provided it is not allowed to descend in essential antitheses or multiple mirrorings of prejudice. It reminds us to evaluate not simply the validity of constructions of the Other, but also to see in them the motives, desires, and fears of the image makers. In addition, it enables the isolation of similar patterns of domination in circumstances as different as those structuring the representation of Islamic culture at the world's fairs and working-class women in the dance halls of Montmartre.

Regressive theories of representation would suggest that the belly dance be read symptomatically, as the token or alienation of an already-given doctrine—colonial discourse, the denigration of feminine lack. Often, however, this procedure settles accounts by trivializing the contents of difference while leaving the framework of power intact. For the moment we have preferred to write a skeptical ethnography of one aspect of Parisian culture, greatly doubting, to put a final spin on Barthes's words, that yesterday's truths will be the exact match of today's laws.[69]

NOTES

We would like to thank Betsy Cromley and Janet Kaplan for giving us the opportunity to present this paper at the Feminist Art History Conference at Barnard College in October 1989, Margaret Higgonnet for soliciting it for a conference on colonialism and gender held at the Minda de Guunzberg Center for European Studies at Harvard University in April 1990, and Michael Hays for including it in a lecture series at the Graduate School of Design, Harvard University, in September 1990. We are also grateful to Seyla Benhabib, Mary McLeod, Molly Nesbit, Linda Nochlin, Paul Summit, and Perry Winston for their comments.

1. To wit, Malcolm Forbes's Moroccan birthday bash in August 1989, with its hundreds of belly dancers and charging calvary. The extensive press coverage lambasted its conspicuous consumption but never questioned its reinvigoration of the same old stereotypes of Islamic culture.

Ethnography and Exhibitionism at the Expositions Universelles

2. Roland Barthes, "Myth Today [1957]," in *Mythologies,* selected and trans. Annette Lavers, New York: Hill and Wang, 1972, p. 128.

3. One indication of this conjunction of interests may be found in Said's observation, six years after the publication of *Orientalism,* the founding text for postcolonial criticism: "Thus, for example, we can now see that Orientalism is a praxis of the same sort, albeit in different territories, as male gender dominance, or patriarchy, in metropolitan societies: the Orient was routinely described as feminine, its riches as fertile, its main symbols the sensual woman, the harem, and the despotic—but curiously attractive—ruler." Edward Said, "Orientalism Reconsidered," *Cultural Critique* 1 (Fall 1985): 103.

4. Our collaboration developed from joint sessions of courses held in the History, Theory, and Criticism and Aga Khan programs at MIT during the academic year 1988–89; we considered the issues surrounding Orientalism, postcolonial and feminist theory.

5. Of course, demystification is thoroughly appropriate, not to mention enjoyable, in many circumstances. In the case of Gauguin, for example, see Abigail Solomon-Godeau, "Going Native," *Art in America 77,* no. 7, July 1989, pp. 118–128, 161.

6. A more extensive discussion of the architectural representation of Islamic cultures at the nineteenth-century world's fairs will appear in Zeynep Çelik, *Displaying the Orient,* Berkeley: University of California Press, 1991.

7. In 1867, for example, two electrically lit towers or "lighthouses" were erected by France and England in the park surrounding the main exhibition building. See Patricia Mainardi, "The Eiffel Tower and the English Lighthouse," *Art Magazine* 54, March 1980, pp. 141–144, and idem, *Art and Politics of the Second Empire: The Universal Expositions of 1855 and 1867,* New Haven: Yale University Press, 1987, pp. 146–147.

8. Hippolyte Gautier, *Les Curiosités de l'exposition universelle de 1867,* Paris, 1867, 2, pp. 85–86.

9. G. de Wailly, *A travers l'exposition de 1900,* Paris, 1900, 8, p. 6.

10. Timothy Mitchell has argued, in fact, that the "process of exhibiting" epitomized the expositions as well as the Western "experience of order and truth." See Timothy Mitchell, "The World as Exhibition," *Comparative Studies in Society and History* 31, no. 2, April 1989, pp. 217–236; the article is based on the first chapter of his book *Colonizing Egypt,* Cambridge: Cambridge University Press, 1988, pp. 1–33.

11. James Clifford, Virginia Dominguez, and Trinh T. Minh-ha address such temporal and social hierarchies in "Of Other Peoples: Beyond the 'Salvage' Paradigm," in *Discussions in Contemporary Culture* 1, ed. Hal Foster, Seattle: Bay Press, 1987, pp. 121–130, 131–137, 138–141, respectively, and 142–150, for a discussion.

12. Burton Benedict, "The Anthropology of World's Fairs," in *The Anthropology of World's Fairs,* ed. Burton Benedict, Berkeley: Scolar Press, 1983, p. 2. Ralph Greenhaughl points out that the rise of anthropology as a discipline occurred between 1878 and 1889 in Paris. See his *Ephemeral Vistas, the Expositions Universelles, Great Exhibitions, and World's Fairs, 1851–1939,* Manchester: Manchester University Press, 1988, p. 86. Anthropology was largely influenced by Arthur de Gobineau's *Essai sur l'inegalité des races humaines,* Paris, 1853. Han-

which took place at the 1900 exposition, the main character Isa is distressed and embarrassed by the performance of belly dancers in the Egyptian theater and argues that the dance does not represent his country. See Louca, *Voyageurs et écrivains égyptiens,* p. 232.

24. Barthes, "Myth Today," p. 128.

25. In spite of Said's repeated attempts to dissociate himself from a search for "authentic" representation, many studies published in the wake of *Orientalism* seemed to take its central argument as an injunction to do just that. See "Orientalism Reconsidered," and, especially, *Orientalism,* pp. 273–274, where he refers to Barthes on the issue of representation as deformation.

26. In fact; Oriental decor was featured in Parisian establishments from the late 1830s on; for example, a Moroccan tent covered the dance floor at La Grande Chartreuse (founded 1838); see Edmond Texier, *Tableau de Paris,* 2 vols., Paris, 1850, 1, pp. 173–175. Its successor, the Closerie de Lilas, was decorated with "gawdy Oriental paintings that some joker dubbed the Alhambra genre" (Alexandre Privat d'Anglemont, *La Closerie de lilas: Quadrille en prose* [Paris, 1848], 19). On parallels between the Islamic districts and the café-concert noted by commentators in 1889, see Sylvianne Leprun, *Le Théâtre des colonies: Scénographie, acteurs et discours de l'imaginaire dans les expositions 1855–1937,* Paris: Editions L'Harmattan, 1986, pp. 72–78.

27. See Corbin, *Les Filles de noce,* pp. 250–254. Further information on the *brasseries à femmes,* unfortunately simplistically "applied" to the paintings of Manet and Degas, can be found in Theresa A. Gronberg. "Femmes de Brasserie," *Art History* 7, no. 3, September 1984, pp. 329–343.

28. Mariel Oberthur, *Cafés and Cabarets of Montmartre,* Salt Lake City: Gibbs M. Smith, 1984, pp. 55–57.

29. In fact, in the early modern period the word was used primarily for plants and merchandise. See Vincenette Maigne, "Exotisme: Evolution en diachronie du mot et de son champ semantique," in *Exotisme et création,* Actes du Colloque international, Lyons, 1983, Lyons: L'Hermès, 1985, pp. 9–16. and Jacques Huré, "Exotisme et rencontre des cultures: La Route de la soie," in ibid., pp. 217–227.

30. The most pointed of a number of discussions of this issue is Abigail Solomon-Godeau, "The Legs of the Countess," *October 39,* Winter 1986, pp. 65–108.

31. The standard, thoroughly documented source on popular dancing is François Gasnault, *Guinguettes et lorettes: Bals publics et danse sociale à Paris entre 1830 et 1870,* Paris: Aubier, 1986. For later periods, the primary source is the Rondel Collection of the Bibliothèque de l'Arsenal, which has informed the literature on Toulouse-Lautrec. Other useful discussions can be found in Alex Potts, "Dance, Politics and Sculpture: *Jean-Baptiste Carpeaux* by A. M. Wagner," *Art History* 10, no. 1, March 1987, pp. 91–109; Gale B. Murray, "The Theme of the Naturalist Quadrille in the Art of Toulouse-Lautrec: Its Origins, Meaning, Evolution, and Relationship to Later Realism," *Arts Magazine* 55, no. 4, December 1980, pp. 68–75; and Jean-Claude Lebensztejn, *Chahut: Seurat revisité,* Paris: Hazan, 1989.

32. *Adieux au monde* sold six thousand copies of an edition of ten thousand before being seized in 1854. See Gasnault, *Guinguettes et lorettes,* 237–240, and [Ernest Blum], *Mémoires de Rigolboche,* Paris, 1860.

nah Arendt suggests that by 1900, Gobineau's text had become "a kind of standard work for race theories in history." See Hannah Arendt, *Imperialism,* 1951, New York: Harcourt, Brace, Jovanovich, 1968, pp. 50–51.

13. Johannes Fabian, *Time and the Other: How Anthropology Makes its Object,* New York: Columbia University Press, 1983, p. 43.

14. See Edward Kaufman, "The Architectural Museum from the World's Fair to Restoration Village," *Assemblage* 9, 1989, pp. 21–39, and Debora L. Silverman, "The 1889 Exhibition: The Crisis of Bourgeois Individualism," *Oppositions* 8, Spring 1977, pp. 70–91.

15. Anouar Louca, *Voyageurs et écrivains égyptiens en France aux XIXe siècle,* Paris: Didier, 1970, pp. 193–194.

16. See Edward William Lane, *An Account of the Manners and Customs of the Modern Egyptians, Written in Egypt During the Years 1833–1835,* London: Dover, 1978, pp. 373–375, and Sarah Graham-Brown, *Images of Women: The Portrayal of Women in Photography of the Middle East 1860–1950,* London: Quartet Books, 1988. Other accounts of the belly dance, which uncritically present it as an Islamic art form, can be found in Morroe Burger, "The Arab *danse du ventre,*" *Dance Perspectives* 10 (Spring 1969), pp. 4–41, and Wendy Buonaventura, *Serpent of the Nile: Women and Dance in the Arab World,* New York: Interlink Publishers, 1989.

17. See, for example, Ahmed Mithad, *Jön Türk* (The young Turk), Istanbul, 1910; quoted and discussed in Orhan Okay, *Bati Medeniyeti Karsisinda Ahmed Mithad Efendi* (Ahmed Mithad Efendi vis-à-vis Western civilization), Ankara, 1975, pp. 99–100, and Fanny Davis, *The Ottoman Lady: A Social History from 1718 to 1918,* New York: Greenwood Press, 1986, p. 162.

18. The Algerian commander Abd al-Qadir, who had led the first uprising against the French between 1832 and 1841, attempted unsuccessfully to ban the Ouled-Nail girls from traveling to different parts of Algeria to dance and to practice prostitution. See Hubertine Auclert, *Les Femmes arabes en Algerie,* Paris, 1900, p. 116. Algerian-born women remained a small percentage of *registered* prostitutes in France during the second half of the nineteenth century, according to records compiled by Corbin. For the period 1880–1886, only 4.74% of *filles soumises* in Paris were foreigners. In the port town of Marseilles, not surprisingly, a greater percentage were foreign-born (the largest number were Italians, followed by Spaniards, Swiss, and Germans); exact figures are not given for Algerian women, but they look from his graph to be roughly 4.6% of the foreign-born women and 1.3% of the total number of 3,584 tallied. See Alain Corbin, *Les Filles de noce: Misère sexuelle et prostitution, 19e et 20e siècles,* Paris: Aubier Montaigne, 1978, p. 75; see p. 97 for map.

19. Auclert, *Les Femmes arabes,* p. 114.

20. See Clifford, Dominguez, and Minh-ha, "Of Other Peoples."

21. See Edward W. Said, *Orientalism* New York: Vintage Books, 1979, and, for the first article to grasp its significance for the interpretation of nineteenth-century painting, see Linda Nochlin, "The Imaginary Orient," *Art in America* 71, no. 5, May 1983, pp. 118–131, 187–191.

22. Ahmed Mithad, *Avrupa'da Bir Cevelan,* Istanbul, 1890, pp. 164–165.

23. Ibid. In a scene from Mohammad al-Muwaylini's novel *Ar-Rihla Ath-thaniye,*

33. Gérôme, unidentified clipping, 1865, Dossier Ro. 12910, Bibliothèque de l'Arsenal, Paris.

34. See *La Seine* (10 October 1886), Arthur Pougin, *Le Théâtre à l'exposition de 1889,* (Paris, 1890), pp. 120–121, and Julien Tiersot, *Musiques pittoresques, promenades musicales, l'exposition de 1889,* Paris, 1889, pp. 82–83.

35. Gasnault, *Guinguettes et lorettes,* pp. 47–56.

36. Ibid., Chaps. 2–3. Official policy, of course, varied with administrations; there was also an opinion that entertainment served to distract the populace from conspiracy and therefore should be surveilled but not condemned or restricted (see p. 82).

37. *Paris Cythère,* Paris, 1894; cited in Ph. Huisman and M. G. Dortu, *Lautrec by Lautrec,* trans. Corinne Bellow, New York: Chartwell Books, 1964, p. 78, and in Murray, "The Theme of the Naturalist Quadrille."

38. Joris-Karl Huysmans, "Bartholomé—Raffaëlli—Stevens—Tissot—Wagner—Cézanne—Forain," in *Certains,* 1889; reprint, Paris, 1975, p. 302; translation altered from Murray, "The Theme of the Naturalist Quadrille," p. 72.

39. Gustave Kahn, "Seurat," *L'Art moderne* 11 (5 April 1891); cited in *Seurat in Perspective,* ed. Norma Broude, Englewood Cliffs, N.J.: Prentice-Hall, 1978, pp. 24–25.

40. For documentation of this street, see Delort de Gléon, *La rue du Caire à l'Exposition Universelle de 1889,* Paris, 1889.

41. Edmond de Goncourt, *Journal: Mémoires de la vie littéraire* (Monaco: Les Editions de l'Imprimerie Nationale de Monaco, 1956), 16, p. 100, 2 July 1889.

42. Ibid., p. 101.

43. On the origins of pornographic and erotic photographs of dancers, laundresses, and artists' models in the 1860s, see Elizabeth Anne McCauley, *A. A. E. Disdéri and the Carte de Visite Portrait Photograph,* New Haven: Yale University Press, 1985, and Solomon-Godeau, "The Legs of the Countess." The demand for small, portable depictions of women's bodies evolved into a burgeoning market in postcards of colonial women; see Malouk Alloula, *The Colonial Harem,* trans. Myrna and Wlad Goldzich, Minneapolis: University of Minnesota Press, 1987; Graham-Brown, *Images of Women,* and David Prochaska, "L'Algérie imaginaire: Jalons pour une histoire de l'iconographie coloniale," *Gradhiva* 7, Winter 1989, pp. 29–38.

44. For photographs of Oriental dancers, see Graham-Brown, *Images of Women,* pp. 170–181.

45. René Maizeroy, "Les Théâtres ephémères à l'exposition, le théâtre égyptien," *Figaro Illustré* 124, July 1900, pp. 142–143.

46. See Charles Rearick, *Pleasures of the Belle Epoque: Entertainment & Festivity in Turn of the Century France,* New Haven: Yale University Press, 1985, p. 121, and *Fêtes de l'Exposition: Programme offert par Le Rappel,* 6 May 1889, Séries "Actualités," Bibliothèque Historique de la Ville de Paris.

47. Marcel de Bare, "Les Mémoires du Moulin Rouge: Anecdotes et souvenirs inédits sur le bal célèbre," *Oeuvres libres* 48, June 1925, Dossier Ro. 12965, Bibliothèque de l'Arsenal, Paris.

48. On Oller, see Rearick, *Pleasures of the Belle Epoque,* and Ferran Canyameres, *L'Homme de la Belle Epoque* (Paris: Les Editions Universelles, 1946). On the

Moulin Rouge, see especially, "Moulin Rouge," Dossier Ro. 12967, Bibliothèque de l'Arsenal, Paris, Georges Montorgueil, *Paris dansant* (Paris: Théophile Bélin, 1898), Götz Andriani, *Toulouse-Lautrec* (London: Thames and Hudson, 1987), and Jean Sagnes, *Toulouse-Lautrec* (Paris: Fayard, 1988), pp. 221–253.

49. Letter 133 to his mother, 25 January [1892], in *Unpublished Correspondence of Henri de Toulouse-Lautrec,* ed. Lucien Goldschmidt and Herbert Schimmel, trans. Edward B. Garside, London: Phaidon, 1969, p. 139.

50. Sagnes, *Toulouse-Lautrec,* 232, puts her salary at eight hundred francs a month. See also Dossiers Ro. 12912 "La Goulue," Ro. 12913 "Grille d'Egout," and Ro. 12923 "Nini Patte-en-l'air," Bibliothèque de l'Arsenal, Paris; *Grille d'Egout et la Goulue: Histoire réaliste,* Paris, 1885; and Montorgueil, *Paris dansant,* pp. 170–179.

51. *At the Moulin de la Galette, La Goulue and Valentin le Désossé,* oil on cardboard, 52 × 39.2 cm, Musée Toulouse-Lautrec, Albi, Dortu II, p. 282; see Adriani, *Toulouse-Lautrec,* pp. 65–66, fig. 23.

52. Barthes, "Myth Today," pp. 125, 127.

53. Dossier RF 2826, Musée d'Orsay, Paris; Luce Abèlés, *Toulouse-Lautrec: La Baraque de la Goulue,* exhibition catalogue, Cahiers Musée d'Art et d'Essai, Palais de Tokyo, no. 14 (Paris: Editions de la Réunion des Musées Nationaux, 1984).

54. La Vie Parisienne, 6 July 1895, p. 392.

55. Arsène Alexandre, "Toulouse-Lautrec," *Figaro Illustré,* April 1902, p. 13.

56. Abèlés, *Toulouse-Lautrec,* 8, suggests that La Goulue was inspired by the popularity of the belly dance at the 1889 fair, which was taken for granted in earlier literature. André Warnod even claims that La Belle Fathma is shown with La Goulue, "Que vont devenir les Toulouse-Lautrec peints pour la Goulue?" unidentified clipping, 2 October 1929, Ro. 12909, Bibliothèque de l'Arsenal, Paris. In 1900 the American dancer Loïe Fuller commissioned Henri Sauvage to build a pavilion for the exposition, where she performed a dance of the veils, another variation on "Islamic" dancing. For a discussion of Fuller's dance within the context of art nouveau, see Debora L. Silverman, *Art Nouveau in Fin-de-Siècle France: Politics, Psychology, and Style,* (Berkeley: University of California Press, 1989, pp. 299–300.

57. Maizeroy, "Les Théâtres ephémères," p. 144.

58. "Quadrille de la Chaise Louis XIII à L'Elysée-Montmartre," *Le Mirliton* (29 December 1886). The drawing is in the Musée Toulouse-Lautrec, Albi, Dortu V, D. 2973.

59. For a discussion of this phenomenon, see Şerif Mardin, "Super Westernization in Urban Life in the Ottoman Empire in the Last Quarter of the Nineteenth Century," in *Turkey, Geographic and Social Perspectives,* ed. Peter Benedict, Erol Tümertekin, and Fatma Mansur, Leiden: Brill, 1974, pp. 403–446.

60. See Okay, *Ahmed Mithad Efendi,* pp. 101–107, and Said Naum-Duhani, *Vieilles Gens, vieilles demeures, topographie sociale de Beyoglu au XIXème siècle,* Istanbul, 1947, pp. 70–71.

61. Naum-Duhani, *Vieilles Gens,* p. 100.

62. See Jean-Paul Sartre, *Being and Nothingness: An Essay on Phenomenological On-*

tology, trans. Hazel E. Barnes (New York: Philosophical Library, 1956); idem, *Anti-Semite and Jew,* trans. George J. Becker (New York: Schocken Books, 1948); Simone de Beauvoir, *The Second Sex,* trans. H. M. Parshley (New York: Vintage Books, 1974); and Frantz Fanon, *Black Skins, White Masks,* trans. Charles Lam Markmann (New York: Grove Press, 1967).

63. Beauvoir, *The Second Sex,* xxvii.

64. Fanon's later books are A *Dying Colonialism (L'An V de la révolution algéri-enne),* trans. Haakon Chevalier (New York: Grove Press, 1965), whose chapter on Algeria's European minority first appeared in *Les Temps modernes* 59–60 (May-June 1959), and *The Wretched of the Earth,* preface by Jean-Paul Sartre, trans. Constance Farrington (New York: Grove Press, 1968), whose chapter on violence first appeared in *Les Temps modernes* 181 (May 1961).

65. Barthes, "Myth Today," 126 n. 7, 133 n. 11, 136, 152.

66. Roland Barthes, "Change the Object Itself: Mythology Today" [1971], in *Image—Music—Text,* trans. Stephen Heath, (New York: Hill and Wang, 1977, pp. 165–169.

67. "Dr. Lacan" had appeared in the footnotes of *The Second Sex* as well as in those of *Black Skins, White Masks.* In her discussion of childhood, Simone de Beauvoir notes the significance of "the mirror stage" for the ego, which "retains the ambiguous aspect of a spectacle" (p. 303). Fanon asserts that Lacan's concept establishes that "the real Other for the white man is and will continue to be the black man" (*Black Skin, White Masks,* p. 114). Here is a glimpse of the conflict between feminism and postcolonialism that will emerge, as well as of the leading role that psychoanalysis will assume in defining the Other. Sartre and Beauvoir first met Fanon in Rome in 1961, the year of his death, although *Les Temps modernes* had previously published his work. See Simone de Beauvoir, *The Force of Circumstance,* trans. Richard Howard, New York: G. P. Putnam's Sons, 1964, pp. 583, 591–597, 606–607, and Annie Cohen-Solal, *Sartre: A Life,* trans. Anna Cancogni, ed. Norman Macafee, New York: Pantheon Books, 1987, pp. 404, 431–435.

68. The phenomenological Other is radically incompatible with the proposition of split subjectivity and linguistic drift. This incompatibility is implied in all of Homi K. Bhabha's references to Fanon and in his attempt to reorient the latter's existential Other in a Lacanian framework. See especially, "The Other Question: The Stereotype and Colonial Discourse," *Screen* 24, no. 6 November-December 1983 pp. 18–36. For reservations about this use of Fanon's writing, see Benita Parry, "Problems in Current Theories of Colonial Discourse," *Oxford Literary Review* 9, nos. 1–2, 1987, pp. 27–58.

69. "Utopia is an impossible luxury for [the mythologist]: he greatly doubts that tomorrow's truths will be the exact reverse of today's lies," Barthes, "Myth Today," 157.

The Family and the Father:
The *Grande Jatte*
and Its Absences*

S. HOLLIS CLAYSON

Seurat's *Sunday Afternoon on the Island of the Grande Jatte* was first exhibited at the last Impressionist exhibition of 1886, which, as mentioned, also featured the series of nudes discussed by Carol Armstrong. The article reproduced here was one of several on the painting published in an issue of the Chicago Art Institute *Museum Studies* (vol. 14, no. 2). As Susan Rosen wrote in the foreward to that issue, the essays marked a clear departure from the formalist approaches to the painting illustrated by the 1935 monograph by Daniel Catton Rich, and which still dominate many discussions of it. Consideration of the *Grande Jatte* within a social and historical context is not altogether new: investigation of these aspects was suggested by Meyer Schapiro in a 1935 article in the *Columbia Review*. More recently, T.J. Clark offered a reading of the work in terms of class structure in the conclusion to his 1984 book, *The Painting of Modern Life: Paris in the Art of Manet and His Followers.*

Clark's observations on the significance of bourgeois Sunday leisure (seen in contrast to the lower class custom of taking Monday off) provide a point of departure for Clayson's reading of the *Grande Jatte* in relation to Seurat's earlier *Bathing at Asnières* (1884). Reviewing the observations made by other art historians on Seurat's representation of class, she shifts the focus of her inquiry to the issue of gender. Although not previously remarked, she notes that the nuclear family is (with one exception) conspicuously absent from the picture, and that the scene is in fact dominated by women and children. What is the significance of this imbalance? Clayson offers some tentative answers to this question by reading the image in the light of contemporary discourse concerning the role of Sunday, promoted by moralists as a day to spend with the family. The connotations of Sunday become even more apparent when they are read in juxtaposition to the meaning of the male dominated culture of *Saint Lundi* "Holy Monday," which, according to Clayson, is the theme of *Bathing at Asnières.*

Amateur and professional admirers of Georges Seurat's *Sunday Afternoon on the Island of the Grande Jatte* (Fig. 45)[1] would agree that color blindness could decisively

*"The Family and the Father: The Grande Jatte and Its Absences," by Hollis Clayson, *Museum Studies,* (The Art Institute of Chicago), 1989. Reprinted with permission of The Art Institute of Chicago.

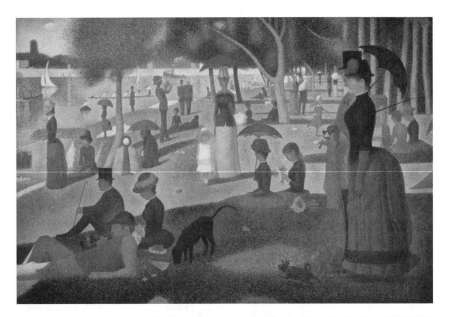

Figure 45 Georges Seurat, *A Sunday afternoon on the Island of the Grande Jatte* 1885–1886, 207.5 × 308 cm., Helen Birch Bartlett Memorial Collection, 1926.224. Photograph © 1994, The Art Institute of Chicago, All Rights Reserved.

distort a clear vision of the painting. Another disabling condition is less often acknowledged: what I call "gender blindness" has consistently hindered our comprehension of Seurat's epic picture. Motivated by a desire to compensate for this blind spot in the art-historical literature, I have sought in this essay to establish a rereading of the painting in which issues of gender receive the consideration they deserve.

On Ascension Day (May 22) 1884, the twenty-four-year-old Georges Seurat began work on a project that resulted in an epic, almost seven-by-ten-foot painting (Fig. 45) and eighty-odd related works, including more than forty oil sketches on small wooden panels known as *croquetons,* three larger studies on canvas, and about thirty conté-crayon drawings.[2] The large painting itself was completed in March 1885 for inclusion in the second Indépendents' exhibition, but it was cancelled. Perhaps spurred on by advice from artist Camille Pissarro, Seurat set to work on the painting again in the fall. He finished his revisions by May 1886 in preparation for what turned out to be a double exhibition: it was part of the eighth and final Impressionist show (from May 15 to June 15) and the postponed second Indépendents' exhibition (from August 21 to September 21).

During the 1885–1886 session of work on the painting, Seurat altered the contours of the major figures in the foreground of the composition.[3] A close look at portions of the painting in the Art Institute reveals demarcations between the work undertaken during the first and second campaigns, such as the back edge of the dress worn by the large woman at the right. The original,

straight, vertical contour of her gray-blue skirt is still visible two to three inches inside the present, irregularly curving profile of the garment.

In choosing the theme of leisure activities out-of-doors, Seurat used what was in 1884 a familiar subject for Parisian modern-life painting, but he altered the way it had been used by its nineteenth-century pioneers, the Impressionists and some of their contemporaries. Indeed the difference between Seurat's and the Impressionists' articulation of this theme has been the focus of much *Grande Jatte* scholarship in the twentieth century. Meyer Schapiro was probably the first modern scholar to focus on this issue. In 1935 he noted the contrasts between the *Grande Jatte* and a typical work by Claude Monet of the mid-to-late 1860s. "In Seurat the figures are isolated individuals, in Monet they are more sociable and are clustered in communicating groups."[4] Because Schapiro believed that both pictures were socially accurate descriptions, he argued that the key to their visual differences was social—that their differing styles owed directly to the contrast between the habits of Monet's upper-middle-class fun-seekers and Seurat's lower-class ones.

In recent iconographical studies of Seurat's *Grande Jatte,* battle lines have been drawn around the issue of whether or not the artist selected a social subject that deals with class contrasts. John House followed Schapiro's line of thinking in his 1980 discussion of the differences and continuities between Seurat's first two large-scale paintings—*Bathing, Asnières* (Fig. 46) and the *Grande Jatte*—and most recently in his paper presented here.[5] House argued that the paintings were conceived as a pair, because they were originally exactly the same size (Seurat enlarged the *Grande Jatte* in 1890 by adding a painted "frame") and because of a topographical continuity between the two: the group in each picture faces the other one from the opposite bank of the same river. House also observed that the pictures vary in style and in representing different classes of people. He compared the lower-class figures of *Bathing* (who appear "very much at their ease" because, he implied, the lower classes were more accustomed to not working), to their somewhat vulgar social superiors on the *Grande Jatte* (who appear stiff and awkward, according to House, because they were still newcomers to the realm of leisure). As T. J. Clark has conclusively shown, in the late years of the nineteenth century, leisure was the symbolic field in which the lower middle class was actively attempting to be part of the bourgeoisie.[6] House recognized the symbolic and actual importance of leisure at the time and concluded that the distinct leisure style of each of the two populations accounts for the dissimilarities of style that Seurat adopted for each painting; but he offered a controversial explanation of the differing recreational behaviors shown in the two paintings: "Both are about leisure and recreation, and these are natural for one class but artificial for the other."[7]

Several other scholars who share Schapiro's belief in the appropriateness of Seurat's style to the class of the island's Sunday visitors have argued that the population of both the island and the painting was socially diversified rather than homogeneous. Griselda Pollock and Fred Orton suggested in 1980 that the

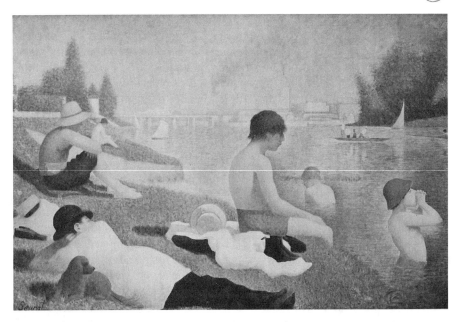

Figure 46 Georges Seurat, *Bathing at Asnieres,* 1884, National Gallery, London. Photo: Erich Lessing from Art Resource.

subject of Seurat's picture may be "the confusions and contradictions of social relations and encounters that were part of the Grande Jatte at that time."[8] In his 1985 book on Seurat and in his article included here, Richard Thomson agrees that Seurat's Sunday afternoon pleasure-seekers are a socially diverse group.[9]

In 1984 Clark argued that the *Grande Jatte* quite definitely visualizes differences of class, showing worker and bourgeois sharing the same pleasures, most vividly in the group of three in the painting's lower-left corner.[10] For Clark, recognizing and picturing social distinctions in this fashion is one of the unique features of Seurat's picture and marks the artist's salutary departure from what Clark sees as the mythologizing, evasive, and even duplicitous images of later nineteenth-century modernism. Clark was the first art historian to recognize the connection between certain social developments in the second half of the nineteenth century and the development of modern painting that is "blurred" both in its appearance and in its narrative.

Clark recognized that the emergence of a new class, the lower middle class (*petite bourgeoisie*), was the key social development of the period. The expanding number of government employees, white-collar workers in the private sector, and small shopkeepers were the three most important groups within this class, which nearly doubled in size between 1870 and 1910.[11] With origins in the working class and with aspirations to full membership in the bourgeoisie, it was "uncertain of its own social position, at once confronted with, but also actively cultivating, its own sense of rootlessness and marginality."[12] This intro-

duced into life in Paris—which possessed an otherwise legibly stratified population—a new atmosphere of fluidity, especially in certain public sites of pleasure. According to Clark, too many Impressionist painters complacently registered the new ambiguities, and, in so doing, gave form to a spectacular fiction, "according to which 'class' no longer mattered or indeed no longer effectively existed."[13] It is in view of this disparaging verdict on many Impressionist pictures of Parisian life[14] that Clark found Seurat's *Grande Jatte* to be unusually and admirably truthful in its representation of the coexistence of different classes and the tensions that this produced.

Despite the probity of various discussions of Seurat's figuration of social variety in the painting,[15] its abstracted, formal language, with the clean edges of its forms and stylized costumes, has made difficult any decisive verdict on Seurat's depiction of class difference. Indeed it is somewhat ironic that the aspect of identity about which the painting is least distinct—social-class membership—is the item that scholars of iconography have scrutinized most extensively. The characteristic Marxist concern with social stratification has led scholars to focus on class in the painting, but so has an insensitivity to and general disinterest in issues of gender and age. Clearly the crowd in the painting contains people of both sexes and of a wide variety of ages. If we sort out the forty-odd figures in the painting by gender, the women outnumber the men. It is clear that Seurat decided to feature women and children. Of the painting's eighteen largest figures, fourteen are female.[16] Of the females, three are young children and one is an adolescent, leaving ten adult women sharing the foreground with only four adult men.

Certain figure groupings merit comment in this regard. The mother and child holding hands and facing the viewer at the center of the picture underscore the thematic importance given here to family relations, and call attention to the contrasts between them and the partial family units that surround them. There are three additional pairs of mothers and daughters in the foreground space of the picture;[17] none is accompanied by a man. Only one complete nuclear-family group—man, woman, and child—can be found in the picture. Just to the right of the large, branched tree, near the picture's center, is a mother fussing over the blanket of the baby held by the father. Those women who are clearly accompanied by men do not have children with them. The most prominent of them is the large woman in the right foreground, leading a monkey on a leash and walking with a dandy sporting a monocle and smoking a cigar. Just to the left of their faces, the small figure of the other escorted woman strolls, her back to the viewer, with a companion who holds his hands behind his back. Indeed, tracing our way back and forth, in and across the space of the picture, as its construction and staging invite us to do, we happen upon all manner of diverse, nonfamilial relationships: a nurse and an old woman, two soldiers, a young woman fishing accompanied by a female friend, a dreamy man leaning against a tree, a short-skirted girl with parasol gazing at the river, a young woman with white umbrella seated alone on the grass, and so forth.

The principal two-dimensional compositional device deployed to organize the painting's foreground population is an irregular triangle whose corners are formed by the three key groups of figures: the mother and child at the apex; the trio of two men, a woman, and a dog at the lower left; and the strolling couple with the monkey and leaping pug at the right. The deliberateness and obviousness of this organizational strategy and the large scale of the figures show that Seurat meant his epic account of contemporary social life to be read principally in these seven figures. In fact, what the painting says about contemporary social relations is spoken most loudly by them, or rather by the relations and differences between them, both in their small, separate groups and across the triangular structure.

In order to evaluate the significance of Seurat's elaborate choreography, we need to consider, if only briefly, the relationship between what is in the picture and what Seurat found on the island during his many visits to it.[18] The artist spent many summer and early fall mornings in 1884 painting on the island, and just as many afternoons working in his studio. In numerous painted sketches (done on-the-spot on his father's cigar-box lids), there is no suggestion of nuclear family groupings, let alone children. Adult figures are generally not paired or grouped, but are shown seated or standing alone on the grassy banks. Many such solitary and relaxed figures did not survive Seurat's editorial procedures. Other motifs in the studies became keynotes of the large canvas. For example, sketching on the island, Seurat recorded a strolling mother and child which, as we have seen, became the central group of the finished work.[19] Another panel shows two women seated side-by-side and facing into the landscape before a three-wheeled, rattan baby carriage. In the final painting, Seurat repeated the two women and baby carriage (partially overlapped by the silhouetted back of the woman with a monkey) and added a child, whom one of the women encircles with her arm. The placement of this intimate group was painstakingly studied in a conté-crayon drawing. In the finished composition, a little blond girl in red runs across the grass, presumably toward the seated threesome.

Even with only a glimpse of the painstaking procedure by which Seurat adjusted perception to conception, we can see how he gradually established the right half of the picture as a domain of women and children whose space is forcefully penetrated by the huge couple in the foreground. Why did Seurat include so many women and children and relatively few men in his picture of a summer Sunday? Perhaps he found the island filled up in this way, but the evidence of the small-scale studies suggests this was not so.[20] And since both concept and percept mattered equally to Seurat in the mid-1880s, we must stretch well beyond our knowledge of his subject in order to explain his painting of it. To find out why he devised this cast of characters and handled them the way he did, we need to focus on the painting's two principal social themes—the day off and the family—and how they are interrelated here.

The traditional practice of stopping work on the Sabbath and religious

holidays changed during the nineteenth century. The practice was suspended after the revolution of 1789, but reinstated by law in 1814, at the start of the Bourbon Restoration. It was apparently allowed to lapse from about 1830.[21] The right to leisure was debated with fervor in 1871, during the Paris Commune, when work was attacked as social regimentation. This debate inspired Paul Lafargue's pointed and widely circulated 1880 critique of the obligation to work, entitled "The Right to Laziness."[22]

The Third Republic government was of two minds about Sundays off: it believed that the regularization of leisure was very important, but, not wanting to impose or recognize religious obligations, it formally repealed the 1814 law in 1880.[23] Afterward, the question was discussed vigorously in a variety of fora, partially in the context of the increasingly active labor-union movement in France. However, of the 4,560 strikes held in France between 1871 and 1890, only twenty-three were directly caused by a demand for a regular day off.[24] A law guaranteeing all female and child workers a day off was passed in 1892, and one securing the same right for male workers was passed in 1906.[25]

By the date of Seurat's picture, Sunday was virtually a universally shared day of rest, because almost all salaried workers and most day laborers were off, along with those who never worked because they did not need to.[26] But even though most Parisians had Sundays off, this did not mean that members of different social strata were likely to spend that day in the same way, in the same social groupings, and in the same sorts of places. In fact the ways in which Parisians of the lower classes were likely to spend Sundays at the time was a matter of principal concern to a number of highly placed parties in later nineteenth-century France.

In 1874, for example, the French Academy of Moral and Political Sciences announced an essay competition on the theme of "The weekly day of rest from the point of view of morality, intellectual culture, and industrial progress."[27] The winning entry, by a Parisian lawyer named Joseph Lefort, saw in the Sabbath the means of "revitalizing family life." He praised houses in the country, celebrated gardening, and proposed that French taverns shorten their hours. Of particular interest is the following disciplinary insight: "The secret of working-class morality lies in a Sunday day of rest."[28] The connection between revitalized family life and appropriate Sunday leisure is drawn in no uncertain terms in Lefort's sanctimonious essay. It is clear that Sunday was conceived as a showcase to demonstrate proper family behavior on the part of a population still on the road to respectability. During the World's Fair held in Paris in 1889, an international congress of weekly repose (Congrès international du repos hebdomadaire) was convened which praised the Sunday day of rest as a "liberal and democratic institution" that would yield favorable results for "the normal development of physical, intellectual, and moral life, family life, social peace, and the prosperity of the nation."[29] The phrase "the normal development . . . of family life" shows that the reformers firmly believed that proper Sundays would beget moral families.

Historians of nineteenth-century France have observed that the family was the object of regulations intended to control and discipline a heterogenous population by homogenizing the structure and values of French domestic life.[30] Lower-class French men and women were urged to embrace the "bourgeois mode of life," whose organizational and ideological touchstone was thought to be a rigorous home- and child-centered family structure.[31] The ideal family comprised one set of parents and their children, detached from other relatives and from the outside world. Children were therefore expected to learn everything from their parents; families were no longer to rely upon the network of the street, the traditional source of social, practical, and moral models and advice.

Such immersion in family was believed to be pleasurable as well as moral because of the emotionally satisfying companionship it can provide. (In other words, take this medicine because it will heal you, and, luckily for you, it tastes good, too.) Indeed the satisfactions of home life were held out to men as compensation for deprivations they suffered in the realm of work. (Emotional satisfaction in the roles of spouse and parent was taken for granted for women.) By the mid-1880s, however, cracks were plainly visible in the facade of the domestic ideal: the *Loi Naquet,* passed in 1884, legalized divorce for the first time since the 1789 Revolution.

There were of course large and small transgressions of the family ideal short of divorce court. Since, to paraphrase Lefort, working-class morality resided in a properly spent Sunday, one way of disobeying the family mandate was misbehaving on Sunday. For the reformers, a misspent Sunday was synonymous with male absence from family activity, because the assumption was that most women would naturally stick close to home. A transgressive practice of long-standing among working-class men was taking off work on Monday in celebration of *Saint Lundi,* in addition to Sunday.[32] On Monday one extended one's absence from the workplace by enjoying the company of friends. It was widely believed that workers who took both days off often spent them in the same way: drinking with friends and therefore badly. Thus the moralists' agenda was to eliminate altogether the pursuits of Monday and to make Sunday into a time spent with family.

A missed day of work was an economic loss for employer and laborer alike: the patron lost a man's labor; the worker lost a day's wages. In 1875 an American observer of European workers queried: "May not even the loss of this one day's wage suffice to put a stop to all possibility of saving, or even in some cases be sufficient in itself to throw a family into inextricable difficulties?"[33] Although the forceful voices of the time recognized the unfortunate financial consequences of worker disobedience, they believed that the health of family life was what ultimately mattered. Indeed, not spending time relaxing with one's wife and children (the consequence of an incorrectly spent Sunday) was considered just as bad as having no money for clothes and food (the effect of missing work on Monday).

Ironically the problematic demands of the bourgeois family united the ab-

sentee worker and his disapproving employer by bonds of maleness. Although social leaders and theorists believed that the family is or should be the center of society's intelligibility, men tended to regard the position as an unacceptable limitation of their masculine freedoms, as patent emasculation. Sundays off required them to act like women, who were always expected to emphasize their family-defined roles of wife and mother, even in the workplace.[34] Lower- and middle-class men alike resisted the pressure to spend spare time in the company of their families, preferring the society of men friends or other women. And if workers did the right thing on Sunday, some resisted wholesale regimentation of their lives—by "society" and by their wives—by continuing to skip work on Monday.

Looking closely at the artist's earlier riverine leisure picture, *Bathing, Asnières,* will help us to better grasp his characterization of Sunday off in the *Grande Jatte.* House was the first to observe that the two paintings constitute a pair; I concur that they are connected, but I will argue that they represent Monday and Sunday, respectively.[35]

Bathing has never been labeled "Monday"; yet its tranquil assembly of men and boys resting against the backdrop of a working factory must have been inspired by the all-male work-stopping rituals of *Saint Lundi.* The link between *Bathing* and the celebration of *Saint Lundi* in the 1880s reveals the simultaneous contemporaneity and chronological incongruity (which I will call "anachronicity") of Seurat's social awareness and descriptive practice, a combination that shows up in the *Grande Jatte* as well.

By the time Seurat completed *Bathing* in May 1884, the working-class tradition of Mondays off was changing. Workers had come to associate its celebration not with resistance to employers or to wives, but rather with the resignation and frustration of admitting to being a worker.[36] During the Second Empire, for example, workers preferred to take off Monday because, unlike Sunday, there was no need to dress up. But, by the 1880s, workers dreamed of escaping from their blue smocks and dressing like the middle class did.[37] Indeed, more and more workers managed to do precisely that: analysis of workers' budgets in the later nineteenth century shows that an increasingly large percentage of income was expended on leisure-time clothing in order to reduce the traditional sartorial distinctions visible between the classes on Sunday.[38]

As Thomson has shown, in its early stages, *Bathing* was conceived as a proletarian picture but was transformed into an image of shopkeepers and artisans in the course of the development of the project.[39] In the final canvas, knee-length white cloaks, tabbed leather boots, bowlers, and straw boaters (shopkeeper's garb) were substituted for the blue smocks and *casquettes* worn by the men in earlier sketches. Seurat updated the subject of his first major painting by replacing a working-class population with members of the ascendant class of the day, the lower middle class—recruits from Léon Gambetta's "nouvelles couches sociales" (new social ranks).[40]

Right from the start, Seurat's version of the theme was somewhat idiosyn-

cratic. A tavern was the customary setting for images of Monday, such as Jules Breton's (1858; St. Louis, Washington University Collection), but Seurat's errant, male workers do not drink while they bask in hazy sunshine alongside the river. He recast the conventional image of laborers on Monday by giving it an Impressionistic setting. His final move—to substitute *petit-bourgeois* shopkeepers for manual laborers—made the painting undeniably contemporary. By featuring *the* expanding class of the 1880s within the framework of a proletarian leisure tradition, Seurat presented it with forthrightness as an entity not entirely distinct from the proletariat. The origins of the *petite bourgeoisie* were working-class after all. While the painting's reference to *Saint Lundi* in the 1880s betrays Seurat's "anachronicity," the disposition of the men on the riverbank in the final composition avoided the old-fashioned iconography of tavern and drink.

Because the class of the picture's occupants has always been such an important issue, the absence of women from the composition has passed unnoticed, which has in turn retarded efforts to identify its subject. In fact the single sex of the painting's population is its surest link with the theme of Mondays off, which, as we have seen, was an exclusively male form of resistance against the related ethics of work and family responsibility. Gender blindness has again taken its toll.

The least clearly familial and most antisocial of any of the groups in the *Grande Jatte* is the trio at lower left. The three appear to be strangers who temporarily share a patch of shaded grass. Their sharing of the space and time for leisure, according to Clark, "does not result . . . in an infinite shifting so much as an effort at reaching a *modus vivendi,* agreeing to ignore one another, marking out invisible boundaries and keeping oneself to oneself."[41] The woman passes the time by reading and sewing, while the men spend it gazing off toward the river. The smaller man, in bourgeois dress from head to toe, appears uncomfortably hot, and tense, suggesting the special effort he exerted to be well turned out on Sunday. The other male idler is sprawled out and relaxed like the reclining man in *Bathing,* and his sleevelessness connotes an ostentatious disregard for standards of dress of the others on the island. He is also the most massive and detailed male figure in the painting.

Surely Seurat accorded him such prominence because he seems to have recognized the role that such a character played in the classed and gendered game of Sundays off, straddling, as he does, the dividing line between the lower middle class and the proletariat. For workers in the 1880s who maintained an old-fashioned mentality, the shame of not being able to afford being well dressed kept them away from bourgeois parts of the city on Sundays. On the other hand, the credo for the progressive majority of workers was: "I might only be a worker, but I can certainly turn myself out as well as any bourgeois."[42] These laborers made a no-holds-barred attempt to efface signs of class in their Sunday dress. This certainly applied to lower-middle-class leisure-seekers as well, such as the small, top-hatted man in the *Grande Jatte.* And there were the

hardcore hold-outs, such as the sprawling, muscular sportsman in the painting, who wore workers' clothes with swaggering and obstinate affection, defying those who wished to moralize and transform them.[43] Just as Seurat showed his modernity (and perhaps his politics) by replacing the lower-class figures in sketches for *Bathing* with shopkeepers in the final canvas, he gave a defiant, proletarian body to his foreground male figure in the *Grande Jatte,* but provided him with a less explosive wrapping: clothing that indicates his affiliation with a then-popular, physically demanding form of Sunday leisure—rowing. His body retains the memory of "old-fashioned" proletarian sartorial protest, while his dress converts him into a believable, if nonconformist, member of the crowd. While he is the odd-man-out in this image of island society, his protest is accommodated without a fuss by the new, cool means of dealing with encounters in a public park.[44] In addition he challenges the social order by lounging about without any apparent family. Elsewhere in the painting, as we have seen, it is the *absence* of men that expresses this challenge.

The large couple profiled at the right of the painting furnishes the most explicit deviation from the prescribed mode of family behavior. From the painting's first showing in 1886, the female figure with the large bustle and the monkey has been identified as a loose woman (*cocotte*).[45] She and her dandified companion are the painting's leading emblems of venality and indecency. The man may be a husband and father spending the day with a woman who flaunts her disregard for society's maternal script. The right half of the picture, with its group of women flanking the foreground couple, seems to have been structured to emphasize the *cocotte's* defiance of bourgeois ethics. The constraints upon the close-knit group of women and children sitting on the grass at the right are further reinforced by the dandy's cane, which hems in and sharply delimits their space. And the general fragility of family-based social relations seems to be expressed in the way that the clusters of women doing their best to oversee children while enjoying the park appear overwhelmed by the size, placement, volume, and darker tonality of the foreground couple.

The woman with the monkey is the moral opposite of the mother. As such she poses problems for men, as well as for women and children. She all but obscures her companion, and, placed as she is directly in the path of the little girl in red running across the grass, she becomes an ominous obstacle to "innocence." Because the composition seems to emphasize the vulnerability of unaccompanied women and children, and because the picture's population of leisure-seekers does not conform to normative patterns, we might ask just what Seurat had in mind concerning the Sundays of his day.

Seurat's personal history does not explain his position on these issues, but aspects of his life are illuminating nevertheless.[46] His family was very well off. Three years before Georges's birth in 1859, his father, Antoine Seurat, at the age of forty-one, sold his lucrative notary business[47] at La Villette, then an independent commune north of Paris, to spend the rest of his days as a wealthy, nonworking Parisian. Georges was the third child of four (but he resumed the

position of youngest child when his younger sibling died at the age of five). By all appearances, he was a respectful son in an active and close-knit extended family. Throughout his adulthood, when his family was in residence in Paris, he ate every night at his mother's dinner table. When Edgar Degas spotted him, dressed-to-kill, walking from his studio to his parents' apartment at dinner time, he lampooned Seurat's conventionality by calling him a notary.[48] When the Seurat clan was off to this or that chic vacation spot, Georges usually went along.

His sister, Marie Berthe, delighted her parents by marrying an engineer who became a wealthy industrialist; Georges and his amateur playwright, older brother, Emile, took no such steps toward financial and social prominence and security. Begrudgingly their father granted them each a living allowance. It is difficult to determine whether Georges Seurat, the obedient participant in the social rituals of the Seurat and Faivre clans (his mother was born Ernestine Faivre), found it all an onerous obligation or a pleasure. He is reported to have taken obvious delight in the company of his cousins' children, but no other record of the artist's feelings on this subject survives. One thing we do know of course is that he lived a completely secret personal life, utterly unknown to and unsuspected by his parents. When he appeared mortally ill at the family apartment at 110 Boulevard Magenta, on March 17, 1891, he was accompanied by his pregnant mistress, Madeleine Knobloch, and their thirteen-month-old son, Pierre Georges. Within one, extraordinary, thirty-six-hour period, Antoine and Ernestine Seurat learned of Georges's liaison and child and witnessed their younger son's death at the age of thirty-one.

Seurat's membership in a wealthy family of Second Empire and early Third Republic Paris is no guarantee of his espousal of bourgeois values and biases, especially since his personal life seems to have been a rejection of the expectations built into the circumstances of his own origins. Another big question mark remains the artist's politics and the degree to which he shared the anarchocommunist ideas of other Neo-Impressionists.[49] Since labor historians suggest that anarcho-communist worker organizers may have called for a return to the regular celebration of *Saint Lundi* as a form of resistance,[50] this is a particularly significant gap in our knowledge that could bear directly upon his intentions for *Bathing* and the *Grande Jatte*.

Certainly Seurat's painting of the Sunday rituals of relaxation among the lower middle classes went against the grain of the practices of his own family. The image also opposes the moralists' campaign for correct leisure, because it resists presenting the family as a bounded universe that guarantees society's coherence and stability. At the same time, the fracturing of the family and the coexistence with strangers visible in the picture are not shown as emotional or psychological gains for these Parisians. Their release from family ties has won them freedom, but at a cost: it is freedom without relaxation, without apparent fun, without meaningful connections to one another.

In the *Grande Jatte*, the institutions of the family and of the Sunday holi-

day—the former defined principally by gender, the latter by class—interfere with one another. In effect leisure seems to disrupt families. As a group, the population of the picture is made to appear more ardent about the pursuit of Sunday sunshine and freedom than about the preservation of family togetherness on a shared day off. Given the fundamental mismatch here between family-structured and day-off activities, it could be argued that the oft-remarked immobility of the *Grande Jatte's* population records an emotional and social stalemate resulting from the tensions and conflicts between the determinedly upwardly mobile men and women in the painting.

For Seurat it seems that once women are part of the day off, problems begin and tensions multiply. A critical difference between *Bathing* and the *Grande Jatte* is that one picture is all male and the other mostly female. The presence of women with children in the *Grande Jatte* introduces the responsibilities of the home, which men considered constraining. In fact it seems as though men are not on the island because children and their mothers are. Mother-child relations, however, are sympathetically recorded. There are only three instances of people touching one another in the entire painting, and they are all between mothers and children. It seems that for Seurat the absence of fathers is the prerequisite for parent-child warmth, even coexistence.[51]

One yearns to be able to equate the *Grande Jatte* with a position fully inside or against the ideology of correct leisure, but the visual contradictions and complexities of the picture do not let it be categorized quite so tidily. Its classical structure, smoothly sculptural figures, and scientific surface appear to be respectful of its subject, while the inconsistencies of its scale, space, handling, and detail seem to denote the absurdities of the customs and appearances portrayed.[52] But because relations are so obviously tense in the *Grande Jatte,* Seurat may have wanted to comment on the emotionally unrewarding unorthodoxy of lower-class pursuits, or to remark upon the incommensurability of a lower-middle-class Sunday and a middle-class one.

For most of the people in Seurat's *Grande Jatte,* the desire to spend a day in the sun—to have what a bourgeois deserves—has won out over a concern to comply with the terms of another bourgeois ritual: tending the flame of domesticity in order to maintain the conventions of respectable family life. Leisure has overwhelmed the family. Small wonder that the all-male assembly of *Bathing*—given its relatively uncomplicated theme—appears so calm and relaxed by comparison

NOTES

The conversations I have had with Richard R. Brettell (former Searle Curator of European Painting at the Art Institute) in front of the *Grande Jatte* launched the line of thinking that became this essay. I have benefitted as well from the comments of Ann Adams, Carol Duncan, and Carol Zemel on this material, and from Martha Ward's vast knowl-

edge of Neo-Impressionism. Nancy Ring's remarks were decisive for the completion of this article. I am grateful for their help.

1. Although this is the title that is most widely used today for the painting, Seurat gave it a slightly different one whenever he exhibited it. He called it *Un Dimanche à la Grande-Jatte (1884) (A Sunday on the Grande Jatte [1884].)* The year 1884 was invariably appended to the title in order to mark the date of its inception rather than 1886, the year of its completion.

2. In a letter to Félix Fénéon, dated June 20, 1890, Seurat claimed that he began all aspects of the project on Ascension Day. See Dorra and Rewald 1959, p. 157. By giving one date of birth to the entire enterprise, Seurat wished to assert that he worked on the huge canvas and the smaller pieces simultaneously. But the completion of some of the small-scale works preceded the conclusion of the large canvas: nine of the sketches and one study for example were shown in the first Société des Artistes Indépendants exhibition, in 1884.

3. See Richard R. Brettell's summary of the second campaign in his *French Impressionists, The Art Institute of Chicago,* Chicago and New York, 1985, p. 89; also see Inge Fielder, "A Technical Evaluation of the *Grande Jatte,*" in Chicago Art Institute *Museum Studies* 14, 2, pp. 173–179.

4. Schapiro 1935, p. 14.

5. House 1980, esp. pp. 346–349; and idem, "Reading the *Grande Jatte,*" *Museum Studies* 14, 2, pp. 115–131.

6. Clark 1984, Chaps. 3 and 4; see esp. pp. 155, 204.

7. House 1980, p. 348.

8. Griselda Pollock and Fred Orton, "Les Données Bretonnantes: La Prairie de representation," *Art History* 3, 3, Sept. 1980, p. 331.

9. Thomson 1985, pp. 122–126; and idem, "The *Grande Jatte:* Notes on Drawing and Meaning," *Museum Studies* 14, 2, p. 185.

10. Clark 1984, p. 265.

11. See Patrick H. Hutton, ed., *Historical Dictionary of the Third French Republic 1870–1940,* New York and Westport, Conn., 1986, pp. 701–702. See also Heinz Gerhard Haupt, "The Petite Bourgeoisie in France, 1850–1914: In Search of *Juste Milieu,*" in Geoffrey Grossick and Heinz Gerhard Haupt, eds., *Shopkeepers and Master Artisans in 19th Century Europe,* London, 1984, pp. 95–119.

12. Christopher Prendergast, "Blurred Identities: The Painting of Modern Life," *French Studies* 40, 4, Oct. 1986, p. 404. In his review of Clark 1984, Prendergast presented and summarized Clark's argument better than anyone else has to date.

13. Ibid.

14. Clark 1984 came down particularly hard on Claude Monet: "I cannot see, for example, that Monet's two pictures of *Le Boulevard des Capucines* in 1873 do more than provide that kind of touristic entertainment, fleshed out with some low-level demonstrations of painterliness" (pp. 70–72).

15. An original analysis of the critical reaction to Seurat's *Grande Jatte* in 1886 can be found in Ward 1986. Ward observed that critics did not generally remark upon the social diversity of the population of Seurat's *Grande Jatte* for two reasons: be-

cause by 1886 critics were becoming more interested in aesthetic than in social issues, and because the painting's population is not diversified. On these points, she disagreed with Clark and Thomson.

Although Clark and Thomson for example agreed on the presence of social difference in the picture, they parted company on its significance and its precise signifiers. Thomson 1985 wrote: "The simplified visual language of popular imagery, a refined range of specific types, the punning invocation of argot, and the associations of animal imagery. These were the means that enabled Seurat . . . to come to terms with the complex modernity of the suburbs" (p. 126). Evaluating the picture from an entirely different standpoint, Clark 1984 stated that he was making "the following claims for [Seurat's *Grande Jatte*]: that it attempts to find form for the appearance of class in capitalist society, especially the look of the 'nouvelles couches sociales' [see note 40 below]; that the forms it discovers are in some sense more truthful than most others produced at the time; and that it suggest ways in which class might still be painted" (p. 261).

16. I have drawn an imaginary line laterally across the painting's middleground, connecting the horn player at the left to the running girl at the right. I have included these two figures and all the figures in front of them in my inventory.

17. I am counting the following pairs as mothers and children: 1) the seated female pair on the edge of the large foreground shadow—the girl (the daughter) is admiring a nosegay, while the mother, protected by her red hat and red parasol, surveys the island; 2) the red-headed, hatless woman at far right, seated near the baby carriage and encircling the child (daughter) alongside her with an arm; 3) the seated woman in a straw hat at the farthest right edge of the picture, who appears to await the child (daughter) in red running in her direction.

18. On what the island of the Grande Jatte was like at the time, see House 1980, p. 347; Clark 1984, p. 261; and Thomson 1985, pp. 116–119.

19. *The White Dog* (study for the *Grande Jatte*), 1884. Oil on panel; 15.5 × 25 cm. United States, private collection.

20. Russell 1965 believed that Seurat did not study the island on Sundays: "Seurat's tendency was to give the Ile de la Grande Jatte its Monday face; later, when getting on to the big picture, he would people the island as he pleased" (p. 146). Russell was surely correct in warning his readers away from the trap of assuming that Seurat only painted what he saw.

21. E. Levasseur, *Questions ouvrières et industrielles en France sous la Troisième République,* Paris, 1907, p. 448.

22. Lafargue encouraged workers to claim what the bourgeoisie claimed: leisure and intellectual life. I learned of Lafargue's "Droit à la paresse" from an excellent lecture given by Kristin Ross (titled "The Right to Laziness") at the Colloquium in Nineteenth-Century French Studies (13th Annual Meeting), Northwestern University, 1987. See also idem, "Rimbaud and the Resistance to Work," *Representations* 19, Summer 1987, pp. 62–86.

23. Levasseur (note 21), p. 448.

24. Michelle Perrot, *Les Ouvriers en grève: France 1871–1890,* Paris and the Hague, 1974, vol. I, p. 260.

25. Levasseur (note 21), pp. 448–449.

26. Perrot (note 24), p. 227, reported that by 1893 ninety-three percent of French workers benefitted from Sunday off.

27. Philippe Meyer, *The Child and the State: The Intervention of the State in Family Life,* Cambridge, 1983, pp. 33–34.

28. Joseph Lefort, "Du Repos hebdomadaire," cited in Meyer (note 27), p. 125 n. 20.

29. Levasseur (note 21), p. 449.

30. See Meyer (note 27), chaps. 1–3; Jacques Donzelot, *The Policing of Families,* New York, 1979; and E. P. Thompson, "Time, Work-Discipline, and Industrial Capitalism," *Past and Present* 38, Dec. 1967, pp. 56–97.

31. The classic study is Philippe Ariès, *Centuries of Childhood: A Social History of Family Life,* New York, 1962. A good, short overview of the shift to the modern family ideal appears in the series of articles by Christopher Lasch in *The New York Review of Books:* "The Family and History," Nov. 13, 1975, pp. 33–38; "The Emotions of Family Life," Nov. 27, 1975, pp. 37–42; and "What the Doctor Ordered," Dec., 11, 1975. An excellent feminist critique of recent family history is Rayna Rapp, Ellen Ross, and Renate Bridenthal, "Examining Family History," in *Sex and Class in Women's History,* ed. by J. L. Newton, M. P. Ryan, and J. R. Walkowitz, London, 1983, pp. 232–258.

32. See Thompson (note 30), pp. 73ff.; Perrot (note 24), pp. 225–227; and Georges Duveau, *La Vie ouvrière en France sous le Second Empire,* Paris, 1946, pp. 243ff.

33. Edward Young, *Labor in Europe and America; a special report on the rates of wages, the cost of subsistence (etc.),* Philadelphia, 1875, p. 674. Young was chief of the U.S. Bureau of Statistics.

34. Joan W. Scott and Louise A. Tilly, "Women's Work and the Family in Nineteenth-Century Europe," in Charles E. Rosenberg, ed., *The Family in History,* Philadelphia, 1975, pp. 145–178.

35. John House would disagree with my interpretation of *Bathing* as a depiction of Monday. In comparing the two works, he wrote: "The contrast of staffage is clearly a question of class: working-class leisure [in *Bathing*] opposed to the fashionable classes on display [in the *Grande Jatte*]." See House 1980, p. 347. But, even though House reproduced Roger Jourdain's *Sunday and Monday* (prints after lost paintings that hung in the Salon of 1878; see p. 126, figs. 13, 14) to support his observation of class differences between Seurat's canvases, he did not conclude that they are Sunday and Monday pictures like Jourdain's. Nor would Clark (whose book also reproduces the above-mentioned engravings of Jourdain's *Sunday and Monday* in connection with Seurat) share my view; see Clark 1984, pp. 157–158, 201–202, 261–263.

36. Perrot (note 24), p. 226.

37. In Perrot (note 24), p. 226, are the phrases "pas de toilette à faire" ("no dressing up to do") and "il rêve d'échapper à la blouse et d'être mis en bourgeois" ("he dreams of escaping from his smock in order to wear bourgeois clothes").

38. Ibid., pp. 225–226.

39. Thomson 1985, p. 125.
40. By the mid-1870s, Léon Gambetta (1838–1882) was the leading republican politician in France. To recognize the greater differentiation within the middle class toward the end of the nineteenth century, Gambetta coined the expression "nouvelles couches sociales;" he used it for the first time in a speech in 1872. He imagined this rapidly growing sector of the middle classes as the potential basis of a new political coalition under the Third Republic.
41. Clark 1984, p. 265.
42. "On n'est qu'un ouvrier, mais on sait se tenir aussi bien qu'un bourgeois," Duveau (note 32), p. 366. On this issue, see also Perrot (note 24), pp. 225–228.
43. See Duveau (note 32), pp. 367–368; and Perrot (note 24), pp. 225–228. The sportsman is not however, as Stephen Sondheim interpreted him in his musical *Sunday in the Park with George* (1984), an angry worker looking for a fight.

 The identification of this figure has been controversial. (For a cogent discussion of the disputed identity and complete citations for the 1886 criticism, see Ward 1986, pp. 434–436, 495–496.) Fénéon's June 1886 review mentions the presence in the *Grande Jatte* of a *canotier* (rower or canoeist). His September 1886 article on the Eighth Impressionist Exhibition specifically identifies the reclining man as a *canotier*. Jules Christophe's 1886 review enumerated the following social types in the painting: elegant men and women, soldiers, nannies, bourgeois, workers ("élégants, élégantes, soldats, bonnes d'enfants, bourgeois, ouvriers"). Clark 1984 (p. 265) believed that the reclining man in Seurat's picture is the worker on Christophe's list, while House 1980 argued that this figure is Fénéon's *canotier*. House wrote: "Fénéon and other contemporaries identify him as a *canotier,* and *canotage* was a recreation which belonged integrally to this demi-mondaine world" (p. 347). In his review of Clark's 1984 book, House 1986 pointedly expressed his dissent over the identity of the reclining figure: "The man smoking a pipe cannot be confidently identified as a worker; his hat and vest seem rather to be the casual gear of a bourgeois *canotier*" (p. 297). My ideas about the identity and function of this figure do not rely upon a strictly either/or position.
44. See Clark 1984, p. 265.
45. See Thomson 1985, pp. 121–123; and Ward 1986, pp. 434–436. The outlandish monkey confirmed her venal status for most early viewers. The contours of her dress dramatized the size of her bustle so that her fashionable outfit threatened to appear "hyper-fashionable" (an outright exaggeration of current fashion). At the time, female "hyper-fashionability" was usually understood to connote immorality.
46. All of the biographical information comes from Jean Sutter, "Recherches sur la vie de Georges Seurat (1859–1891)," unpubl. ms. (eighty copies circulated "aux Amis de Georges Seurat"), 1964. I thank Martha Ward for bringing this to my attention.
47. To be exact, Antoine Seurat was a minor court official (*huissier*) of the Tribunal of the Département de la Seine at La Villette.
48. Gustave Kahn, "Au Temps du pointillisme," *Mercure de France* (Apr. 1, 1924), p. 13. I am grateful to Martha Ward for the exact reference. See also Russell 1965, p. 23. Ironically, in an 1888 letter to Emile Bernard, Vincent van Gogh used the

same term to describe Degas: "[Degas] lives like a little notary . . ." ("Lettre IX," *Lettres de Vincent van Gogh à Emile Bernard* [Paris, 1911], p. 102).

49. The definitive account of the relationship between Neo-Impressionist art and anarchist politics is John G. Hutton, "A Blow of the Pick: Science, Anarchism, and the Neo-Impressionist Movement," Ph.D. diss., Northwestern University, 1987.

50. Perrot (note 24), p. 226.

51. For a psychoanalytical reading of the *Grande Jatte* in which the frequent absence of Seurat's own father is correlated with the iconography of the painting, see Mary Gedo, "*The Grande Jatte* as the Icon of a New Religion: A Psycho-Iconographic Interpretation," in *Museum Studies* 14, 2, pp. 224–225, 233.

52. The best analysis of the coexistence of these opposing qualities in the painting remains Schapiro 1935, pp. 12–13.

Berthe Morisot
and the Feminizing
of Impressionism*

TAMAR GARB

Rodin's Reputation*

ANNE M. WAGNER

In their articles on the *Ramdohrstreit* and on Manet, Mitchell and Fried used contemporary criticism to establish the innovative nature of a painting or to introduce discourse surrounding its creation. The two articles that conclude this anthology discuss criticism in relation to the construction of authorial identity. For both Morisot and Rodin, criticism serves as a bridge between the artist and the posthumous reputation perpetuated by the history of art.

Garb places criticism of Berthe Morisot within the context of the 1890s to identify Impressionism as a feminine style. Morisot's identification with Impressionism thus implied that her painting was created intuitively. But because of its assumed spontaneity, Morisot's art is also seen as appropriate to her gender, in contrast to the more masculine Mary Cassatt. Stepping back from the world of art criticism, Garb shows how the construction of Morisot as the paradigmatic woman painter paralleled contemporary attempts to essentialize the nature of femininity. But no matter how "scientific" these observations purported to be, they remain masculinist and implicitly derogatory in their assertion of women's inability to analyze or function on what was presumed to be a higher, intellectual plane.

The discourse of gender and sexuality of the 1890s is also essential to understanding the reading of Rodin's works and the concomitant identity of the artist. If Morisot, the Impressionist, embodies all that is feminine, Rodin would at first seem to stand as her masculine antithesis. Creating figures of stone, he was identified as the genius. As Wagner shows, that genius was inextricable from his masculinity, which was in turn seemingly confirmed by his representation of the female body. On one level, the insistent sexuality of Rodin's works might seem to share with popular journalism of the 1890s an essentialist identification of male and female with, respectively, possessor and possessed.

A new complexity emerges however as the physicality and strength of certain figures—male as well as female—implicitly transgressed the gender distinctions accepted in polite society and portrayed in several of Rodin's works. Rodin and his contemporaries identified masculinity with genius—an identification

*Perspectives on Morisot, ed. by T.J. Edelstein; N.Y.: Hudson Hills Pres 1990.
*"Rodin's Reputation," by Anne M. Wagner in *Eroticism and the Body Politic*, Lynn Hunt, ed. The Johns Hopkins University Press. Baltimore/London, 1990.

made explicit not only by his reputation, but also by his sculpture *Balzac*. And as Wagner shows, the juxtaposition of this work to *Iris* leaves no doubt of the identification of phallus with genius, and of the female genitalia as the essence of woman. But *Iris* also challenges nineteenth-century conventions as female sexuality comes to enjoy a potency as vital as that traditionally ascribed to the male.

Dispersing, piercing those metaphors—particularly the photological ones—which have constituted truth by the premises of Western philosophy: virgin, dumb, and veiled in her nakedness, her vision still naively "natural," her viewpoint still resolutely blind and unsuspecting of what may lie beneath the blindness.

—Luce Irigaray, 1974

In an article published in *La Nouvelle revue* in the spring of 1896, the year of the posthumous retrospective of Berthe Morisot's work, the prominent critic Camille Mauclair announced that Impressionism was dead.[1] It had become history. It was an art form that had lived off its own sensuality, and it had died of it. It was possible, now, in the 1890s, to detect the unsatisfactory and illusory principle on which it had been founded. For Mauclair, Impressionism was a style based on the misguided aim of restricting itself to the seizing of visceral sensation alone. It rejected all general and underlying truths in favor of the appearance of the moment. Its meagre resources were the hand and the eye. Like many of the supporters of Symbolism in the 1890s, Mauclair approved of the Impressionists' assertion of "subjectivity" ("nature seen through a temperament," in Emile Zola's words) and their rejection of old-fashion beliefs in academic beauty, but he objected to their reliance on what he called "realism." By precluding from its orbit anything that was not to be found in the world of immediate experience, he claimed, Impressionism had destroyed itself. While understandably avoiding the excesses of idealism, it had lapsed into crass materialism.[2]

Although this view of Impressionism became prevalent in the 1890s, Impressionism had for some time been regarded as an art form of spontaneous expression, as a means of finding the self in the execution of a painting whose very technique came to represent a direct and naïve vision, however hard won. For its supporters it could be defended in terms of its "sincere" and "truthful" revelation of the temperament of the artist, who filtered the world of visual sensation through the physical acts of making marks on a surface, approximating those sensations by inventing an appropriate technical language and thereby presenting a just and personal vision of the outside world. For many of its detractors, though, Impressionist painting could be construed as a thoughtless, mechanical activity, which required no exercise of the intellect, no regard to time-worn laws of pictorial construction, and involved simply the unmediated reflex recordings of sensory impulses, a practice that smacked of both decadence and superficiality.

It was, however, Impressionism's alleged attachment to surface, its very celebration of sensory experience born of the rapid perception and notation of fleeting impressions, that was to make it regarded in the 1890s as a practice most suited to women's temperament and character.[3] Indeed, Mauclair himself, while denigrating Impressionism at large, called it a "feminine art" and proclaimed its relevance for the one artist whom he saw as having been its legitimate protagonist—a woman, Berthe Morisot. In turn, Impressionism's demise is traced to its allegedly "feminine" characteristics: its sensuality, its dependence on sensation and superficial appearances, its physicality, and its capriciousness.[4]

While the discourse that produced this apparently seamless fit between Impressionist superficiality and women's nature attained the level of a commonplace in avant-garde circles in the 1890s, those critics who read the art press had long heard Morisot's works discussed in terms that inscribed them as quintessentially "feminine."[5] In 1877 Georges Rivière had commented on her "charming pictures, so refined and above all so feminine."[6] When *Laundresses Hanging Out the Wash* was exhibited in 1876 and *Young Woman in a Ball Gown* in 1880, the works were praised for their delicate use of brushwork, their subtlety and clarity of color, their refinement, grace, and elegance, their delightfully light touch.[7] Her paintings were repeatedly praised for what was described as their "feminine" charm. Although many critics lamented the lack of finish in her work, some could still observe as Albert Wolff did that: "Her feminine grace lives amid the excesses of a frenzied mind."[8] She was seen, at worst, as the "victim of the system of painting that she has adopted."[9] On one occasion her lack of "finish" was attributed to a primordial feminine weakness. Paul de Charry, writing in *Le Pays,* asked, "With this talent, why does she not take the trouble to finish?" and answered himself, "Morisot is a woman, and therefore capricious. Unfortunately, she is like Eve who bites the apple and then gives up on it too soon. Too bad, since she bites so well."[10]

It is true that the qualities of "grace" and "delicacy" were on some occasions used to describe the techniques of the male Impressionists. Alfred Sisley was even credited with a "charming talent," and his *The Bridge at Argenteuil in 1872* was said to show his "taste, delicacy and tranquility."[11] Camille Pissarro on the occasion of showing his *Path through the Woods* (1877) was said to be gifted with a fine sensibility and great "delicacy."[12] But the analyses of work by men in these terms alone were few and far between. What is more interesting than such occasional applications of traditionally "feminine" attributes to individual male artists is the "feminizing of Impressionism" as a whole.[13]

The first critic to develop a sustained argument seeking to prove that Impressionism was an innately "feminine" style was the Symbolist sympathizer Théodor de Wyzewa, who, in an article written in March 1891, claimed that the marks made by Impressionist painters were expressive of the qualities intrinsic to women.[14] For example, the use of bright and clear tones paralleled what he called the lightness, the fresh clarity, and the superficial elegance that make up

a woman's vision. It was, he wrote, appropriate that women should not be concerned with the deep and intimate relationships of things, that they should see the "universe like a gracious, mobile surface, infinitely nuanced. . . . Only a woman has the right to rigorously practice the Impressionist system, she alone can limit her effort to the translation of impressions." In his preface to the catalogue for her first solo exhibition, in 1892, Gustave Geffroy had called Morisot's a "painting of a lived and observed reality, a delicate painting . . . which is a feminine painting."[15] In the same year Georges Lecomte had claimed that Impressionism, with its "sincerity" and "immediacy," was more suited than any other mode of expression to allow "this delicate female temperament which no external influence alters or corrupts, to develop."[16] Writing in the *Revue encyclopédique* in 1896, Claude Roger-Marx felt able to assert that "the term Impressionism itself announces a manner of observation and notation which is well suited to the hypersensitivity and nervousness of women."[17]

These sentiments were echoed in a review of the work of women artists in Boston by the Parisian critic S. C. de Soissons, who stressed that the superficiality that attended woman's fitting restriction of her sensibility to the mimetic function central to Impressionism would be recompensed by her "incomparable charm, her fine grace and sweetness."[18] Arguing for the suitability of Impressionist technique to women's manner of perception, de Soissons wrote:

> One can understand that women have no originality of thought, and that literature and music have no feminine character; but surely women know how to observe, and what they see is quite different from that which men see, and the art which they put in their gestures, in their toilet, in the decoration of their environment is sufficient to give us the idea of an instinctive, of a peculiar genius which resides in each one of them.[19]

Women artists, according to de Soissons and his colleagues, could give expression to their intrinsic natures by being Impressionists. What was peculiar to women were the sensitivity of their sensory perceptions and the lack of development of their powers of abstraction. What was peculiar to Impressionism was its insistence on the recording of surface appearance alone. As such they were made for each other. A particular construction of "Woman" and "Impressionism," which becomes operative and meaningful within the political and aesthetic climate of the 1890s (although its formation can be traced back for decades and its influence can still be seen today), is at stake here. In the context of the Symbolist valorization of the imagination on the one hand and the resurgence of various forms of idealism on the other, Impressionism came to connote a relatively inadequate aesthetic model based on the filtering and recording of impressions, hastily perceived, of the outside world. "Woman" was the graceful, delicate, charming creature, nervous in temperament, superficial in her understanding of the world, dexterous with her hands, sensitive to sensory stimuli and subjective in her responses, who could most legitimately make use of this

mode of expression. Berthe Morisot came to represent the happy fusion of these two constructions.

In order for the myth of Morisot's well-adjusted femininity to function as naturalized speech, however, her artistic practice had to be seen as the result of an unmediated outpouring. The condition of myth according to Roland Barthes is that it emerge "without any trace of the history which has caused it."[20] Implicit in much of the Morisot criticism during this period is the assumption that her painting was achieved without effort. Gustave Geffroy compared her hands to those of a magician. Her paintings were the result of "delicious hallucinations" that allowed her quite naturally to transport her "love of things" to an intrinsic gift for painting.[21] Moreover, her strength was said to reside in her feminine powers of observation that allowed for an intuitive filtering of the outside world, uncorrupted, in Georges Lecomte's words, by any learned system of rules.[22]

Morisot's success, the critic George Moore wrote, lay in her investing "her art with all her femininity," thereby creating a "style" that is "no dull parody of ours" (men's); her art is "all womanhood—sweet and gracious, tender and wistful womanhood."[23] But such gifts, necessarily, set her apart from other women artists. She had since the 1880s been compared with her female contemporaries whom she was said to outstrip in "femininity." The most famous casualties in such comparisons were Rosa Bonheur, Marie Bashkirtseff, and even Morisot's fellow Impressionist Mary Cassatt, described by Roger-Marx as "that masculine American."[24] None of these artists eschewed linearity, precision of execution, or contrived compositional arrangements. None of them was prepared to concentrate on color at the expense of line. All of them were accomplished at drawing. As such they were often seen to be reneging on their natural feminine attributes. The general mass of women artists were regularly described as imitative, sterile, and unconsciously derivative. They had, in the words of de Soissons, "a hatred for feminine visions; they make every effort to efface that from their eyes." They wished to usurp a masculine mode of seeing. Writing to his assumed male audience, he claimed:

> Many even succeed in assimilating happily our habits of vision; they know marvelously well the secrets of design and of colors, and one could consider them as artists, if it were not for the artificial impression which we received in regarding their pictures. One feels that it is not natural that they should see the world in the way in which they paint, and that while they execute pictures with clever hands they should see with masculine eyes.[25]

The slippage between seeing and representing is easily achieved. While vision is fleetingly acknowledged to be habitual and in that sense cultural, de Soissons quickly moves on to the conflation, common among his peers, of seeing with rendering. If women are constitutionally different from men, it follows that they should see differently. Art, in this discourse, is produced as the extension of a

manner of seeing and is, in that sense, an extension of a process that is by nature sexually differentiated. Where Morisot's talent allegedly triumphed over her misguided female contemporaries was in her intuitive translation of perception through a natural ability to draw and harmonize color. Her work seemed, to her critics, to be untainted by any intellectual system of drawing or composition. She was praised, therefore, for not reneging on the characteristic intrinsic to her sex. As the *Journal des artistes* critic put it in 1892, she was praiseworthy for the appropriateness of her ambition, which, unlike that of other would-be women painters, propelled her toward an art "entirely imbued with the essential virtues of her sex," an art that was devoted to the idea of a *"peinture feminine."*[26] Her work managed, according to Théodore Duret, to escape "falling into that dryness and affectation which usually characterises a woman's workmanship."[27] Lecomte praised her for resisting the temptation of creating "an artificial nature, a man's vision." She managed to ignore the sentimentality and gratuitous prettiness to which most women artists fell prey.[28] According to Roger-Marx she "escaped the law which pushes women towards a sterility of invention, passivity and pastiche."[29] By being an Impressionist, Morisot was being, truly, herself.

If such claims are to make sense at all, it is crucial to appreciate the context within which these comparative assessments were made. Morisot, exemplary *haute bourgeoise*, a *"figure de race,"* as Mallarmé called her, came to represent for her admirers the acceptable female artist.[30] In her refined person and her secluded domestic life-style, she was seen to embody the dignity, grace, and charm regarded as the mark of a peculiarly French femininity. In comparison with the deviant women who threatened to disturb traditional social and moral values, the *femmes nouvelles,* focus of anxiety for numerous French commentators in 1896, the year of the large International Feminist Congress in Paris, Berthe Morisot, wife, mother, and elegant hostess, could be acclaimed as a suitably womanly woman. What was more, her wholehearted adoption of Impressionist techniques could express an intrinsically feminine vision at the very moment women were being accused of denying their unique qualities and adopting the perverse posture of the *hommesse.* Paris of the 1890s, characterized by fear of depopulation and a suspicion of the recently proven German military strength and growing industrial prowess, saw the collaboration of scientific populists, politicians, and social theorists to create a xenophobic defense of the notion of a "racial" Frenchness, centering on the traumatic Dreyfus affair at home and the attempts of the assimilationists in the colonies. It was to women that many of the commentators turned for salvation. If women did not renege on their natural duties, France's future would be assured.[31] Berthe Morisot's work and person came to symbolize for her supporters, therefore, the essence of a Frenchness under threat and of a femininity at risk.[32] It is not surprising that her paintings were embraced by many of her defenders as, in the words of the avid Francophile George Moore, "the only pictures painted by a woman that could not be destroyed without creating a blank, a hiatus in the history of art."[33]

The discourse on art and femininity that produced Berthe Morisot as its heroine must also be situated within the more specific debates on women's potential and actual contribution to art at their height in Paris in the late 1880s and 1890s. The mobilization of women in organizations to represent their own interests had resulted in the foundation and growth of the Union des femmes peintres et sculpteurs, formed in 1881, which by the 1890s offered a venue for the display of some one thousand works by women at its annual exhibitions.[34] This decade witnessed concerted campaigns for women's professional rights. Attention was focused on the protracted struggle of women artists, led by the leaders of the Union des femmes peintres et sculpteurs, to open tuition at the Ecole des Beaux-Arts to women, to end the male monopoly on the competition for the Prix de Rome, and to elect women to Salon juries and to the Académie française. Such initiatives and the Union leadership's policy to encourage the press to review the women's exhibitions catalyzed a public debate on women's relationship to artistic practice.

Discussion of women's art at the Union exhibitions was permeated with the same concerns evident in the Morisot criticism. But whereas many critics felt satisfied that Morisot's oeuvre in the 1890s adequately and appropriately expressed the femininity of its creator, such was not the case at the Union. Many of the critics were disappointed at the neutrality of the work, at its apparent sexual indifference. Besides the abundance of flower paintings that the critics expected from an exhibition of women's work, there was little in the art itself to prove it had been created by the hands of women. In a culture that constructed masculine and feminine subjects as intrinsically different, critics wanted art to provide a concrete instance, a visible manifestation, of difference. When that did not occur, women were accused of masculinization. Critics complained that women mimicked the work of their male teachers. Some, like Charles Dargenty of the *Courrier de l'art,* even contended that the overeducation of women was to blame. If only women would remain untutored and natural, their work would express their innate characters and not the lessons absorbed from their male mentors.[35]

Against such a background Morisot's apparent ability to harness the art of her time into a practice that expressed her femininity deserved the highest praise. While many critics commented on her indebtedness to Manet, most praised her for successfully transforming his art into one of grace and charm befitting a lady of her class and background. She translated his lessons into "a language which is very much her own."[36] And it was not, as we have suggested, primarily in the subject matter of her paintings that Morisot's femininity was seen to be most evident. Although critics commented on the woman's world she pictured, her true femininity was seen to lie in her manner of perceiving and recording that world: "Close the catalogue and look at the work full of freshness and delicacy, executed with a lightness of brush, a finesse which flows from a grace which is entirely feminine . . . : It is the poem of the modern woman, imagined and dreamed by a woman," wrote one enthusiast.[37] Femininity in

painting, according to these critics, was a question of technique, although to name it thus would have brought it into the realm of conscious choice rather than unmediated expression. To function ideologically, Morisot's adherence to a particular set of pictorial practices had to be viewed as an unconscious and happy expression of self and sex.

That certain kinds of mark making were regarded as masculine and others as feminine was by no means accidental. The debates on the relatives merits of *dessin* and *couleur* had been couched in gendered terms since at least the seventeenth century. In the seventeenth and eighteenth centuries, however, sexual difference provided one of many ways of conceptualizing the relative merits of the terms of this binary opposition and seems to have operated more on the level of metaphor than as a framework for the assessment of the pictorial practices suited to men and women. By the midnineteenth century, drawing, *dessin,* with its connotations of linearity and reason, and the closely associated design, *dessein,* with its connotations of rational planning and cerebral organization of the elements on the surface, were firmly gendered in the masculine. They were not only descriptive terms but indicators of a manner of perceiving exclusively suited to the male of the species. Color, on the other hand, with its associations with contingency, flux, change, and surface appearance, was firmly grounded in the sphere of the feminine.[38]

For late nineteenth-century students the gendering of formal language was most clearly expressed in Charles Blanc's widely used textbook *Grammaire historique des arts du dessin* (1867) with which most fin-de-siècle artists and critics were familiar. Blanc proclaimed the dominance of line over color, taking issue with the relative importance that thinkers like Diderot had attributed to color. "Drawing," he stated, "is the masculine sex in art, color is its feminine sex."[39] Drawing's importance lay in the fact that it was the basis of all three *grands arts:* architecture, sculpture, and painting, whereas color was essential only to the third. But the relationship between color and drawing within painting itself, Blanc wrote, was like the relationship between women and men: "The union of drawing and color is necessary for the engendering of painting, just as is the union between man and woman for engendering humanity, but it is necessary that drawing retains a dominance over color. If it were otherwise, painting would court its own ruin; it would be lost by color as humanity was lost by Eve."[40]

Color plays the feminine role in art, "the role of sentiment; submissive to drawing as sentiment should be submissive to reason, it adds charm, expression and grace."[41] What is more, it must submit to the discipline of line if it is not to become out of control. A formal hierarchy is framed within an accepted hierarchy of gender that functions as its defense. The language of form and the language of sexual difference mutually inflect one another, creating a naturalized metaphoric discourse that operates on the level of common sense in late nineteenth-century parlance.

Such claims would not have made sense had they not drawn upon as-

sumptions deeply embedded in nineteenth-century culture and legitimated across a number of discourses. Aesthetic theory was not alone in representing the world to itself in gendered terms. Indeed it provided only one site among many for the articulation of sexual difference. Where the nineteenth century's approach differed from previous centuries' was in its attempts to understand these differences scientifically, to prove them empirically and thus use them as the basis for social theory. What had been the stuff of religion, philosophy, and common sense became increasingly a matter for medicine, the new discipline of psychology, and social policy. Where the theologians and artists had used faith and metaphor to support these contentions, now the scientists offered "facts" and "evidence."

In the face of nineteenth-century feminist agitation, the conservative medical and anthropological establishments used science to corroborate the belief in the natural hierarchy of the sexes.[42] Scientists' overriding conclusion was that women were not equipped to deal with the superior mental functions, especially those for abstract thought. In organizing thoughts, synthesizing material, and making judgments based on evidence, women and people from so-called inferior races were stunted. Such inferiority was physically determined and depended on differences in the structure, size, and weight of the human brain. Although the relevance of these factors in determining mental capacities was disputed and the findings of experiments often hotly contested, the discoveries of craniology, as the pseudoscience of comparative brain measurement came to be called, generally endorsed the contemporary view of men and women. What was controversial was not the belief in the superiority of European males itself but the craniologists' conviction that it could be proven through measurement and quantification. As each form of comparative analysis was shown to be inadequate because it failed to prove the known "facts," new and more complicated instruments and procedures were developed. There were, of course, social theorists who thought the scientists had got it all wrong, but they produced their own evidence based on evolutionary theory, social conditioning, or simple observation to support essentialist theories of sexual difference.[43] While not all spoke of women's inferiority to men, all were convinced of their difference. The manner of describing this difference and the values placed on it were what varied.

Science's findings by no means remained the preserve of the experts. Robert Nye has shown that medical theories pervaded everyday life in late nineteenth-century France and that doctors became credible mediators between laboratory experiments and society's problems.[44] Research findings were widely disseminated in popular scientific and general journals, the finer points of dispute and doubt often eradicated. A general reference book like the *Grande encyclopédie,* for example, drew heavily on current scientific knowledge in its entry for *femme.* Henri de Varigny, the author of the article, wrote that the differences between men and women could be explained through anatomical and physiological factors. The origin of woman's mental weakness was found in the

structure of her brain, which de Varigny described as "less wrinkled, its convolutions . . . less beautiful, less ample" than the masculine brain. In men, he asserted, "the frontal lobes, in which it is agreed that the organ for intellectual operations and superior psychic functions are placed, are preponderant; they are also much more beautiful and voluminous when it is a question of the more civilised races."[45] Men also, he added, were endowed with greater blood irrigation to the brain than women, which was presumed to help their capacity for thought. Theorists like Alfred Fouillée, favorite of Republican politicians, who were skeptical of such forms of explanation, nevertheless endorsed the belief in men's superior capacities for rational and abstract thought. Although he distanced himself from the evidence used by the well-known defenders of masculine superiority Gustave Le Bon and Cesare Lombroso, who were widely quoted during the period, Fouillée endorsed the universally held belief in women's intellectual inferiority. The cause of this he attributed to women's social role: "Woman's brain is now less capable of prolonged and intense intellectual efforts, but the reason is entirely creditable to her: her rôle in the family involves a development of heart-life and moral force rather than of brain force and intellectual life."[46]

The idea that women's mental capacities were necessarily stunted so that they could fulfill their maternal role was widespread. Pregnancy and menstruation were widely thought to lead to mental regression, and women's generative capacities were regarded as responsible for their innate nervousness and irritability. The development of women's intellectual capacities, it was feared, would result in the deterioration of their capacity to breed and to mother effectively. Women were thought, therefore, to stop developing intellectually at the onset of puberty when their constitutions became consumed with their reproductive functions.[47]

Women's intellectual deficiencies were compensated by capacities that were more highly developed in them than in men. According to de Varigny, in women it "was the occipital lobes [of the brain] which were the most developed . . . and it is here that physiology locates the emotional and sensitive centres." Although women were intellectually weak they possessed greater *sensibilité* than men.[48] And together with their heightened capacities for feeling, they were believed to possess a "more irritable nervous system than men," hence the claims, across a number of discourses, for women's "nervousness" and "excitability."[49] Some commentators believed women had a larger visceral nerve expansion and hence were endowed with greater visceral feeling than men. Women thus experienced the world more directly through their senses, acting upon the impulse of the moment. Whereas European men's responses to sensory impulses were delayed, complex, and deliberate, the result of cerebral reflection, those of women, children, and "uncivilized races" were direct and immediate. Peripheral stimuli, in these groups, produced unmediated reactions. These groups shared a similar psychological makeup: they had short concentration spans; they were attracted indiscriminately by passing impressions; they

were essentially imitative, their mental actions dependent on external stimuli; and they were highly emotional and impulsive. Their strengths lay in their highly developed powers of observation and perception.[50]

One hears echoes of the art critics here. Theirs was obviously not a discourse that was elaborated in isolation. Popular scientific theory of the late nineteenth century projected Woman as a person who was not quite in control. Hysteria was the extreme expression of the characteristics intrinsic to all women (and certain men). Prey to her sensory impulses, Woman could become excessive, dangerous. Like color, she threatened to overspill her boundaries, to corrupt the rational order of *dessin/dessein*. She needed to be disciplined, controlled by rational forces.[51] But she could not usurp that world of reason and make it her own. To do so would be to step outside the natural boundaries on which order and civilization were based, to destroy sexual difference—that is, the fundamental binary opposition, masculine/feminine, self/other, on which culture is founded. In the sphere of art practice and criticism, it follows that it would be laughable, even unnatural, for women to absorb academic art theory, to aspire to *la grande peinture* or to ambitious imaginative work. Such work called upon capacities that women did not possess. Their attempts could only amount to, at worst, crude pastiche, at best, skillful copying. Science had proved this and morality and social order demanded that it remain so.

Berthe Morisot's position within this nexus of anxieties is fascinating. A woman, lauded for demonstrating women's most appreciable qualities in her art: "sparkling coquetries, gracious charm, and above all tender emotion," she was also widely praised for the dignity of her person, her elegance, and her high breeding.[52] A delicate balance is struck. In Morisot, women's innate qualities are turned to the good. They are harnessed to a project that is seen as the fulfillment of her sex and as unthreatening to the social order. Her life, with its necessary domesticity, and her art, content to sing the praises of the surface, are exemplary. Only occasionally do we sense the fear that she will go over the edge, that she will live out her femininity too fully and become ill. One such instance was in 1883 when Joris-Karl Huysmans described Morisot's work as possessing "a turbulence of agitated and tense nerves," suggesting that her sketches could perhaps be described as *hysterisées*.[53]

But for the most part critics in the 1890s saw in Morisot's work the realization of a well-adjusted femininity. Her painting gave stature and dignity to a way of perceiving different from men's. For a man to be an Impressionist in the 1890s would have been to relinquish his powers of reason, of abstraction, and of deliberate thought and planning. It would have led to an art that was weak, an "effeminate" art. But for a woman to be an Impressionist made sense. It was tantamount to a realization of self. In the words of Roger-Marx, Morisot's practice proceeded "according to the logic of sex, of temperament and of social class." Hers was "a precious art, . . . which successfully employed the most vibrant and impressionable apparatuses of the organism, and a refined almost sickly sensibility, [which was] the hereditary privilege of the eternal feminine."[54]

NOTES

I am grateful to Kathleen Adler, Briony Fer, Rasaad Jamie, and Paul Smith for their invaluable comments on an earlier draft of this article. The first art historians to comment critically on the conflation of Morisot's "femininity" with "Impressionism" were Rozsika Parker and Griselda Pollock, in *Old Mistresses, Women, Art and Ideology* (London, 1981), 41–42. It was this work that first stimulated my interest in the issue and I gratefully acknowledge it.

1. Camille Mauclair, "Le Salon de 1896," *La Nouvelle revue* 1, May–June 1896, p. 342.
2. Mauclair supported a return to "abstract principles" so that "realism" would be tempered by "idealism." For a discussion of these debates, see Richard Shiff, *Cézanne and the End of Impressionism,* Chicago, 1984, pp. 70–98.
3. Of course, this construction of Impressionist technique took no account of the efforts artists made to affect the appearance of spontaneity and immediacy in their works. The aesthetics of the *non fini,* the sketchiness of the surfaces of so many Impressionist paintings, and the apparent informality of their compositional structures allowed them to be read as unmediated records of visual appearance. A study of the technique of an artist like Claude Monet reveals how inadequate such an understanding of Impressionism is. For such a discussion, see John House, *Monet: Nature into Art,* New Haven, 1986.
4. Camille Mauclair, "Les Salons de 1896," p. 342.
5. Many articles on Morisot's retrospective exhibition held in March 1896 at Durand-Ruel mentioned the fact that her work was little known at this time. See, for example, "L'Oeuvre de Berthe Morisot," *Moniteur des arts,* no. 2227, 20 March 1896, p. 125. Mallarmé also made this point in his preface to the catalogue: "Paris knew her little. . . . " Stéphane Mallarmé, *Berthe Morisot (Mme Eugène Manet): 1841–1895,* exh. cat., Durand-Ruel, Paris, 1896, p. 5. "Poor Madame Morisot, the public hardly knows her!" wrote Camille Pissarro to his son Lucien on the eve of her funeral on 6 March 1895. See John Rewald, ed., *Camille Pissarro: Lettres à son fils Lucien,* Paris, 1950, p. 371.
6. Georges Rivière, "L'Exposition des impressionnistes," *L'Impressionniste,* no. 1, 6 April 1877, reprinted in Lionello Venturi, *Les Archives de l'impressionnisme,* Paris, 1939, p. 308.
7. The Fine Arts Museums of San Francisco and National Gallery of Art, *The New Painting,* exh. cat., Geneva, 1986, pp. 182, 328.
8. Albert Wolff, *Le Figaro,* 3 April 1876, quoted in Monique Angoulvent, *Berthe Morisot,* Paris, 1933, p. 54.
9. Charles Bigot, *La Revue politique et littéraire,* 8 April 1876, quoted in *New Painting,* p. 182.
10. Paul de Charry, *Le Pays,* 10 April 1880, quoted in *New Painting,* p. 326.
11. Georges Rivière, *L'Impressionniste,* 10 April 1877, quoted in *New Painting,* p. 240.
12. Edmond Duranty, *La Chronique des arts et de la curiosité,* 19 April 1879, quoted in *New Painting,* p. 288.

13. In 1877 Paul Mantz had already claimed that there was only one "real Impressionist" in the group, Berthe Morisot: "Her painting has all the frankness of an improvisation: it does truly give the idea of an 'impression' registered by a sincere eye and rendered again by a hand completely without trickery." *Le Temps,* 21 April 1877, quoted in Monique Angoulvent, *Berthe Morisot,* p. 56. At the same time Philippe Burty wrote of her "double privilege of being both a woman and an artist," invoking the eighteenth-century pastellist Rosalba Carriera as her predecessor in "liberty and charm." *La République française,* 25 April 1877, reprinted in Venturi, *Archives de l'impressionnisme,* pp. 291–292.

14. Théodor de Wyzewa, "Berthe Morisot," in *Peintres de jadis et d'aujourd'hui,* Paris, 1891, pp. 215–216.

15. Gustave Geffroy, *Berthe Morisot,* exh. cat., Boussod and Valadon, Paris, 1892, pp. 12–13.

16. Georges Lecomte, *Les Peintres impressionnistes,* Paris, 1892, p. 105.

17. Claude Roger-Marx, "Berthe Morisot," *Revue encyclopédique,* Paris, 1896, p. 250. This thesis was later expanded in his "Les Femmes peintres et l'impressionnisme," *Gazette des Beaux-arts* 38 (1907), pp. 491–507. In keeping with the construction of Morisot as "intuitive Impressionist" who does not self-consciously adopt a style or working method, contemporary critics rarely, if ever, allude to changes or developments in her working practice. So, for example, the stylistic changes in her work in the early 1890s, such as her increased linearity, are not the subject of much discussion by her contemporaries.

18. S. C. de Soissons [Charles Emmanuel de Savoie, comte de Carignan], *Boston Artists: A Parisian Critic's Notes,* Boston, 1894, pp. 75–78.

19. Ibid., p. 76.

20. Roland Barthes, "Myth Today" (1972), reprinted in Susan Sontag, ed., *Barthes,* Oxford, 1982, p. 111.

21. For an appreciation of Morisot's works in these terms, see Gustave Geffroy, *Berthe Morisot,* 6, 10. Geffroy's comments paradoxically inscribe Morisot as attentive to Edouard Manet's lessons and as an intuitive, untutored painter: "Mme Berthe Morisot, who heard and understood the good lesson in painting given during this period by Edouard Manet, has arrived totally naturally, by her love of things, to the development of the gift which is within her." Ibid., p. 10. The construction of Morisot as the intuitive painter has been perpetuated in the Morisot literature, most notably in the writings of Denis Rouart, who in 1950 declaimed: "It is essential to her nature to be a painter and everything is a pretext for painting. . . . She could not stop painting the people and the things she loved for with her to love was to paint. The way in which 'she lives her painting and paints her life' gives her work a special quality which Paul Valéry has rightly compared 'to the diary of a woman who expresses herself by colour and drawing.'" Denis Rouart, in Arts Council of Great Britain, *Berthe Morisot,* exh. cat., London, 1950, p. 5. Even a cursory reading of her letters compiled by Rouart himself, which indicate both Morisot's struggle as an artist and her conscious identification with certain painters and practices, undermines the reading of her work as an intuitive outpouring. See Denis Rouart, ed., *The Correspondence of Berthe Morisot,* trans. by Betty W. Hubbard, introduction and notes by Kathleen Adler and Tamar Garb, London, 1986.

22. Georges Lecomte, *Les Peintres impressionnistes,* p. 105.

23. George Moore, "Sex in Art," *Modern Painting,* London, 1898, p. 235.

24. Claude Roger-Marx, *Les Impressionnistes,* Paris, 1956, p. 39. Indeed, the comparison of Morisot's and Cassatt's styles in terms of what were thought of as intrinsic French and American characteristics had been around for some time. Not only were ostensible national character traits brought into play here, but an idea of a national construction of "femininity" had great currency at this time. For a comparison of Morisot's and Cassatt's work in these terms, see C. E., "Exposition des peintres indépendants," *La Chronique des arts,* no. 17, 23 April 1881, p. 134. For a discussion of the peculiarities of French women as opposed to their Anglo-Saxon sisters who are described as excessively masculine, see Gustave Le Bon, "La Psychologie des femmes et les effets de leur éducation actuelle," *Revue scientifique* 46, 11 October 1890, p. 451.

25. S. C. de Soissons, *Boston Artists,* pp. 77–78.

26. Raoul Sertat, "Berthe Morisot," *Journal des artistes,* no. 23, 13 June 1892, p. 173.

27. Théodore Duret, *Manet and the Impressionists,* trans. by J. E. Crawford Flitch, Philadelphia, 1910, p. 173.

28. Georges Lecomte, *Les Peintres impressionnistes,* p. 105.

29. Claude Roger-Marx, *Revue encyclopédique,* p. 250.

30. Stéphane Mallarmé, *Berthe Morisot,* p. 5.

31. For a discussion on the fear provoked by the *femme nouvelle,* see Debora Leah Silverman, *Nature, Nobility and Neurology: The Ideological Origins of "Art Nouveau" in France, 1889–1900,* Ph.D. dissertation, Princeton University, 1983.

32. For a general discussion on the atmosphere of gloom and the fear of degeneration that obsessed intellectuals in this period, see Eugen Weber, *France: Fin de Siècle,* Cambridge, Mass., 1986.

33. George Moore, "Sex in Art," p. 234. For another statement proclaiming Morisot the only woman to prove women's capacities in painting in the nineteenth century, see H. N., "Berthe Morisot," *Journal des artistes,* no. 10, 10 March 1895, p. 955.

34. For a broad overview of feminist campaigns and personalities in this period, see Jean Rabaut, *Féministes à la belle-époque,* Paris, 1985. For a discussion of the formation of the Union, see Charlotte Yeldham, *Women Artists in Nineteenth-Century France and England,* New York, 1984, vol. 1, pp. 98–105. For a contextual analysis of the formation of the Union, see Tamar Garb, "Revising the Revisionists: The Formation of the Union des femmes peintres et sculpteurs," *Art Journal* 48, Spring 1989, pp. 63–70.

35. For a discussion of the criticism of the exhibitions, see Tamar Garb, "'L'Art Féminin': The Formation of a Critical Category in Late Nineteenth-Century France," *Art History* 12, March 1989, pp. 39–65.

36. The critic for the *Moniteur des arts* put it as follows: "Sister-in-law to Manet, it was under his direction that she made her first essays in painting, penetrating his ideas but not submitting to his influence and rendering her impressions in a language which is very much her own: modest, without working for a public but for herself, for the satisfaction of her artist's dreams, without care for fashion, without desire for fame." "L'Oeuvre de Berthe Morisot," *Moniteur des arts,* no. 2227, 30 March 1896, p. 125. For a representative example, see also Raoul Sertat, "Mme

Berthe Morisot," *Journal des artistes,* no. 11, 15 March 1896, 1381. Morisot's femininity is seen to reside in her indifference to a public and the sale of her works; she is, therefore, suitably modest and withdrawn from the public sphere. Even the most cursory glance at her correspondence with its many allusions to sales, dealers, and public exhibitions exposes the myth of such a construction. The allusions are too numerous to itemize. See Rouart, *Correspondence,* passim.

37. "L'Oeuvre de Berthe Morisot," p. 125.

38. The link with makeup was already made in the seventeenth century by Roger de Piles. I am grateful to Katy Scott for her helpful comments in relation to the gendering of pre-nineteenth-century academic theory.

39. Charles Blanc, *Grammaire historique des arts du dessin,* Paris, 1867, p. 22. I am grateful to Jennifer Shaw for her discussions with me on this book. It is not surprising that Blanc became hostile to Impressionism, regarding its realist enterprise as trivial. For his views on Impressionism, see Charles Blanc, *Les Beaux-arts à l'exposition universelle de 1878,* Paris, 1878.

40. Charles Blanc, *Grammaire historique,* p. 23.

41. Ibid., p. 24.

42. For a discussion of the links between the discoveries of science and an antagonism toward feminism, see Elizabeth Fee, "Nineteenth-Century Craniology: The Study of the Female Skull,"*Bulletin of the History of Medicine* 53, Fall 1979, pp. 415–433.

43. For a representative account of this type, see Alfred Fouillée, *Woman: A Scientific Study and Defense,* trans. by Rev. T. A. Seed, London, 1900, based on Fouillée's *Temperament et caractère selon les individus, les sexes et les races,* Paris, 1895.

44. Robert A. Nye, *Crime, Madness and Politics in Modern France: The Medical Concept of National Decline,* Princeton, 1984.

45. Henri de Varigny, "Femme," in *La Grande encyclopédie,* vol. 17, Paris, 1892–1893, p. 143. For a critical analysis of de Varigny's theories in the context of late nineteenth-century medical and psychological studies on women's intellectual capacities, see Jacques Lourbet, *Le Problème des sexes,* Paris, 1900, pp. 63–72.

46. Alfred Fouillée, *Woman,* p. 48.

47. For a representative argument of this type, see Gaston Richard's review of Jacques Lourbet, *La Femme devant la science contemporaine,* Paris, 1896, in *Revue philosophique* 43, 1897, p. 435. See also Charles Turgeon, *Le Féminisme français,* Paris, 1907, p. 315.

48. Henri de Varigny, "Femme," 145. There were theorists who were reluctant to grant women a greater sensibility than men. Lombroso, for example, distinguished between *irritabilité* and *sensibilité,* according the former to women, the latter to men.

49. Prof. M. Benedict, "La Question féminine," *Revue des revues,* August 1895, p. 182.

50. The most extreme proponent of such views in France was the scientific populist Gustave Le Bon, who likened women's psychological makeup to the uncontrollability of a crowd. The qualities shared were:"impulsiveness, irritability, incapacity to reason, the absences of judgement and of the critical spirit, the exaggeration of

the sentiments." Quoted in Susanna Barrows, *Distorting Mirrors: Visions of the Crowd in Late Nineteenth Century France,* New Haven, 1981, p. 47. For a detailed discussion of his beliefs regarding the qualities intrinsic to women and their concomitant social roles, see Gustave Le Bon, "La Psychologie des femmes et les effets de leur éducation actuelle," pp. 449–460. For a discussion of women's and men's capacities in these terms, see the much-quoted H. Campbell, *Differences in the Nervous Organisation of Men and Women,* London, 1891.

51. In 1887 George J. Romanes compared women's emotions with men's, describing the former as "almost always less under control of the will—more apt to break away, as it were, from the restraint of reason, and to overwhelm the mental chariot in disaster." "Mental Differences Between Men and Women," *Nineteenth Century* 21, May 1887, p. 657.

52. These are the qualities identified by Gustave Le Bon as women's great strengths. They are also the ones that frequently recur in the Morisot criticism. See Le Bon, "La Psychologie des femmes," p. 451.

53. Quoted in Claude Roger-Marx, "Les Femmes peintres," p. 499.

54. Ibid., p. 508.

Rodin's Reputation

ANNE M. WAGNER

> Fame, after all, is but the sum of all the misunderstandings that accumulate about a new name.
>
> —R. M. Rilke, "The Rodin-Book"

> The principle of Rodin's work is sex—a sex aware of itself, and expending energy desperately to reach an impossible goal.
>
> —Arthur Symons, "Les Dessins de Rodin"

Rodin's reputation is still in the making. Efforts at understanding—and consequent misunderstandings—continue to collect; what is interesting about the most recent round of additions to the public Rodin is the way it echoes the views of Rodin's contemporaries. Our Rodin, like theirs, is both famous and infamous; his art and sexuality (his own and that of his works) are still hopelessly commingled. So much is clear; less apparent is what the evident connectedness of sex and art in Rodin might be said to mean nowadays. It cannot quite be ignored, as Richard Dorment would have us do. Repulsed by the "perversity" of much of the artist's work and conduct, Dorment wishes simply to leave its less savory aspects out of account: "I'm convinced," he writes, "that Rodin's ultimate reputation will rest on his finished bronze monuments and portraits."[1] Repulsion does surface when dealing with Rodin, yet a concept of "ultimate reputation" (on Judgment Day, perhaps?) is nonetheless hard to cope with. Even more difficult to countenance is the radical bowdlerization on which Dorment's final accounting would rest—corrective surgery from which the patient might well not recover. Yet privileging sexuality has its own risks: package a selection of Rodin's drawings in coffee-table format; give the book an unambiguous title, *Rodin: Dessins érotiques;* add the musings of a contemporary French sculptor, Alain Kirili, on art, love and woman; ask that literary bellwether Philippe Sollers for a steamy, breathless contribution ("Le Secret de Rodin"); and infamy is with us once again.[2]

There is enough of the farcical about Dorment's worries and the Frenchmen's elucubrations to suggest that as we enter our own fin de siècle, history is repeating itself, more or less on schedule. Yet these two latter-day responses—the efforts at excluding "perversity" and packaging titillation—no longer quite add up to business as usual in the world of art criticism. The equation Rodin made between art and sex is problematic today in ways that have uncoupled and exposed to view the terms on which his reputation was founded long ago.

Rodin's worldwide stature as the artistic genius of his age rested on, and was enabled by, responses to both his own sexuality and the sexual intensity of his art. Rodin's first viewers—men and women, poets and literati, amateurs and professionals, artists, cartoonists, and sociologists—argued for his preeminence in terms rooted in their readings of his creativity as sexual performance and his art as sexual truth-telling. These viewers were, if not Rodin's only audience, certainly his most influential one. They had access to his art; it inspired their accounts. And it was their efforts, rather than Rodin's sculpture *tout court,* that provided the terms in which man and artist alike entered the culture at large.

One reliable measure of the pervasiveness of sexualized—hence gendered—readings of Rodin's genius is the way they crop up in both ambitious and commonplace guises. Take, for example, the realms of high-art photography and journalistic caricature: for instance, Edward Steichen's portrait of the master from 1901 and a 1913 cartoon by Sem (Figs. 47 and 48). While it is safe to say that both images are preoccupied with Rodin's genius, such a pronouncement is relatively uninformative. Nor is it enough simply to note their mutual concern with defining that genius. Steichen for his part certainly embraced these purposes, but more important is the characteristic hyperbole, the sheer dramatic excess, with which he gave them form. Rodin, Steichen here tells us, is not just a man among men, but an immortal among immortals, with his entry into that brotherhood secured by a creativity as masterful as it was profound. Three emblems were overlapped to make the point: Victor Hugo, as Rodin sculpted him; another poet, Rodin's *Thinker;* and the sculptor himself.[3] Under this same celebratory rubric, not incidentally, came the articles with titles like "Rodin, est-il un dieu?"[4] Steichen's answer (like Rilke's or Octave Mirbeau's) was evidently, grandly, yes. Thus the photographer in 1907 engineered another encounter with Rodin—white-robed, godlike—and linked him to another emblem emphasizing his creativity, this time with peculiarly biblical force. Apparitional, yet fully formed, Eve seems to emerge from the master's body, in an effect that again is hardly accident; Steichen apparently meant the later photograph as a kind of post facto pendant complementing the earlier work.

Though Steichen's photographs may seem excessive, they are by no means isolated in the work they do toward defining Rodin's reputation. There are scores of similarly calculated portrayals: the master declaiming, or taking the measure of his 1900 one-man show, or caught by Gertrude Kasebier in a moment of reflection, or even, still pensive, leaning his head against *Adam* with an intimacy rather absurdly unlike his detachment from *Eve.*[5] Such imagery helped to reinforce the contemporary canonization of the artist going on apace in print. Its manifestations were widespread, mounting up in stodgy reviews and adventurous ones, and running the gamut of the scores of little magazines in between.[6] Some critics, supporters of the better-kept secret that was Rodin in the 1880s, began to grumble as the tide of words rose. "Seated on a pedestal of articles, Rodin has become God." This is one of those erstwhile 1880s supporters,

Figure 47 Edward Steichen, *Rodin in Profile beside the Thinker, with the Monument to Victor Hugo in the Background,* 1901, Musée Rodin, Paris, transfer negative, Bruno Jarret. (C) 1995 Artists Rights Society (ARS), New York/ADAGP, Paris.

Félicien Champsaur, in 1898, sure that success on these terms meant debasement: "Ultimately, his brain first intoxicated, then softened, Rodin could do no more than pronounce memorable words worthy of a man definitively installed as resident genius."[7] (Rodin, it is worth noting, had few qualms in this respect: he commissioned portraits from writers and photographers alike and subscribed to clipping services to keep track of the results.)

Sem's gloss on Rodin's reputation, on the other hand, falls into a category that apparently has rather less to do with art. For a contemporary parallel, let me quote Marcelle Tirel, a woman who in 1906 became the sculptor's secretary. The scene is their first meeting: ". . . he began to question me about myself, my life, my work, and my means. I answered all his questions fully and frankly, he studying my face the while. 'Would you sit for me?' he asked. 'I have models, but I can never depend on them.' 'No, *Maître,* I have never yet sat for an artist, and I certainly will not sit for you: your reputation is too bad.'"[8] This, of course, is the suggestion made explicit—with notable visual economy—in Sem's caricature. There the artist and the man necessarily share the same body—Rodin's body—but the smock and goat hooves nonetheless ensure that the two notorious

Figure 48 Sem, Rodin Dancing the Tango, 1913, wood engraving (reproduced from Robert Descharmes and Jean-François Chabrun, Auguste Rodin [Lausanne, 1967], p. 216).

aspects of his persona—his profession and his unbridled sexuality—both remain distinctly legible; the one body here has two guises. A sculpture and a woman are likewise overlapped in a single set of forms; the distinction between them is drawn on the one hand by the traces of violence and breakage by which Rodin was rumored to produce his art, and on the other by the uncanny vitality of the all-too-human torso that remains in the master's embrace.

The ambitions of Sem's and Steichen's images are obviously very different. But their intended humor or gravity do not require us to take one or the other more seriously. Instead, I want to argue not simply for the importance of each view but for their interconnectedness, their mutual dependency. Rodin's genius (his genius as a preeminently male attribute), his representations of women, and even the tattle about his goatlike behavior, were necessary and mutually consistent components of the public phenomenon that was Rodin. In fact, it is because ideas about Rodin's own sexual behavior were so much caught up

in that phenomenon that both Steichen and Sem must have a founding status here. I shall claim that these two views of Rodin, which alternately see their task as either the representation of genius or the description of the multiple levels of the artist's relationship to women, both within and outside art, are in fact not usefully separable. For Rodin's contemporaries, his brilliance and the intimacy and violence of his uses and representations of the female body together meant his genius.

The substance of this chapter is involved in explicating that linkage—that is, in demonstrating the centrality, within Rodin's reputation, of his own particular dance with woman. The place to begin, accordingly, is with Rodin, with the self of the artist; not as some absolute and knowable quantity, of course, but as that self was authorized to appear in print. The first task for most of Rodin's commentators involved inventing a self for the artist, *un moi*—a consciousness or way of being in the world that would carry with it the terms that could secure Rodin's particular value—his relevance—to the reader. This emphasis on individuality was, of course, widespread in the later nineteenth century: we need simply remember the roster of symbolist heroes, from van Gogh to des Esseintes. But selves like these, with their emphases on psychic or aesthetic extremes, would not do for Rodin. The guarantee of selfhood in that emerging myth was not mind or taste, but the physical world, tangible reality. The first test of Rodin's existence was not genius but his relation to materiality, and the first proof of his creativity was his bodily labor, his unmediated contact with raw and uninflected matter.[9] This linkage of man and matter has visible effects on writing about Rodin. It means, for example, that the literary visit to the artist's studio, as shopworn a conceit as it is, survives intact. Time and again Rodin is summoned from work to confront our scrutiny: "The man comes up to you, his clothes soiled with plaster, hesitant and timid."[10] Or, another version, "The man, there he is before you, his clothes soiled with plaster, his hands sticky with modelling clay."[11] And sometimes his workplace alone can personify the artist: "The studio of Auguste Rodin possesses a sincere austerity; nothing there makes a show; he's made no sacrifice to elegance. It is an atelier in the true sense of the word, in its toilsome, workman's meaning; a room which has no other purpose than the work it houses."[12]

The slippage here, which equates a man and his place of work, insists on the material as the sign of the self. And Rodin's physique could likewise be made to offer such proof. What was at stake, accordingly, in assessing the rash of portraits of the artist was not mere resemblance, but the way a portrait's individual features could be made to stand for the essence of the man. Take, for example, this description of the bust of her teacher and lover modeled by Camille Claudel in 1888.

> With its vigorous features, the serenity of its clear glance, the long patriarch's beard, the broad vigorous shoulders [Claudel's bust of Rodin] makes us think

(since his attractions are hardly those of today) of the masters of the first days of the Renaissance, those forceful creators whose instincts were richer and more decisive than talent alone. Above all she has noted what there is in him of the instinctual, she has treated him in the manner of those antique sculptors who managed to represent, under the names of the gods, the forces of nature; she has grasped and rendered the secret harmony between his invisible, dreaming soul, and the stones which his hands work. I have rarely seen a portrait which betters this revealing bronze in explaining, commenting, completing a physiognomy. It is certainly M. Rodin, but even more, it is *The Sculptor;* it is also *The Creator* whose thoughts conceive life and whose hands give it; and it is as well a *force,* immaterial and powerful, which the magic of art manifests to our eyes.[13]

This kind of criticism (the work of Edouard Rod, in the pages of the *Gazette des Beaux-Arts*) is admittedly not much to my taste; my point is to show the way that, here and elsewhere, Rodin's visage, like his place of work, could be made to stand for a version of the truth of the self. It is an elemental truth, an instinctive one: the truth of the body and its maleness, its square shoulders and patriarch's beard. It is a truth that equates the mere man with something—some force or fecundity—"richer and more decisive than talent alone": call it nature, call it creativity; Rod is at pains to do both.

Rodin's subjectivity, I am arguing, was constructed as essentially, elementally male—and as such, a self that returned to a first, primitive engagement with the world's materiality: "Rodin c'est un moi aux prises avec la nature"—a self grappling with nature.[14] Or less violently, "Rodin, c'est un être en pleine communion avec les forces de la nature"—a being in full communion with the forces of nature.[15] Those variations on this theme, which prefer to call Rodin a pagan, rather than a self or a being, make the same point via a slightly different route: "Rodin is above all a sculptor," Mirbeau wrote, "and, let us assert it bravely, a pagan sculptor. I mean that he has a single belief, because he has a single love: the love and belief in nature. Nature is the unique source of his inspiration."[16] (Does it matter, I wonder, that the "pagan" Rodin spent much of the year 1862, aged twenty-two, as Brother Augustin, a novice in the Society of the Sacred Heart?)

There are two key words in passages like these. One, of course, is the self—*le moi*—or its stand-in, *un être.* The other is *nature,* even in the 1890s not yet an entirely vitiated category. I grant that some of the glosses offered in writing about Rodin are resolutely banal. Mirbeau's certainly is: "The ability to see nature, to know nature, to penetrate nature's depths, to understand the immense and simple harmony that contains within the same language of form the human body and the clouds above, the tree and the mountain, the pebble and the flower, is granted to very few."[17]

But there are more impassioned, and more revealing, accounts of Rodin's relationship to nature than Mirbeau's. Take that of Charles Morice, in a text written in 1899; there Rodin's nature is less material than overtly female:

Unique mistress, absolute mistress. Mistress, nevertheless, in the two senses of the word: a queen, and also a lover. The artist obeys her with sensual pleasure and possesses her with reverence. He accepts orders and counsel only from her, but he asks also that she deliver him up her secrets; and if, in his hours of contemplation, he venerates her with a kind of ecstatic mysticism, in his hours of work, of action, he attacks her, penetrates her, he clasps her in the drunkenness of triumphant love; all the secrets the mistress has left for her disciple to discover, the artist abuses in order to conquer—even his caress is that of a conqueror.[18]

At this point Morice manages to pull himself up and make as if to return to the more familiar usages of criticism; in other words, he cites precedents and parallels for his opinion. "This extraordinary spiritual sensuality," he continues, "has very often been noted. it is Jean Dolent who has defined it most vividly: 'Rodin,' dit-il, 'c'est l'esprit en rut.'" (A literal translation would render Dolent's phrase as "the mind in rut"; its essence is perhaps better caught with "the mind on a sexual rampage.")

There are, I think, three possible responses to criticism like this. The most tested is to discount it, to read past or over it, as yet another distasteful example of fin-de-siècle critical hyperbole. The second is to say something like, "Ah yes, of course, nature is a woman"; perhaps to invoke the categories we have ready-made for such observations: male/female, culture/nature, and to let it go at that.[19] The third is to decide that something quite particular may be being said here about Rodin's art; criteria for its appreciation are evidently being set out; a reputation is being constructed. True, these criteria are elaborated in terms of a metaphor about how Rodin worked, but the metaphor is meant to stand for and respond to what we see—what a writer asks us to see—when we look at the results. And if those results are a sculpture of a woman, so much the better, particularly if our task is the assessment of the special elemental character of Rodin's talent. Witness the following: "Where the instinctive genesis of Rodin's conceptions can best be seized is in that admirable series of half-roughed-out marbles, masterpieces of science and lyricism, where the swelling buttocks and upthrust breasts of women invoke a mystery from which they can extract themselves only with difficulty, where convulsed lips attract fecund kisses, where limbs, as if spent and broken, entwine confusedly in the last shudders of the spasm."[20] This is the poet Stuart Merrill (in the pages of the special 1900 issue of *La Plume* devoted to the sculptor) in an article that, despite its title, "The Philosophy of Rodin," does not dwell only on the metaphysical.[21] But among these estimations of the peculiar qualities of Rodin's talent, Jean Dolent demands the last word. Morice has already given us its opening aphorism: "Rodin is the mind in rut." The text continues: "Rodin seeks to reap some benefit from the sensuality from which he suffers. A group by Rodin captures the second stage in a rape, the instant the violence is accepted, is submitted to. A woman by Rodin is shown at the exact moment which precedes or follows the crime. Ah *femelle!*"[22]—by which Dolent meant, presumably, "female animal," or even "bitch."

Faced by such criticism, the issue of appropriate responses again seems paramount. Should Dolent's views be taken seriously? Would we not now be justified in taking a leaf from Dorment's book and calling them, not merely perverse, but abhorrent, and moving on? I think not. Dolent's opinion is extreme, but at the same time ordinary, almost normative: Morice reused it without a second thought. The imagery of orgasm, penetration, even rape, provided a real route of access to Rodin's art at the turn of the century: pointing to the works' sexual violence was, so these critics evidently felt, a way of pointing to their truth.

Nonetheless this is an imagery that goes against the discretion and circumspection of other, equally urgent, versions of the sculptor's practice in circulation at the time; most particularly, perhaps, against the claims of a remarkable photograph of about 1895, apparently the work of one Duchêne (Fig. 49). It is as if the photographer (acting at Rodin's instigation?) were out to refute Dolent's rhetoric point by point. Rodin's art is *work,* not pleasure; it is a matter of externals; it involves a chaste, meticulous process of verification of its relation to a real—in this case, the body of a notably self-possessed model. Perhaps the photograph's insistence was partly the result of the plethora of other images that maintained the opposite about sculpture; the all-too-frequent cartoons—in *Gil Blas,* for example—that saw the touch of the artist's verifying calipers simply as another kind of foreplay. And there are the related paintings—one, at least by J.-L. Forain, seems to take Rodin (or his twin) as its chief protagonist—suggesting that dealings with one's model are very far from neutral and have nothing to do with her self-possession.[23]

Sure, scrupulous craftsmanship; the bodice lowered to reveal the truth; no drunken heat or conquest; only the body's firm health. Such are the photograph's claims; it is hard not to wonder why they were made and to whom they were first addressed. They are reminiscent, oddly enough, of another of the many photographs taken under Rodin's direction, showing the artist carving a marble. High theatrics, this: Rodin's *praticiens* invariably did such work, with the master's own physical contribution limited to occasional finishing touches.[24] The assertions of the 1895 photograph are about as hard to believe in securely. Can its claims for Rodin's seriousness and propriety stand up, I wonder, against the salvo of a caricature by Louis Morin, published in the *Revue des Quat' Saisons* in 1900 (Fig. 50)? It offers another version of Rodin at work from the model, one as brutal as the photograph is circumspect. The artist is unmistakably Rodin, recognizable, though distorted to a base and hairy criminality (perhaps the closest visual parallels are the caricatures of Jews published in *Der Stürmer* in the late 1930s). True to type, he is not so much sculpting as caressing the buttocks of his figure, the simulacrum of the model crouching on the stand, all the while staring into her privy parts. This is presumably Rodin "penetrating into the innermost secrets of nature"; and we are meant to understand in this case that each of the sculpted figures in the background, with their limbs convulsed and intertwined (the critics' language seems no more than adequate now), required the same self-exposure and abnegation on the part of a posing model.

Figure 49 Duchêne {?}. *Rodin Sculpting a Model with Bared Torso* ca. 1895, Musée Rodin, Paris, Ph. 2448; transfer negative, Bruno Jarret. © Photo Bruno Jarret par ADAGP et © musée Rodin. (C) 1995 Artists Rights Society (ARS), New York/ADAGP, Paris.

This is caricature, of course, not photography. Yet it seems to me that Morin was aiming, even in caricature, at a certain degree of recognizability, of accurate likeness. It is there in the stocky, bearded Rodin, and there as well in the figure he models—an actual sculpture called the *Danaid,* which was finished in marble and exhibited by 1889, to be acquired by the state straightaway (Fig. 51).[25] To cognoscenti, then, Morin's allegations—the etiology he offers for Rodin's figures of women—were entirely specific, as opposed to the seamless generality—the anonymous studio, the lack of specific about known masterworks—that are the stock-in-trade of Duchêne's image.

Figure 50 Louis Morin, "La Sculpture Moderne," *Revue des Quat'Saisons,* no. 3, 1900 (Biblio-thèque Historique de la Ville de Paris).

Morin's lithograph was meant to be readable as Rodin; but all the same it is perhaps not yet clear that he—or the sculptor's other critics, for that matter—intended to allege anything very particular about the sculpture as opposed to the man. It is the beast in the smock that matters; but might it not be the case that even Morin means the sculpture to 'scape whipping? Maybe not; the gallery of contortionists and the tacked-up sheets of graffiti (Rodin's notorious "instantaneous" drawings) are certainly outlandish. But what about *us?* Might we not want to separate the working process from the work that resulted? Might not the intensity of concentration that the caricature attributes to Rodin be merely a matter of necessity? And *is* Rodin's rendering of sex so very remote from the sculptural norm of the day? After all, nature in sculpture, at least around 1900, could only be the body. The museums were full of marbles of nudes. Pick a photograph, an installation shot, not quite at random: the Musée du Luxembourg, say, at the turn of the century. Rodin's *Danaid* is there on the left, just another nude, with its seemingly appropriate companions, the Eves, the Vestals, the Apollos, and the like. Is its nudity not merely a matter of convention—a protocol, moreover, not restricted to statues of women? The pose of the *Danaid* had its male counterpart in Rodin's oeuvre; there is the *Danaid*, in other words, but there is also *Despair.*

These questions are essential. No doubt the language and imagery of

Figure 51 Auguste Rodin, *Danaide,* 1889–1890, Musée Rodin, Paris. © Photo Bruno Jarret par ADAGP et © musée Rodin. (C) 1995 Artists Rights Society (ARS), New York/ADAGP, Paris.

Rodin's critics are extreme; but is the extremism that of the *culture's* general discourse of sexual difference, which merely attaches itself here to a set of strong ("natural") representations; or are the representations themselves actually productive of a special kind of criticism—of Dolent, of Morice and Mirbeau and Morin? The answer is somewhat equivocal. It was commonplace for critics in the nineteenth century, and even before, to inscribe their sexual fantasies on sculpture, should it represent the female body with any physical specificity whatsoever. The responses of Raoul Ponchon in *Le Courrier Français* to Alexandre Falguière's *Nymphe chasseresse,* shown at the Salon of 1888 can stand as a representative case in point.[26] Ponchon's effort there—it is enhanced by his use of the pseudo-immediacy of dialogue—is to insist on the availability of the *Nymphe* to libidinal fantasy and imagination. Against all odds, we might say, looking at Falguière's less-than-spirited work; but the trick is managed by Ponchon's attributing to this marble creature a sexuality with which his readers could think themselves familiar. Thus looking at the *Nymphe,* one of his characters enthuses, "I can tell you that this *nature* [*sic*] fits me like a glove." And his companion affirms: "Here's a woman who's good for something." He continues, "Evidently this nymph of Falguière's is no goddess, or even a quarter of a goddess. She's a modern little woman, Parisian certainly. She's rendered in flesh and blood, very much in flesh, all plump and flirtatious, with dimples

everywhere. She has already lost her virginity, I would wager ["elle a déjà vu le loup"]; she's a young person one has already encountered in her chemise. She's called Nini, Popo, or Titine. She likes salad and chips." This is not, of course, elegant or inspired criticism; nor does it mean to be. Yet Ponchon is not without a purpose; he means here to undercut elegance, to familiarize by denigration; he makes the work and the body it depicts knowable within a familiar circumference. Thus the *Nymphe* becomes Nini, with her penchant for fries; and the viewer/reader can thereby indulge the appetites and morality that customarily feed him; unthreatened, his confidence is further bolstered by the little *vanitas* Ponchon offers in closing: even this firm flesh, "ripe for the picking," will soon fall and fade; "demain il serait trop tard."

Ponchon's (barely fictionalized) response to the nakedness of Falguière's *Nymphe* works to fit it into an order of which he is entirely sure: the current order of sex and class. And reactions to Rodin's bared bodies often proceed with similar— if stylistically more ambitious—assurance. Looking at Rodin's *Eternal Idol,* for example, Charles Morice wrote poetry, not dialogue: elegance was essential:

A Auguste Rodin, Qui Sculpta "L'Hostie"

La Forme, la Substance, et l'Elément
Sont dieux. Je vénère en ma foi profonde
Le pur metal et le feu véhément,
Et la ligne harmonieuse et féconde.
Je crois que la Croix a sauvé le monde
Et l'ardent encens de ma piété
Fuse vers le flanc doré d'Astarté.
Mais plus haut que tout j'adore et j'acclame
Dans le mystère de leur Unité
Le Front d l'homme et le Sein de la femme.

En eux s'inscrit le courbe firmament,
Ils sont les pôles de la mappemonde,
Et rejoints par un mutuel aimant
Mystiquement l'un sur l'autre se fonde,
Et l'un console l'autre, qui l'émonde
A la Pensée oreiller souhait!
Consécration de la Volupté!
C'est le supême et total anagramme,
La divinité de l'humanité:
Le front de l'homme et le Sein de la femme.

Rite sacré, symbolique et charmant,
Ma prière: O grande soeur blanche et blonde,
Laisse qu'agenouillé pieusement
Devant toi debout, Marie ou Joconde,
Je pose ma tête où l'avenir grande

Sur la gorge que la virginité
Bat de son flot d'éphemére léthé!
Que ta candeur à mon ardeur s'enflamme
Et montrons ensemble au ciel enchanté
Le Front de l'homme et le Sein de la femme.

Envoi

Rodin, révélateur de la Beauté,
Tu nous as dit toute la vérité
Quand ton ciseau enivré de ton âme
A réuni dans l'infini sculpté
Le Front de l'homme et le Sein de la femme.[27]

Ponchon courted banality; Morice here risks blasphemy, elevating the "redemptive" unity and interdependence of the male mind and female body even above the Cross. To him Rodin's sculpture evokes a fine exalted order, new mysteries on a par with Christian ones, centering on the "consecration of pleasure" achieved by an imagery of male thought cushioned on the female breast. But of course it is not the novelty of Morice's vision—or of his prosody, for that matter—that first strikes us, but rather its familiarity. The sexual order of things he discovers in Rodin's marble smacks of Ponchon's order, with a rhyme scheme added. How much does it matter if the male sphere is the mind, or purchasing power, when in both cases its object, the female body, stays the same?

We should not forget how much this order, and the roles men and women were to take in it, was insisted upon at this particular moment in history. It was the life and breath of belle époque culture—ever-present, unavoidable. Subscribe to an illustrated paper—the weekly supplement to *Gil Blas,* for example. See what you would get in the morning post. Turn its pages. Some of the jokes are familiar and sophomoric: Monsieur once again receives his horns from Madame the huntress. Or on a visit to the cemetery, another Monsieur, a widower, looks up Mademoiselle's skirts and consoles himself for his recent loss. Other images apparently intend to make more of the issues of sex and class—at least we visit brothels and boarding houses, as well as the boulevard and boudoir. Yet the story accompanying Steinlen's *Viol*—also called "Viol," it is the work of Jules Ricard—ends with the victim, a servant girl, curtseying shyly and murmuring, "Thank you very much, Monsieur." Ponchon would no doubt approve.

There is no use pretending that *Gil Blas* had nothing to do with Rodin. His art was reviewed there; he kept clippings from its pages over the years. But more important, its writers—Octave Mirbeau, Gustave Geffroy, Séverine, Félicien Champsaur, and others—were his writers, his supporters. And high art itself penetrated its pages. Take one two-page spread: a Salon picture, *Nature morte,* its naked model smoking at table amidst (and part of) the careful artlessness of the studio disarray, sits across from the week's illustrated love poem. It happens to be by Paul Verlaine. Or take another: a different lyric, a different

nude, now playing at *bilboquet,* catching the round ball on the upraised stick. The artist's symbols are not much subtler than the cartoonist's antlers; what is striking is how much at home, how ordinary and appropriate, Salon nudes seem in such company. If anything, their status as art licenses a level of physical explicitness that other genres of illustration did not dare.

Now it is not the case, at least to my knowledge, that Rodin's sculpture was engraved and reproduced in *Gil Blas.* Yet nonetheless these sample pages are not offered simply as "background" or "context"—as a means toward the modicum of cultural familiarity necessary to a reading of Rodin's art. Rather I am arguing that the characterization of the relations between women and men explicitly imagined in these pages—man endlessly chasing after, peering at, pursuing, possessing, and being possessed by one object, woman (and then, very often, like the Monsieur at the cemetery, saying "Keep the change")—*applies to,* is active in, Rodin's art. This, after all, was the social order, the economic reality; a reality, moreover, that in the age of the *nouvelle femme* was increasingly perceived as under threat. It should not strike us as odd to find that the various levels of imagery—the high and the kitsch, fine art and commercial arts—are equally implicated in it.

Yet I also want to stress that the ideological complicity I am claiming for Rodin's art does not—and did not—mean that his sculpture is best read as *reproducing* the categories and attitudes of *Gil Blas.* We shall see in what follows that the work laid itself open to many and different constructions—including some (in its praise) that would have described themselves as feminist. Not that I necessarily want to endorse those readings, any more than Morice's or Dolent's. I believe that Rodin and *Gil Blas* were, at some level, all of a piece. Rodin, we might say, operated with *Gil Blas's* categories—but he produced them, rather than reproduced them; he was able to give specific, sometimes unexpected, form to accustomed fictions, and that form enabled readings in which the matter of sexual identity was often by no means simply a comfortable "given."

Locating the essential difference between Rodin and *Gil Blas*—or Falguière, for that matter—means several things. It means, first of all, acknowledging not just basic similarities but also fundamental differences in the kinds of responses these representations did and do produce; it means admitting the likeness between Ponchon and Morice, for example, but also the points at which they part company. Here tone is of the essence. Looking at Falguière's *Nymphe,* for example. Ponchon is full of confidence that a man can buy, use, and discard bodies like this one; here art is taken both to illustrate and substitute for a transaction that the viewer can imagine himself to control. And as a critic, no doubt, Ponchon could cite aesthetic reasons for his reaction: does Falguière not knowingly trivialize the distinctly unathletic body of his so-called huntress? Is her chignon not too up-to-date to be anything other than mundane? Such a treatment—and the response it provoked—dismisses sexuality simply by representing the kinds of bodies "known" to be bought and sold; it declares sexual hungers to be trifling and commonplace, their satisfaction merely a matter of a

well-timed purchase. For Morice, on the other hand—for the Morice who claims to speak in his poetry, I mean—celebrating an art of the grisette would have been entirely degrading. His stake in sexuality was higher than that; it meant investing belief and emotion, with the return on that investment a concept of personal identity in which sexuality played a paramount role. And Rodin's *Eternal Idol,* for all its refusal to destabilize the central premise of that identity—that is, the relative roles played by male and female within it—is nonetheless at pains to offer the means for a close personal identification by viewers like Morice. The group does not dwell on bodily particulars so much as offer a set of authoritative and attractive generalizations about male and female. A way is opened thereby toward a more or less profound self-engagement, not the knowing dismissal Falguière arouses; the process rests, I think, on the way Rodin's forms are cleared of the customary overtones of time and place and class without being allowed to stray back onto the familiar, barren terrain of gods and heroes—that is, of nineteenth-century sculptural idealism.

Seen in isolation, the *Eternal Idol* may appear banal; it may simply be too difficult nowadays to look past the postures of passivity and worship and to take the bodies that hold them as evidence of the special attitude toward sexuality I am claiming for Rodin's art. Put the group in a context, though; give it its companions of the *1880s: Fugit amor* (c. 1887), say, or *Paolo and Francesca* (1887), or *Je suis belle* (1882). Follow these with figures, male and female, of the 1890s: with *Iris, Messenger of the Gods* (c. 1890; Fig. 52), for example, or with *Balzac* (completed 1898; Fig. 53). A context and a project emerge in the process, one in which male and female bodies are time and again brought into close contiguity; where they appear to act and react through the needs of their bodies; and where the sexualized character of those bodies is stated with ever-greater clarity—so that in these last two works, *Iris* and *Balzac,* Rodin's insistence on sexuality is at its most extreme. There the couplings are broken apart; male and female stand separately; each body is made to assume something like an archetypal form. In this the great age of sculptural circumlocution and selective focus, Rodin here insists on giving access to what was more and more seen as the essential, determining aspect of the human being.

In the case of the *Iris,* when the key to sexuality is a place, a location—the markings on the body defining it as that of a woman—then the place must be shown, declared, sliced out of the clay and cast into the bronze. The ultimate sign of the woman, Rodin here tells us, is no mystery; as the determining matter of bodily identity, of being, it can and should be exposed to view. And so, legs tense, energized, widespread in a movement quite unlike flight, *Iris* is made to figure her sexual difference. Headless, her body becomes the gesture that performs the necessary demonstration, while its sheer density and physical mass give substance to the sign. Hers is a rhetorical difference, of course, but it is a corporeal one as well. Corporeal, let it be said, in a special, unexpected way. There is the mute, powerful gesture of revelation, to begin with, which seems to equate the body with its movement; *Iris* and her sexual display are one and the

Figure 52 Auguste Rodin, *Iris, Messenger of the Gods,* ca. 1890, bronze. Musée Rodin, Paris. © Photo Bruno Jarret par ADAGP et © musée Rodin. (C) 1995 Artists Rights Society (ARS), New York/ADAGP, Paris.

same. And neither the body's substance nor its activity have anything to do with the sculpted vocabulary of the feminine current at the time. Nothing is soft, or delicate, or dimpled: the neck and one arm are only ragged stumps, the feet are clublike, the breasts lumpen, the belly pocked and pitted, the limbs seamed by mold lines left unsmoothed. Looking at the thing, how possible is it to dream of flesh ripe for the picking, when any belief in the illusion of flesh is so difficult to sustain? The sense of bodily corporeality and presence is assimilated to and counterweighted by Rodin's insistence that the viewer register the sculptor's role as author of that body. The *Iris* is meant to strike us as more artificial than natural, more made than seen; hence her notable effectiveness as a sign.

It is worth noting that *Iris*'s unreserved offer was once intended for a specific recipient; its rhetoric was directed, and frankly phallocentric. She was first conceived as an attendant to male genius, meant to hover muselike, with other female figures, above a Victor Hugo lost in thought;[28] surely Morice must have savored that motif. In the end, however, Hugo was memorialized without

Figure 53 Auguste Rodin, *Balzac,* 1898, bronze, Musée Rodin, Paris. © Photo Bruno Jarret par ADGAP et © musée Rodin. (C) 1995 Artists Rights Society (ARS), New York/ADAGP, Paris.

muses. Iris's head was severed from her body—Medusa-like, of course—and, though bruised and mutilated, became a sculpture in its own right. The pain of the loss of a body seems visible there; it is as though bodily absence is emblazoned on her face.

Although I would be the first to admit that the *Iris* is a special moment in Rodin's art, it is by no means an isolated one. Rodin made other so-called flying figures whose legs open to reveal the identifying markings of sexual difference, or whose bodies seem bound and weighted by the sheer effort of such exposure. And there are dozens and dozens of drawings that strip away the pretext of flight and take us back to the scenario of the studio, where day after day, opening their legs, hired models put themselves to work supplying the means by which Rodin tried endlessly to describe their sexual organs. Masturbating, they obliged the regressive fantasy that woman's body has its own completeness and autonomy as a source of sexual pleasure. Yet the resulting drawings are most

often far from complete; the abruptness of their framing, as well as Rodin's fascinated insistence on the workings of their active hands, gives these images, like the *Iris*, something of the character of mime: wordless demonstrations of the very existence of the female genitals.

The genitality of the *Balzac* is in its own way dependent on a scenario of masturbation; one of the studies for the final work even represents the act. It came about as Rodin explored the question of portraying Balzac, laboring over the problem of how, quite literally, to embody him. Should Balzac's body be the historical casing—short-legged, big-bellied—that birth and abuse had allotted him? Or was another body image more important? The eventual decision was to equate genius with the phallus, and to subsume the particularities of history under a symbol meant to contain them. One stage in that process is a carefully developed study at three-quarters life size. It is Balzac, if not his body; it is Balzac the creator, though he is headless. His person centers rather on the stupendously, unnaturally swollen penis, which he grasps with vigorous composure (the right hand holds the penis; the left encircles the right wrist as if helping to support the weight). The same framework that shaped Rodin's stature with his contemporaries is here applied to another creative genius. Its hallmark is virility: heroic talent demands a heroic penis, whether or not nature has previously obliged. Yet then to locate that equation in a bodily representation—to make of the body a phallus—is to venture one final rash wager, to gamble that the gains won through such a thoroughgoing substitution will outweigh the loss of historical detail. This symbol of male potency is what we need remember of Balzac, Rodin's sculpture declares: as a result, the substance of Balzac's body—the assurance of wholeness, of density, of weight to which our sense of our fellows is tied—is entirely sacrificed to the phallic sign.

The phallic Balzac and the vaginal Iris: both despite and because of their bodily candor, these works epitomize Rodin's insistence on sexuality as fundamental to his art. Yet they are not, of course, strictly comparable. Balzac is not Everyman; nor even simply Balzac. This is Balzac in a special aspect, "in the fertility of his abundance," according to Rilke; it is Balzac as the incarnation of creativity; it is "Creation itself," the poet continues, "assuming the figure of Balzac that it might appear in visible form; the presumption, the arrogance, the ecstasy, the intoxication of creation."[29] Iris, by contrast, does not incarnate some special ethos or power achieved by a few chosen women: she is Everywoman. Her meaning lodges in the facts of her body, the facts she so urgently displays. The vagina, according to Rodin, is a figure for the body of woman; the phallus, for the powers to which men may attain.

Yet does not the sexual unconstraint of these objects mark them off from the rest of Rodin's oeuvre? How justified is it—so the questioning might begin—to offer such images as at all relevant to Rodin's *public* reputation? Are these works not really cabinet pieces—high art pornography, we might say—essentially private works meant for perusal after dinner, with cigars and a few carefully chosen friends? As such, are they any different from Courbet's *Origin*

of the World, for example, which its first owner, Khalil Bey, apparently kept shrouded with curtains and showed only to a few cognoscenti? Did they really *figure* in Rodin's reputation? Should I not base my analysis of that reputation on, say, *The Kiss?*

The answer to that last question is certainly yes. I shall make the effort before too long. But attending to the better-known aspects of Rodin's art will not mask the fact that the *Iris* and the *Balzac*—and even the studies related to both—were also indubitably public works of art. They were published and reproduced; in fact the Balzac study illustrated Merrill's article "The Philosophy of Rodin." And they were encountered in the flesh, so to speak. The writer Séverine saw a naked Balzac in Rodin's studio in 1894: "tout nu, l'horreur," she wrote.[30] The *Iris* too was on view in that art lovers' mecca, placed prominently in front of the great plaster of the *Gates of Hell.*[31] Even the drawings—and even the drawings of women masturbating and making love—were discussed in the press and offered up for the delectation of those who visited Rodin. Read Arthur Symons in the 1900 *La Plume;* there can be no doubt of the kinds of drawings he has seen and here discusses: "[Rodin's drawn woman] is a machine in motion, monstrous and devastating, acting automatically and possessed of the rage of an animal. Often two bodies intertwine, flesh grinding into flesh in all the exasperation of futile possession . . . here, as always, these are damned women on whom nature has imposed no limits, and who have created for themselves an abominable and unnatural pleasure. It is hideous and overpowering, and possesses the beauty of every extreme form of energy."[32]

One of the most dramatic pieces of evidence concerning the visibility of Rodin's erotic drawings was confided by the essayist and critic Maurice Barrès to the pages of his journal.[33] The passage has all the immediacy of first-person testimony: "Je parlais, je disais, j'évitais de regarder," Barrès writes, as if mining a store of memories, still fresh, of a visit to Rodin's studio one December afternoon in 1905. But the sense of personal experience recollected is entirely misleading, since it seems that Barrès was actually transcribing an account of the reactions of one of Rodin's *female* visitors, the poet Anna de Noailles.[34] (Barrès and de Noailles were intimate friends for several years after 1900.) The drawings were shown to her as part of a lengthy preamble to a posing session. The sculptures came first: even some of these were embarrassing, apparently, and on the whole the countess thought it best not to look, though she kept up a steady stream of talk. Another woman left the room, and she made as if to follow. Rodin held her back: "No, you stay here." "Comment désobéir à un génie?" she wondered, rhetorically. (If Barrès answered her question, he did not record his response.) And so the two of them, Rodin and his visitor, together turned to the drawings:

> He showed me drawings, magnificent drawings of women—but can one really imagine representing such things? One above all—how did that woman dare so shamelessly to take her sad pleasure [*prendre son triste plaisir*] in front of the old

draughtsman? He was watching the effect this was having on me. Very respectfully. I avoided looking and said completely naturally, "Come, Monsieur, let's get to work."

So the sitting commenced; by the end of it, the countess was drained: "He exhausts me with his manner of looking, with his way of figuring out how I'd look naked, and with the necessity he imposes of preserving my dignity against his hunter's watchfulness."

I am excerpting a long passage; even so, there is plenty to suggest how remarkable this is as a description of an encounter between artist and audience. The conventions of class and patronage are set aside in Rodin's studio; the artist's reputation and his drawings take their combined toll on his sitter's sang froid. He seems to be enveloped in a cloud of burgundy. He moves the key to the inside of the door, and she remembers that he is said sometimes to take off his clothes ("On dit qu'il se déshabille"). Not, however, that the experience kept de Noailles from posing; she returned the following Tuesday. And not that she kept the story to herself. It was grist for her mill, and apparently for Barrès's as well.

It matters, somehow, that Barrès's version of his friend's experience has Rodin showing her his erotic drawings and muttering between his teeth, "Quel beau dessin on ferait de vous." The detail is important because it helps to keep in circulation—even here, in that most private of places, a journal entry—the key elements of the artist's public identity. Sexuality and creativity were one and the same thing in Rodin: evidently the threat to a woman's modesty was to be savored, not reviled. What the sculptor offered his audience was—on several levels, it seems—an image of female openness and male virility, an imagery that despite, or, perhaps better, *because of,* its explicitness, was especially compelling to this particular section of the viewing public. Its impact lay not so much in anatomical truth or accuracy, needless to say, as in the way it was seen to give explicit sculpted form to a particular understanding of the modern sexual condition. Rodin's art could admit to the extremes of sexual feeling, show men and women wracked by desire and gripped by passion—without that extremism upsetting the essential order of things. If anything, it only confirmed what the new sciences were then trying to teach about sexuality in general: the new truths about its status as a cornerstone of the human personality; the crippling disorders and diseases to which it was heir; the promise of pleasure once a cure was effected.

The turn-of-the-century preoccupation with matters sexual helps, among other things, to explain the popularity of *The Kiss*. Its familiarity should not obscure the tightness of its weave of eroticism and decorum, its careful ordering of a particular image of bodily intimacy. Contemporaries had no difficulty finding here a version of love that struck a new, improved balance between the carnal and the spiritual, the ideal and the idealized. Read Gustave Geffroy on this topic:

The man, large and strong yet slim and supple, with a solid and elegant line, is seated. The woman, in the flowering of puberty, rests on the man's left knee, but her body is projected with such élan, confides itself with such sweetness, that one has only the idea of a gentle brushing, the alighting of a bird. The same sweet contact is visible in the gesture of possession with which the man surrounds the woman. One arm makes her a collar of flesh; a hand grasps her thigh, yet grasps it lightly, with the fingertips, demonstrating its desire, despite its formidable muscular and nervous vigor (it is a hand made to strike and strangle), to be soft, delicate, stroking. The woman's abandonment is complete. She clings like a vine, surrounding the man's neck with a gesture in which there is both gratitude and avidity for his caresses.[35]

Geffroy's commentary is caught up in the assurance of Rodin's treatment of these bodies. Sexuality is of the essence: a man and woman are naked together; there is none of the brittle miming the Salon painters were so good at. In fact, because of this volatile contiguity, the two forms are in some ways more generalized than they are specific; like the *Eternal Idol,* they tell us little about time and place and class. Even some aspects of sex could be placed in jeopardy: one purchaser of a marble version of the group had to specify by contract that he wanted the man's genitals included.[36] The stipulation did not come amiss, because these bodies (unlike *Iris* and *Balzac*) are made material around an overall distillation of difference rather than the more obvious genital equipment: hard male musculature; round female softness; male possession, female surrender. This is accomplished, skillful generalizing; the message is clear enough, genitals or not, to allow for a reading like Geffroy's, which need not surrender its fantasies of violence and dependency, even while acknowledging that the sculpture has proposed a new equation where just these matters are concerned: the man might strike, but is gentle; the woman clings because she desires. And so we come to recognize once again Rodin's reinflection of the sexual language of sculpture. There is nothing here that could not be seen as perfectly consistent with *Iris,* or with *Balzac,* for that matter—that is, with the ethic of male and female identity instantiated in both these works. Or, to quote Geffroy once again: "The sculptor's intentions are visible in each manifestation of his art."[37] And whatever the level of displacement and generalization, those intentions are most powerfully and repeatedly figured in woman: she is the core of Rodin's project. Representing her meant demonstrating her relationship to a masculinity she can now be seen to desire. Thus Geffroy continues: "Woman, who dreams, who submits, who weeps, who is inflamed or who is angered, she is a proud and tortured prisoner, revolting in vain against her senses. But she is also true grace and proud beauty. From Eve's strong muscles to the *faunesse* with her long arms, childish belly, and heavy breasts, one can follow the search for a wild charm and a refined force that haunt the sculptor like an ideal as he struggles with reality."[38]

We have circled back into now-familiar territory. We learn once again

that the truth of Rodin's art lies in his attentions—tender and assertive—to reality; reality that again collapses into a single figure, the captive female body. Breasts and legs and arms and belly once again become, for the viewer, the confirmation of the optimum relationship between woman and man—a confirmation that marks the limits on the distance Rodin's art travels from the dominant sexual economy of his day.

But what, finally, of the cases when the viewer was a woman? They did exist; they were well known to exist. The fact was an irritation to certain male critics, who laid the worst excesses of the Rodin cult at the door of their female counterparts. "It is the so-called *femmes de lettres,*" one wrote, "who in their hysteria have showered Rodin with the most absurd and foolish praise."[39] The critical spleen only makes it more necessary to ask what forms female praise actually took. There are real questions here: How was a woman to respond to Rodin's art? Were its truths hers? Or could they be adopted as such? (Remember that in Eisenstein's *October* the soldiers of the Women's Battalion lay down their arms and rediscover their femininity at the sight of Rodin's *Eternal Springtime.*) What, then, for the female convert, of the charges of brutality, the metaphors of penetration and violation? These, after all, were the very threats that, according to the best clinical knowledge of the day, produced in hysterics not admiration but the symptoms of their disorder.

There are many kinds of testimony that might help to answer these questions. Some only go to show that certain of Rodin's female audience—Isadora Duncan, Gwen John, and others—responded to Rodin in the terms the myth of his creativity provided. They were prepared to play Iris to his Hugo, in other words, and did. The celebrated passage where Isadora Duncan describes her encounter with the master sets the tone well enough:

> He gazed at me with lowered lids, his eyes blazing, and then, with the same expression that he had before his works, he came towards me. He ran his hands over my neck, breast, stroked my arms and ran his hands over my hips, my bare legs, and feet. He began to knead my whole body as if it were clay, while from him emanated heat that scorched and melted me. My whole desire was to yield to him my entire being, and, indeed, I would have done so if it had not been that my absurd upbringing caused me to become frightened.[40]

Once again the overlap between man and artist is essential: Rodin looks at Duncan as if she were a piece of sculpture and kneads her like a clay figure. But even so, this is not *quite* a response to Rodin's art *tout court;* nor can it be said to define the range of women's reactions to his work. There were artists—Clara Westhoff, Paula Modersohn-Becker and Camille Claudel among them—who mined Rodin's art for inspiration and sought his counsel on their own efforts. And there were critics—Séverine, Valentine de Saint-Point, and Aurélie Mortier, for example—who tried to explicate the nature of his phenomenal public appeal. Of these, it was Mortier, writing under the pseudonym Aurel, who

saw that public selectively; she tried above all to account for women's responses to Rodin's art. A suffragist, a symbolist fellow traveler, and a contributor to *Mercure de France,* it was Mortier who before Rodin's funeral protested that no woman was scheduled to speak; only then did Séverine mount the podium.[41] In 1919, two years after the sculptor's death, Mortier wrote *Rodin devant la femme.*[42] Rodin, the judge of a woman, was there judged in his turn. And the verdict was overwhelmingly positive. Rodin, she wrote, had changed her world, and had changed art. "If ever an art has ceased to be unisexual, has opened itself to human sensibility, that is to say, to woman as well as man: if ever an art has steeped itself in feminine force and has taken from it a greater acuity, a violence, a sting: if ever an art was the son of woman, it is that of Rodin."[43] This is Mortier speaking: for her, Rodin meant something akin to liberation. Thus she continued, "In front of Rodin woman dares to be free and to reject all pretense. She can stop playing at being man's quarry, his sweet, expensive plaything. She embraces her greatness and her autocracy. She can become an animal."[44]

It is my belief that this reading of Rodin, like the others I have cited, is predicated on the sexual content of his art. The sculpture's bodily plain speaking is taken as a counterproposal to the studied feminine *faiblesse* that mothers urge on daughters. Women's traditional trade in flirtation and kittenish behavior is replaced, in Rodin's brave new world, by the directness of animal passions. His bronze and marble women act out those passions, and their movements are the medium of Mortier's self-discovery; they show her the truth beneath the social veneer of women's seductive strategies—a truth once again conceived as that of the body as it really is. Rodin's art allows women to possess their bodies—that is Mortier's claim—and she, for one, is grateful.

One of the several ironies behind this feminist reading of Rodin (for such it certainly is) lies in the nature of another intellectual debt that Mortier admits.[45] The man who taught her to write, who gave her the courage to speak, was Jean Dolent, the littérateur who likened Rodin's art to the second stage in a rape. Mortier, needless to say, here parts company with her teacher; no suggestion of compliance with his fantasies of art and violence marks her work. Rather, Mortier self-consciously looks as a woman; Dolent as a man. The difference hinges on individual subjectivity, on the consciousness that approaches the works in question: or, stated rather differently, on the space art allots for the entry of the individual subject. Mortier saw Rodin's art as giving her back herself—a self that till then she had only half suspected. Dolent, by contrast, took the same objects as a space for desire, a trigger for the free play of fantasy—in short, as fulfilling one normal function that viewers of the day demanded of visual experience.

It is not now necessary to prefer one reading or the other, or even to take one as more "correct"—that is, in finer tune with the artist's intentions. (In any event, correctness and preference might very well be at odds.) It *is* necessary, however, to grasp that in neither model of looking, Mortier's or Dolent's, is that

activity performed as the function of some pure bodily essence, the result of the biological "fact" of being a man or a woman. Both readings, rather, are social performances, the declarations of complex, often contradictory, allegiances, beliefs, and avowals. Mortier's act of looking accordingly does not necessarily mean that she aligns with all other women; or Dolent's that he sides with all other men. Instead, each occupies a place within patterns and habits of thought that took on special density in bourgeois culture of the late nineteenth century. Could relations between the sexes be rewritten on a different basis? Could bourgeois women repossess their sexuality, understand and savor it? Could that sexuality be acknowledged and embraced in public; could it be seen as the equal of male desire? Or should the traditional order of dominance and possession be preserved at all costs? Rilke seems to agree with Mortier on these matters. For him, too, Rodin's art—above all, the passionate, intertwining bodies of the *Gates of Hell*—opened the prospect of a hitherto unknown parity between male and female passion:

> Here was desire immeasurable, thirst so great that all the waters of the world dried in it like a single drop, here was neither deception nor denial, and here the gestures of giving and receiving were real, were great. Here were vices and blasphemies, damnation and bliss, and suddenly one understood that the world, if it did not exist, must indeed be poor. It did exist. Running parallel with the whole history of the human race, there was this other history, innocent of covering, of convention, of rank and class—which knew only conflict. It, too, had had its historical development. From being a mere instinct, it had become a longing, from being an appetite between man and woman, it had become a desire of one human being for another. And as such it appears in Rodin's work. It is still the eternal conflict of the sexes, but woman is no longer the forced or willing animal. Like man, she is awake and filled with longing, it is as though the two made common cause to find their souls.[46]

With Rodin as a guide, Mortier and Rilke mean to take their distance (a limited and measurable distance, to be sure) from the fixity and stasis of the current notion of woman as sexual object, rather than sexualized subject. Yet their willed self-separation from the former position cannot stand here as the preferred reading of Rodin, simply because of the ways his art could be made to figure in the alternative account; above all, because of the ways it could be assimilated to the dominant habit, around 1900, of emblematizing fin-de-siècle social and sexual disarray in woman. Read Félicien Champsaur once again: "Today, under the setting sun of the last great century, the world's tyrant, Woman, whispers the dreams of her body and its lascivious gardens to men exhausted by novelties, by Sodom and Lesbos, by thought itself. Racked by desire, a neurotic and bewitched populace is haunted by sexual attraction."[47] This, of course, is no new woman, but her antithesis, the eternal feminine, exuding her aura of otherness and mystery, waiting, demanding to be known. Or at least so many of Rodin's

supporters believed; their confidence on this point helped to license the other reading of Rodin's treatment of sexuality (one chief agent of their "knowledge" of woman) as mastery, violence, and penetration.

And that reading of Rodin's art described Rodin himself, artist and man, the public figure and the private individual: that is to say, it characterized the way both aspects of his identity were overlaid in Rodin's reputation. Private became public in Rodin's case: "c'est l'esprit en rut." Critics repeated the phrase knowingly, sure that it spoke the truth. Remember that passage continues: "Rodin seeks to reap some benefit from the sensuality from which he suffers." To the extent that the sculptor could be imagined as founding an artistic practice on his own sexual appetites (an idea to which Rodin, with his view of male creativity, must in some sense have subscribed), he was to be understood as operating under the aegis and impulse of desire. (This, let it be noted in passing, was a force that, according to contemporary opinion, a woman could not easily tap when making art: "A sculptress loses her skill when confronted with the task of modelling the male body; a girl whom her teacher embraces whenever she successfully accomplishes a task, cannot achieve anything more.")[48] Hence, Arthur Symons wrote, in an assertion that serves as the epigraph to this chapter, "The principle of Rodin's work is sex—a sex aware of itself, and expending energy desperately to reach an impossible goal."

This was the late-nineteenth-century verdict on desire; it is still with us. And reading Freud in this context, as he too reckons with the possibility that something in the nature of the sexual instinct itself inhibits complete satisfaction, only affirms our sense of the deep roots of Rodin's reputation in contemporary thought. The various dimensions of the sculptor's public identity come together around this concept of desire. It is both the subject of his art and its motor. Accordingly, Rodin's recurrent efforts at locating the place where desire could at last be slaked—the pages and pages of drawings, the plasters and more plasters, the bronzes based on them, which attribute a ready openness and convenient accessibility to the female body, or sometimes see it already quickened by the sensations proper to love—these could and can be seen as projections of a desiring, lacking self as much as responses to an other, to a woman. Not that live models did not go through the motions Rodin describes; we know their names; experts even assure us of their genuine affection for their employer. But Rodin's project goes far beyond the limits of simple *description* of the female body, or even of female sexuality. This is a femininity that time and again, day after day, was made urgently, insistently genital, through a process of imagining and reimagining the site of desire. Little wonder that Symons wrote in 1900, about Rodin's drawn woman, "She turns herself in a hundred attitudes, turning always upon the central pivot of her sex, which emphasizes itself with a fantastic and frightful monotony."[49] But Symons gets the drawings wrong, of course; the monotony is Rodin's.

Yet Rodin's preoccupations were also those of his culture—and particularly those of the singular cross section of intellectuals who, in responding to his

art, first formed his reputation. To some readers, even at the time, their arguments must have seemed as extreme, as much a case of special pleading, as they may now appear.[50] That extremity was tempered, even licensed, by the contemporary view of the modern individual, of the modern condition: restless, movemented, unstable, feverish, indecisive, and at the mercy of a psyche that can find neither repose nor engagement. It was exactly *this* aspect of modernity, according to the sociologist Georg Simmel, that Rodin made visible, and had the viewer reexperience, with cathartic effect: "Rodin delivers us because he delineates with exactitude a precise image of this life, which is preoccupied by the passion of movement; a Frenchman has said of him: 'He is Michelangelo with three centuries of misery added.'"[51] The extremity and passion of the sculptor's figures, according to Simmel, is their truth, and their contemporaneity; their impact lay in the shock of self-recognition they provided. Mirbeau agreed: "What is poignant about Rodin's figures . . . , why they touch us so violently, is because we recognize ourselves in them, and because they are, as Stéphane Mallarmé has said, 'our companions in suffering.'"[52]

The sense of fit between Rodin's figures and contemporary self-understanding that his supporters convey is a verdict that intersects with their impassioned endorsements of the sexuality of his art. In fact, the two judgments are interdependent, to the extent that the fin-de-siècle reading of its own particular "modern condition" of suffering and neurosis decisively acknowledges a sexual basis for that state. Rodin's art—so its enthusiasts claim—embodies the new conditions of desire, gives them a range of representations, makes them flesh. And it does so most decisively, in their eyes, when it treats the sexuality of woman. Since she is the object of male (heterosexual) fantasy, representations of her sexuality can conveniently substitute, in art, for the sustained exploration, via drawing and sculpture, of the related, but veiled, topic of male sexuality. In fact, female sexuality *is* male sexuality for many of Rodin's viewers (and even for Rodin himself); that is to say, his representations of the surface and substance, energies and orifices, shudders and spasms, of female bodies sustain the confidence that they exist for, and confirm the functions of, male desire. In defining the woman as her body, Rodin's art thus seems to endorse both male mastery of woman and the fiction of male sexuality that takes mastery as its premise.

Yet these selfsame drawn and modeled bodies were also seen, by certain viewers, at least, to give heterosexual relations a new inflection. For some, no doubt, it was merely a matter of a timely adjustment, another case of the stylish updating that modernism seemed to call for on all fronts. For others, however—notably Mortier and Rilke—the sculpture offered a rather more far-reaching vision, an imagery confirming and celebrating the very existence of an unbridled female sexuality as the complement, rather than the object of male desires. That sexuality, it could now be acknowledged, meant strength, rather than abnegation; the bourgeois woman could embrace her carnality without it being equated with the pathetic and dismissible pleasures of a Nini or a Popo. A remarkable

moment, this, when female sexuality is reclaimed as bourgeois, and the century-wide gap between woman's identities as Madonna or Magdalen begins, ever so slowly, to close. Rodin's art, I believe, participated in that process, even while contributing to the maintenance of at least some of the attitudes to which Mortier saw it opposed. That the same representations could give rise to two such varying accounts—the patriarchal and the bourgeois feminist—should not strike us as odd or unexpected, but rather as a familiar and inevitable product of the complexity and volatility of Rodin's dealings with his subject, and of the subject itself. Is it not the case that the uses of sexuality are still disputed in patriarchy by a bourgeois feminist critique? One need only consider the current arguments about pornography and abortion, or imagine the possible reception of an art of the nude now, a century after Rodin. It is when alternative accounts can no longer feed themselves on the imagery proposed by the dominant culture that there is cause for concern.

NOTES

An earlier version of this paper was delivered in 1987 at the Department of History of Art, University of California, Berkeley. I am grateful for the responses of listeners on that occasion, for the comments of students in a seminar at Berkeley in 1988, and especially for the suggestions of Tim Clark.

Epigraphs:

R. M. Rilke, "The Rodin-Book [1902]," in *Rodin and Other Prose Pieces,* trans. G. Craig Houston (London: Quartet, 1986) p. 3, and Arthur Symons, "Les Dessins de Rodin," French trans. by Henry D. Davray, *La Plume,* numéro exceptionnel, 3me fasicule (1900): 383. Some passages of this brief text were reused by Symons in his longer essay, "Rodin," *Fortnightly Review,* June 1902, pp. 957–967, but this sentence and those quoted elsewhere in the present essay do not recur.

1. R. Dorment, "In the Hot-house," *Times Literary Supplement,* April 8–14, 1988, p. 379 (review of Frederic V. Grunfeld, *Rodin: A Biography* [New York: Holt, 1987]). Dislike and disgust for Rodin's conduct as a man and the contents of his art permeate Dorment's review. These attitudes accompany the belief that the artist, a "basically simple sculptor, was the creature and ploy of the Svengali-like literati, Octave Mirbeau and others, who urged him towards perversity."

2. Kirili insists particularly on taking these drawings as evidence of Rodin's emotional and sexual liberation, and above all, of his virility. "La répétition de ces vulves, pubis fouillés, mouillés, caressés est le signe profond que Rodin a surmonté la crainte de la castration, l'inquiétude irrationnelle de l'autre sexe" (p. 16). "Rodin est un grand amoureux et son érotisme reflète d'abord un tempérament et une existence riches en passions pour ses modèles, élèves, et égéries. Il a le souvenir d'une quantité de liaisons, de caresses, d'étreintes, d'orgasmes, de violences et de

douceurs. Que de mouillures et de foutre, que d'orgasmes il faut pour créer ce débordement impudique" (p. 18). Sollers, for his part, dwells even more enthusiastically than his co-author on a notion of the godlike Rodin (often called "le Créateur" in these pages) as a masterful impresario of female bodies, of female sexual secrets: "Rodin, jupitérien sous forme d'une pluie d'ondes, les pénètre de toutes parts, ces mortelles ou demimortelles, il se situe exactement à l'intersection de leur jouissance et du trait" (p. 9). And he relishes, for all the world like the author of a Paris-by-night guidebook, the idea of "Paris, la ville-mystère": "Vous qui entrez dans Paris, perdez toute espérance d'en apprendre davantage ailleurs. C'est ici, et ici seulement, qu'on étudie de près la Luxure" (p. 6). See Philippe Sollers and Alain Kirili, *Rodin: Dessins érotiques* (Paris: Gallimard, 1987).

3. For the photographer's account of the genesis of this photograph, as well as his attraction to the sculptor, see Edward Steichen, "Rodin's Balzac," *Art in America,* September 1967, p. 26.

4. Louis Vauxcelles, "Rodin, est-il un dieu?" *Gil Blas,* April 16, 1910. A similarly ambitious endorsement is undertaken by Georg Simmel in his "Rodin's Plastik und die Geisterichtung der Gegenwart," *Berliner Tageblatt,* September 29, 1902, rendered in French as "Rodin comme l'expression de l'esprit moderne," in *Mélanges de la philosophie relativiste,* trans. A. Guillain (Paris: F. Alcan, 1912), pp. 126–138.

5. The many photographic records of Rodin's person are spread widely through the literature. The single most useful source is Albert E. Elsen, *In Rodin's Studio: A Photographic Record of Sculpture in the Making* (Ithaca: Cornell University Press, 1980). See also *Rodin: L'Homme et l'oeuvre* (Paris, 1914), passim; *Rodin Rediscovered,* ed. Albert E. Elsen (Washington, D.C.: National Gallery of Art, c. 1981), pp. 245–247; Robert Descharnes and Jean-François Chabrun, *Auguste Rodin,* trans. Haakon Chevalier (New York: Viking Press, c. 1967), passim.; and Catherine Lampert, *Rodin: Sculpture and Drawings,* trans. David Macey unless otherwise noted, catalogue of an Arts Council exhibition in London, November 1, 1986–January 25, 1987 (London: Arts Council of Great Britain; New Haven: Yale University Press, 1986), passim.

6. For a view of the development and modification of journalistic responses to Rodin through the decades of his career, see Ruth Butler's introduction to her collection of criticism, *Rodin in Perspective* (Englewood Cliffs, N.J.: Prentice-Hall, 1980).

7. "Un Raté de génie," *Gil Blas,* September 30, 1896. Cited in translation in Butler, *Rodin in Perspective,* pp. 86–87.

8. Marcelle Tirel, *The Last Years of Rodin,* trans. R. Frances (London: A. M. Philpot, n.d.), p. 16. Published in French as *Rodin intime, ou l'envers d'une gloire* (Paris: Editions du Monde Nouveau, 1922). The Bibliothéque Nationale catalogue notes twelve editions before 1923. The sculptor's son, Auguste Beuret, is the author of a brief "Lettre-préface," testifying to the "exactitude et verité" of her account. In 1919 excerpts from Tirel's book were serialized in the press under the title "Mémoires d'un chien de garde." See clippings in Rodin 106, Fonds Vauxcelles, Institut d'Art et d'Archéologie, Paris.

9. An interesting point of comparison to the construction of this view of Rodin's special relationship to the material world is the notion of Courbet that emerged in

obituary notices and articles published after his death in 1877, particularly the observations produced by Camille Lemonnier in *G. Courbet et son oeuvre. Gustave Courbet à la Tour de Peilz. Lettre du Dr. Paul Colin* (Paris: A. Lemerre, 1877). There a fascinated focus on Courbet's bodily appetites as a younger man and the swollen, diseased body of his last years substitutes for a sustained endorsement of his talent; it is as if his flesh and mortality become the condition that most limited the full development of his genius.

10. Léon Riotor, cited in Gustave Coquiot, *Le Vrai Rodin* (Paris: Librairie G. Taillandier, 1913), p. 3.

11. Gustave Geffroy, "Auguste Rodin," in *La Vie artistique,* vol. 2. (Paris: E. Dentu, 1893), p. 67. Geffroy dedicated this volume of his collected criticism (there were eight in all, between 1892 and 1903) to Rodin, in terms that merit reproducing: "Je vous dédie ces pages de bataille et de rêverie, mon cher Rodin, en reconnaissance de la compréhension d'art et de la joie de pensée que nous a donnée votre oeuvre. Vous avez affirmé, avec un accent nouveau, la profondeur des sentiments humains, la tristesse et l'allégresse de l'amour, la grandeur de l'intelligence, la beauté sans trève et sans fin de la vie. Je suis heureux d'inscrire ici mon nom comme celui de l'un des admirateurs du statuaire et des amis de l'homme." Geffroy's essay "Auguste Rodin" was first published, in a slightly different version, in *Revue des Lettres et des Arts,* January 9, 1889, pp. 289–304, and the same year served as Geffroy's contribution to the catalogue of the joint exhibition of works by Monet and Rodin staged at the Galerie Georges Petit. See Galerie Georges Petit, *Claude Monet. A. Rodin,* catalogue of an exhibition held in Paris in June, 1889 (Paris, 1889), pp. 46–84. By the time it was reprinted again in 1893 it had become one of the cornerstones of Rodin's reputation.

12. Edouard Rod, "L'Atelier de M. Rodin," *Gazette des Beaux-Arts,* 3d. per., 19 (May 1, 1898): 419.

13. Ibid., p. 420.

14. Geffroy, "Auguste Rodin," p. 115.

15. Rod, "L'Atelier de M. Rodin," p. 430. According to Rod, the phrase was coined by Eugène Carrière, an essential member of Rodin's artistic circle and the author of a portrait of the sculptor. Yet the notion of Rodin as a being in communion with nature had wide currency. It is repeated, for example, in an article written by the young Georges Rouault, "Trois Artistes," *Mercure de France,* November 16, 1910, pp. 654–659; there "communing with nature" is given explicitly mythological form; Rodin is made to address his remarks to the god Pan, "l'âme même de la nature."

16. Octave Mirbeau, *La Plume,* numéro exceptionnel, 2me fasicule (1900): 338. Note that Mirbeau's description of the "pagan" Rodin follows on the heels of his protest at the tenor of the uses made of Rodin by other (unnamed) critics: "A les en croire, M. Auguste Rodin serait tout, thaumaturge, poète satanique, philosophe mystique, mage, apôtre, astrologue, tout, sauf l'étonnant et parfait statuaire qu'il est" (p. 337).

17. Ibid., p. 338.

18. Charles Morice, *Rodin* (Paris: Editions Floury, 1900), pp. 10–11. This text was read by Morice on May 12, 1899, at the Maison d'Art, Brussels, on the occasion of an exhibition of the sculptor's works.

19. See Sherry B. Ortner, "Is Female to Male as Nature Is to Culture?" in *Woman, Culture, and Society,* ed. M. Z. Rosaldo and L. Lamphere (Stanford, Calif.: Stanford University Press, 1974). The writings of Jules Michelet, of course, offer one extreme, but by no means isolated, view of the interconnectedness of woman and nature: "La femme est nature autant que personne." See Gladys Swain, "L'Ame, la femme, le sexe et le corps: Les Métamorphoses de l'hystérie à la fin du XIX^e siècle," *Le Débat,* no. 24 (March 1983): 107–127. I am grateful to Thomas Laqueur for bringing this article to my attention.

20. Stuart Merrill, "La Philosophie de Rodin," *La Plume,* numéro exceptionnel, I^{er} fasicule (1900): 306.

21. Merrill's view of the metaphysics of Rodin's art locates the sculptor as "le grand poète de la douleur et de la passion," in an age of pain and passion—a view that parallels the opinions of Mirbeau and Simmel cited below.

22. Jean Dolent [Charles-Antoine Fournier], *Maître de sa joie* (Paris: Alphonse Lemaire, 1902), p. 126. The passage is dated within the text to January 1889; given Morice's partial citation (n. 18 above), it seems likely that it was published elsewhere before its appearance in 1902, but I have not yet located an earlier version. The full passage was quoted by Coquiot in *Le Vrai Rodin,* pp. 44–45, in 1913.

23. Forain's hostility to Rodin gave rise to a caricature published in *Le Figaro,* June 3, 1912, showing the sculptor directing a female model to undress in the former chapel at the Hôtel Biron; in 1916 the image fueled the debate, conducted in the French Senate and Chamber, and joined by journalists on the right like Louis Dimier, on the advisability, from the point of view of public morality, of accepting Rodin's proposed gift of his estate to the nation. See Louis Vauxcelles's coverage of the affair in his weekly column, "Le Carnet des ateliers." Clippings in Rodin 106, Fonds Vauxcelles, Institut d'Art et d'Archéologie, Paris. The debates of both Houses, as well as the report of the committee charged with studying the proposed gift, are reproduced in Gustave Coquiot, *Rodin à l'Hôtel Biron et à Meudon* (Paris: Librairie Ollendorff, 1917), pp. 130–224.

24. For a discussion of the production of marbles in Rodin's studio and his use of carvers, see Daniel Rosenfeld, "Rodin's Carved Sculpture," in *Rodin Rediscovered,* ed. Elsen, pp. 81–104, and Grunfeld, *Rodin,* pp. 566–571.

25. A marble of this figure was shown at the Rodin-Monet exhibition at the Galerie Georges Petit, Paris, in 1889; the same figure was exhibited the following year at the Salon du Champs de Mars. See Nicole Barbier, *Marbres de Rodin: Collection du Musée Rodin* (Paris: Musée Rodin, 1987), no. 58, pp. 140–143.

26. Raoul Ponchon, *Le Courrier Français,* June 3, 1888.

27. Morice, pp. 5–6. "L'Hostie" (the victim, or the sacrifice) was the name Morice here attributed to the *Eternal Idol.* It was not unusual for Rodin's works to be renamed several times in the course of their public display and criticism; Rodin was himself often—though not always—the source of the various titles.

28. For a discussion of the significance of the stages of the Hugo monument, see Jane Mayo Roos, "Rodin's Monument to Victor Hugo: Art and Politics in the Third Republic," *Art Bulletin,* December 1986, pp. 632–656. See also Rosalyn Franklin Jamison, "Rodin's Humanization of the Muse," *Rodin Rediscovered,* pp. 105–126.

29. Rilke, "Rodin-Book," p. 41.

30. Séverine [Carline Rémy], "Les Dix Mille Francs de Rodin," *Le Journal,* November 10, 1894.

31. Elsen, *In Rodin's Studio,* Fig. 95.

32. Symons, "Les Dessins de Rodin," p. 384.

33. Maurice Barrès, *Mes cahiers* (Paris: Plon, 1931), 4:124–127.

34. This identification, proposed by Grunfeld, *Rodin,* pp. 474–475, seems plausible, both on the basis of the references to Anna de Noailles surrounding this set piece in Barrès's journal and given the close relationship of the two writers at this time.

35. Geffroy, "Auguste Rodin," pp. 93–94:

36. Patricia Sanders, "Auguste Rodin," *Metamorphoses in Nineteenth Century Sculpture,* ed. Jeanne L. Wasserman (Cambridge, Mass.: Fogg Art Museum, 1975), p. 170.

37. Geffroy, "Auguste Rodin," p. 98.

38. Ibid., p. 99.

39. Coquiot, *Le Vrai Rodin,* p. 6. The subject of Rodin and his female admirers is much larger than the treatment it receives here, as is likewise the issue of his relationships with female models. The pamphlet *Pour le Musée Rodin* (Tours: E. Arrault, 1912), with an introductory essay by J. Cladel, provides a good list of the bourgeois women prepared to support Rodin in public. It is reproduced in the extensive bibliography compiled by J. A. Schmoll, gen. Eisenwerth, *Rodin-Studien: Personlichkeit, Werke, Wirkung, Bibliographie,* Studien zur Kunst des neunzehnten Jahrhunderts, vol. 31 (Munich: Prestel-Verlag, 1983), p. 450.

40. Isadora Duncan, *My Life* (New York: Liveright, 1927), pp. 89–91.

41. Grunfeld, *Rodin,* p. 634. The text of Séverine's address was published as "Auguste Rodin," in *La Vie Feminine,* December 2, 1917. The archives of the Musée Rodin give a slightly different twist to the story that Grunfeld reports. In fact Mortier proposed herself as the necessary female speaker rather than Séverine. On November 24, 1917, she sent a telegram to Léonce Benédite that read: "Il serait injuste de ne pas porter tantot à Rodin l'adieu de la femme. Je suis prête à le faire en 50 mots la dernière, si voulu." The telegram is quite consistent with the sense of Mortier's rather self-serving relations with Rodin conveyed by her letters to the sculptor, which are also housed in the Musée Rodin archives. (Other of Mortier's papers were her gift to the Bibliothèque historique de la Ville de Paris.) After initiating a correspondence with him in September 1904, she occasionally tried to produce the sculptor as a kind of "special attraction" at the various lectures and benefits she organized in Paris. More interestingly, however, her letters to Rodin served as the vehicle in which she first phrased many of the ideas about his art that she was later to publish in her essay and book about him (see note 42 below). The route Mortier took to a career as a writer, via the influence of Rodin and Jean Dolent, increasingly became part of her public message; her purpose was to influence other women to begin to write themselves. During the war her feminist message became more and more overlaid with nationalism, and a kind of reactionary or regressive feminism was the result. Valentine de Saint-Point, whose "La Double Personnalité d'Auguste Rodin," appeared in *La Nouvelle Revue,* 43 (1906): 29–42, 189–204, followed her own reactionary path as the author of the "Manifeste de la femme fu-

turiste" (1912), with its call for female rediscovery of women's supposed instinct for violence and cruelty.

42. Aurel [Aurélie Mortier], *Rodin devant la femme* (Paris: Maison du Livre, 1919). The book is a considerable expansion of her article "Rodin et la femme," *La Grande Revue* 86 (July 25, 1914): 206–219.

43. Aurel, *Rodin devant la femme,* p. 9.

44. Ibid.

45. Aurel, *Jean Dolent et la femme* (Paris: Eugène Figuière, 1911). The text reproduces a lecture given by Mortier at the Salon d'Automne in 1910. It should be noted that although Mortier shows no interest herself in sexual violence (unlike Valentine de Saint-Point) she does cite here the passage in which Dolent likens Rodin's art to rape. She does so in order to illustrate Dolent's style and the equation she and Dolent (and Rodin) made between style and sexuality: "Le style, c'est l'amour" (p. 9).

46. Rilke, "Rodin-Book," p. 22.

47. Félicien Champsaur, *Dinah Samuel, édition définitive* (Paris: Paul Ollendorff, 1889), pp. xxxviii–xxxix. The quotation is from the novel's preface, "Le Modernisme."

48. Sigmund Freud, in *Minutes of the Vienna Psychoanalytic Society,* vol. 1 (New York: International Universities Press, 1962), p. 211, meeting of October 9, 1907, cited in Juliet Mitchell, *Psychoanalysis and Feminism* (New York: Pantheon, 1974), p. 433. Freud's remark occurs in the course of discussion of a paper by Wilhelm Stekel, "The Somatic Equivalents of Anxiety and Their Differential Diagnoses." Freud agrees with Adolf Deutsch that sexual abstinence has an adverse effect on female talent. "The fact that many women are ruined by abstinence," Freud states, "has much bearing on the problem of women's emancipation."

49. Symons, "Les Dessins de Rodin," p. 384.

50. Camille Mauclair, one of Rodin's chief supporters later in his career, argues that Rodin's reputation was relatively late in coming simply because for many years it appeared that responses to him were the biased observations of friends. And, of course, it was exactly those conditions that allowed the emergence of the sexualized account of Rodin's genius I have tried to detail. See Mauclair, *Idées vivantes* (Paris: Librairie de l'Art Ancien et Moderne, 1904), pp. 6–8.

51. Simmel, "Rodin comme l'expression de l'esprit moderne," p. 138. The list of adjectives given in the text to describe the modern condition is distilled from this essay.

52. Octave Mirbeau, "Les Oeuvres de Rodin á l'exposition de 1900," *Des Artistes,* 2d ser. (Paris: Flammarion, 1924), p. 224.